A COMPLETE HISTORY OF AMERICAN

PETER LANG
New York • Washington, D.C./Baltimore • Bern
Frankfurt am Main • Berlin • Brussels • Vienna • Oxford

SHIRREL RHOADES

A COMPLETE HISTORY OF AMERICAN

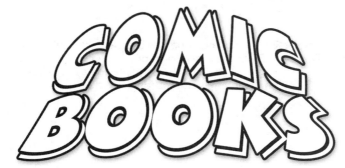

COMIC BOOKS

AFTERWORD BY STEVE GEPPI

PETER LANG
New York • Washington, D.C./Baltimore • Bern
Frankfurt am Main • Berlin • Brussels • Vienna • Oxford

Library of Congress Cataloging-in-Publication Data

Rhoades, Shirrel.
A complete history of American comic books / Shirrel Rhoades.
p. cm.
Includes bibliographical references and index.
1. Comic books, strips, etc.—United States—History—20th century.
I. Title.
PN6725.R54 741.5′6973—dc22 2007043460
ISBN 978-1-4331-0110-6 (hardcover)
ISBN 978-1-4331-0107-6 (paperback)

Bibliographic information published by **Die Deutsche Bibliothek**.
Die Deutsche Bibliothek lists this publication in the "Deutsche
Nationalbibliografie"; detailed bibliographic data is available
on the Internet at http://dnb.ddb.de/.

Author photo by Scott C. Campbell
Cover design by Clear Point Designs

The paper in this book meets the guidelines for permanence and durability
of the Committee on Production Guidelines for Book Longevity
of the Council of Library Resources.

© 2008 Peter Lang Publishing, Inc., New York
29 Broadway, 18th floor, New York, NY 10006
www.peterlang.com

Printed in the United States of America

CONTENTS

I had a great feel for comics. I was very optimistic about the future.[1]
 —Jack Liebowitz, one of the founders of DC Comics

I never thought that Spider-Man would become the worldwide icon that he is. I just hoped the books would sell and I'd keep my job.[2]
 —Stan Lee, legendary Marvel Comics editor and co-creator of Spider-Man

PREFACE

So a squirrel, Jack Kirby, and a Mormon all walk into a bar. . . . Okay, that's not going to work, a Mormon wouldn't walk into a bar—So a squirrel and Jack Kirby walk into a bar. Okay. The squirrel says to Kirby, "Tell me that story about Stan again . . ."[1]

—Valerie D'Orazio, an "Occasional Superheroine"

SO here I am, a footnote in the history of comics. But it feels pretty good, having been publisher of Marvel Comics. (And yep, I can tell you a few stories about my ol' colleague Stan Lee.)

Comic books have an interesting history, filled with quirky people, funny anecdotes, and amazing imaginations. People argue about its roots—cavemen, pharaohs, medieval scribes, American entrepreneurs—but there's no denying that the comic book as we know it today had its beginnings in the 1930s. What we like to call the Platinum Age. Those ages that

follow—the Golden Age, marked by the appearance of Superman; the Silver Age, invigorated by Stan Lee and Jack Kirby; the Bronze Age, with the rise of the X-Men; and today's Modern Age, with its darker, more psychological take on superheroes—are parts of a twisted tale filled with eccentric creators and intriguing creations. Dr. Frankensteins breathing life into a myriad of heroes and monsters.

Well, if not monsters, then mutants, changelings, atomized scientists, gamma-ray accidents, and supernaturally empowered heroes and villains that challenge the imagination and spark the secret identities lurking within all of us.

Okay: How did I get to be publisher of Marvel Comics?

An old friend, Jerry Calabrese, was president of Marvel at the time. He knew me from the magazine industry, where I'd worked with titles ranging from *Harper's* to *Ladies' Home Journal.* It didn't matter to Jerry whether I read comics or not. (He didn't.) He needed publishing help and he offered me a six-month consulting gig to help him figure out how to structure the company. "Give me a White Paper," he instructed. "And if you're smart, you'll tell me I need a publisher and that you're the guy."

A few weeks later, to my surprise, Jerry left Marvel (though he later came back for a short time) to be replaced by an investment-banker type named Scott Marden. Scott drew up an employment contract to officially make me the publisher (although we couldn't call it that at the time, for Stan Lee's contract specified that *he* would retain that title, even if in name only). A short time later Scott gave up his role, replaced by a former NBA marketing exec named David Schreff. He gave me the title of executive vice president as parity with my counterpart at DC Comics (that being Paul Levitz's title at the time).

Shortly after that, David was essentially dethroned when a Turner Network exec named Scott Sassa was hired as chairman and CEO of Marvel by then-owner Ronald O. Perelman.

This was the beginning of what a book by Dan Raviv calls the Comic Wars, an epic battle between billionaire Ron Perelman and takeover titan Carl Icahn for control of Marvel Entertainment.

In my almost three years as publisher of Marvel I reported to five presidents and four chairmen under four "ownerships."

When I arrived at Marvel, the publishing division was losing money. When I left, it was the only division *making* money.

I've often said it was the best job I ever had—and the worst.

Marvel had been in a slump, and I was determined to "publish our way out of it." We launched new titles, new imprints, explored new and old genres.

During that period Marvel won the coveted Wizard Award for Publisher of the Year. I have the bronze statuette sitting atop my bookcase here in Key West, where I now live.

The publishing staff rallied around me. While I convinced upper management—that ever-changing array of presidents and chairmen—that I was their watchdog over publishing, at the same time I convinced the staff that I was *their* buffer against the suits upstairs. And I proved it to them more than once. Comic book fanatics that they were, they started calling me the Human Shield, the guy who would take a bullet for them.

However, an even dicier audience was the comic book retailers. At the first San Diego Comic-Con I attended, my meeting with a group of key retailers started off with the challenge, "What makes you think you're qualified to be the publisher of Marvel?" A tough crowd. I started talking about the comic books I read and collected. How I liked the *Micronauts* art of Michael Golden. How I collected old *Airboy* comics. How I owned *Amazing Spider-Man* #1 (then valued at $40,000 according to *Wizard*'s price guide). How I liked Chris Claremont's run of *X-Men* but admired where Bob Harras had taken the series. Whew!

I won them over. Yes, I was one of them—a fanboy.

After that, me (as publisher), Bob Harras (then editor in chief), and Jim "Ski" Sokolowski (then VP of editorial planning) were known to insiders as the Holy Trinity—Father, Son, and Holy Ghost.

But all things come to an end. The result of the Comic Wars was the eventual takeover of Marvel by Toy Biz's Ike Perlmutter, a notorious penny pincher. All the high-priced execs were chopped off—then me, then Ski, and finally Bob.

As it turned out, after another series of staffing changes, Marvel's publisher is now Dan Buckley, whom I had recruited back to the publishing company from Fleer/Skybox, and the editor in chief is Joe Quesada, whom I had brought in to create the critically acclaimed *Marvel Knights* line.

And in the years that followed, I've done some strategic consulting for DC Comics—and Bob Harras and Ski work there now.

So I have friends in *both* Universes!

For those reasons—my insider knowledge of comics, my access to the top publishers, and my passion for the sequential art form—Peter Lang Publishing asked me to write this history of the American comic book, and the companion guide on how the comic book industry actually works.

Start with this volume. Then read the second one.

I hope you will find—to use Bob Harras's highest praise—that "it doesn't suck too bad."

Shirrel Rhoades
Key West, Florida

HISTORY OF THE COMIC BOOK WORLD

To look back and know that I have had a pivotal role in the development of comics is something I'm very proud of, although it's not something I think about unless someone brings it up. Comics have become a unique art form. When I and the other young artists were working in comics, our work carried with it a particularly American slant. After all, we were Americans drawing and writing about things that touched us. As it turned out, the early work was, you might say, a comic book version of jazz. In the sense, that is, that jazz too was a uniquely American art form.[1]
—Joe Simon, the artist-writer who co-created Captain America

JOE Simon complains that comic book histories aren't written by people who were there.[2] Unfortunately, there aren't too many of them still around. Joe wants to tell his own story. And Stan Lee jovially claims he can barely remember last week.[3] So you'll have to make do with me and the friends I've called on. No, I wasn't around in the old days. But I did have my foot in the door.

WHEN IT ALL BEGAN

The **comic book** (as we know it) originated in the early 1930s as a way of binding Sunday funnies into a magazine-like format. **Comic strips** had begun appearing in newspapers in the late nineteenth century. These sequential panels of cartoon drawings were mostly humorous in nature—hence "comics."

The term *comic book* evolved from *comic strip*. This misnomer has caused minor confusion over the years, since "comic book" refers to the medium, not the type of content being published. Even the colloquial description of "funny book" implies a sense of mirth that's often missing in today's somber superhero battles between Good and Evil.

SO WHAT IS A COMIC BOOK?

Before we go any further, let's make sure we agree on what we're talking about—although you'd have to be John Carter's neighbor on Mars not to recognize a comic book when you see one.

My favorite definition calls comic books "the rock 'n roll of literature."[4] But that may be a bit vague to you Martians out there.

One dictionary defines a comic book as "a magazine devoted to comic strips."[5]

Hmm, true. But perhaps a bit simplistic.

Let's try again.

In *Understanding Comics,* Scott McCloud waxes philosophical: "Comic books are considered a visual piece of art in sequence." He elaborates that comics are "juxtaposed pictorial and other images in deliberate sequence, intended to convey information and/or produce an aesthetic response in the viewer."[6]

Huh?

Heck, let's take a crack at it ourselves:

> **com·ic book (n.)** Most often a 6 5/8-by-10 3/16-inch stapled magazine that consists of thirty-two pages plus cover and contains sequential panels of four-color art and written dialogue that tell an original story for entertainment purposes.

There you have it, a workable definition for our purposes. That's not to say there aren't exceptions: variation of sizes (digests, slims, and so on), variation in page count (sixteen-page minis, thick "phone books"), variation in coloring (spot colors, black-and-white only), variation in editorial content (factual stories, Bible stories, memoirs, diaries), varia-

tion in purpose (educational, promotional, journalistic). Yep, you can easily find every rule being broken.

Nonetheless, the majority of mainstream comics—those published by the two dominant comic book companies, DC and Marvel—fit our ad hoc definition. And given today's market, these comics are likely to present the adventures of costumed superheroes in epic battles against supervillains. Kinda like WWE wrestling—with a plot.

EARLIEST COMICS?

Some sticklers contend that comic books had been around since the previous century. *The Adventures of Obadiah Oldbuck,* a pirated translation of Rodolphe Töpffer's *Histoire de M. Vieux Bois,* was published in the United States as a magazine-formatted newspaper supplement in 1842. And *Journey to the Gold Diggins by Jeremiah Saddlebags*—"the earliest known American-created sequential comic book"—had appeared in 1849.[7]

FOOTNOTE

Collector Steve Meyer recently acquired a rare copy of the 1849 *Journey to the Gold Diggins by Jeremiah Saddlebags* for $11,500. This same comic sold for 25 cents back in the late 1840s. "I am very humbled and honored to now own such a historically important and very rare piece of Americana . . . the 1st comic book by American creators," says Meyer.[8]

These early efforts *were* sequential art storytelling but didn't quite resemble today's comic book in size and presentation. You might say, "Close, but no cigar!"

Not until Maxwell C. Gaines (father of *Mad* magazine founder William M. Gaines) came up with a little number called *Funnies on Parade* in 1933. But more on that in the next chapter . . .

AN AMERICAN ART FORM

Comic books and jazz are often described as being the two uniquely original American art forms. (But what about rock 'n' roll? And shouldn't you credit Andy Warhol et al. with Pop Art too?)

Some historians point out that earlier "comics" had appeared in Europe: Töpffer's *Histoire de M. Vieux Bois* (The Story of Mr. Wooden Head) was completed in 1827 but not published until 1837.[9] And *Les Aventures de Tintin* (The Adventures of Tintin), by Hergé, made its appearance as a supplement in a Belgium newspaper in 1929.[10]

Despite various claims to earlier firsts abroad, there's no disputing that Americans nurtured and developed the fledgling new medium into something uniquely their own.

As comics analyst and artist Scott McCloud observes, "I don't think comics were invented in America as is often claimed, but the U.S. did give comics an exciting rebirth in the 20th Century."[11]

ROCK OF AGES

FOOTNOTE

Today I'm the president of the Key West Art & Historical Society, overseeing three museums: the Custom House, the Light House, and Fort East Martello. So, as I take you on this tour of comic book history, I can actually claim credentials as a historian. History is important. Understanding that which came before affords us a better understanding of where we are today. (End of "Author's Message.")

Historians like to sort American comic books into a number of distinct "ages" or historical eras—Platinum, Golden, Silver, Bronze, and Modern. The beginning and ending of each era tend to be fuzzy, with various experts asserting one event or another as starting points.

Since I'm writing this book, you'll have to accept my "expert" opinions. But trust me, you won't find them far off the general wisdom.

Many historians outline the so-called **comic book ages** like this:

TIME PERIOD	COMICS AGE
1897–1937	Platinum or Pre-Golden Age
1938–55	Golden Age
1956–72	Silver Age
1973–85	Bronze Age
1986–present	Modern Age (also called the Plastic, Tin, or Iron Age)

"Always a hot topic of debate amongst comic book collectors, the exact start dates of each period are not firmly set in stone," acknowledge comic historians writing on the Everything2 website.[12]

EVERYBODY HAS AN OPINION

In *The New Ages: Rethinking Comic Book History,* Ken Quattro makes some good suggestions for revising these ages, the best one dividing them into larger groupings he calls eras:

TIME PERIOD	COMICS ERA
1938–55	First Heroic Era
1955–58	Code Era
1956–86	Second Heroic Era
1986–present	Third Heroic Era

"These Eras don't necessarily correspond exactly with the Ages," explains Quattro. "Trends sometimes precede an Age, as a harbinger of what would eventually become the prevailing direction of the comic medium. Other times, they span several Ages."[13]

I like these era groupings as a way of putting comic books into a larger historical perspective—especially when looking at the three big

"waves" of superhero comics. Nevertheless, we'll stick to the ages concept in examining the finer points of comic book history.

OVERSTREET WEIGHS IN

All this notwithstanding, Steve Geppi's Gemstone Publishing has proposed the following amendments to the dating of comic book ages:

TIME PERIOD	COMICS AGE	CATALYST
1828–82	Victorian Age	
1883–38	Platinum Age	
1938–45	Golden Age	*Action Comics* #1
1946–56	Atom Age	Fear of Bomb
1956–71	Silver Age	*Showcase* #4
1971–85	Bronze Age	Death of Gwen Stacy (*AMZ* #121)
1986–92	Copper Age	DC's *Crisis*
1992–99	Chrome Age	Image Comics debuts
2000–present	Modern*	

*Not the same "Modern Age" as described above, below, and in other history books, this is merely a proposed reassignment of the term.

Since Gemstone is the publisher of the authoritative *Overstreet Comic Book Price Guide,* we're obligated to take these suggestions seriously. As noted in its *Scoop* newsletter, "Our intent here is to challenge our readers and ourselves to more accurately define an important part of comic collecting. . . . We're looking forward to hearing what you think!"[14]

After receiving reader feedback, their list has been slightly amended from time to time, but the above chart is a good reference point for comparing *our* proposed timetable.

HEY, BUDDY, GOT THE TIME?

For this particular history of the American comic book, we won't dwell on the "proto-comics" of the Victorian Age beyond the passing references made earlier in this chapter.

Nor will we start the beginning of the Platinum Age until Max Gaines's introduction of the "modern" comic book format in 1933. We're consistent with Quattro on this (although he calls the era by another name).

And while we agree that the Atom Age defines a specific period of genre diversification, we'll leave it as a subset of the Golden Age.

In the same way, we will treat the Copper Age (which we're measuring from the appearance of *The Dark Knight Returns* and *Watchmen*) as a subset at the beginning of the Modern Age. And the newly proposed Chrome period (marked by the 1992 debut of Image Comics) will provide a second subset that completes the so-called Modern Age.

Finally, we will argue for a Postmodern Age (call it the Adamantium Age, if you like) that stretches from the postbankruptcy period of Marvel up until the present. This is when Marvel's *Ultimate* line appeared, the industry started getting back on its feet, and graphic novels became a growing force in the heretofore underpenetrated bookstore market. Some have referred to this age as "a new Golden Age," but we won't confuse matters by reusing this glittery terminology.

And if you want to quibble, 1992 through 1999 should be more accurately tagged Chromium than Chrome, for this period marked the downturn that resulted from flooding the speculator market with variant covers, pseudo #1's, holograms, embossing, and, yes, chromium covers.

As for what to call more recent ages, perhaps in another dozen years we'll have enough perspective to more properly assign bright and shiny metal names to all the relevant segments.

So our timetable (for the purposes of this book) is as follows:

TIME PERIOD	COMICS AGE	CATALYST
Pre-1933	Victorian Age	Proto-comics
1933–37	Platinum Age	Max Gaines' *Funnies on Parade*
1938–55	Golden Age	DC's *Action Comics* #1 (Superman)
1946–55	Atom Age	Multiple genre (horror, sci-fi, teen)
1956–70	Silver Age	DC's *Showcase* #4 (superheroes return)
1970–85	Bronze Age	DC's *Fourth World* (Kirby leaves Marvel)
1986–99	Modern Age	Darker, psychological comics
1986–92	Copper Age	DC's *Dark Knight Returns*, *Watchmen*
1992–99	Chromium Age	Image Comics debuts
1999–present	Postmodern Age	Marvel's *Ultimate* retcon, graphic novels

There you have it, a workable structure to analyze the history of comics. To gain a better understanding of the American comic book, we'll examine these ages one at a time.

But more important than these so-called ages, we will identify a baker's dozen of events that have been important **milestones** in making the comics industry what it is today.

So hold on to your jetpacks. Set your decoder rings. Here we go!

THE PLATINUM AGE

THE FIRST COMICS

Geeks, gangsters and the birth of the comic book—we'll look back at the tawdry roots of the comics industry, a far cry from today's stories starring square-jawed heroes.[1]

Harry and his peers were just trying to make some money, have some fun, and print some pictures of naked girls. But they assembled a machine out of cheap paper and crooked distribution and young men's hunger that could deliver dreams no one had dreamed before.[2]

IT was just a quick way to make a buck, this reprinting the Sunday funnies. Nobody was trying to invent a new publishing medium. Nobody was trying to create a new art form.

Most of the early comic book publishers were already in the business, cranking out pulp magazines and dime novels. This was just another way to put shekels in the till, reprinting newspaper comic strips and selling them through newsstands.

These collections included such well-known newspaper strips as *The Yellow Kid, Mutt & Jeff, Dick Tracy, Popeye, Katzenjammer Kids,* and *Mickey Mouse.*[3]

"The crash of the Stock Market in 1929 was a turning point in the comic books' history," observes historian Rafael de Viveiros Lima.[4] The Great Depression created a demand for escapist entertainment, particularly a type that was cheap.

A PLATINUM PAST

Comic books published during the short five-year span of 1933 to 1938 are considered part of the **Platinum Age of Comics**. As noted in the last chapter, we date its beginning with the appearance of Maxwell C. Gaines's *Funnies on Parade.*

‹MILESTONE #1:
THE COMIC BOOK FORMAT IS INVENTED.›

In 1933, when Gaines devised the first four-color saddle-stitched newsprint pamphlet, he invented the format that would become the standard for the comic book industry.

A big man with a gimp leg, Max "Charlie" Gaines was a salesman at heart. But things were slow as the country came out of the Great Depression. Gaines, "like a great many Americans of the time, badly needed income."[5]

The notion for the "comic book" came to him one day "when he was cleaning his mother's attic, and he started reading a stack of old newspaper comic sections."[6] Hmmm. He took his idea to Eastern Color Printing, only to learn that Eastern was already doing comic strip reprints as tabloid-sized promotional giveaways. Gaines suggested folding the tabloid in half to create a sixty-four-page magazine format. The result was *Funnies on Parade.* And Proctor & Gamble bought copies to use as a premium.

Funnies on Parade had all the physical requirements of a "standard" modern-day comic book:

» A magazine format;
» Sequential art that told a story; and
» Four-color printing.

What it didn't have (yet):

» Original editorial material;
» Superhero genre; and
» A price on the cover.

NEXT STEPS

Max Gaines's second comic book was *Famous Funnies: A Carnival of Comics.* Also printed in 1933, it contained sixty-four pages of recycled newspaper strips—favorites like *Dixie Dugan, Joe Palooka, Keeping up with the Joneses,* and *Hairbreath Harry.* This pamphlet was distributed to the public through Woolworth department stores.[7] A collaboration between Eastern and George Delacourte's Dell, it has been called "the cornerstone for one of the most lucrative branches of magazine publishing"—that is, the comic book industry.[8]

Gaines believed he could also sell these comics on the newsstand, but his boss was doubtful that anyone would pay for a comic strip they had already seen in the newspapers. To try out his idea, Gaines slapped ten-cent stickers on some copies and took them to local newsstands over the weekend. "He told the newsstands what he was testing to see if these could sell and that he'd be back Monday to see how they were doing. Monday came around and to his surprise, they had all sold out and the newsstands were asking for more."[9]

By May of the next year, Gaines had produced another "first issue" of *Famous Funnies* especially to be sold on newsstands. After that, it was published on an ongoing twice-a-month schedule.[10]

What a great idea, selling these cartoon stories that everybody loved to read!

ENTER THE COMPETITION

Famous Funnies was a hit. However, "shortly after the [bi-]monthly began, Eastern cut Gaines out of the deal and kept the comic book for itself. Gaines responded by partnering up with McClure Syndicate . . . to publish comic books of his own, reprinting *Moon Mullins, Don Winslow of the Navy, Alley Oop* and many others; and suddenly *Famous Funnies* had competition."[11]

The success of these ventures attracted pulp magazine publishers such as Martin Goodman (founder of what would become Marvel Comics), printers such as Harry Donenfeld and Jack Liebowitz (founders of what would become DC Comics), as well as newspaper comic strip producers like King Features Syndicate, "and within a few years comic

books, in the format pioneered by *Famous Funnies,* had become firmly established as a branch of the U.S. publishing industry."[12]

A NEW KIND OF PUBLICATION

Famous Funnies was "the first that a modern reader would instantly recognize as a comic book," says Don Markstein, who chronicles the history of comic books in his online *Toonopedia.* "It was a fraction of an inch wider than its latter-day cousins (publishers saved money by shrinking them a little) and about twice as thick (for years, publishers responded to inflation by dropping pages rather than raising prices); and the paper and printing technology have certainly improved since then. But the modern comic book is a linear descendant of *Famous Funnies,* and still packaged in the same basic format."[13]

ORIGINAL MATERIAL

Then in 1935, Major Malcolm Wheeler-Nicholson's **National Allied Publications** came out with *New Fun: The Big Comic Magazine* #1—the first time original characters and stories had appeared in a comic book format.

"Wheeler-Nicholson was keen on the money to be made in the new-fangled comic books. As he saw it, the big problem was that the newspaper syndicates charged exorbitant fees for the rights to their strips."[14] He figured that "it was cheaper . . . to purchase new material from aspiring cartoonists suffering from the effects of the Depression and desperate for any kind of work, than to buy reprint rights from the syndicates."[15]

A colorful character, Wheeler-Nicholson claimed to have "chased bandits on the Mexican border, fought fevers and played polo in the Philippines, led a battalion of infantry against the Bolsheviks in Siberia, helped straighten out the affairs of the army in France [and] commanded the headquarters cavalry of the American force in the Rhine." He was a bizarre figure who often garbed himself in a French officer's cloak and a beaver cap.[17]

A regular contributor to pulp magazines like *Argosy,* the major had set up a company in 1929 to syndicate a daily comic strip based on Robert Louis Stevenson's *Treasure Island.* Seeing the success of Gaines's *Famous Funnies* and other comic strip reprints, he founded National

FOOTNOTE

The two guys who would later create Superman—Joe Shuster and Jerry Siegel—"sent an envelope full of story ideas to Malcolm Wheeler-Nicholson, the publisher of *New Fun Comics* in New York, and received a response back in June 1935. Two features were accepted on the condition that Joe redraw them on proper drawing paper. They were so poor, the originals had been done on the backs of old wallpaper rolls! For the grand total payment of $20, the boys were now in the comic book business!"[16]

Allied Publications and came out with *New Fun* #1 (February 1935). A thirty-six-page tabloid-sized magazine with a card-stock cover, it was the first such publication to contain all-original material. The magazine had been retitled *More Fun* by the seventh issue.

Despite Wheeler-Nicholson's optimism, newsstand returns were high. Poor cash flow made the intervals between issues unpredictable. Artist Creig Flessel recalled that "the major flashed in and out of the (office), doing battles with the printers, the banks, and other enemies of the struggling comics."[18]

Constantly plagued by financial problems, Wheeler-Nicholson was "not only the first man to publish comic books but also the first to stiff an artist for his check," recalled Sheldon Mayer, an editor who left National Allied Publications because he didn't get paid.[19]

Strapped by tight finances, Wheeler-Nicholson moved his publications to Harry Donenfeld's Donny Press, where he could print on credit.[20] Little did the major know he was putting ol' Harry into the comic book business.

ACCIDENTAL PUBLISHER

How did a guy like Harry Donenfeld—"who cared little about kids, or even about publishing or entertainment"—become the founder of one of the most famous comic book publishing companies in the world?[21]

In *Men of Tomorrow: Geeks, Gangsters and the Birth of the Comic Book*, Gerard Jones chronicles the "flimflammery" of those "dreamers and outcasts . . . hustling for their piece of the American dream."[22]

"That's why my favorite character in the book is Harry Donenfeld, the jovial huckster and semi-pornographer who co-founded DC Comics and first published Superman," says historian Rob MacDougall. "Jones situates Donenfeld in the tradition of Jewish entrepreneurs who made their fortunes at the unrespectable edges of American life—vaudeville, Tin Pan Alley, early film and radio—and basically created the Twentieth Century's popular culture by locating uptight Protestant America's unruly id and selling it right back to them."[23]

Born in Romania, Harry Donenfeld arrived in America at the age of five as part of that wave of Jewish immigrants landing in Manhattan's Lower East Side in the early 1900s.

As a kid he worked the streets as a barker, dragging customers into clothing stores or luring them into five-cents-a-dance music halls.[24]

"His skill at hucksterism led to the lucrative practice of hawking moonshine for gangsters during Prohibition," notes Jay Schwartz in a

study called "Jews and the Invention of the American Comic Book." "Smuggling booze led to a racket in the newspaper business, and then pornography. Whatever he could sell, he sold."[25]

FLASHBACK

Bob Harras and Ski were my partners in crime at Marvel. Bob was a short, dark-eyed guy with a sharp wit. Ski was a giant with a beard. Me, the older guy who dressed in black with bright Marvel neckties. I won't say we disobeyed any orders from the ever-changing parade of presidents or battling owners, but I think it's fair to say our first loyalty was to the comic books and their readers. This was too important a part of fans' lives – a cornerstone of pop culture, a modern mythology that bordered on literature – to let a bunch of moneymen trash it like disposable tissue. Despite the court battles for control of the Marvel empire, we kept to the publishing schedule without regard to who was in charge on a given day.

"The 1920s were a time of explosive growth in magazine publishing. There were more than 2,000 magazines on the newsstands, and new titles were constantly springing up. It was a business for someone with street smarts, a business made for Harry Donenfeld," observes *BusinessWeek*'s Robert J. Rosenberg.[26]

Ever the entrepreneur, Donenfeld bought his older brothers out of Martin Press in 1923 and renamed it after himself. His Donny Press mainly printed pulp magazines—so-called smooshes like *Tattle Tales* or *Bedtime Stories,* art nudies like *Gay Parisienne,* true crime like *Police Gazette,* and weirdies like *Strange Suicides* and *Medical Horrors.*[27]

One day an old client asked Donenfeld to find a job for his son, so the printer agreed to hire young Jack S. Liebowitz as his company's business manager. It was a good move. Liebowitz's financial savvy kept the business afloat while many others went under. The pair has been described as "the fast-talking salesman and the close-mouthed number-cruncher who built the company that would become DC Comics."[28]

Observing that a publisher could make "a fortune on the smallest investment," Donenfeld decided to publish his own magazines.[29] In August 1929, he and Liebowitz formed Irwin Publishing and began producing magazines with suggestive titles like *Juicy Tales* and *Hot Tales.* Merle Williams Hersey was editor and "front" for the company.[30]

By 1931 Irwin Publishing went bankrupt, but Donenfeld had "sold" his titles to Merwil Publishing, another company that he owned. This corporate shell game was skillfully played by the early pulp magazine publishers.[31]

Donenfeld's publications were distributed to newsstands by Eastern News—a company owned by Paul Sampliner and Charles Dreyfus. The same trucks that delivered magazines also carried "Margaret Sanger's (then illegal) birth control, Al Smith's campaign literature, and Frank Costello's mob liquor."[32] When Eastern News failed, Donenfeld was left with no distribution for his magazines—and no money. So he and Paul Sampliner created a new distribution company called **Independent News,** financed by Sampliner's mother.[33]

In May 1932, Donenfeld acquired Frank Armer's struggling group of pulp magazines—*Pep, La Paree,* and *Spicy Stories*—in exchange for printing debts.[34] Armer continued editing them for the new owner.[35]

Donenfeld and Armer flooded the market with a new Spicy line—*Spicy Tales, Spicy Adventure Stories, Spicy Mystery Stories, Spicy Westerns,* and *Spicy Detective Stories.* A typical cover of *Spicy Detective Stories* pictured a skimpily dressed woman turning from her mirror as an armed intruder enters her bedroom.[36]

Spicy indeed!

More important, *Spicy Detective* was the first of Donenfeld's publications to feature a comic strip, *Sally the Sleuth,* drawn by Adolphe Barreaux.[37] Sales shot up—and most of Donenfeld's pulps carried a comic strip thereafter.[38]

Harry Donenfeld was a step closer to being in the comic book business!

A MAJOR TURNING POINT

In 1937, Major Wheeler-Nicholson found himself financially overextended with his printer. In order to continue publishing, he had little choice but to take Harry Donenfeld on as a partner. **Detective Comics, Inc.,** was formed early that year, with Wheeler-Nicholson and Donenfeld's business manger, Jack S. Liebowitz, listed as owners.[39]

‹MILESTONE #2: DC AND MARVEL COMICS EMERGE.›

The new company's first production, *Detective Comics #1* (March 1937), was the first true DC comic book. The character of Batman was introduced in issue #27 (May 1939) of that series.[40]

Independent News—Harry Donenfeld and Paul Sampliner's "upstart company"—took over the comic's distribution from McCall's beginning with *Detective Comics #2.*[41]

As a result of his flamboyant lifestyle, Wheeler-Nicholson was constantly facing personal and professional financial crises. Artist Lyman Anderson, whose Manhattan apartment the major used as a rent-free pied-à-terre, recounted that "his wife would call (from home on Long Island) and be in tears . . . and say she didn't have money and the milkman was going to cut off the milk for the kids. I'd send out ten bucks, just because she needed it."[42]

In early 1938, Harry Donenfeld sent Wheeler-Nicholson and his wife on a cruise to Cuba to "work up new ideas." When they returned, the

major found the lock to his office door changed. In his absence, Harry had sued him for nonpayment and pushed Detective Comics, Inc., into bankruptcy. A judge named Abe Neiman, one of Harry's old Tammany buddies, had been appointed interim president of the company and arranged a quick sale of its assets to Independent News. Donenfeld gave the major a percentage of *More Fun* as a token to shut him up and sent him packing. Wheeler-Nicholson gave up on comics and went back to writing war stories for the pulps.

Harry Donenfeld was now CEO of both National Allied Publications and its sister company Detective Comics, Inc. Liebowitz managed the offices, heading up accounting and the creative activities, while Donenfeld expanded the distribution though Independent News. Not long after that, National Allied Publications and Detective Comics were merged to form a new entity called **National Comics.** But even back then the company was known colloquially as **DC.**[43]

FLASHBACK

My father used to buy me a comic book every day. As he came home from work, he'd stop at Pete's Market to pick up various convenience store items – as well as a 10¢ comic book for me. He grabbed whatever comic was handy on the spinner rack, without regard for content. One day I might receive a *Batman* (wow!), the next day it might be *Uncle Scrooge's Christmas Annual* (ah, the fond memories), and the next *Nancy and Sluggo* (good for trading with kids in the neighborhood, particularly girls). Thus, I became a "fanboy" without ever knowing the term.

AN IMMIGRANT MAKES GOOD

Born in the Ukraine in 1900, Yacov Lebovitz came to America with his family at the age of ten and grew up in a predominantly Jewish neighborhood on New York's Lower East Side. As with many immigrants, his name was anglicized to Jacob Liebowitz and then shortened to Jack.

As a kid Jack Liebowitz had been a newsboy. In the 1920s he went to work for printer-distributor Harry Donenfeld, eventually teaming with him on a number of small publishing ventures. Donenfeld was more huckster than businessman, but Liebowitz applied his accounting skills to keep Donenfeld's schemes on track.[44]

Deciding they needed another publication, Liebowitz coined the title *Action Comics* and asked editor Vin Sullivan to find some material to fill it. Desperate, Sullivan contacted his friend Sheldon Mayer, who was now working for Max Gaines at McClure Newspaper Syndicate. Mayer fished a strip called "Superman" from the syndicate's slush pile and sent it over. Although DC had previously

FLASHBACK

While Halloween was the BIG holiday for the Marvel staff – after all, we got to dress up in costumes like our favorite superheroes for a party in the bullpen – we also got together each year at Christmas. There were usually two important gatherings: One at editor in chief Bob Harras's home in New Jersey, a ragtag collection of comic book creators ranging from high-paid talent to lowly staffers. The other a Twelfth Night party at Chris Claremont's brownstone in the Bronx, a slightly more intellectual group of writers and artists. There was also a summer outing, where staff and freelancers trekked to a park in the boondocks to eat hotdogs and play baseball. Other holidays were celebrated more quietly by the Marvel gang, with drinks at our then-favorite hangout The Abbey Tavern.

rejected the strip, Sullivan included Superman in *Action Comics* #1 (June 1938)—little suspecting it would become the most successful comic book property ever created.[45]

Arguably, this appearance of Superman in *Action Comics* #1 was the most significant event in comic book history.

‹MILESTONE #3: THE SUPERHERO GENRE IS INTRODUCED.›

The brainchild of two youngsters from Cleveland, Superman was the first true comic book superhero. And he has proven to be the most enduring.

"Faster than a speeding bullet, more powerful than a locomotive, able to leap tall buildings in a single bound"—we all know the spiel.

"He's better known than the president of the United States, more familiar to school children than Abraham Lincoln," extolled Jenette Kahn, a former president of DC Comics. "And although only a handful of people ever achieve international acclaim, he not only is hailed the world over but also retains honorary citizenship in every country on our globe. And yet this hero, this champion of justice whose earnestness and passion for right irradiate his entire being, is not an ordinary human nor even an extraordinary one. Instead he is Superman, a fictional character who lives so vividly in our imaginations that we suspend our incredulity and believe for the reading and rereading of a comic book, while his voice still echoes in our radios, until the credits roll on our television sets or the lights come on again in a movie house that he is flesh and blood."[48]

"What was the appeal?" asks E. Nelson Bridwell, a longtime DC editor. "Superman's exploits held something for everyone. There was his science-fiction background and his ancestry on the planet Krypton. There was high adventure in his incredible feats of strength and daring, each one topping the last. There was a maddening romantic triangle, wherein Clark Kent, reporter for the *Daily Planet*, fell in love with coworker Lois Lane, who, it seemed, had eyes only for Clark's secret identity as Superman! How perplexing! Clark was his own competition for Lois' affections, his own chief rival."[49]

FLASHBACK

In my personal comic book collection I have a tattered copy of *Action Comics* #1—the 1938 comic book featuring Superman's debut. While this is one of the most desirable comics sought by collectors—one auctioned for $195,000 in 2006—mine has a far lesser value due to its damaged and coverless condition.[46] It took a while to confirm that mine was the real deal, but Steve Geppi, president of Diamond Comic Distributors, pulled a bound volume out of his priceless collection to show me one. Fewer than a hundred copies are known to exist. Geppi has a standing offer to pay $1 million for a near-mint copy, although a copy in such good condition has never been discovered. [47]

COMICS TRIVIA

Superman co-creators Jerry Siegel and Joe Shuster were two imaginative kids who loved science fiction. Their superhero concept first appeared in a 1933 issue of their self-published sci-fi fanzine. The story—"Reign of the Superman"—portrayed the character as a world-conquering villain. Hmm, no good. So the following year, they revamped him as a hero, hoping to sell this new version as a daily newspaper strip—but still got no takers.[50]

DC co-founder Jack Liebowitz recalled how he came to publish Superman: "We were going to publish a [new] magazine," he said. "Didn't have any material because in those days there weren't any writers or artists available easily. So I asked [McClure] if they had any material ready, if they had any material lying around. And they sent over a lot of stuff. Big bunch of stuff. In there was the Superman, six panels. They were prepared for a newspaper syndication, which . . . every syndicate had turned down. We picked it up, we liked it, enlarged it into a 13-page story, and off she went."[51]

The story played on every geeky boy's fantasy: the hero within!

Disguised as a mild-mannered newspaper reporter named Clark Kent, this superpowered hero fought evil while wearing an acrobat's blue tights and a flowing red cape. And he stood for the virtues of "truth, justice, and the American way."[52]

Very nifty!

Despite intellectual attempts to link Superman's origins to Nietzsche's *Übermensch* or Philip Wylie's *Gladiator*, the character clearly owed more to *Doc Savage* pulps and the Jewish Golem legend.[53] "The Golem story inspired the artists and writers who created the modern comic book industry, many of whom were Jews. . . . Siegel and Shuster created a modern-day Golem in Superman."[54]

Superman's impact on the public's imagination—and on comic book sales—was immense.

"It was well conceived, well drawn, and we admired the people that produced it," recalled artist Jack Kirby. Predictably, it wasn't long before other companies were publishing their own superhero comics.[57]

Most historians cite the 1938 appearance of Superman as the beginning of the **Golden Age of Comics.**

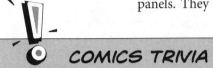

COMICS TRIVIA

Although Superman wielded "powers and abilities far beyond those of mortal men," there were limitations in the beginning. Originally he did not fly, but could jump really high. Nor did he start out with X-ray vision. According to *Action Comics* #1, Superman could "leap 1/8 of a mile; hurdle a twenty-story building . . . raise tremendous weights . . . run faster than an express train . . . and nothing less than a bursting shell could penetrate his skin!"[55] Over time his powers increased, reaching almost godlike levels by the 1970s. John Byrne's 1986 rewrite cut them back some, but the Man of Steel has regained his super-strength over the years.[56]

QUESTIONS FOR FURTHER THOUGHT

1. Who would you credit as the founder of DC: Major Malcolm Wheeler-Nicholson? Harry Donenfeld? Jack Liebowitz? Max "Charlie" Gaines?

2. Was Harry Donenfeld a crook? An opportunist? A rascal? Or simply a shrewd businessman?

3. If Superman was such a great concept—as history has proven—how come so many publishers turned down the Shuster/Siegel strip before it was rescued from the scrap pile?

4. Was Major Wheeler-Nicholson a visionary or a fool? And what was with that cloak and beaver cap? (Bonus points if you've ever seen a movie featuring his granddaughter, an actress named Dana Wheeler-Nicholson.)

5. Who should get credit for discovering Superman? Sheldon Mayer, the syndicate guy who fished it out of the reject pile? Vin Sullivan, the editor who was looking for material? Jack Liebowitz, the bigwig who okayed the strip? Or was it just dumb luck that it got included in *Action Comics* #1? Argue your viewpoint.

THE GOLDEN AGE

THE FIRST SUPERHEROES

While I got a kick out of doing comics, it was just a job to me. Being the ultimate hack, I would start doing my thinking when I sat down in front of the typewriter, and not a minute before. . . . Anyway, there was so much going on that there wasn't time for a lot of introspection.[1]

—Stan Lee

THE period from 1938 through the mid-1950s is described as the **Golden Age of Comics.**

"The period saw the arrival of the comic book as a mainstream art form, the creation and first dominance of the 'superhero' archetype, and the defining of the medium's artistic vocabulary and creative conventions by its first generation of writers, artists, and editors," notes one historian.[2]

This new publishing format provided many jobs, albeit at low wages in sweatshop conditions. "So the comic book writer . . . certainly couldn't be in it for the money," says Stan Lee.

"And, unlike other forms of writing, there were no royalty payments at the end of the road. No residuals. No copyright ownership. You wrote your pages, got your check, and that was it."[3]

Artist Gil Kane recalled his stint at MLJ (the comic book company that would eventually become Archie Comics). "Everybody worked at home, there was a little production room about the size of the living room of your house . . . fifteen-by-fifteen, or twenty-by-twenty feet. So everybody was packed in. People used to come in and drop their stuff off."

When Kane was fired for being "too noisy," he went over to Jack Binder's studio in Midtown Manhattan. "It was one large room some-where on one of the upper floors of an older building on Fifth Avenue. . . . At that time, something like 40 or 50 artists penciling or inking or lettering were all sitting at these different tables doing their specialty and in effect getting work that was solicited by Jack Binder. They never had to step away from the board, the work was all given to them, they got paid either by the page which was a very cut-rate, like $2 or $3 a page, or else they got a salary."[4]

Will Eisner elaborated: "The way we worked in Eisner and Iger was that I would design a story in the very beginning, maybe sometimes in blue pencil, and then Jack [Kirby] would take it and do it, or Bob Powell would take it and do it. For example, I designed the character Sheena, Queen of the Jungle. So, I made the first drawing. Sometimes I would do the cover first, and then give it to somebody and say, 'Here, you do it.' That how we worked."[5]

Gil Kane added: "Eisner and Iger used to pay salaries of $18 and $19 a week for people like Louie Fine. This was a little later on. A guy like Clem Weisbecker also got more, a very fine artist, a painter and sculptor, as several of these guys were. Irving Novick came into comics from advertising, he hated comics, always held himself above it, but the economic situation was that there wasn't enough of that work out there, and all of a sudden there was this market."[6]

A BRAND-NEW MEDIUM

LOOKING BACK

"I wanted a newspaper strip," admits comic book legend Carmine Infantino. "That was always my ultimate aim. It's never happened. I could never sell one. I tried them, but they all failed, one after the other."[8] This from a member of the Comic Book Hall of Fame.

"Many early comic-book creators had no love for the medium," notes historian Claude Lalumière. "The pay was meager, the work grueling and usually uncredited. They worked in comic books in the hope that one day they'd 'make it' and 'graduate' to newspaper comic strips."[7]

SORCERER'S APPRENTICE

Carmine Infantino recalls his entry into the comics scene: "One day I went to this place on 23rd Street, this old broken-down warehouse, and I met Harry Chesler. Now, I was told he was a mean guy and he used people and he took artists. But he was very sweet to me. He said, 'Look, kid. You come up here, I'll give you a dollar a day, just study art, learn, and grow.' That was damn nice of him I thought . . . a buck a day was a lot of money in those days."

Like Eisner and Iger, Chesler's was a shop that packaged comics for others. "It was an old factory building, and there was this broken elevator, and it rattled its way up to about the fourth floor—it was a five-story building. And as you got off the elevator, you faced a brick wall. In front of the brick wall was Harry Chesler sitting with his cigar in front of an old, broken-down desk, puffing away. That was one room. Then when you went in to your right there was a larger room where about five or six artists and letterers sat, and did their artwork. That was it. But they worked most of the day, they didn't talk much. They rarely kidded around, not that much, because Harry would be sitting out there watching everybody, and puffing his nickel cigars. . . .

"It was my first year in high school, the School of Industrial Arts. So I would probably be 14 or 15," continues Infantino. "I just sat and copied. There were a couple of people whose artwork I studied there. . . . I'd practice my inking, and then they'd come over and make corrections for me, they'd show me what I was doing wrong and why it was wrong. And they encouraged me to go to the Art Students League at night. It was a little tough at that time—I was still going to high school. But they pushed it and I knew I needed it, so I started to go. So during the day I'd go to regular school, then I'd go to Chesler's for a couple of hours, then I'd run down to school at night. It was a very long day. But when you're young you can handle that kind of thing."[9]

A FOXY MOVE

Victor Fox was an early comic book publisher. "Victor was short, round, bald and coarsely gruff, with horn-rimmed glasses and a permanent cigar clamped between his teeth," remembered editor Al Feldstein. "He was the personification of the typical exploiting comic book publisher of his day—grinding out shameless imitations of successful titles and trends, and treating his artists and editors like dirt."[10]

"He was a very strange character," recalls Joe Simon, who worked for Fox in the early days. "He had kind of a British accent; he was like

5' 2"—told us he was a former ballroom dancer. He was very loud, menacing, and really a scary little guy. (laughter) He used to say, 'I'm the King of the Comics. I'm the King of the Comics. I'm the King of the Comics.' (laughter) We couldn't stop him. So that's the task I had when I went in to start that job."

As Simon tells it, "He was an accountant for DC Comics. He was doing the sales figures and he liked what he saw. So, he moved downstairs and started his own company called Fox Comics, Fox Publications, Fox Features Syndicate, Fox Radio, Fox this, Fox that—and he didn't have a staff there, but Eisner and Iger were supplying art and editorial material. I happened to get a job; I went over to Fox and became editor there, which was just an impossible job, because as I said there were no artists, no writers, no editors, no letterers—nothing there. Everything came out of the Eisner and Iger shop.

"Fox had a character called Wonderman; he just took the DC character Superman and made him Wonderman and took Batman and made him Bat-something. (laughter) . . .

"He told Will Eisner to copy Superman and they called him Wonderman; and Donenfeld sued Victor Fox and he sued Will Eisner, and Will Eisner was asked to do a Bill Clinton thing—disguise the situation. (laughter) And Will got scared and he backed out. That's when I took over."[11]

"I refused to lie on the witness stand for Fox," Eisner later said. "So I told the truth: that he—Fox—set out to imitate Superman. His defense disappeared. As a result, Fox refused to pay Eisner and Iger about $3,000 he owed us, an absolute fortune at the time."

With Eisner's testimony, DC obtained a permanent injunction, ensuring that there would not be a second appearance of Wonderman.[12]

According to comic historian Gerard Jones, Simon's memory is faulty in that Victor Fox never worked as an accountant for Detective Comics, Inc.[13] The fact is, Fox had a shady past. He'd been indicted for mail fraud and a boiler-room "sell and switch" stock scheme. His contemporaries often described him as a "scoundrel." Eisner said he was "a very, very shifty, fast-footed businessman."[14]

"After a while, I learned . . . that Fox was getting himself into financial trouble and that I should make sure that I was fully paid for each book I delivered before I started the next one," recalled Al Feldstein. "Seems Victor was associated (so the rumor had it) with the bent-nose guys in a business venture: the San Juan [Puerto Rico] Race Track . . . and that there were some monetary problems associated with getting it going."[15]

What goes around, comes around. When Victor Fox's newsstand distributor went under owing the company $173,551, he was forced into involuntary bankruptcy. Fox brought the company out of bankruptcy by promising to pay creditors one third of its *Blue Beetle* profits, but that was short lived. With the company unable to emerge from bankruptcy a second time, Fox himself declared personal bankruptcy.[16]

EVERYBODY LOVES RAYMOND

Golden Age artist Sheldon Moldoff recalled the influence newspaper strips had on comic books:

MOLDOFF: I had met M.C. Gaines when I first walked into Sheldon Mayer's office, and he took a shine to me. . . . He's the one who said, "We're going to put you on *Hawkman,* and do whatever you want with it. Do a good job; I know you can do it." And that was it!

INTERVIEWER: How did the idea come to you to employ the Alex Raymond approach?

MOLDOFF: . . . when I looked at *Hawkman* and read a couple of stories, I said to myself, "This has to be done in a Raymond style." I could just feel it, like Raymond—or Foster.

INTERVIEWER: How did you work it? Had you kept a collection? Because you obviously couldn't go out and buy a collection of *Flash Gordon* or *Prince Valiant* in 1939 the way you can now.

MOLDOFF: Oh, I saved those Sunday pages and the daily papers for years! There isn't an artist around that does not have a file . . . a "morgue."

INTERVIEWER: Everybody uses swipes; there's nothing wrong with that.

MOLDOFF: We all leaned on these guys to learn—and we were very lucky, because while we were learning, we were selling the product, and I guess I was probably one of the best at that. I spent a lot of time on it. I had books on anatomy and shadows and wrinkles; I studied, and I worked very hard on it, and I think it showed.

INTERVIEWER: What quality do you think your work had . . . that made DC's editors say, "We want you, rather than the interior artist, to do the cover of *Flash Comics* #1 or the first Green Lantern cover on *All-American* #16?"

MOLDOFF: As I said, M.C. Gaines took a shine to me. He liked my style; he liked the realism. We were competing with the newspapers. When he picked up the Sunday papers, he saw *Flash Gordon, Prince Valiant, Terry and the Pirates.* When he picked up a comic book, there was a tremendous difference in the quality of the art. And then, all of a sudden, he saw me . . . an 18-year-old coming around, and I'm almost a student of Raymond, and by God, the stuff looks good—it looks like Raymond![17]

Alex Raymond was best known for creating the newspaper strip *Flash Gordon* in 1933. Others he drew included *Secret Agent X-9, Rip Kirby, Jungle Jim,* and *Tillie the Toiler.* "His realistic style and skillful use of 'feathering' (a shading technique in which a soft series of parallel lines helps to suggest the contour of an object) has continued to be an inspiration for generations of cartoonists."[18]

ALPHABET SOUP

In 1939 Maurice Coyne, Louis Silberkleit, and John L. Goldwater got together to form a publishing company. Using their first initials, they called it MLJ Comics.

Maurice was the accountant, Louis the businessman who understood distribution, John the creative guy.

This new comics enterprise focused on superheroes—like the Shield, America's first patriotic superhero. And later the Fly, said by some to be the progenitor of Spider-Man.

"They originally published pulp magazines under the name of Columbia," relates Michael Silberkleit, whose father was one of the three founders. "They had writers like Harold Robbins and Isaac Asimov working for 1/8¢ a word. As a kid I can remember seeing all these guys show up in the office to borrow money."[19]

BATMAN'S BEGINNINGS

A young artist named Jerry Robinson started working with Bob Kane in 1939. Kane had a "mini shop," consisting of Robinson and

writer Bill Finger and himself. His studio was his bedroom in his parents' apartment in the Bronx, so Robinson and Finger worked out of their own rooms in the neighborhood.

As Robinson recalled it in a *Comics Journal* interview, "Bob was given the assignment to come up with a character to compete with Superman by Vin Sullivan—who was the art director [of DC]. . . . Bob immediately went back and called Bill to help him create the character, and flesh out the concept and write the story. Bob took it down to DC and signed up and presented himself as the sole creator. Nobody knew anything about Bill or myself until later on. . . .

"He should have credited Bill as co-creator, because I know; I was there. The Joker was my creation, and Bill wrote the first Joker story from my concept. Bill created all of the other characters—Penguin, Riddler, Catwoman. He was very innovative. The slogans—the Dynamic Duo and Gotham City—it was all Bill Finger," says Robinson.

"We began to get offers all over the place once Batman became successful. They couldn't get Bob, so they went after his staff. . . .

"Once we got other offers and wanted to leave, DC stepped in and made us an offer to work directly for DC. After the first year and a half maybe, we switched over and we no longer worked directly for Bob. In fact, I rarely saw him after that. . . .

"We closed that studio and began to work for DC at 480 Lexington Avenue. So those were the few years that I actually worked at DC, which was a very interesting time. Working there at first were Siegel and Shuster, before the breakup. Jerry would come in at times and do his writing. And Joe Shuster was doing the drawing, and he worked at the next drawing board.

"The next desk on the other side was Jack Kirby. The next desk was Fred Ray, who did the great *Superman* covers, and also *Congo Bill.* Mort Meskin, who was one of my best friends, who I brought up from MLJ . . . they had a big bullpen.

"We began, as I said, to get these offers. I got an offer from Busy Arnold, who was one of the big publishers who began to make offers to Bill and myself. He offered to make me editor in chief of his line of books. I could draw whatever characters I wanted. I wondered if I could have done it, in retrospect. I really sweated over that decision. But I was still imbued with Batman. I was there from the beginning. . . .

"I still finished Bob's drawings for a long time, but I ended up doing my own Batman covers and complete stories on my own. The stories I did, I would do complete—pencils, inks, backgrounds and, at times, even the color.

"I long thought that Bill . . . Well, as you know, he got a really raw deal, he was unappreciated in his time. He died broke, never got credit as co-creator of Batman."[20]

ALL-AMERICAN BOYS

LOOKING BACK

"All I did was take samples up to National," recalls Golden Age artist Irwin Hasen. "Jack Liebowitz was the main accountant then. I'll never forget, he used to wear shiny black suits. Jack was Donenfeld's right-hand man, and my uncle knew Jack, so my uncle said, "Go down there. I made an appointment for you. Show some samples." So I went to National and Jack looked at my work and he didn't know. He said go down to 225 Lafayette Street, [and see] M. C. Gaines. . . . So I took the subway and there was Shelly Mayer and M. C. Gaines, and that's how I started in comics."[23]

Reluctant to add extra titles to DC's schedule, Jack Liebowitz and publisher Maxwell C. Gaines started a sister company called All-American Comics in 1940. Its roster of characters would include the Flash, the Green Lantern, Hawkman—and eventually Wonder Woman, the first major female superhero.[21]

Liebowitz picked Gaines not just because he had invented the format of the modern comic book, but also because it had been Gaines's editor Sheldon Mayer who suggested that DC publish Superman.[22]

In 1944 Liebowitz merged All-American into **National Comics**. Then he organized National Comics, Independent News, and other affiliated firms into a single corporate entity, **National Periodical Publications.** This was the direct precursor of today's DC Comics. National Periodical Publications became publicly traded on the stock market in 1961.[24]

FOOTNOTE

In 2006, the circular DC logo known as "the Bullet" was redesigned. The new design is informally referred to as "the Swirl." Why the change after all these years? "We're talking about a multibillion-dollar brand," said Kevin Tsujihara, the Warner Bros. executive vice president for corporate business development and strategy, whose portfolio includes DC Comics. "There was a level of concern that we weren't fully utilizing the power of DC."[26]

THE DC BULLET

Despite the official names of National Comics and National Periodical Publications, the logo "Superman-DC" was commonly used throughout the line, with the collective companies known as DC Comics for years before any official adoption of that name. And after Liebowitz merged his and Donenfeld's companies, the All-American titles bore the DC logo.[25]

GROWING NUMBERS

"While comics were largely viewed as 'penny-ante kids fare,' Jack Liebowitz believed the genre was a large market that was then untapped by larger publishers."[27]

How right he was: this was a time when successful comic book titles sold between 200,000 and 400,000 copies per issue. But each issue of

Action Comics—featuring only one Superman story—consistently sold around 900,000 copies. DC soon launched a second title, aptly called *Superman,* which for a time established industry records by selling a staggering 1.3 million copies per bimonthly issue.[28]

COMICS TRIVIA

MLJ Comics' *Roy the Superboy* preceded *Superboy* by half a decade. And MLJ's *Steel Sterling* was called "the Man of Steel" before *Superman.* However, none of these MLJ characters achieved great popularity.[29]

A competitor known as Timely Comics published million-selling titles featuring the Human Torch, Sub-Mariner, and Captain America.[30]

And Quality Comics published the ever-popular Plastic Man. Created by artist Jack Cole, the stretchable superhero first appeared in *Police Comics* #1 (August 1941).

In its June 1941 issue, *Writers Digest* hailed these as boom years: "The number of comics on the stands continue to grow in unbelievable fashion. It is reported there are 115 of them on the stands right now, and that by September this will be increased to 136."[31]

Sales were booming. Wasn't life grand?

BIG RED CHEESE

As it turns out, the bestselling superhero of that time was not Superman or Sub-Mariner or Plastic Man, but a character in a red costume and cape who looked a lot like Fred MacMurray and was nicknamed "the Big Red Cheese." At the height of its popularity, *Captain Marvel Adventures* was selling better than 1.3 million copies an issue.[32]

Created by artist C. C. Beck and writer-editor Bill Parker, Captain Marvel made his first appearance in Fawcett's *Whiz Comics* #2 (1940). With a premise that tapped into adolescent fantasy, Captain Marvel was the alter ego of a kid named Billy Batson, who worked for a radio station but had the ability to turn into a superhero simply by uttering the magic word "Shazam!"

As writer-historian Ron Goulart explains it, "Parker's basic premise, a boy with the power to change into a full-grown superhero, was beautiful in its simplicity and inherent appeal. Youngsters were snared because the adventures were about a kid who could take a shortcut to adulthood when he needed help with a serious problem."

In truth, Captain Marvel and his chief rival were polar opposites: Superman was a superhero from another planet posing as a mortal named Clark Kent. Billy Batson was a mortal who could turn himself into a superhero named Captain Marvel by saying a magic word. Their true identities were reversed—an alien and a human. That difference

was reflected in Captain Marvel's billing as the "World's Mightiest Mortal." Not that this helped when DC sued Fawcett for copyright infringement and won![33]

A TIMELY START

Brooklyn-born Martin Goodman was a pulp magazine publisher who cranked out such titles as *All Star Adventure Fiction, Complete Western Book, Mystery Tales, Uncanny Stories, Real Sports,* and *Star Detective.* One was prophetically called *Marvel Science Stories.*

Up until now his miscellaneous companies had been lumped under the banner of Red Circle, thanks to a common logo he put on all his magazines. Like many other pulp magazine publishers, Goodman's business strategy involved having a multitude of corporate entities all producing the same product.[34]

"Martin Goodman had about six or seven companies," explained his one-time editor Vincent Fago. "If he was ever sued or went bankrupt, he'd still have these other companies! Goodman knew the hard times, and though things were going great, he banked on things changing later. And he was right."[35]

Goodman's pulp magazines were not selling well, so he wanted to try out this newfangled comic book format. Quick to jump on new trends, he contracted with a comic book packager called Funnies, Inc. to supply him with original material. His first release was *Marvel Comics* #1 (October 1939). It contained several new superhero characters—an android called the Human Torch, a costumed detective known as the Angel, and a mutant antihero Namor the Sub-Mariner.[36]

Marvel Comics #1 quickly sold out its eighty thousand copies, prompting Goodman to go back for a second printing (cover-dated November 1939). That second go-round sold approximately 800,000 copies. Realizing he had a hit on his hands, Goodman decided to hire an in-house staff.[38]

Joe Simon recounts the experience: "Martin Goodman, who owned Timely and Daring and Marvel—it was all the same company—was buying stuff from us through an agency called Funnies, Inc. Martin was their biggest customer but then he decided to eliminate the middleman, so he hired us from Funnies, Inc. and gave us more money."[39]

Along with Simon came Jack Kirby as staff artist. Their first work at Timely (Marvel) was Red Raven Comics. Simon considers it the

FOOTNOTE

The Sub-Mariner was the first mutant superhero from a company that would eventually bring readers the X-Men. Namor was the "son of a human sea captain and of a princess of the mythical undersea kingdom of Atlantis. . . ." He had the super-strength and aquatic skills of the *Homo mermanus* race. Although mermen have a lifespan of 150 years, they cannot survive outside of water for more than five minutes without aid.[37]

worst comic they ever produced. "The worst comic book—I had a lot of competition there," he laughs. "In the early days, the Red Raven got the worst sale . . ." [40]

Later they added Syd Shores as the third employee. Shores tells it this way: "I tried my own hand at work, doing a seven-page piece called *The Terror*. I was proud of it then of course, but in looking back it really was a terror! Amateurish, and crude—it was a monstrosity. I took it up to Timely Comics to try to sell it, and wound up chatting with Joe Simon and Jack Kirby, who were the only two people at Timely at the time. Kirby chomped on his cigar a little and said it had promise, that I showed promise, and offered me a staff job at $30 a week, just essentially inking."[41]

With the company's dependence on two main superheroes—the Human Torch and the Sub-Mariner—Goodman set Simon and Kirby to creating a batch of new characters such as Hurricane, Tuk the Cave-Boy, the Vision, and Comet Pierce.[42]

Along with newly renamed *Marvel Mystery Comics,* they began cranking out additional titles such as *Daring Mystery Comics* #1 (January 1940) and *Mystic Comics* #1 (March 1940). However, featuring a hodgepodge of different characters in each issue, these new books never caught on.

Timely Comics would have been in big trouble, except for an idea that Funnies, Inc. artists Bill Everett and Carl Burgos came up with. Why not have their two characters, the Human Torch and the Sub-Mariner, meet each other? They represented fire and water, two opposite elements, so wouldn't it be interesting to have them face off against each other?

This confrontation in *Marvel Mystery Comics* #8 and #9 represented the industry's first major crossover, a two-issue battle between two superheroes—the story told from the different perspectives of each character.

"This was a first, something that had not been done before in superhero comics," observes maven Jess Nevins. "There were a number of superhero comics out at this point, and even at this early point companies were being known for their families of comics, but the idea of different characters, in different strips and books, inhabiting the same universe, was a new one. It's hard, for modern comic book readers, to understand just how different this idea was; we've all grown up with the idea of shared universes, and so it seems like a natural assumption to us. But in the summer of 1940 this was a new and very different concept."[43]

INVENTING "STAN LEE"

In 1939 a seventeen-year-old Brooklyn kid named Stanley Martin Lieber started working for Timely Comics—the company owned by his cousin's husband, Martin Goodman. His uncle Robbie brought him in one day, telling artist-editor Joe Simon that "Martin wants you to keep him busy."[44]

As Simon recalls, "This place, Timely, was full of relatives: (laughter) Uncle Robbie, Martin, Abe, Dave. Martin was the founder of the whole Marvel thing and he was very bright. I never heard this confirmed but he was supposed to have only gone through the 4th grade in school. He had a great mind. He was very shy. He had all his relatives around him."[45]

"[Uncle Robbie] Solomon just sat in the offices and talked," recalled Vince Fago. "He had a store on 34th Street and sold women's hats, but he'd always come into the offices. He never worked. He was loud and talked all the time and knew absolutely nothing. He was just a watchman for Goodman."[46]

The new kid's main job was to fetch coffee for Joe Simon and Jack Kirby. It wasn't very demanding. "Stan used to drive Jack Kirby crazy," recounts Simon. "He'd sit there while Jack was working, while we were all working. He'd sit in the corner with a flute, and he'd play the flute. Jack and the guys would throw things at him. (laughter) Finally, to give him something to do, we told him he could . . . every comic book had to have a page of text to get Second Class mailing privileges, which are not that important today. But it would take three issues for a publication to be credited with that mailing privilege; then the publisher would get money back from the Post Office. So, it was very important to get that mailing privilege, and to qualify you had to have a page of text. They didn't have a lot of letter columns in those days, they had all artwork. So we gave Stan some of the text to do. Nobody wanted to do that stuff because nobody read it—and so Stan did it, and he treated it like it was the great American novel. (laughter) And he kept doing them, and he loved doing them, and it turned out he made a career out of it. He respected it—I give him credit for that."[48]

Young Stanley's first published work was a text filler titled "Captain America Foils the Traitor's Revenge" in *Captain America Comics* #3 (May 1941). Adopting the pen name of Stan Lee (saving his real name to put on "the prizewinning novel I would one day write"), he started scripting a few comics.[49]

LOOKING BACK

"My memory is not the best," says Stan Lee, "but I thought that Joe was the editor and sort of Jack's boss. I got that feeling. Generally, Jack would be sitting at the drawing board drawing and chewing his cigar, muttering to himself. Joe would be walking around, chewing his cigar and mumbling, and also handling whatever business there was to handle under Martin Goodman."[47]

A NEW INDUSTRY IS BORN

The comic book industry was gaining a foothold. According to one study, "By 1941 thirty comic-book publishers were producing 150 different titles monthly, with combined sales of 15-million copies and a youth readership of 60 million, making the emerging comic-book industry one of the few commercial bright spots of the Great Depression."[50]

At that time Quality Comics, DC Comics, and Fawcett Comics were the three best-selling companies. Compared to them, Timely's sales were mediocre, with *Marvel Mystery Comics* the only decent seller.[51]

"CAP"

That same year Martin Goodman asked Joe Simon and Jack Kirby to create a character to compete with a patriotic hero named the Shield who was appearing in MLJ's popular *Pep Comics*.

So Simon and Kirby came up with a new character who embodied the quintessence of patriotism—a red-white-and-blue superhero known as Captain America.

"The Nazis were a menace, an evil in the world," recalls Simon. "The U.S. hadn't yet entered the war when Jack and I did Captain America, so maybe he was our way at lashing out against the Nazi menace. Evidently, Captain America symbolized, if that's the correct word, the American people's sentiments. When we were producing Captain America, we were outselling Batman, Superman, and all the others."[52]

Kirby agreed with this assessment. "The times were very turbulent, very patriotic, and it was time to be an American. So in the world of comic art, we had to develop characters like Captain America. It was a natural thing to do."[53]

Goodman was so taken with the idea that he assigned Simon and Kirby to create enough stories for Cap to have his own book. This was a highly unusual move, as most new characters were tried out in anthologies like *Daring Mystery* or *Mystic* before getting their own title. *Captain America Comics* #1 (cover-dated March 1941) went on sale in December 1940. With its eye-catching cover of Cap socking Hitler on the jaw, that first issue made a big impression on an American

FLASHBACK

Back when I was a vice president and group publisher at Scholastic, the chairman often described my management style as "consultative." And that's the same team spirit I tried to engender when I became publisher of Marvel Comics but for a very different reason: I couldn't have done my job without the support of then editor in chief Bob Harras and our right-hand man Jim "Ski" Sokolowski. Although I'd been a longtime fanboy, I still had to rely on the in-depth knowledge that Bob and Ski afforded me. Bob had never had a job outside of comics (unless you count his brief after-college stint selling neckties at Macy's). Ski came out of the newsstand world, but he'd only worked at Curtis Circulation so he could get on the Marvel account. We were a tight threesome, huddling together in Ski's cluttered, smoky office (located midway between Bob's corner office and mine) to make editorial decisions. Or talk about those shadowy machinations that were taking place in Ron Perelman's uptown headquarters known as "the Townhouse." It was a time when three heads were better than one.

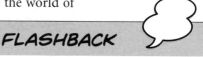

FLASHBACK

I own an original Jack Kirby pencil drawing of Captain America. It's hanging on my wall at home. Okay, so it's signed to "My Buddy Joe." I'm thinking of changing my name.

FLASHBACK

The white-haired gentleman who steps into my Marvel office gives me a friendly nod. "I'm Joe Simon," he says. Here I am in the presence of one of the guys who *created* the comic book industry, a living piece of history! When I stand up to shake his hand, I notice how tall he is, an imposing figure despite his age. Born in 1913, he's in his eighties at the time. "I brought you this poster," he says modestly. "Thought you might like it." He hands me a spectacular image of Captain America, the character he'd co-created with Jack Kirby. The special drawing is signed: "To Shirrel Rhoades." Today it hangs on my wall in a place of honor near my Jack Kirby sketch.

TRUE FACT

When Timely/Atlas revived Captain America in 1954, Joe Simon and Jack Kirby—now out on their own—created yet another patriotic hero to go head-to-head with their most famous character. The result was the Fighting American, a thinly disguised clone whose book lasted only seven issues. In 1997 Rob Liefeld licensed Fighting American from Simon in his snit with Marvel over being fired off the Captain America book in the *Heroes Reborn* event. It led to lawsuits. One of the clauses in the settlement specified that the Fighting American could never throw a shield like Captain America does.[56]

public ready for war. It was an immediate hit, selling nearly a million copies.[54]

Captain America was one of comics' most memorable characters: a star-spangled superhero who represented the pinnacle of American patriotism. Turned down by the army, weakling Steve Rogers is transformed into a "super soldier" by his participation in a secret military experiment. Armed with nothing but a shield and superhuman agility, he takes on equally memorable villains.

"The Red Skull was kind of a showpiece," said Kirby. "We needed a Nazi spy who had to be spectacular in some way, so Joe and I conjured up the Red Skull, and he was an immediate hit. The readers—they loved to see him in the stories."[55] A classic bad guy you loved to hate!

The first ten issues of *Captain America*—penciled by Kirby and inked by Simon—are legendary. Kirby's use of dynamic perspectives and cinematic technique exceeded previous boundaries of comic book art. The use of two-page center spreads was a visual device that impressed readers (and comics art historians).[57]

Kirby and Simon came up with a teen gang called the Sentinels of Liberty, led by Cap's sidekick Bucky. The Sentinels were a hit with the kids, and a fan club was started, complete with a news page in the comics themselves. This proved so popular that Goodman ordered up a book devoted just to the Sentinels. In response, Simon and Kirby produced *The Young Allies* #1 (Summer 1941).[58]

SIMON AND KIRBY DEPART

As it happened, Simon and Kirby had been entertaining offers from rival publishers when Goodman asked them to create Captain America. Having him over a barrel, they managed to get an agreement that promised Simon 15 percent of the profits from the sales of *Captain America Comics,* and Kirby 10 percent. Such an agreement was unheard of in comics at the time.

Then one day, Timely's accountant—Maurice Coyne—let it slip that Goodman wasn't paying them their fair share of *Captain America*'s

profits. It's been speculated Coyne's reason for leaking this info was that he owned part of MLJ Comics (he was the "M") and thought if Simon and Kirby left Timely, they'd go to MLJ.

Angry to learn that Goodman had been cheating them, they immediately contacted Jack Liebowitz, publisher of DC. Liebowitz jumped at the chance to hire them, giving them a year's contract and doubling their salaries to $500 a week. Their plan was to secretly do the DC work on the side while keeping their day jobs at Timely.

Stan Lee grew suspicious and tailed them to the hotel where they were working on their pages for DC. Caught red-handed, the two men told him about their deal with DC and swore him to secrecy.

According to one version, Stan snitched and Goodman fired them. Stan claimed he didn't do it, but Kirby said, "The next time I see that little son-of-a-bitch, I'm gonna kill him."

With their sudden departure, Timely was left without an editor in chief and an art director. Thus, in 1942—just shy of his nineteenth birthday—Stanley Lieber took over both positions by default. The ambitious youngster from Brooklyn had moved from the bottom of the company's roster to the top slot in a blink of the eye.[59]

Excelsior!

DC DAYS

With a lucrative new contract in their pocket, Simon and Kirby raced over to DC to revamp the Sandman in *Adventure Comics*.

Next they dusted off the "kid gang" concept that they'd originated at Marvel. The Newsboy Legion made its debut in DC's *Star Spangled Comics* #7 (April 1942). This one featured the adventures of a group of crime-fighting kids aided by a shield-carrying hero known as the Guardian.[60]

"The kid gang comics were a natural part of my life, and it was something I knew very well," explained Kirby, the scrapper who had grown up in New York's Hell's Kitchen. "What I did was take the kids from my environment and put them into strips. There was always one tough kid in every strip, and that kid would be modeled on myself."[61]

Again combining their successful kid gang formula with the war comics genre, Simon and Kirby created the Boy Commandos in 1942. This team premiered in *Detective Comics* #64 and proved popular enough to get a series of its own that same winter.

LOOKING BACK

"Joe [Simon] was a very sharp writer," reminisces one-time DC editor Carmine Infantino. "People don't give him much credit for that. He wrote most of his stuff; he would . . . take classics and turn 'em into comic book stories. Remember the Boy Commandos with the Trojan Horse? He did that all the time. He'd take a classic, twist and turn it around, and use it, and it would be great. He was very clever. I don't think he got enough credit in his whole process. But that's not to take anything away from Jack, obviously—the combination was magic."[62]

"All the service men were reading *Boy Commandos,*" boasts Simon. "For a while, we were told by Jack Liebowitz that *Boy Commandos* was DC's number one book."[63]

TIMELY'S BOY EDITOR

Meanwhile, back at Goodman's publishing house, his wife's young cousin was settling in as editor in chief. "I was responsible for all the stories, either writing them myself or buying them from other people," Stan Lee says. "In comics—in those days, anyway, and always when I was there—being the editor meant being the art director too, because you can't just edit the stories without making sure the artwork is done the right way so it enhances the stories . . . and the stories have to enhance the artwork. They have to go hand in hand. So I was really the editor, the art director, and the head writer."[64]

Stan had his own office now, even though small and Spartan. From this cubbyhole he managed a growing assortment of staffers and freelancers. Artists like cover maestro Alex Schomburg and bullpen regular Dave Berg, who later made his mark with *Mad.* Carl Burgos and Bill Everett, who were still doing the Human Torch and the Sub-Mariner. Freelance writers like Mickey Spillane and a young assistant named Rona Barrett.

But Stan was still cranking out many of the scripts himself. "I thought he was the Orson Welles of the comic book business," says artist Dave Gantz.[66]

LOOKING BACK

"Mickey Spillane wrote quite a bit there. I remember the first time I met him," reminisces Golden Age artist Allen Bellman. "I had just finished up an assignment. I walked over to Stan Lee's office and knocked on the door. 'Come in,' says a voice from inside, Stan's voice. There's a GI standing there talking to Stan. Stan introduces me . . . 'Allen, I want you to meet Mickey Spillane. Mickey, I want you to meet Allen Bellman.' I shook his hand. He had a crew cut and was in an army uniform. Then Stan handed me a script to draw as my next assignment. In those days as soon as you finished one job you turned it in and was handed another script. Spillane had just brought it in and it was handed over to me."[65]

"Stan would write me a script or part of a script, and I'd go home and pencil it," recalled Vince Fago. "It used to take me about 45 minutes to pencil a page. I would ink my stuff unless my brother Al was available."

Did Stan write complete scripts? "No, never. He wrote the story and dialogue, but he didn't break the story down into panels," confirmed Fago. "That was left up to me. I drew a lot of his scripts. He didn't stage the scenes for me."

Stan's collaborative approach became known as the **Marvel Method.**

Fago explained: "He had to handle writers and artists and production, and that didn't leave him with much time. Stan put in the pay vouchers for the freelancers, too. Goodman never interfered with what

Stan was doing. He had faith in Stan. He knew Stan was in control and that his work was good."[67]

SUPERHEROES GO TO WAR

Superheroes declared war on Germany and Japan long before the U.S. government did.

As early as 1939 the Sub-Mariner battled a Nazi submarine in *Marvel Mystery Comics* #4. In mid-1940 Marvel Boy fought the Nazis in *Daring Mystery Comics* #6. And by early 1941, the Human Torch and Sub-Mariner teamed up to fight the Nazis in *Marvel Mystery Comics* #17.

And Captain America took on Der Führer in the pages of *Captain America Comics* #1 (March 1941). Along with his sidekick Bucky, ol' Cap bravely faced Nazis, Japanese, and other threats to America during the Big War.

"In contrast to the complex and controversial issues surrounding the Great Depression, the outbreak of World War II united Americans in opposition to a common enemy," writes historian William W. Savage, Jr. "Comic book publishers seized upon the national mood and created heroes, such as Captain America, that reflected the newfound patriotism. Superhero comics changed their focus from crime-fighting to war stories, but retained their escapist nature. Allied heroes and Axis villains were almost always portrayed in black and white terms, and the stories still featured many fantastical elements. War comics were very popular among active-duty soldiers and may have played an important role in keeping up morale. And the popularity of war comics among traditional teen audiences on the home front indicates how eager Americans were for stories that applauded the war effort and glorified U.S. soldiers."[68]

The Nazi propaganda machine responded by calling Superman-creator Jerry Siegel an "intellectually and physically circumcised chap" who'd invented "a colorful figure with an impressive appearance, a powerful body, and a red swim suit who enjoys the ability to fly through the ether." The diatribe concluded with the admonition, "Woe to the American youth, who must live in such a poisoned atmosphere and don't even notice the poison they swallow daily."[70]

Over at DC the comics were generally pro-intervention, while the All-American books were pro-isolation, and Timely was distinctly anti-Hitler.[71] In November 1942, Stanley Lieber enlisted in the Army Signal Corps. He would fight the Evil Axis as a PR flack stationed in North

COMICS TRIVIA

Almost two years before Pearl Harbor, *Look* magazine asked Jerry Siegel and Joe Shuster, "How would Superman end the war?" They responded with a comic strip showing the Man of Steel scooping up both Hitler and Stalin and depositing them at the League of Nations to answer for their war crimes.[69]

Carolina and Indiana, drawing cartoons to help train payroll clerks and creating posters to warn troops about the dangers of syphilis.[72]

TIMELY MARCHES ON

Before shipping out, Stan Lee handpicked Vincent Fago to become Timely's third editor in chief.

"Stan hired me, because he got drafted," recalled Fago in an *Alter Ego* interview. "He says, 'How would you like to take my job?' I said I'd have to think about it. I really didn't want to work in the office five days a week. But after a while I figured I was supposed to be doing it. It was good and I made a lot of money."

As Fago told it, "The owner, Martin Goodman, was doing comics, pulps, detective magazines, and sex hygiene books." In August 1942 he had moved from the McGraw-Hill Building to the fourteenth floor of the Empire State Building to "put everything in the same area."

Everyone liked the new locale. "They had a little reception area," remembered Fago. "They had a long corridor that stretched from Martin Goodman's office to way in the back where they were doing the magazines. And off that was a promenade. They had offices with windows where the staff people worked."

Vince Fago listed his fellow editors: "Mel Blum did the detective magazines. He also used to go out in the mornings and take pictures for them. Bess Little put out the love magazines. I never saw them . . . so they must have been elsewhere in the building. You ever hear of Elizabeth Hardwick? She started the *New York Review of Books* and was a pulp editor for Martin Goodman at the time. She came in on Tuesdays and Thursdays."

Fago felt Goodman was good at following the trends. "Martin Goodman used to lie back in a big chaise lounge, and he'd look at the sales charts every day. He was counting his money. He had been a hustler who'd had a rough life and he was trying to live it up. Goodman did things the hard way, but he succeeded."[73]

"Goodman spent most of his days sleeping on the chaise lounge in the corner, near the windows and the spectacular view of Manhattan," recounts author Ronin Ro in *Tales to Astonish*. "When Fago came in with artwork, he'd open his eyes, sit up, glance quickly at the covers, and tell Fago to run with it."[74]

Was the comic book division as important to Goodman as his magazine department? "Even more so," confirmed Vince Fago. "The print runs were 250,000 to 500,000 copies. Sometimes we'd put out five books a week or more. You'd see the numbers come back and could tell that Goodman was a millionaire. The comics were what gave him that chaise lounge."[75]

"We had a good working relationship," said Fago. "He'd go in and sleep on that chaise lounge. It was in a corner near the windows. I'd come in and look at him and make believe I'd turn away. He'd open his eyes and tell me to come in. Goodman never once said no to anything I wanted. He was scared of me in some way, because if I decided to quit (and I did look for other jobs), then he'd be stuck."

Goodman was somewhat mercurial, in Fago's opinion. "He seemed like a kind man to me at times. But then he'd say, 'After the war, I'll get those sons of bitches!' . . . [referring to] his staff and freelancers. Anybody who was working for him. So I figured he felt the same way about me."[77]

FOOTNOTE

"Once a week, a guy named Frank Torpey would come in and Martin would give him a check for 25 bucks," recalled Vince Fago. "This was his reward because Torpey talked Goodman into publishing comics. That was good money then. Torpey was a magazine pusher."[76] Torpey, in fact, was a salesman for Funnies, Inc., the original supplier of comic strips to Goodman.

THE WAR YEARS

"Clearly, the world needed heroes," observes Rabbi Simcha Weinstein, author of *Up, Up, and Oy Veys*. "So even before their own country went to war with Hitler, young Jewish American artists and writers (some barely out of their teens) began creating powerful characters who were dedicated to protecting the innocent and conquering evil."[78]

World War II had a significant impact on comic books, particularly sales for the superhero genre. Comics gained in popularity during the war as inexpensive, portable, easy-to-read stories about good triumphing over evil. At the time, people needed that kind of inspirational archetype.

"In the early days of World War II," observes comics chronicler Don Markstein, "one of the popular sub-genres of comic-book superheroes was the patriotic variety—the guys who would dress up in what comics writer Roy Thomas later called 'Uncle Sam's underwear.' With flag-draped figures like The Shield, Captain Freedom and even Uncle Sam himself having paved the way, Captain America was the first successful character published in his own comic."[79]

Superheroes from many different publishing companies fought against the Axis during World War II. Among them were All-American's Red, White, and Blue; AC's Miss Victory; DC's Star-Spangled Kid; MLJ's Captain Flag; Better's Fighting Yank; Fox's the Eagle; Prize's Fighting American; and Quality's Uncle Sam.

Comic book covers of the time made the message clear:

» On *Action Comics* #58, the Man of Steel cranks out a message on a printing press that boldly announces, "Superman says: You can slap a Jap . . ." (with war bonds, that is).
» On *World's Finest Comics* #9, Batman helps his super pals "Knock out the Axis with Bonds and Stamps!"
» On *Master Comics* #33, a headline heralds "Captain Marvel Jr. Swats the Swastika!"
» On *Young Allies* #3, one of Toro's mates shouts, "Remember Pearl Harbor!" while Bucky throws a bomb at a Japanese officer.
» On *Captain America* #13, Cap clobbers a Nazi officer, shouting, "You started it! Now—we'll finish it!"

The comic book was a key weapon in the country's propaganda arsenal during the war. "A lot of GI's went to war with a comic book rolled up in their back pants pocket," says collector Ethan Roberts. "In fact, comic books sold better during the War than they did any other time in their history."[80]

The enemy was often savagely parodied: Germans were square-jawed *dumbkoffs.* Japanese were yellow-skinned devils with slanty eyes and buckteeth. But they were no match for Captain America.

One in four magazines shipped to U.S. troops was a comic book. Popular comic stories included "The Terror of the Slimy Japs," "The Slant Eye of Satan," and "Funeral for Yellow Dogs."[81]

Krauts and Japs and Red Skull—oh my! Un-PC by today's standards, but a rallying cry for patriotism during World War II.

BOY SIDEKICKS

Captain America had a **sidekick** known as Bucky. The character of James Buchanan Barnes had been created by Joe Simon and Jack Kirby as a second banana in *Captain America Comics* #1 (March 1941). Bucky also teamed up with the sidekicks of other heroes in a group called the Young Allies.

Bucky and his pals—Knuckles, Jeff, Tubby, Whitewash, along with the Human Torch's sidekick Toro—took on the Nazi villain known as the Red Skull in *The Young Allies* #1 (Summer 1941).

But wait! In the closing days of World War II, Captain America and Bucky were "killed" in an exploding airplane. Figuring that the deaths of two superheroes would be bad for America's morale, President Harry Truman asked a hero known as the Spirit of '76 to assume the identity

of Captain America. Posing as Bucky was Fred Davis, a former batboy for the New York Yankees.[82]

Ah, the stuff of fiction!

Meanwhile, over at DC Comics Joe Simon and Jack Kirby were creating such "kid gangs" as the Boy Commandos and the Newsboy Legend. And MLJ's the Shield partnered up with a kid named Dusty Simmons in *Pep* #11. Even Quality's elasticized Plastic Man had his fat pal Woozy Winks.

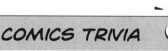

COMICS TRIVIA

While a superhero has sidekicks, a villain's supporters are usually called henchmen, minions, cronies, or lackeys—but never sidekicks.

TEAMS

The Justice Society of America (or JSA for short) is credited with being the first **team** of superheroes in comic book history. Conceived by editor Sheldon Mayer and writer Gardner Fox, the JSA first appeared in the All-American (later DC) *All-Star Comics* #3 in the winter of 1940. Because the publisher wanted to showcase lesser-known characters, the JSA was limited to heroes who didn't have their own titles. Therefore, Superman and Batman were only honorary members, while Hawkman, the Spectre, Hourman, and Dr. Fate were regulars.

The Freedom Fighters was a minor DC team made up of characters acquired from the now-defunct Quality Comics. The earliest version has the Freedom Fighters being assembled on December 7, 1941, to fight the Japanese—but alas, they failed to prevent the attack on Pearl Harbor.

Another team that DC acquired from Quality was the Blackhawks, comprised of a multinational collection of World War II flying aces. Originally appearing in *Military Comics* #1 (1941), Blackhawk—the team's leader—got his own self-named title some three years later.

Over at Fawcett, the Marvel Family became established in 1942 after the introduction of Captain Marvel's partners: the Lieutenant Marvels (*Whiz Comics* #21), Captain Marvel Jr. (*Whiz Comics* #25), and Mary Marvel (*Captain Marvel Adventures* #18). Captain Marvel was the first superhero to have a team who shared his own powers and abilities, a concept later adapted for heroes such as Superman and Aquaman.[83]

In the postwar era, Captain America led Timely's first superhero team in the *All-Winners Squad*. But the popularity of superheroes had begun to fade, and the title was cancelled after two issues.

COMICS TRIVIA

Elvis Presley was a big fan of Captain Marvel Jr., the crippled newsboy who could turn into a superhero by uttering the name "Captain Marvel!" Elvis even styled his hair after the young superhero, right down to the stray spit curl in front. When Elvis graduated high school, he said to his cousin Earl, "You know, I believe there's a superboy inside me, just waiting to bust out."[84]

Later teams included DC's Legion of Super-Heroes in 1958 and Justice League of America in 1960. And Marvel's Avengers was formed in 1963.

Perhaps the ultimate superhero team is the X-Men, a group of mutants who currently form the backbone of the Marvel Comics Universe. Created by Stan Lee and Jack Kirby, they debuted in *The X-Men* #1 in September 1963. Numerous characters with strange powers populated this series—Cyclops, Angel, Beast, Iceman, and Jean Grey. Later, more X-Men characters would be added, among them Storm, Rogue, Mystique, Kitty Pryde, and the breakout star Wolverine. And as about everyone on the planet knows, a series of successful movies have carried the X-Men's popularity into the new millennium.

Teams were big. Coming on the scene in late 1965, the T.H.U.N.D.E.R. Agents were portrayed as an arm of the United Nations, notable as everyday people whose heroic careers were merely their day jobs.

Mighty Crusaders was a group created by Archie under their *Mighty Comics* banner in the mid-1960s. At that time, the team members consisted of Black Hood, the Fly, Fly Girl, Shield III (son of the original Shield), and the Comet (the first superhero killed in the line of duty).

Making their appearance in *Marvel Feature* #1 in 1971, the Defenders constituted a "nonteam" led by Dr. Strange, its fluid membership including the Silver Surfer, Namor, and the Hulk—each a popular superhero in his own right.

Marvel's Alpha Flight is noteworthy as one of the few Canadian superhero teams. Created by Chris Claremont and John Byrne, the group first appeared in *Uncanny X-Men* #120 (August 1979).

Eclipse Comics' DNAgents was a team of superheroes created through genetic engineering by the sinister Matrix Corporation. Launched in the 1980s, this series' Matrix Corporation has no connection with the Wachowski brothers' *Matrix* movie trilogy.

X-Force was one of many spin-offs from Marvel's popular X-Men franchise. Conceived by artist-writer Rob Liefeld, it was formed in *The New Mutants* #100 (1991).

TRUE FACT

Larry and Andy Wachowski were comic book writers on such Marvel titles as *Ectokid* and *Gambit*—before coming up with the concept for the *Matrix* movies. The *Matrix* trilogy has grossed more than $1.6 billion worldwide.[85]

Stormwatch was a United Nations–sponsored superhero team in the Wildstorm Universe, created by Jim Lee in the early 1990s. And WildC.A.T.s was a mid-'90s carbon copy of Lee's earlier work on Marvel's *The X-Men.*

The Thunderbolts were first presented as a group of superheroes like the Avengers, both to readers and to the Marvel Universe. However, in reality, the Thunderbolts were the Masters of Evil in disguise. This revelation, made at the end of *Thunderbolts* #1 (April 1997), is considered to be "one of the most well-conceived plot twists in the history of American comic books."[86]

Veteran comic book collector Aaron Albert list the Top 10 Superhero Teams as (1) X-Men, (2) Justice League of American, (3) Fantastic Four, (4) Avengers, (5) Teen Titans, (6) The Authority, (7) Justice Society of America, (8) League of Extraordinary Gentlemen, (9) Defenders, and (10) The Watchmen.[88]

DOLLARS IN THE CASHBOX

In the 1940s, comics had become big business. "Over 15 million comic books were sold each week. Superman had a regular radio show, and some 35,000 copies of *Superman* alone were sent to soldiers each month. By 1943, comic book sales reached $30 million, not bad for a 5-year-old industry."[89]

OFF TO WAR

Simon and Kirby had been doing well at DC, but America's entry into World War II interrupted their careers. Both were drafted in 1943—Simon going into the coast guard, while Kirby served with the Third Army combat infantry. Before shipping out, they hurriedly built up a backlog of stories that could be used while they were away. This ensured that substantial royalties from DC would accrue for them during their absence.

After the war, Simon and Kirby began an abortive line of books for Harvey Comics. These titles, which included *Stuntman* and *Boy Explorers,* never really got off the ground because of distribution problems, so Simon and Kirby moved over to Crestwood.

"All I know is that Liebowitz was very upset that they didn't come back to him and do more books for DC," says former editor Carmine Infantino. "Joe and Jack were getting a piece of the action at Crestwood, but I think he would have given them that, actually. So he was quite upset they didn't give him a chance to make an offer. He loved 'em. They made a lot of money for DC."[91]

FOOTNOTE

Wizard magazine cited the revelation of the Thunderbolts' identities at the end of the first issue as "Comics's Greatest Moment of 1997"— and in 1999 placed it at number eleven on a list of "The 25 Greatest Comic Moments Ever."[87]

FLASHBACK

"Busiek and Bagley have come up with a great idea, but we can't tell you," says Ski, my number two at Marvel. "Whattaya mean you can't tell me, I'm the publisher—not to mention your boss," I grumpily point out. "Trust us," he says, grinning at Marvel's editor in chief, Bob Harras. Yeah, right. It takes me days to worm it out of them. Marvel managed to keep the secret of the Thunderbolts so tightly under wraps that when word finally got out, the first issue sold out very quickly. We had to go back for a second printing, as well as release a mini-trade paperback that collected the first two issues under one cover. As Ski would say, Sweet!

LOOKING BACK

"After we went off during the War, we had talks with Alfred Harvey who was very successful (with Harvey Comics) at that time," recalls Joe Simon. "He was stationed in Washington, DC and I was stationed in Washington, DC and Will Eisner was stationed there. Jack was off fighting somewhere, putting up fences in the Army. But I made a deal with Al Harvey to be part of the business and get 50 percent shared profits. DC had voluntarily been paying us royalties on Boy Commandos—characters we left behind. They did wonderfully by us and we appreciated it, but we just couldn't pass up this partnership deal with Harvey. And after the War, we went back there. We went back with him. It was just business; not something I'd be proud of, but that's what you have to do in business. I guess we're talking about a businessman again. (laughter)."[90]

A REDHEAD TEEN

MLJ Comics had joined the war effort with such patriotic heroes as the Shield, the Comet, and a brutal character called the Hangman. Surprising that this company would come up with the most popular comic book teen of all time.

The Archie character was conceived by one of the three owners, John L. Goldwater (the "J" in MLJ). The story is, he conceived the idea after watching Mickey Rooney in an *Andy Hardy* movie.

Archie Andrew's first appearance was in *Pep Comics* #22 (December 1941), drawn by Bob Montana and written by Vic Bloom.

As Archie's popularity grew, the company gradually phased out the superheroes. In 1945, MLJ officially changed its name to Archie Comics.[93]

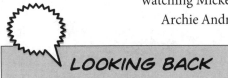

LOOKING BACK

"John thought there should be an Everyman character to balance off all those superheroes," says publisher Michael Silberkleit. "So he went to the art staff and said, 'I have an idea, but I can't draw.' Of all the artists, Bob Montana came up with a likeness for the character that John liked best. So Bob was hired to do this new teenage character called Archie."[92]

THE WAR IS OVER!

Twenty-two-year-old Stanley Lieber returned in September 1945 from the Big War—although he'd seen no action (being one of nine enlistees classified as a "Playwright"—how did that happen?).

His military career was undistinguished. He'd dutifully served stateside in the signal corps writing manuals, slogans, and training films. His greatest contribution was an anti–venereal disease poster that read: "*VD? Not me!*"

Although Vince Fago hadn't seen any service, he proved himself a good soldier by giving up his $250-a-week editor in chief position to return Stan's job to him.[95]

LOOKING BACK

"And there I was, a humble comic book scribe," Stan says modestly of his time in the army. "Of course, I eventually made my mark in the world. I've no idea what happened to poor Capra and Saroyan and the others."[94]

Settling back into his office, Stan tried to pitch new superhero concepts, but as usual Goodman insisted on following the trends.

"Well, what happened was that—until the early '60s—I did everything the publisher wanted," says Stan Lee, "and his way of publishing was to follow the trends. Whatever was selling at the moment—he would publish books in that genre. For instance, when it looked as though Westerns were hot . . . we added a lot of Western titles. When Romance stories were doing well . . . we published a lot of Romance books. Then we did a lot of War magazines. Then Horror. Then Crime. Then the Animated-type of characters . . . the Terrytoons-type of things. We did Teenage titles. We never were leaders in the field—we always

followed the trends. In those days—until the early '60s—comic books were very cyclical. There were trends . . . One year, Romance books would be hot . . . One year it would be Horror stories . . . whatever . . . and we just went along. We were like a production house—we just kept producing whatever was hot at the moment."[96]

ATOMIC AGE?

The bombs that dropped on Hiroshima and Nagasaki had a profound effect on comic-book storytelling. "The rise of gritty crime and horror related comics, such as those of EC Comics, [came] in the late 1940s and early 1950s. This shift, along with the particular appearance of superheroes created by nuclear explosions and similar events, has led some (such as the National Association of Comics Art Educators) to describe the period from the mid-1940s to the mid-1950s as the Atomic Age of Comic Books."[97]

A DOWNTURN IN SALES

"Sales slumped with victory and peace," observes *The Guardian*. "Nastier products helped to reverse the sales downturn: true-crime stories featuring beatings, shootings and stabbings in titles such as *Crime Does Not Pay* and its eager imitators, *Gangsters Can't Win* and *Lawbreakers Always Lose,* all proving that crime pays very well."[98]

EDUCATIONAL OR ENTERTAINING?

1944 was the year Max Gaines decided he'd had enough of superheroes (which he'd never personally liked), so he sold all his properties to National Periodicals (DC)—except for *Picture Stories from the Bible* and *Picture Stories from World History*. Instead of retiring with the ample proceeds of the sale, he used those two titles as the foundation for a new publishing venture, Educational Comics—better known as EC.[99]

Tragically, Max Gaines was killed in a boating accident in 1947 and the company subsequently was taken over by his twenty-five-year-old son, William M. Gaines. The younger Gaines promptly changed directions, publishing titles like *Saddle Justice* and *Crime Patrol*. But his breakthrough came in 1950 when he and editor Al Feldstein launched *The Vault of Horror* and *Tales from the Crypt*.[100]

They called this lurid style "A New Trend in Comic Books," quickly adding titles such as *Weird Science, Haunt of Fear,* and *Crime*

SuspenStories to the lineup. These comics made stars of artists Wallace Wood, Jack Davis, Will Elder, John Severin, and Al Williamson.

Another up-and-comer, Harvey Kurtzman, was editing and writing *Two-Fisted Tales* and *Frontline Combat* for EC. In 1952 he convinced Gaines to publish a humor comic called *Mad.* To keep Feldstein happy, EC also launched a sister humor publication called *Panic.*

Bill Gaines was a great eccentric who collected airship models and Statue of Liberty memorabilia (both snow domes and statuettes).[101] A giant of a man with shoulder-length gray hair who typically wore a T-shirt and jeans, Gaines was easily recognizable at comics conventions. An avid wine enthusiast, he would sometimes fill the office water cooler with a fine wine, or trade comic books from his vault for rare vintages. He left the contents of his magazines up to the creative teams, declaring that his job was to create the "proper atmosphere."[102]

EC had now moved its editorial approach from "Educational Comics" to—*ta da!*—"Entertaining Comics."

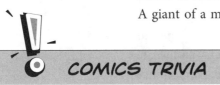

COMICS TRIVIA

In the good old days, *Mad* employees were invited on a yearly cruise, all expenses paid by Bill Gaines. To be eligible for the cruise it was necessary to have written or illustrated at least eighteen pages for *Mad* during the previous year. One writer who had only done seventeen pages was disappointed to be informed, "You didn't do enough pages!" Later, when Gaines's mother passed away, the writer was asked if he was coming to the funeral. He replied in typical *Mad* fashion: "I didn't do enough pages."—which Gaines thought was quite humorous.[103]

ANOTHER SON STEPS IN

As Irwin Donenfeld recalled, "In 1948, I was already married and had a child. I graduated from college and went up to DC and I showed them that I was a college graduate; I had a keen intellect, and they hired me because my father was the boss."[104]

Harry Donenfeld's son applied himself to both the business and editorial sides of publishing. His attention to distribution allowed him to see what types of magazines were selling around the country. He would ask the accountants to enter each issue's sales figures into scrapbooks accompanied by the book's cover. Then he'd spend hours studying the trends, trying to decide what elements on each cover had caused sales to go up or down. He'd tell the editors, "Sales went up when you put a dinosaur on the cover" or "Sales go down when you use a lot of brown on the cover."

With the popularity of superheroes waning in the late 1940s, this newsstand input helped guide DC into more diverse genres—starting with westerns and later expanding into romance, crime, war, mystery, and science fiction.

"Harry was an alcoholic with a penchant for getting into trouble and an inability to run his own business," writes Mark Evanier of POVonline. "The financial decisions therefore fell to his former accountant, Jack

Liebowitz, and the creative ones to the editorial division. Bridging the gap between them . . . was Irwin."

Although Irwin Donenfeld served as DC's editorial director from 1952 to 1957 and executive vice president and business manager from 1958 to 1967, he was generally disinterested in the contents of the comic books, believing that "good, intriguing covers were about all that mattered." He once said the only DC Comic he read every issue was *Sugar and Spike*.[105]

NEW GENRES

Although the creation of the superhero was undisputedly the Golden Age's most significant contribution to comics, many other genres appeared following the war. Newsstands abounded with funny animals, teen humor, westerns, science fiction, jungle, romance, crime, horror, and satire.

Stan Lee recalls those times: "We and all the other publishers tried everything we could do to find a formula that would work in the postwar market. All anyone had to do was name a category and we slapped a few comics together in that department."[106]

"Publishers would fall in love with a new genre faster than politicians can kiss a baby and would jettison even successful titles if a new genre might increase sales by even a few copies. This does nothing to help promote brand loyalty," observes historian-in-the-making Ray Bottorff Jr.[107]

Except for three enduring originals—Superman, Batman, and Wonder Woman—superheroes had all but disappeared by 1952.[108]

WESTERNS

Movie cowboys led the posse: Tom Mix (1940) and Red Ryder (1940) were followed down the trail by Gene Autry (1941) and Roy Rogers (1945). No matter that the singing cowboys couldn't warble on the pages of comics, they could still outride, outrope, and outshoot those bad guys in the black hats.

The real explosion in western comics began in 1948, with Fawcett and Dell heading the pack. Fawcett focused on licensed cowboy heroes with titles like *Rocky Lane Western* (1949), *Lash*

FLASHBACK

(at twelve): I owned more comic books than any kid in my neighborhood, a status symbol. The stack was about three feet high. *Blackhawk* was a favorite. And *Firehair*, a cowgirl with flame-red hair. *Jumbo Comics*, with its jungle girl in a skimpy leopard skin. EC's *Vault of Horror* with its gory covers. *Nancy and Sluggo*, always good for swapping with girls in the neighborhood. *Lash LaRue*, that cowboy with a bullwhip. A Tarzan rip-off called *Thun'da, King of the Congo* (drawn by Frank Frazetta). *Tim Holt*, a cowboy busting out of the panels in a simulated 3-D.

But then I made an amazing discovery, a cardboard box of old comic books stored at my grandmother's house, a remnant of my uncle's teenage years. Here were comics from another day: *Don Winslow of the Navy. Blue Bolt*, an athlete given superpowers by a bolt of lightning. *Bulletman*, a superhero who could fly as fast as a bullet. A magician billed as *Ibis, the Invincible*. A sexy heroine known as *Phantom Lady*. A comic called *Air Fighters*, featuring a flying ace known as Airboy. *Police Comics*, with Plastic Man stretching like a rubber band. *Whiz Comics*, starring the "world's mightiest mortal," Captain Marvel. And *Master Comics*, with Freddie Freeman, a crippled newsboy who could turn into Captain Marvel Jr. Yes, Golden Age comic books—the mother lode!

LaRue Western (1949), and *Bill Boyd Western* (1950). Charlton joined the roundup with *Tim McCoy Western Movie Stories* (1949) and *Tex Ritter Western* (1950).

Cowboys' sidekicks like *Gabby Hayes* (1948) and *Smiley Burnett* (1950) got their own comic books. Heck, even cowboys' horses had their own titles, as exhibited by *Black Fury* (1955) and *Rocky Lane's Blackjack* (1957).

Nonetheless, fictional cowboys held their own with Marvel titles like *The Two-Gun Kid* (1948), *Kid Colt* (1948), *Arizona Kid* (1951), *The Trigger Twins* (1951), and *The Rawhide Kid* (1955). Marvel launched *Wild West* #1 in 1948 and renamed *All Winners Comics* (Volume Two) as *All Western* the following year.

Lev Gleason Publications offered *Desperado* in 1948 and *Black Diamond Western* the following year. Charlton tried *Six-Gun Heroes* (1950) and other shoot-'em-ups. Dell stuck with its formula of licensing, picking up several westerns from popular television series: *Gunsmoke* (1956), *Maverick* (1958), *Rawhide* (1959), and *Bat Masterson* (1959).[109]

FUNNY ANIMALS

From Walter Lantz's Woody Woodpecker to Walt Disney's Mickey Mouse, kids and their parents loved anthropomorphic cats, dogs, and mice—although there was debate about exactly what species Mickey's friend Goofy might be.

Ducks were popular characters. Donald Duck made his appearance in an animated cartoon back in 1934, but his first American comic book appearance wasn't until 1942 with Western Publishing. There, the character was assigned to a former Disney artist named Carl Barks, who did ten-pagers for *Walt Disney's Comics and Stories*. He created Scrooge McDuck in 1947, and by 1952 the "World's Richest Duck" had his own title with *Uncle Scrooge* #1.[110]

Ignoring Disney's famous duck family, Marvel had been publishing *Dopey Duck Comics* for years, renaming it *Wacky Duck Comics* in 1946. Later, in 1973, the company introduced Steve Gerber's Howard the Duck, an anthropomorphic character in a humanoid world. The ill-tempered quacker got his own title (*Howard the Duck* #1) in 1976. Known for its tongue-in-cheek style and metafictional awareness of the limitations of the medium, the series developed a cult following. A *Howard the Duck* movie followed in 1986—executive produced by none other than George Lucas. It's considered to be among the one hundred worst films ever made.[111]

Previously known for its stories about The Flash, DC's *Comic Cavalcade* was revamped completely with issue #30 (January 1949), becoming a funny-animal humor book when super-heroes faded from popularity in the postwar era. Animal characters in the new version included the Dodo and the Frog, Nutsy Squirrel, and the Fox and the Crow.[112]

In addition to *Krazy Komics*, Timely's funny-animals department cranked out such titles as *Komic Kartoons, Funny Frolics, Comedy Comics, Comic Capers, Krazy Krow, Funny Tunes, Animated Movie Tunes, Dopey Duck, Silly Tunes, Ideal Comics,* and *Comics for Kids.*

FLASHBACK

When editor in chief Bob Harras and his wife were expecting triplets, we promptly dubbed them "Huey, Dewey, and Louie"—knowing full well that Bob was not a Disney fan. After they were born, I gave him an original Carl Barks sketch of Donald Duck's nephews as a baby gift. Always thoughtful.

INTERVIEWER: You drew in the Timely offices, right?

ALLEN BELLMAN: Yes, I was a staff artist and Timely had a large staff.

INTERVIEWER: How was the staff set up in the Timely offices?

ALLEN BELLMAN: There was a separation of the guys who worked on the adventure books from the guys who worked on the animation books.

COMICS TRIVIA

Along with funny-animal features like Silly & Ziggy, Frenchy Rabbit, Toughy Tomcat, and Posty the Pelican, Ed Winiarski liked to include caricatures in *Krazy Komics* of Timely bullpenners like himself, Mike Sekowsky, George Klein, and Vince Fago, as well as Martin Goodman and Stan Lee.[113]

INTERVIEWER: You mean the funny-animal books?

ALLEN BELLMAN: Yes. We called them the "animators." I remember one time Walt Disney sent them a letter telling them to stop copying their characters.[114]

Funny animals even crossed over into the superhero genre with Mighty Mouse, originally a Terrytoons animated cartoon but becoming a comic book with Timely in 1946, St. Johns in 1947, and Pines in 1956. A similar character was Charlton's Atomic Mouse, a superpowered rodent making his first appearance in 1953. Standard Comics published Supermouse the Big Cheese. Timely also had Super Rabbit, while Fawcett claimed Hoppy the Marvel Bunny.[115]

TEENS

The most popular comic book teenagers were those perennial students of Riverdale High—Archie Andrews, his pal Jughead, and those two pubescent babes Betty and Veronica. In fact, the redheaded hero

was so darn popular the publishing company even carried his name: Archie Comics.

Another teen cutie was Patsy Walker, who debuted in the second issue of Timely's *Miss America Magazine* in 1944. She got her own comic in 1945 but continued to appear in *All-Teen, Teen Comics,* and *Girls' Life* during the 1940s and '50s. Also a redhead, Patsy was more or less a female Archie.

In 1947 Marvel spun *Junior Miss* from *Human Torch Comics.* And *All Winners Comics* (Volume One) was renamed *All-Teen Comics* with issue #20, then by the following issue shortened to *Teen Comics.* Getting right to the point.[118]

TRUE FACT

Today, the funny-animal genre is sometimes called **"furries."** Examples range from the kid-friendly *Sonic the Hedgehog* and *Scooby Doo* to the more sexually mature *Omaha the Cat Dancer* and *Shanda the Panda.*[116]

COMICS TRIVIA

Long before there was an Archie, there was Harold Teen. Known as "America's Typical Teenager," he appeared in a comic strip syndicated by the *Chicago Tribune*, but later was used as a back-pages feature in Dell's *Popular Comics.*[117]

SCIENCE FICTION

The World of Tomorrow got its due in the pages of comics. Here, space ships could be depicted much more realistically than those tin cans on a string you saw in Saturday-morning serials like *Flash Gordon Conquers the Universe* (1940) or *King of the Rocket Men* (1949). It would take more than half a century for Hollywood's special effects to catch up with the dazzling visuals drawn by Wallace Wood and Al Williamson in EC Comics' celebrated sci-fi titles *Weird Fantasy* (1950) and *Weird Science* (1950).

DC Comics' *Strange Adventures* (1950) and *Mystery in Space* (1951), the classic sci-fi titles edited by aficionado Julius Schwartz, got high marks from young space cadets. And a *Mystery in Space* series called "Space Cabby" cannot be beat for deep-space zaniness—the story of a cab driver taxiing passengers between planets.

Ziff-Davis put its toe in the water with *Weird Thrillers* (1951) and *Space Busters* (1952). Avon tried its hand with *Flying Saucers* (1950), *Strange Worlds* (1950), *Earthman on Venus* (1951), and *Space Detective* (1951).

There were even hybrids between genres—like Charlton's *Space Western Comics* (1952) starring Spurs Jackson and his Space Vigilantes.

The late 1950s featured various sci-fi titles like Charlton's *Mysteries of Unexplored Worlds* (1956) and *Outer Space* (1958), followed by Marvel's *Tales to Astonish* (1959).

In the 1960s, Dell followed up with *Space Man* (1962), *Outer Limits* (1964), and *Flying Saucers* (1967). Charlton would try again with *Space*

Adventures (1968), *Outer Space* (1968), *Space: 1999* (1975), and *Space War* (1978).

Future years would see Marvel's *Star Wars* (1977), *Micronauts* (1979), various *Star Trek*–themed series (1996), and *Men in Black* (1990 and 1997).[119]

JUNGLE

Fiction House's *Jungle Comics* #1 introduced Kaanga, Lord of the Jungle, in 1940. Like Tarzan, Kaanga was a young Caucasian boy whose parents died in the jungle, leaving him to be raised by apes. That same company's *Jungle Stories* starred another Tarzan clone named Ki-Gor.

FOOTNOTE

Science fiction is a genre of fiction in which the story depends (at least in part) upon some change in the world as we know it that is explained by science and technology. So if you want to get technical, almost all superhero titles could be classified as "science fiction."

Fawcett's *Nyoka the Jungle Girl* made her appearance in 1945. Not accurately a "jungle girl" comic, Nyoka was simply an American girl who lived in the jungle—like Standard's *Jungle Jim* (1949) and *Ramar of the Jungle* (1954).[120]

Other jungle-themed comics included the aptly named *Jungle Thrills* (1952), *Jungle Action* (1954), and *Jungle Tales* (1954*)*.

Fox Feature Syndicate was responsible for a plethora of jungle royalty, among them *Jo-Jo, Congo King* (1947), *Zago, Jungle Prince* (1948), *Tegra, Jungle Empress* (1948), and *Rulah, Jungle Goddess* (1948).

Perhaps the best-known jungle girl of the time was Sheena, Queen of the Jungle. Originally appearing in a British tabloid, she made her American debut in Fiction House's *Jumbo Comics* #1. Based on a sketch by Will Eisner, Sheena starred in this series from 1938 through 1953.

COMICS TRIVIA

When Gold Key Comics lost the publication rights to Tarzan, the company whipped up a new series to take its place: *Jungle Twins*, the story of twins Tono and Kono, European kids raised by an African chieftain. The idea being if one Tarzan was good, two were even better. The series lasted seventeen issues.[121]

Over the next several years, her success spawned a host of imitators, including Charlton's *Zegra, Jungle Empress* (1948), Marvel's *Jann of the Jungle* (1955), and DC's *Rima the Jungle Girl* (1974). Most were female versions of Tarzan, with more curves.

Later Tarzan contenders included Charlton's *Konga* (1960). And a jungle denizen named *Ka-Zar* was reintroduced by Marvel in 1965 and again in 1997.[122]

Boonga bonga!

ROMANCE

In the late 1940s, two crusty, cigar-chomping guys—Joe Simon and Jack Kirby—created the first romance title, *Young Romance* #1 (September 1947), and are credited with inventing the field of romance comics.

Yes, believe it or not, girls read comics back in those days. They loved following the adventures of Marvel's *Millie the Model* (1945), along with numerous spin-offs like *A Date with Millie* (1956), *Life with Millie* (1960), *Modeling with Millie* (1963), and *Mad about Millie* (1969)—not to mention *Chili, Millie's Rival* (1969).

And just to make sure readers got enough of a good thing, Marvel also published such self-imitative titles as *Tessie the Typist* (1944) and *Nellie the Nurse* (1945).

Among other glamour queens were Marvel's *Powerhouse Pepper* (created by Basil Wolverton in 1943*),* Superior Comics' *Brenda Starr* (1948), and Archie's *Katy Keene* (1949) with her cutout paper-doll pages.

Feeling romantic? Girls could turn to Fawcett's *True Stories of Romance,* Prize Comic's *Young Romance* and Marvel's *My Romance* (1948), *Romance Diary* (1949), *Romance Tales* #7 (a spin-off from *Western Winners*), *Mitzi's Romances* #8 (renamed from *Mitzi's Boyfriend*), and *Mollie Manton's Romances* (1949).

If girls wanted True Love they could find it in Marvel titles such as *Love Adventures, Love Classics, Love Dramas, Love Romances* (renamed from *Ideal Comics*), *Love Secrets, Love Tales* #36 (a spin-off from *Human Torch Comics*), *Best Love* (a spin-off from *Sub-Mariner*), *Lovers* #23 (renamed from *Blonde Phantom*), *My Love,* and *Our Love*—all launched in 1949. [123]

More romance? Marvel also had *Cupid* (1949), *Faithful* (1949), and *Young Hearts* (1949). It even created hybrids between genres: *Western Life Romances* (1949), *Rangeland Love* (1949), *Cowboy Romances* (1949), and *Romances of the West* (1949)—everything a young girl dreams of, romance *and* horses!

Quality Comics also made a run at the love market with such titles as *Love Diary* (1949), *Love Confessions* (1949), *Love Letters* (1949), *Secret Loves* (1949), *Flaming Love* (1949), *Forbidden Love* (1950), *Love Scandals* (1950), *Love Secrets* (1953), and *Girls in Love* (1955), among others.

By the late 1940s, Fox Features practically dominated the romance market with more than twenty-five titles, like *My Desire, Young Romance,* and *My Love Secret.* These Fox titles were a tad racier than other companies' books.

As usual, Charlton trailed the trend with *Brides in Love* (1956), *First Kiss* (1957), *My Secret Life* (1959), *High School Confidential Diary* (1960), *Cynthia Doyle,*

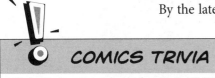

COMICS TRIVIA

Some say that Stan Lee borrowed the "Millie the Model" name from longtime Marvel Comics employee Millie Shuriff, who continued processing artists' payment vouchers for the company well into the late 1990s.[124]

Nurse in Love (1962), *Registered Nurse* (1963), *Career Girl Romances* (1964), *Hollywood Romances* (1966), and *Haunted Love* (1973).[125]

WAR

War comics gained sales in English-speaking countries following World War II.

Believe it or not, Harvey Kurtzman, the humorist who created *Mad*, spent a number of years cranking out war comics for Bill Gaines's EC Comics. *Two-Fisted Tales* (1950) and *Frontline Combat* (1951) often featured "weary-eyed, unheroic stories that were out of step with the jingoistic times." Many of the young readers who picked up on the anti-war bias of Kurtzman's stories would become the war protesters of the 1970s.[126]

G.I. Combat was launched in October 1952 by Quality Comics. When National Periodical Publications (now DC) acquired the rights to Quality's characters in 1957, *G.I. Combat* and *Blackhawk* were among the very few titles it continued publishing.

One of the most prolific publishers of war comics was Charlton. The low-rent company produced a wide variety of war titles in the 1950s, such as *Fightin' Marines* (1955), *Fightin' Army* (1956), *Fightin' Air Force* (1956), *Fightin' Navy* (1956), *Battlefield Action* (1957), and *U.S. Air Force Comics* (1958).

And Charlton carried the war theme into the 1960s and '70s with *D-Day* (1963), *Army War Heroes* (1963), *Navy War Heroes* (1964), *Marine War Heroes* (1964), *Fightin' Five* (1964), *Marines Attack* (1964), *Army Attack* (1965), *War and Attack* (1966), *Attack at Sea* (1968), *Attack!* (1971), and *War* (1975).[127]

Later on, Marvel came up with *Sgt. Fury and His Howling Commandos*, and DC published *Sgt. Rock*.

More recently, a graphic novel *Fax from Sarajevo* (1996), by Sgt. Rock veteran Joe Kubert, was published by Dark Horse Comics. It won two of the industry's major accolades, the Eisner Award and the Harvey Award.[128]

CRIME

We all knew that crime did not pay because we were told so in *Crime Does Not Pay* (1942), that gritty Lev Gleason title featuring hardened criminals, buxom gun molls, and G-men with rat-a-tat-tat Tommy guns. Other popular

COMICS TRIVIA

The English rock band XTC included a song called "Sgt. Rock (Is Going to Help Me)" on its 1980 album *Black Sea*.[129]

titles included Atlas's *Crime Can't Win* (1942), Prize's *Justice Traps the Guilty* (1947), and EC's *Crime Patrol* (1949).

These hardboiled comics echoed such old-time radio fare as *Gangbusters* and *Calling All Cars,* or those gritty mob movies starring George Raft and Edward G. Robinson. In fact, DC published a comic book called *Gang Busters* (1947).

Official True Crime Cases #23 (1947) was a spin-off from Marvel's *Sub-Mariner*—go figure! The following year it launched *Crime Exposed* (1948) and *Crimefighters* (1948).[130]

EC's *Crime SuspenStories* (1950) exhibited a noir-styled approach that differed from other crime comic books of the period. Far from being illiterate drivel, two of the tales published by *Crime SuspenStories*—"Touch and Go" and "The Screaming Woman"—were faithful adaptations of Ray Bradbury short stories.[131]

HORROR

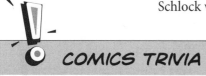

COMICS TRIVIA

As noted, best-selling author Mickey Spillane got his start by writing comics. As a matter of fact, his prototype for the hardboiled private eye Mike Hammer debuted under the name of "Mike Danger" in the 1954 comic book *Crime Detector* #3.[132]

Okay, admit it: Horror comics scared the heck out of us. We shivered as the ol' Crypt Keeper spun his grisly tales in EC's memorable horror line. Who could ever forget *The Vault of Horror* (1950), *The Haunt of Fear* (1950), *The Crypt of Terror* (1950), and *Tales from the Crypt* (1950)? As one observer aptly put it, "These titles reveled in a gruesome *joie de vivre,* with grimly ironic fates meted out to many of the stories' protagonists."[133]

As *Horror Comics: An Illustrated History* recounts, "In a genre with few continuing characters, the Old Witch, Vault Keeper, and Crypt Keeper gave the EC horror comics a personality of their own. Readers loved the puns, the in-jokes, and the smirking bad taste flaunted by the horror hosts."[134]

While many EC tales were known for their twist endings, *Crime SuspenStories* (1950) and *Shock SuspenStories* (1952) positively basked in them. Like "Gee Dad . . . It's a Daisy," penciled by Wally Wood. Or "The Giggling Killer," by Harvey Kurtzman.

Schlock writing? Not so! "The Small Assassin" in issue #7 of *Shock SuspenStories* and "The October Game" in #9 were official adaptations of Ray Bradbury stories.[136]

Horror of horrors, other publishers joined the fray. In the early 1950s over a hundred new horror titles appeared on newsstands, sometimes forty a month. Marvel's *Adventures into Terror* (1953) sported tales like "The Girl Who Couldn't Die."

COMICS TRIVIA

A story called "Kamen's Kalamity" (*Tales from the Crypt* #31) featured cameo appearances by many members of the EC staff, including publisher Bill Gaines, editor Al Feldstein, and the story's artist, Jack Kamen.[135]

Fawcett's *This Magazine Is Haunted* (1952) offered "The Slithering Horror of Skontong Swamp." Fiction House's *Ghost Comics* (1952) screamed "Death Is a Dream." Harvey's *Chamber of Chills* (1951) challenged: "We Dare You to Open the Mysterious Door into a World of Horror!"[139]

"EC's horror comics were neither the first nor the most disgusting, but they definitely stood out from the crowd," says chronicler Don Markstein. "Gaines and Feldstein provided the majority of the stories (with an occasional outside yarn from the likes of Ray Bradbury). . . . These features were done in the style of radio horror shows like *Inner Sanctum* and *Lights Out,* with creepy narrators (in this case, The Crypt Keeper and The Vault Keeper) dishing up grisly tales of rotting corpses and supernatural menaces."[141]

Scary? You've gotta admit that tales like "The Maestro's Hand!" and "The Sliceman Cometh" could make you wet your pants. Doubly scary when you're reading them under the covers at night with a flashlight.

FOOTNOTE

EC's editor Al Feldstein recalled, "I was rather impressed with [Ray] Bradbury's writing . . . and I was introducing that writing style into the comics." According to one critique, Feldstein was creating a "unique style of writing for the EC horror comics that was rich, rhythmic, and evocative."[137] At first, EC simply ripped off Bradbury's plots, but after a note from the author remarking that he had "inadvertently" not yet received payment for their use, Feldstein sent a check and negotiated a more legitimate—if cheap—arrangement.[138]

TRUE FACT

Time magazine, in its May 3, 1954, issue, noted: "Of the 80 million comic books sold in the U.S. and Canada every month, about a quarter are what the trade calls 'horror comics.'" It judgmentally added, "They deserve the title."[140]

QUESTIONS FOR FURTHER THOUGHT

1. Was Bob Kane self-serving in claiming sole creation of Batman? Or were Bill Finger and Jerry Robinson merely paid employees doing Kane's work for hire?
2. Why don't today's comics sell in the hundreds of thousands like those published during the Golden Age?
3. Was Captain Marvel a rip-off of Superman? Do you consider the court's decision correct? Argue your viewpoint.
4. Why aren't there more genres—westerns, funny animals, teen, war, horror, and so on—published today?
5. Did publishers go too far with horror comics? Or was it all just good fun?

SEDUCTION OF THE INNOCENT

A COMICS WITCH HUNT

Badly drawn, badly written, and badly printed—a strain on the young eyes and young nervous systems—the effects of these pulp-paper nightmares is [sic] that of a violent stimulant.[1]

—Dr. Fredric Wertham, *Seduction of the Innocent*

It's hard to believe that just fifty years ago because of *Seduction of the Innocent* by Fredric Wertham comics were being vilified. Comics were blamed for impairing the development of our children and contributing to juvenile delinquency. Dr. Wertham later recanted what he said in that book, but not a lot of people know that. They remember the Kefauver commission hearings and comic book burnings that resulted. But we survived that time, and today, comics are being embraced by our culture.[2]

—Steve Geppi, president of Diamond Comic Distributors and founder of Geppi's Entertainment Museum

AN even greater horror lurked in the shadows: a German-born psychiatrist was about to deal the comics industry a near-death blow. With the publication of his book *Seduction of the Innocent* in 1954, Dr. Fredric Wertham affirmed parents' worst fears: that comics were rotting our brains and turning kids into potential degenerates.

Excerpts from his book were printed in *Reader's Digest* and *Ladies' Home Journal*, "which led thousands of mothers to foam at the mouth."[3] Dr. Wertham's general assertion was that kids imitated crimes committed in comic books, and that such stories corrupted the morals of youth. He felt that juvenile delinquency had increased in direct proportion to the spread of comic books among children.

‹ MILESTONE #4: SEDUCTION OF THE INNOCENT IS PUBLISHED—AND LAUNCHES A WITCH HUNT THAT BEGETS THE COMICS CODE. ›

Seduction of the Innocent raised anxieties about comics by obsessing over sadistic and homosexual undertones in superhero comics. The book seemed to delight in describing overt or covert depictions of violence, sex, drug use, and mutilation within "crime comics"—a term Wertham applied to not only the popular gangster titles, but superhero and horror comics as well.[4]

These were opinions Wertham had been railing about for years. In 1948 he'd moderated a symposium for the Association for the Advancement for Psychotherapy where one of his hand-picked speakers stated, "Twelve years ago, in 1936, there was not one comic book published in the United States (sic). Today, at a conservative estimate, there are five hundred million yearly. The secret of this unprecedented success—the greatest, fastest literary success the world has ever seen—is, of course, violence. All comic books without exception are principally, if not wholly, devoted to violence."[5]

These crime/horror comics were not lacking in gruesome images. Wertham reproduced them extensively in his book, pointing out morbid themes such as "injury to the eye" and "death."[7]

His assertions about hidden sexual themes (for example, images of female nudity secreted in drawings, or Batman and Robin as homosexual lovers) were met with skepticism within the comics industry. But the public took these accusations quite seriously.

TRUE FACT

In September 1954, *Time* magazine reported: "On the newsstands of the U.S. and Canada, more comic books are sold than any other type of magazine. About a quarter of the 80 million comic books that readers buy each month are known as 'horror comics,' bearing such titles as *Tormented, The Thing, Web of Evil.*"[6]

BATMAN AND ROBIN "OUTTED"

The most notorious charge in the book was leveled at *Batman,* a four-page polemic claiming that Batman and Robin were gay. "They live in sumptuous quarters, with beautiful flowers in large vases, and have a butler," the psychiatrist wrote. "It is like a wish dream of two homosexuals living together." He went on to assert that a "Batman type of story may stimulate children to homosexual fantasies."[8]

IS BATMAN GAY?

DC's top editor Dan DiDio offers the definitive answer: "No, Batman is not gay." Why? "Because he isn't written that way."[9]

"The Batman I wrote for 13 years isn't gay," confirms Scottish writer Alan Grant. "Denny O'Neil's Batman, Marv Wolfman's Batman, everybody's Batman all the way back to Bob Kane . . . none of them wrote him as a gay character."[10]

"It depends who you ask, doesn't it?" says Devin Grayson, an openly bisexual comic book writer. "Since you're asking me, I'll say no, I don't think he is. . . . I certainly understand the gay readings, though."[11]

Burt Ward in his autobiography *Boy Wonder: My Life in Tights* notes that the relationship between Batman and Robin could be interpreted as a sexual one, with the show's double entendres and campy style allowing ambiguous interpretation.[12]

Most recently George Clooney said in an interview with Barbara Walters that in *Batman & Robin* he played Batman as gay. "I was in a rubber suit and I had rubber nipples. I could have played Batman straight, but I made him gay."[13]

That aside, Batman (and his alter ego, Bruce Wayne) has been portrayed throughout his years in comics as having romantic relationships with women. His encounters with female adversaries like Catwoman have occasionally displayed sexual tension. Some insiders have suggested that the characters of Batwoman (in 1956) and Bat-Girl (in 1961) were introduced to refute the allegation that Batman and Robin were gay.

"While it remains possible, through deconstruction and re-interpretation, to view these actions as a means by which Batman is deluding himself about his own homosexuality," opines a comics historian, "the gay interpretation of Batman and Robin is ultimately subjective and not intended by creators in most contexts."[14]

Pulitzer Prize winner Art Spiegelman (*Maus*) eschews the superhero genre. "The homo-eroticism of it doesn't appeal to me," he says.[15]

WONDER WOMAN'S FORBIDDEN FEMINISM

Wertham also claimed that Wonder Woman's strength and independence made her a lesbian. This came as quite a surprise to her many fans. After all, she had been dreamed up in 1940 by a Harvard-trained psychologist as a positive role model for young girls.[16] Dr. William Moulton Marston saw her as the idealized woman.

TRUE FACT

Oddly enough, Dr. Marston was best known as the creator of the systolic blood-pressure test, which led to the creation of the polygraph (lie detector).[17]

In an October 25, 1940, interview in *Family Circle,* titled "Don't Laugh at the Comics," Dr. Marston had described the great educational potential of comic books. This article caught the attention of comics publisher Max Gaines, who then hired him as an educational consultant for both All-Star Comics and Detective Comics (now DC).[18]

Noting all the male heroes—Superman, Batman, Green Lantern—Dr. Marston wondered why there weren't any female heroes. Pointing this out to Gaines, he was given the go-ahead to create one.[19]

Marston submitted his first script about "Suprema, the Wonder Woman" to editor Sheldon Mayer in February 1941. The Suprema name was dropped, and Marston picked artist Harry Peter to draw his new creation.[20]

Wonder Woman made her debut in *All-Star Comics* #8. (December 1941). Next she appeared in *Sensation Comics* #1 (January 1942), then in her own self-titled comic in the summer of 1942. *Wonder Woman* is the only comic book featuring a woman to have been published without fail for over sixty-five years.

Armed with her bulletproof bracelets and magic lasso, Wonder Woman (née Princess Diana) epitomized the perfect woman in the mind of her creator—"beautiful, intelligent, strong, but still possessing a soft side."[21]

Writing in *The American Scholar* in 1943, Dr. Marston said, "Not even girls want to be girls so long as our feminine archetype lacks force, strength, and power. . . . The obvious remedy is to create a feminine character with all the strength of Superman plus all the allure of a good and beautiful woman."[22]

COMICS TRIVIA

Dr. William Moulton Marston wrote *Wonder Woman* comics under a pen name—Charles Moulton—his own middle name combined with publisher Maxwell C. Gaines's middle name.[23]

From her inception, Wonder Woman wasn't out to just stop criminals, but indeed to reform them. Transformation Island was a rehabilitation complex created by the Amazons to house and rehabilitate criminals. A large concept in Marston's Wonder Woman was "loving

submission," in which one would be kind to others and be willing to surrender to them.[24]

No wonder Wertham's claim that Wonder Woman had a bondage subtext hit so close to home. Her creator had admitted as much: "Women are exciting for this one reason—it is the secret of women's allure—women enjoy submission, being bound. This I bring out in the Paradise Island sequences where the girls beg for chains and enjoy wearing them."[25]

After being accused of lesbianism—to the surprise of a long line of creators—DC stripped Wonder Woman of her superpowers. Princess Diana took on more of the characteristics of a modern career woman, a glorified secretary who fought crime by conventional means.

"Wonder Woman was now fully neutered," grouses *The Wonder Woman Pages,* a website devoted to the Amazon Princess. "She no longer spoke out as a feminist and was left to moon over Steve Trevor. . . . It was drivel, and didn't change until the 1970's. So, we can thank Dr. Wertham for nearly 20 years of Wonder Woman being drivel."[26]

EXCLUSIVE! YOU READ IT HERE FIRST! Executive editor Dan DiDio says, "DC's official position is that Wonder Woman is still a virgin."[27]

SENATE WATCHDOGS TO THE RESCUE

As a result of Wertham's accusations, anti-crime crusader Estes Kefauver's three-man Senate Subcommittee on Juvenile Delinquency turned its steely eyes onto the comic book industry. Politicians and moral crusaders (without any basis of evidence) blamed comic books as a cause of crime, juvenile delinquency, drug use, and poor grades. Schools and parent groups held public comic book burnings, and some cities actually banned comic books.[28]

As *Time* columnist Richard Corliss puts it, "Wertham, a clinical psychologist specializing in disorders of the young, trembled when he read comic books. Any comic books: Superman (fascist!), Batman and Robin (perverts!), Wonder Woman (lesbian!). Apparently after an encounter with a Looney Tunes comic, he reported, aghast, that 'Ducks . . . threaten to kill rabbits.' He blithely stated that, since most juvenile delinquents he had examined were readers of horror comics, horror comics must be a factor in their misbehavior. (This is the post-hoc-ergo-propter-hoc fallacy of logic. No Senator dared ask if

FLASHBACK

I remember coming across a dusty copy of *Seduction of the Innocent* in my high school's library. It was fascinating to read "scientific facts" about how Batman and Robin were promoting homosexuality and the sneaky subliminal way those comic book artists were hiding sexual imagery in those seemingly innocuous comic book panels. Who would've known? Even in my youth I recognized this as a bunch of poppycock. But apparently parenting groups and the U.S. Senate were much more gullible than me and my teenage friends.

all the delinquents hadn't also listened to 'The Lone Ranger' and eaten mashed potatoes.)"[29]

SPEAKING UP!

"To me, Wertham was a fanatic, pure and simple," says Stan Lee. "I used to debate with him, which was fun because I usually won—but that was rarely publicized. He once claimed he did a survey that demonstrated that most of the kids in reform schools were comic book readers. So I said to him, 'If you do another survey, you'll find that most of the kids who drink milk are comic book readers. Should we ban milk?'"[30]

AT THE CENTER OF THE BULL'S-EYE

One major target of this witch hunt was EC Comics. "EC Comics wasn't the first publisher peddling crime or horror comics to American youth—not by a long shot!" notes comics historian Don Markstein. "Nor were theirs the most lurid, sensational, offensive, corrupting, fill in . . . the adjective. . . . But when we think of the lurid, sensational, etc. crime and horror comics of the 1950s, they're the ones we recall most fondly—possibly because they were the best."[31]

Publishers like Fiction House, Lev Gleason, and Fox Feature Syndicate had been pushing the bounds of good taste, a fact that had not gone unnoticed by politicians and decency crusaders. Most publishers decided to keep their heads low. However, Bill Gaines wasn't about to take this without fighting back. He bravely volunteered to testify before the senate subcommittee. It was a big mistake. Overly confident that he would be vindicated, Gaines didn't reckon with the tenacity of these public watchdogs:

> MR. BEASER: Is there any limit you can think of that you would not put in a magazine because you thought a child should not see or read about it?

> MR. GAINES: My only limits are the bounds of good taste, what I consider good taste.

> SEN. KEFAUVER (alluding to the cover illustration for *Crime SuspenStories* #22): This seems to be a man with a bloody ax holding a woman's head up which has been severed from her body. Do you think that is in good taste?

> MR. GAINES: Yes, sir, I do, for the cover of a horror comic. . . .

> SEN. KEFAUVER: This is the July one [*Crime SuspenStories* #23]. It seems to be a man with a woman in a boat and he is choking her to death with a crowbar. Is that in good taste?

> MR. GAINES: I think so.[32]

"This went over with the senators like Dracula at a Red Cross blood drive," observes Bob "Renfield" Meadows, editor of the *Horror-Wood Webzine*.[33]

ESTABLISHING THE COMICS CODE

Although the committee's final report did not blame comics for crime, it recommended that the comics industry tone down its content voluntarily. Taking this as a threat of government censorship, in 1954 a group of publishers developed the **Comics Code Authority** to censor their own content. "Last week in Manhattan, the Comics Magazine Association of America, a newly formed group representing 90% of the comic-book industry, moved against 'the aggressive minority trying to make a fast buck with horror comics,'" reported *Time* magazine. "Thus the comic-book publishers hope to police themselves and avoid being put out of business."[34]

The ensuing Comics Code was described as "the most stringent code in existence for any communications media"—although Dr. Wertham described it as "inadequate." A **Comic Code Seal of Approval** soon was appearing on the cover of virtually every comic book on newsstands.[35]

CODE FOR COMICS

The Comics Magazine Association of America, created to combat public criticism of horror comics, last week announced its Comic Book Code, which will be enforced by Censor Charles F. Murphy, former New York City magistrate.

Among the provisions: The words "horror" and "terror" are not permitted as comic-book titles, and no "scenes of horror, excessive bloodshed, gory or gruesome crimes, depravity, lust, sadism or masochism" are allowed.

Sympathy for criminals, "unique details" of a crime, or any treatment that tends to "create disrespect for established authority" are banned.

"Profanity, obscenity, smut, vulgarity, ridicule of racial or religious groups" are not allowed, and "all characters shall be depicted in dress reasonably acceptable to society, [with] females drawn realistically without exaggeration of any physical qualities."[36]

EC Comics complained about clauses prohibiting titles with words like *terror, horror,* or *crime,* as well as the rule banning stories about vampires, werewolves, and zombies—but to no avail.

While the Comics Code did not have any legal authority over publishers, Gaines found that many magazine distributors refused to carry comics without the CCA's seal of approval.

"American News quit distributing comic books and started sending bundles back unopened," recalls Michael Silberkleit, whose father helped organize the CCA. "Nobody wanted to handle the magazines, afraid of government retributions." He adds, "In my opinion the Comics Code saved the industry."[37]

At first, Gaines refused to join the code, but in the end he had no choice. His editor Al Feldstein would later claim that the code's chief censor, former New York judge Charles Murphy, had a specific agenda to put EC Comics out of business. "The Comics Code seal could not be placed on any EC comic until it was personally edited by Murphy," said Feldstein.[38]

That forced Gaines to cease publication of his five best-selling titles—the three horror and two *SuspenStories* comics.

Time magazine reported it this way in its September 27, 1954, issue:

HORROR ON THE NEWSSTAND

Last week . . . one of the biggest horror-comic publishers announced he was stopping publication of the books in response "to appeals by American parents."

Gaines last week stopped his own flow of 2,000,000 horror comics a month, plans to substitute a "clean, clean line."

Publisher Gaines had another reason for stopping his horror comics. New York's Mayor Robert Wagner recently ordered the city's lawyers to get injunctions banning the worst books under the state's obscenity laws.[39]

EC tried to comply with the code. Its horror and crime titles disappeared, replaced by stories about pirates, knights in armor, two-fisted newsmen, and the like. But this new line lasted less than a year.[40]

The loss of EC's popular horror titles made the company unprofitable, and eventually all its comics disappeared. Only *Mad* survived, due to its transformation from comic book to magazine format, thus avoiding the code's restrictions.[41]

SPEAKING UP!

"Comics? I hated 'em," Bill Gaines wrote in 1954. "Never touched the stuff. I wanted to be a chemistry teacher."[42]

GAY COMICS? NOT THAT THERE'S ANYTHING WRONG WITH THAT!

Batman and Robin gay? Luring unsuspecting children to a life of homosexuality? "Get real," laughs Dan DiDio.[43]

Dr. Wertham's assumptions are parodied in Robert Smigel's *The Ambiguously Gay Duo,* animated shorts that occasionally appear on TV's *Saturday Night Live.* The parody follows the adventures of Ace and Gary, two superheroes who may or may not be gay. However, their initials, A and G, appear on their Spandex shirts and might just stand for "ambiguously gay."

> **TRUE FACT**
>
> The voices of The Ambiguously Gay Duo are done by Stephen Cobert and Steve Carell.

Television critic Joyce Millman says, "Robert Smigel and animator J. J. Sedelmaier's brilliant, hilarious send-up of the coded gayness of Batman and Robin is so triumphantly in-your-face queer, it's a wonder it ever made it to network TV."[44]

The Warner Bros. *Superman Returns* movie (2006) has been dubbed the "gay Superman movie," although openly gay director Bryan Singer (*The Usual Suspects, X-Men II*) firmly denies it.[45] "[Superman] is probably the most heterosexual character in any movie I've ever made," he says.[46]

Singer has already inked the deal to direct a sequel to *Superman Returns.* However, according to the self-proclaimed "gossip rag" *Defamer,* Singer has been asked by the studio to "butch him up a little this time, OK?"[47]

> **INTERVIEWER:** Which superpower would you have?
>
> **BRYAN SINGER:** I don't know about superpowers, I mean I jokingly say invisibility just because it sounds like a funny idea, you know.[48]

"Brandon Routh? He's pretty," writes Stefania Pomponi Butler, a movie critic for BlogHer. "At times he looked almost computer animated his skin was so porcelain-like and his jaw and cheekbones so finely chiseled. That perfectly springy curl, the devastatingly handsome face, the muscular body in a skintight costume? So hot! . . . *So gay!*

"Don't get me wrong," she continues. "I love Christopher Reeve's take on the superhero, but Routh brings his own flavor to the character. And that flavor is kinda gay. . . .

"At the end of the movie, I asked my husband if he thought that *Superman Returns* had gay undertones and he replied, 'No. This isn't the gay superhero movie. *X-Men II* is the gay superhero movie.'"[49]

"You look at the X-Men movies and it's an allegory for what it's like to be gay, like, if you take the word 'mutant' out of that movie and stick 'gay' in, the movie still works," says filmmaker and comics buff Kevin Smith. "I was really looking forward to [Singer] doing the third one because it would be an out-and-out gay fantasia—I was hoping that the dude would go for a kind of Brokeback Mutant kind of movie, but he opted to do Superman. I thought he'd make a really gay Superman but he didn't; it was more Jesus' Superman . . . a lot of Messianic poses and what not and I was hoping for a little more gay action."[50]

Paul Levitz, president of Superman-owner DC Comics says, "We were all scratching our heads in response to online chatter. He's not a gay character."[51]

Forget the spurious accusations against Superman and Batman, there *are* gay superheroes. Beek's Books maintains a website listing lesbian, gay, and bi superheroes—ranging from DC's Tony Mantegna (*Secret Six*) to Wildstorm's Rainmaker (*Gen13*). Check 'em out for yourself at *www.rzero.com/books/gaysuperfull.html*.

Back in the 1980s, Marvel's then–editor in chief Jim Shooter angered staff and fans alike by declaring that there were no gay characters in the Marvel Universe. Then in 1992 a Marvel superhero named Northstar came out as homosexual, but the public had little recognition of the character or his Alpha Flight team . . . and just didn't care.[52]

Changing morals have made the issue less important today. In fact, a 2006 storyline in the DC series *52* reveals that Batwoman is gay.

"The other day, I visited my local comic book store to inquire about the cultural significance of Batwoman's coming out," writes author Meghan Daum on the *Los Angeles Times* op-ed page. "Suffice it to say that I was upbraided by the clerk, who told me that . . . there are lots of gay comic book characters and the fixation on Batwoman was just another example of the media exploiting a topic it knows nothing about." She went on to say, "DC Comics might be touting the idea of diversity, but I suspect what we're really seeing is an antidote to the rampant girliness of our era presented—how's this for ironic?—in the safest way possible."[53]

The idea that lesbian comic book characters are safe? Fredric Wertham must be turning over in his grave.

QUESTIONS FOR FURTHER THOUGHT

1. Was Dr. Fredric Wertham a well-meaning crusader? Vicious and vindictive? Wrong-headed? Or did he have a point? Discuss these various views.

2. Should Batman have been more careful with appearances as regarding his young ward? Or should people be ashamed for having a dirty mind?

3. Did Wonder Woman's strict Amazonian upbringing sour her on men? Or is she just commitment-phobic due to her unfulfilled romance with Steve Trevor? What's your opinion?

4. Dr. William Moulton Marston was into bondage and ménage à trois. Did he allow too much of his personal proclivities to seep over into the Wonder Woman stories?

5. Did the Comics Code save the industry? Was it an over-reaction? Is it obsolete? Or do all industries need to police themselves for the public good?

CHAPTER 4

THE SILVER AGE

A NEW KIND OF SUPERHERO

[D]uring the fifties they were trying everything. They were trying westerns, they were trying science fiction, they were trying licensing big names like Hopalong Cassidy and so on and so forth. I did that also and I did what I did, "Rex the Wonder Dog." I did whatever, you know, DC determined that, because they, essentially, were the creators of the comics, not the writers or the artists, so they said they wanted this kind of a book and then everybody went about giving them what they required, but they wanted what they ordered, what they wanted made to order.

And that's the way it went pretty much on through the fifties, and then westerns died and the field started to change again. And they fooled around and they came up with the superheroes in *Showcase*, which did very well. And on the strength of DC doing well with their superheroes, Marvel tried it and by 1960 the field was off and running all over again.[1]

—Gil Kane, artist

MANY historians see the publication of Dr. Fredric Wertham's *Seduction of the Innocent* in 1954 as the death of the Golden Age of Comics. Others claim the **Silver Age** began in September 1956 when DC's editor in chief Julius Schwartz revived the superheroes genre that had proven so popular a decade earlier.

Even though DC is credited with revitalizing the genre, it would be Marvel who dominated this period with its "angst-ridden heroes, sympathetic villains, and a dynamic visual style that has influenced every artist who followed."[2]

FLASHY NEW BEGINNINGS

Under Schwartz's direction, artist Carmine Infantino and writer Gardner Fox re-created The Flash in the pages of *Showcase* #4. "Barry Allen, fresh from his electrified chemical bath that gave him superhuman speed (ah, the Silver Age, when origins were simple and totally insane), decided to take on the name and mantle of The Flash, inspired by a character in a comic book he'd read as a kid. That character? The original Golden Age Flash," summarizes author Matt Rossi.[3]

This rebooted version offered a clean, uncluttered presentation of the super-speedster—a *new* Flash. A phenomenal success, it ushered in a second wave of superhero popularity.

Following this not-a-Flash-in-the-pan success, Schwartz expanded DC's line with new versions of Green Lantern, Hawkman, the Atom, and many others. And the Justice Society of America became the Justice League of America.

> **ROY THOMAS:** Why do you think the Justice Society was basically revived, renamed the Justice League, after only two old DC heroes—Flash and Green Lantern—had been brought back in new form? Was this something that came up in an editorial meeting? Do you recall how it happened that this was the time DC decided to come out with a group again?

> **JULIUS SCHWARTZ:** After The Flash proved successful, they said, "What do you want to do next?" I said, "I want to do Green Lantern" because that was really a favorite of mine. When Green Lantern proved successful, they said, "What do you want to do next?" I said, "I'd like to do the Justice Society of America, but I don't like the word 'Society,' because it's like a social group, and I want to use the word 'League,' because it's a more familiar word to young readers, like the National League, American League." And that's how that happened.[4]

All this—plus the popularity of television's *The Adventures of Superman,* starring George Reeves—encouraged other publishers to begin experimenting with the superhero genre again.[5]

ORIGIN OF THE TERM *SILVER AGE*

In the letters column of *Justice League of America* #42 (February 1966) Scott Taylor of Westport, Connecticut, wrote, "If you guys keep bringing back the heroes from the [1930s–'40s] Golden Age, people 20 years from now will be calling this decade the Silver Sixties!"

Shortly thereafter, dealers began categorizing their back-issue inventory into "Golden Age" and "Silver Age."[6]

ONE BIG FAMILY

Archie Comics was doing well with its youthful titles. Artist Dan DeCarlo had left Atlas/Marvel's *Millie the Model* to move over to Archie, where he was responsible for giving a distinctive style to the Archie characters. In addition to redheaded Archie Andrews and his gang, new teen characters were added—Sabrina the Teenage Witch first appearing in *Archie's Madhouse* #22 (1962) and Josie and the Pussycats debuting in *She's Josie* (1963).[7]

Here's how Golden Age penciler Gil Kane described the Archie story to *The Comics Journal:*

GIL KANE: The publishers were Louis Silberkleit, John Goldwater, and [Maurice] Coyne.

INTERVIEWER: Hence the initials MLJ.

GIL KANE: Right. Ultimately, Coyne left the company, Silberkleit got the pulps, and they tried to develop a paperback line. It was Goldwater who got the comics. . . .

INTERVIEWER: Had they published pulps before they published comics?

GIL KANE: Yes, as a matter of fact they were partners with Martin Goodman. And before that all of them worked for Independent News, for Sampliner. They started to see that pulps and comics cost no money to turn out and they brought back an enormous return. Martin Goodman left Sampliner and Independent News

but stayed friendly with Jack Liebowitz, the head of DC up until the time that they opened up the final Marvel thing in 1960.[8]

"Back in the old days everybody was friends—fierce competitors but friends—they got together and played cards," recalls Michael Silberkleit, son of the "L" in MLJ (and now chairman and publisher of Archie). "Jack Liebowitz and Harry Donenfeld and Paul Sampliner and our dads would get together for dinner. They even vacationed together. In those days all of us lived in New York City, so when it got cold in the wintertime you went on a vacation. You didn't use airplanes as much back then, you got on a train in Grand Central station and you went to Miami Beach. Always Miami Beach, they never discovered the West Coast. You'd see all these people down there. It was like a club, smoking cigars and playing cards. You'd go to a restaurant, there would be somebody you knew.

"The husbands would stay a short time, then go back to New York. Wives and kids would stay on. I went to school in Florida for months at a time."[9]

Michael Silberkleit and Richard Goldwater—who took over running the company from their fathers—reminisced about those early days. "I still have pictures of us as kids in Florida," chuckled Richard shortly before his death in late 2007.[10]

"I don't know if the wives actually liked each other," Michael continues the story, "but the men enjoyed each other's company because they had the comics business in common."

This closeness led to a lot of inbreeding of ideas. "Everybody printed at World Color Press in Sparta, Illinois. When you went there, the plant would try to hide the other guys' books that were being printed. But you'd see what the other guys were doing, then try it yourself.

"They would play golf and find out what each other was doing. Everybody copied everybody else. Martin Goodman would go back to the office from the golf course with another idea."[11]

"Jack, Harry, Martin, Sampliner liked to gamble together, especially the horses," adds Michael Silberkleit, sitting in the Archie Comics offices in Mamaroneck, New York. "So did our fathers. At one time we published a line of books called Belmont. You know where the name came from? That's right, the racetrack. There were four Belmont books—a western, a science fiction, a detective, and a mystery.

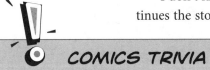

COMICS TRIVIA

According to the University of Nebraska Press website, "The legend goes that sometime in the early sixties Jack Liebowitz, publisher of DC Comics, and Martin Goodman, publisher of Marvel Comics, had a game of golf. At this time DC Comics was doing well but Marvel Comics was on the verge of bankruptcy. Liebowitz was telling Goodman how well they were doing with a title called *Justice League of America* which featured Wonder Woman, the Flash, and Aquaman, along with others to fight crime. Goodman went back to the office and told his editor, Stan Lee, to create an ensemble comic. (Did I mention this story is legend? The heads of both companies deny any such thing happened, but I like the story anyway.) They didn't already have a stable of characters to use like DC Comics did, so Lee started from scratch and created *The Fantastic Four*. But he did something DC Comics didn't do. He made them have problems. And bicker. And be wrong. And have bad days and bad luck. It was a turnaround for Marvel."[12]

Richard and I became photographers, shooting the cover pictures for all four books—using the same two models in different costumes. This man and woman would show up with a suitcase. First, they'd dress up like a nurse and doctor, then like cowboys, and so on."[13]

ONE-EYED MONSTER

Television had invaded America. At the end of World War II less than 1 percent of U.S. households had a TV, but by the end of the 1950s that penetration had climbed to 90 percent. That made a big claim on children's time as they clustered around television sets, fascinated by this new medium "full of noise and action and able to offer a greater illusion of 'reality' than comics."[14]

Many publishers took the attitude of "if you can't beat 'em, join 'em"—releasing an endless stream of comics based on popular television shows.

Dell was one of the leaders with boob-tube titles like *I Love Lucy, Leave It to Beaver, Gunsmoke,* and *Circus Boy.* Fawcett offered *Captain Video.* Marvel had *The Adventures of Pinky Lee.* And DC went with *Sgt. Bilko* and *Bob Hope.*[15]

In 1962 Dell ended its partnership with Western Publishing. After that, Western took over most of the licensed properties and created its own imprint, Gold Key Comics.[17]

LOOKING BACK

"At one time, Dell was the largest publisher of comics," recall Edwin and Terry Murray, two brothers who donated an enormous comic book collection to the Duke University Library. "They had all the Disney; they had the Warner Brothers—Bugs Bunny and Daffy and them; they had Hanna-Barbera—Yogi Bear, Fred Flintstone; they had Woody Woodpecker, Tom and Jerry; they had Tarzan; they had comics for all the popular Westerns from the time—Zorro, Cheyenne, Maverick, Lone Ranger. We got interested in whatever we saw on TV and then went out and bought the related comics."[16]

ATLAS OR MARVEL?

Atlas grew out of Timely Comics, the company Martin Goodman had founded in 1939. Goodman began using the globe logo of Atlas—the name of the newsstand distribution company he owned—on comics cover-dated November 1951. Although Goodman's business strategy involved having a multitude of corporate entities, he used Atlas as the umbrella name for his comic book division during this period. This name united a line that the publisher put out through numerous shell companies, ranging from Animirth Comics to Zenith Publications.[18]

Atlas flooded newsstands with its cheaply produced product. Rather than innovate, Goodman took the proven route of following popular trends in TV and movies—westerns and war dramas popular for a time, drive-in movie monsters another time.

Toward the end of 1956 Goodman shut down his self-owned distributorship, and switched newsstand distribution to American News

Service. The Atlas globe remained on covers through the October 1957 issues, when American News went out of business.

Left without a distributor, Goodman had little choice but go to Independent News, the company owned by rival DC Comics. He dropped the Atlas globe at that time.

The output dipped from fifty or sixty comics to eight or twelve books a month, which was all that Independent News Distributors would accept.[19]

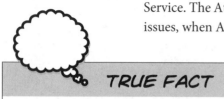

TRUE FACT

The first comic book to be labeled as Marvel Comics was a science-fiction anthology *Amazing Adventures* #3 (August 1961), which showed the "MC" box on its cover.[20]

A CLOSET FILLED WITH ART

Atlas retrenched in 1957. An apocryphal story tells of Martin Goodman discovering a closet full of unused—but paid for—art, leading him to fire virtually the entire staff while using up the inventory.

"[The firings] would never have happened just because he opened a closet door," Stan Lee disputes the tale. "But I think that I may have been in a little trouble when that happened. We had bought a lot of strips that I didn't think were really all that good, but I paid the artists and writers for them anyway, and I kinda hid them in the closet! And Martin found them and I think he wasn't too happy. If I wasn't satisfied with the work, I wasn't supposed to have paid, but I was never sure it was really the artist's or the writer's fault. But when the job was finished I didn't think that it was anything that I wanted to use. I felt that we could use it in inventory—put it out in other books. Martin, probably rightly so, was a little annoyed because it was his money I was spending."[21]

Joe Sinnott, one of Marvel's longtime artists, remembers it differently. "Stan called me and said, 'Joe, Martin Goodman told me to suspend operations because I have all this artwork in-house and have to use it up before I can hire you again.' It turned out to be six months, in my case. He may have called back some of the other artists later, but that's what happened with me."[22]

SIMON AND KIRBY TRY AGAIN

When Simon and Kirby signed the deal with Crestwood's Prize Comics, general manager M. R. Reese wrote about it in the March 1952 issue of *Newsdealer:* "It took a war to give Jack Kirby and Joe Simon a new perspective, a position where they could observe at close range the people who were reading comics—the boys who were now men and demanding comics for men. And it stood to reason there were also the

little girls who once saw in the comic superhero a protecting brother, and were now willing to trade vigor for tenderness."[23]

Their Prize titles like *Young Romance* and *Black Magic* were selling in excess of a million per issue. Although Simon and Kirby were supposed to be earning royalties on sales, they had serious questions about their remuneration from Crestwood.

"Crestwood was stealing from us right from the get-go," declares Simon. "It almost went to litigation."[24]

In late 1953 Joe Simon and Jack Kirby decided that the best financial future for their families lay in self-publishing.

"Comic book publishers were dropping out of the business in wholesale numbers," recalls Joe Simon in his memoir *The Comic Book Masters*. "The printers grew frantic. It was a necessity of their business that the presses keep running. When the presses were silent, printing companies still had to pay overhead, so they were more than willing to back a new comics organization if it showed promise. Since Simon and Kirby had one of the strongest creative records in the business, a printing salesman . . . urged us to start a new line financed by very liberal printing credit."[25]

Still maintaining the contractual output for Crestwood just in case they failed, Simon and Kirby took the royalties they had saved up since the end of World War II and put this nest egg into the launch of Mainline Publications, Inc.

If Joe Simon and Jack Kirby had not picked Leader News as distributor for Mainline, things might have turned out differently. Leader News was also the distributor for EC Comics—and just as Mainline released its first title, millions of copies of EC comic books began being returned after Bill Gaines' "live meltdown" during nationally televised hearings before the Subcommittee of the Committee on the Judiciary to Investigate Juvenile Delinquency.

Joe Simon says, "The sudden demise of EC Comics had put Leader News in a financial crisis and they soon folded their tents, leaving us holding an empty sack. Mainline Publications became insolvent, an innocent casualty in the final victory by 'The People' against the vile forces of Horror Comics."[26]

Mainline's last comics were dated April 1955.

CHARLTON CHARGES ONWARD

The Jack Kirby Museum records the following story: "Two months before the last Mainline comic, Joe and Jack launched a new title called *Win A Prize* for Charlton Comics. Charlton was notorious for their

LOOKING BACK

"Win A Prize was published at Charlton," says Joe Simon, "and they weren't in the business of selling comics. They were printing them, they were distributing them, they were doing everything but selling them. (laughter) They made money; they made money because they had their own distribution, they had their own printing plants. They used to bring in a bunch of guys from Italy who couldn't speak English, put them in a printing plant and, at lunchtime, they'd go out for an hour-and-a-half and put up buildings—they laid bricks, and then they'd go back to the printing plant. (laughter) Great outfit there; they didn't have to sell much."[28]

FLASHBACK

In the late 1980s I'm in the Charlton offices negotiating with John Santangelo to buy the now shell of a company. The deal didn't happen for a variety of reasons, but it wasn't *Hit Parader* and *Country Song Round-Up* that I was after. I'd learned that the basement of the old printing plant was filled with stacks of original comic book art from Charlton's old titles. According to business manager Ed Konick, it contained pages by Steve Ditko, Simon and Kirby, and Dick Giordano, some of them written by Superman co-creator Jerry Siegel, Joe Gill, and Mickey Spillane. Nobody placed any value on this artwork in their quest to sell off the last vestiges of publishing assets.

low page rates. There can be a couple of explanations for this choice of publisher. One explanation is that part of the idea behind *Win A Prize* was the giving away of prizes. The cover announces '500 free prizes, anyone can win,' and Joe Simon insists that they really did give away prizes. For a small company like Mainline this could be a problem. Not only the cost of the merchandise but the logistics of sending the prizes to the winners. Because Charlton had a vertical company structure, they could do everything from producing the comics to printing them and doing the distribution. Charlton was the ideal outfit to handle this sort of thing. Well, except for the problem of being cheap."[27]

Charlton Comics was a division of Charlton Publications, a Derby, Connecticut, company best known for publishing song-lyric magazines. Founded in 1940 by John Santangelo, Sr., and Ed Levy, it was originally called T.W.O. Charles (because both men had sons named Charles). It continued under the Charlton name from 1946 to 1991.

In 1983, DC's Paul Levitz "purchased the Action Hero characters from Charlton, reportedly as a gift for Dick Giordano, the line's original guiding light. In time, the characters were integrated into DC continuity, and almost served as the cast for Alan Moore and Dave Gibbon's opus, *Watchmen*."[29]

In 1988, Roger Broughton, a Canadian publisher, acquired nearly five thousand pages of original art from forty different Charlton titles, some of which would eventually reappear under Broughton's imprint, ACG Comics.[30]

JACK AND JOE REUNITE . . . BRIEFLY

Jack Kirby returned to superheroes in the Silver Age by way of a short reunion with former partner Joe Simon on Archie's *Double Life of Private Strong* (1959) and *Adventures of the Fly* (1959). "Superheroes to me were always the right thing to do," Kirby said.[31]

Private Strong revived the Shield, Archie's patriotic hero from the Golden Age.

The Fly, like the yet-to-be-created Spider-Man, had the abilities of his insect counterpart, including super-strength and the ability to walk on walls.

Simon and Kirby did two issues of each series.[32]

RETURN OF THE KING

Martin Goodman's magazines and paperback books were still successful. However, the comics had become a relatively small part of the business—and Goodman considered shutting the division down.

As Jack Kirby told the story of his return in late 1958 or early 1959, "I came in and they were moving out the furniture, they were taking desks out. . . . Stan Lee is sitting on a chair crying. He didn't know what to do, he's sitting on a chair crying. . . . I told him to stop crying. I says, 'Go in to Martin and tell him to stop moving the furniture out, and I'll see that the books make money.'"[33]

Stan Lee doesn't remember it that way. "Jack tended toward hyperbole, just like the time he was quoted as saying that he came in and I was crying and I said, 'Please save the company!' I'm not a crier and I would never have said that. I was very happy that Jack was there and I loved working with him, but I never cried to him."[34]

Whatever the circumstances, Goodman gave Kirby a job. "And I needed the work!" he admitted. His artwork was soon splashed across countless covers and lead stories, elevating the quality of *Strange Tales* and new titles like *Amazing Adventures* and *Strange Worlds*.[35]

Kirby decided to make monsters the star of the show. *Strange Worlds* #1 (December 1958) was Kirby's first Marvel monster work—and his first joint effort with Stan Lee. Together, they produced bizarre monsters for titles such as *Tales to Astonish*, *Tales of Suspense*, and *Journey into Mystery*.

The underlying theme of the monster stories was that of technology out of control. "The monster phenomenon got started primarily just because people were concerned about science," Kirby recalled. "People were concerned about radiation and what would happen to animals and people who were exposed to that kind of thing."[36]

Marvel's covers began to feature monsters with such made-up names as "Groot," "Krang," "Blip," "Thorr," "Kraa,"

FOOTNOTE

A website called Monster Blog is described as "a celebration of the Marvel monster comics of Jack Kirby and Stan Lee. Here you'll find the pulse-pounding tales of radiation run amok, of scientific experiments gone awry, of shape-shifting, mind-bending aliens from the furthest reaches of outer space!" This exhaustive list of Kirby-Lee monsters has been divided up into the following groupings: Imaginary Monsters, Alien Conqueror, Alien Disguised As Human, Atomic Freak, Atomic Freak/Possible Deviant Mutate, Benevolent Alien, Dragon Creature, Freak of Nature, Freak of Nature/Possible Deviant Mutate, Hoax, Human, Human Mutant, Lab Experiment Gone Wild, Miscellaneous, Mythological Creature, Sea Monster, Sentient Plant Life, Strange Place, Subterranean Creature, Supernatural Being, Technology Gone Wild, Transformed Human, and Unusual Object.[37] *Whew!*

"Goom," "Monstrom," "Monstro," "Oog," "Vandoom," "Gruto," "Sporr," "Gorgilla," "Spragg," "Rommbu," "Trull," and "Moomba."

"Collectors routinely refer to the company's comics from the April 1959 cover-dates onward (when they began featuring Jack Kirby artwork on his return to Goodman's company), as **pre-superhero Marvel**."[38]

A NEW KIND OF SUPERHERO

In 1961 Lee and Kirby created a groundbreaking series that was to change the future of the comics industry. *The Fantastic Four* #1 introduced a team of superheroes "with human failings, fears, and inner demons, who squabbled and worried about the likes of rent money." This was a sharp departure from the unblemished do-gooder archetypes of established superheroes at the time.[39]

‹ MILESTONE #5: STAN LEE AND JACK KIRBY CREATE A NEW KIND OF SUPERHERO.›

Stan tells the story like this:

"Martin mentioned that he had noticed one of the titles published by National Comics seemed to be selling better than most. It was a book called . . . *Justice League of America* and it was composed of a team of superheroes. . . . 'If the *Justice League* is selling,' spoke he, 'why don't we put out a comic book that features a team of superheroes?'"[40]

After two decades as a comic book editor and writer, Stan was starting to find the medium limiting. He was thinking of quitting.

"[My wife] Joan was commenting about the fact that after 20 years of producing comics I was still writing television material, advertising copy, and newspaper features in my spare time. She wondered why I didn't put as much effort and creativity into the comics as I seemed to be putting into my other freelance endeavors. . . . [Her] little dissertation made me suddenly realize that it was time to start concentrating on what I was doing—to carve a real career for myself in the nowhere world of comic books."

So he decided "for just this once, I would do the type of story I myself would enjoy reading . . . and the characters would be the kind of characters I could personally relate to: they'd be flesh and blood, they'd have their faults and foibles, they'd be fallible and feisty, and—most important of all—inside their colorful, costumed booties they'd still have feet of clay."[41]

Stan Lee wrote a two-page outline for the first issue of the new title and gave it to Jack Kirby. This was the shorthand "Marvel Method" Stan

had developed to help him keep up with the workload—a collaboration between artist and writer. Kirby turned that outline into *Fantastic Four* #1 (November 1961).

The plot was fairly hokey: In an attempt to "beat the commies" in the space race, Reed Richards, his fiancée Sue Storm, her kid brother Johnny, and their test pilot buddy Ben Grimm, took off in an experimental rocket bound for the moon. But the ship was bombarded by radiation from the Van Allen belt, and they crash-landed back on Earth after having gained fantastic powers.

However there was a difference: this family of superheroes was more "fallible and naturalistically human" than anything seen in comics up to that time. As Tobey Maguire's character says in the beginning of the movie *The Ice Storm:* "In issue #141 of the *Fantastic Four* . . . Reed Richards has to use his anti-matter weapon on his own son, who Anialis has turned into a human atom bomb. It was a typical predicament for the Fantastic Four because they weren't like other superheroes. They were more like a family. And the more power they had, the more harm they could do to each other without even knowing it. That was the meaning of the *Fantastic Four,* that a family is like your own personal anti-matter. Your family is the void you emerge from and the place you return to when you die. And that's the paradox. The closer you're drawn back in, the deeper into the void you go."[42]

Despite the fact that the four protagonists of *Fantastic Four* were a stretchable man, an invisible woman, a human torch, and a muscled mound of clay, these characters were beleaguered by everyday problems. They bickered, they worried about money, they behaved like . . . a family. Stan Lee and Jack Kirby had unknowingly invented a new kind of superhero, a more vulnerable character with human failings—the same traits teenagers could identify with!

Sales jumped.

"Somehow or other, the book caught on," says Stan. "We had never gotten fan mail up until that point. . . . Sometimes we might get a letter from a reader that would say, 'I bought one of your books and there's a staple missing. I want my dime back.' And that was it. We'd put that up on the bulletin board and say, 'Look! A fan letter!' Suddenly, with *Fantastic Four,* we really started getting mail. . . . 'We like this . . . We don't like that . . . We want to see more of this.' That was exciting! So I didn't quit. . ."[43]

No wonder Stan boldly tagged *Fantastic Four* as "The World's Greatest Comic Magazine" on issue #4.

"The soap opera group dynamics of *Fantastic Four* owed much to Kirby's earlier work in romance comics, but Lee's skills as a writer of

snappy dialogue gave the comic added depth," observes Jeet Heer of *National Post.*[44]

INTERLOCKING STORIES

Marvel's biggest innovation was a storytelling technique that would forever change American comics. "Before *Fantastic Four* #1, comics stories had always been, with only a handful of exceptions, self-contained," observes Claude Lalumière in *A Short History of American Comic Books.*

FLASHBACK

Ski, my VP of editorial planning, saved all the voice messages from Polly Watson, a former assistant who called up to sing original ditties or recite her nonsensical poems. Typical lyrics were (to the tune of "The Girl from Ipanema"): "Thick and brown and incredibly viscous / The gravy goes pouring from the boat to the biscuits / And as it pours, each mushroom passes goes ahh!" Later he put them on a CD that we dubbed "The Best of Polly." She confiscated it!

"Lee, Kirby and their collaborators created stories that not only continued directly from one issue to the next—with subplots and cliffhangers—of a specific title but, with increasing regularity, spilled over into the events of other series to build Lee's much-touted interlocking 'Marvel Universe.' Most of today's mainstream comics are written this way, but at the time this was a radical—and popular—change. DC's lateness in adopting the new style hurt its sales for many years."[45]

DOING THE MONSTER MASH

Next came *The Incredible Hulk,* a blending of the Frankenstein theme and Dr. Jekyll and Mr. Hyde. "I'd always loved the Frankenstein story," Stan Lee says. "With Hulk I wanted to make a hero out of the monster."[46]

It too was a hit.

SPIDER-MAN'S DEBUT

After *The Fantastic Four* and *The Incredible Hulk* there was a noticeable shift to superhero comics. Martin Goodman was ready to jump back on the bandwagon, but he and his editor didn't see eye to eye.

As Stan Lee recounts, "The third book I wanted to do was Spider-Man. [Martin] didn't want me to do it. He said I was way off base. He said, 'First of all, you can't call a hero Spider-Man, because people hate spiders.' I had also told him I wanted the hero, Peter Parker, to be a teenager, and he said, 'A teenager can't be the hero . . . teenagers can just be sidekicks.' Then, when I said I wanted Spider-Man to have a lot of financial problems and family worries and all kinds of hang-ups, he

said, 'Stan, don't you know what a hero is? That's no way to do a heroic book!' So he wouldn't let me publish it."

But Stan persevered. "Later, we had a book that we were going to cancel. We were going to do the last issue and then drop it. When you're doing that last issue of a book, nobody cares what you put into it, so—just to get it off my chest—I threw Spider-Man into that book and I featured him on the cover. A couple of months later when we got our sales figures, that had been the best-selling book we'd had in months. So Martin came in to me and he said, 'Do you remember that Spider-Man character of yours that we both liked? Why don't you do a series with him.' After that, it was much easier. . . . Whatever I came up with, he okayed. After that, came *The X-Men* and *Daredevil* and *Thor* and *Dr. Strange* . . . and the rest. The books did so well that I just gave up all thoughts of quitting."[47]

Spider-Man was introduced in *Amazing Fantasy* #15 (August 1962). He quickly became Marvel's best-selling character.[48]

Here was young Peter Parker, a kid just like you or me, bitten by a radioactive spider at a science exhibit. Next thing you know, he has developed spiderlike powers: the ability to climb walls, superhuman strength and agility, an extrasensory "spider-sense." Very co-o-o-ol!

Yet Peter Parker had normal teenage problems: trouble with girls, a tough boss at work, and money woes. All this made him easier to relate to than any of the superheroes who had gone before.

And he had moral dilemmas: Should he go get the medicine his ailing aunt needs or stop and save the world?

> STAN LEE: He's really just a regular guy. Most anybody can empathize with him. He could be you or me or any fellow really.

> GRANT CURTIS, producer of *Spider-Man 3*: Everybody can plug in and find a little bit of themselves in Peter Parker, whether it be the bashful shy nerd from Queens, or the hero inside of him waiting to get out, I think everybody sees a little bit of themselves in Spider-Man.[49]

The Amazing Spider-Man #1 debuted in March 1963. A second series came out in 1972. Since then, Spidey has had at least two ongoing series at any given time, not to mention guest appearances in other Marvel titles. As of 2007, *The Amazing Spider-Man, Ultimate Spider-Man, The Sensational Spider-Man, Friendly Neighborhood Spider-Man, Marvel Adventures Spider-Man, New Avengers,* and the limited series *Beyond!* and *Civil War* all regularly featured the famous webslinger.[50]

"Lee and Kirby would replicate the Marvel formula (flawed superheroes fighting crime while worrying about their personal lives) in a host of other volumes," notes Jeet Heer. "Captain America was brought back while new comics featured the adventures of The Hulk, The X-Men, The Mighty Thor, The Silver Surfer, and The Black Panther. To this day, the comic book industry and Hollywood are mining the gold found by Lee and Kirby."[51]

What a success story! "In the space of a few years, Timely went from a hole-in-the-wall company on the ropes to overtaking comic books' only superpower, DC," observes indie comics creator Dave Sim.[52]

BUILDING A UNIVERSE

Kirby and Lee continued to pour it on. By 1963 Kirby was cranking out eight to ten Marvel comics per month. He and Lee added the new titles *Sgt. Fury and His Howling Commandos, Avengers,* and *X-Men* to the fold. That year and the beginning of 1964, the foundations of today's Marvel Universe fell into place.

WHO GETS CREDIT?

Who really invented Spider-Man? Good ideas often have many parents.

One story is that Stan wanted a superhero series starring a teenager, so he asked Jack Kirby to come up with one. Jack suggested a concept he and Joe Simon had once kicked around, a superhero called "the Silver Spider" that Jack thought should be called "Spider-Man." It was similar to a series that C. C. Beck and Jack Oleck had unsuccessfully pitched to Harvey Comics.

Simon recalls, "Kirby laid out the story to Lee about this kid who finds a magic ring in a spiderweb, gets his powers from the ring and goes forth to fight crime armed with the Silver Spider's old web-spinning pistol." Jack drew the first few pages of a spiderlike superhero ("Captain America with cobwebs"), but Stan wanted to develop the Spider-Man idea along more realistic lines, so he turned it over to Steve Ditko.[53]

Ditko has said, "Stan Lee thought the name up. I did costume, web gimmick on wrist and spider signal."[54]

Joe Simon, in his 1990 autobiography, disputes this account. He claims that he came up with the character's name, while Kirby outlined the character's story and powers.[55]

FLASHBACK

The DC staff is partying at the end of the week at its usual spot, an upstairs room at McGee's, an Irish pub on West 55th Street. Everybody's here—staffers, freelancers, even a couple of ex-Marvelites. DC's executive editor Dan DiDio is hoisting a beer. Ski, now working at DC, introduces me as a former publisher of Marvel. "Hey," says DiDio with genuine camaraderie. "*Spider-Man* #40 was the first comic book I ever read. It hooked me on comics!"

Stan Lee said he was inspired by seeing a fly climb up a wall, but he admits that he's told the story so many times that he is not sure if it is true or not.[56] Typical Stan.

"There's an interesting story behind Spiderman," grumbles Joe Simon, not one to let it go. "I don't want to go into it fully here, but I can tell you that back in 1953 I created a superhero, a young man with spiderlike qualities. I put the character in a presentation for a publisher and entitled it Spiderman. I designed the Spiderman logo. I had Clarence Beck do the penciled sketches. He was the predominant artist for Captain Marvel, the man who gave Captain Marvel its special comic style, and I believe he came out of semi-retirement to work with me on this. At the last minute, I changed the name from Spiderman to the Silver Spider. I thought at the time there were just too many 'man' titles around—Superman, Batman, that stuff. I took the presentation up to Harvey Comics where it languished. I kind of forgot about it after a while. I was onto new projects. I wasn't looking back; there was no time to look back. You went on; you created.

"In the late 1950s, Archie Comics asked me to create a new line of superheroes," he continues his story. "I gave the Silver Spider sketches to Jack Kirby and I changed the name again, this time to The Fly. Jack held onto the sketches and when Stan Lee asked Jack for new ideas, Jack brought the original Spiderman pages to Marvel Comics. Jack was busy with other work so Stan handed the pages over to Steve Ditko. Ditko, on first seeing those pages, commented, 'This is Joe Simon's Fly.' Steve Ditko worked up his own version of the character's costume. The comic that was published was called Spider-Man. Marvel had stuck a hyphen in between the Spider and the man, for trademark reasons I suppose. Jack told me this years later. A few years before he passed on, he sent me back my original Spiderman logo."[57]

SHARING CREDIT

"Every time that people talk about 'creating the characters,' I always say I co-created them," insists Stan Lee. "I co-created Spider-Man with Steve Ditko. I co-created The Fantastic Four and the Hulk with Kirby. I co-created Iron Man with Don Heck. Very often, when people would write about us in the newspapers or the trades, they would say, 'Stan Lee—Creator of Spider-Man,' and that would get Ditko angry—but I had nothing to do with that! I have no control over what journalists write."[58]

According to authors Jordan Raphael and Tom Spurgeon, "Stan Lee's most significant contribution as an editor of American comic

books was to use his relative autonomy to facilitate greater contributions from the artists. This editorial strategy would cause deep and enduring controversy. When in subsequent years the new Marvel comics became successful, who created which characters, to what extent, and when became important questions, both legally and ethically."[59]

THE JACK KIRBY LEGACY

Jack Kirby has been hailed by *Wizard* magazine as "without any doubt . . . the single most important creator in the History of American Comic Books."[60]

Fans still refer to him as "the King."[61]

Born in New York's rough-and-tumble Hell's Kitchen in 1917, Jacob Kurtzberg was the son of an Austrian Jewish immigrant who worked in the garment industry. A pugnacious street kid, Jake belonged to gangs. He remembered that "fighting became second nature. I began to like it."[62]

However, young Jake wanted to get out of the neighborhood. Trapped, he became a daydreamer who enjoyed drawing pictures of "a dream world more realistic than the reality around me." He tried studying art at the Educational Alliance, but said "they threw me out for drawing too fast with charcoal."[63]

According to Gerard Jones's *Men of Tomorrow,* "Where he found his haven at last was the Boys Brotherhood Republic on East 3rd Street. This was a 'miniature city' where street kids ran their own government, cared for their own facilities, and published their own newspaper. Jake played baseball and boxed, but more than anything he loved drawing cartoons for the paper."[64]

He began his career not in comics but as an "in-betweener" drawing *Popeye* animated cartoons at Max Fleischer Studios.

A few months later he found a job as a cartoonist for the Lincoln Syndicate. In his three and a half years at Lincoln, he produced a number of ongoing strips, political cartoons, and panel gags. While still working for the syndicate, he began freelancing for the Eisner and Iger Studio, drawing comic strips under such *noms de plume* as Curt Davis and Fred Sande and Jack Curtiss and Lance Kirby.

Little wonder that only a few years later he would change his name from Jacob Kurtzberg to Jack Kirby. Almost like having his own secret identity. In future years, he'd get quite angry if someone suggested it was to hide his Jewish lineage. It wasn't so much a matter of concealing his religion as of having a name that sounded like a professional cartoonist's.[65]

One of the Eisner and Iger assignments was to put together an oversized comic for Fiction House Magazines. "The Count of Monte Cristo" and "Wilton of the West," which appeared in September 1938's *Jumbo Comics* #1, were Kirby's first published comic book work.[67]

Even masters have their muses. According to Kirby biographers Mark Evanier and Steve Sherman, he was "the student without an official teacher. He learned from anyone who had something to offer, adopting the virtues and making them his own. An early source of art-inspiration, for example, was Alex Raymond's *Flash Gordon* newspaper strip. Splendidly illustrated, it has served as the model for a majority of today's panel-artists. Some of them have adopted its techniques with little reservations and others, like Kirby, now boast very little of the then-important Raymond influence. He learned techniques, not styles, and then went on to make them his own."[68]

As Kirby recalled, "I began to go up to [various] offices and leave samples of my work, and I began to sell my work that way." This landed him a job at Fox Features Syndicate, where he worked on the *Blue Beetle* newspaper strip, his first experience with a costumed superhero.

That's where Kirby met his future partner, Joe Simon. The two men struck up a friendship, and when Simon went to Timely, he brought Kirby along as his lead artist. This was the beginning of Kirby's off-and-on love/hate relationship with the company that would become Marvel—and the man who had turned himself into Stan Lee.[69]

STAN THE MAN

"Stan Lee was doing what any smart editor would do," writes Jordan Raphael and Tom Spurgeon in *Stan Lee and the Rise and Fall of the American Comic Book*. "He was striving to find methods to replicate the success of his new titles across a majority of the line. He gave his best talent all the work they could handle, found a way of working that maximized their artistic gift, and helped others on the freelance staff to produce material that was similar to that which was moving titles. He also

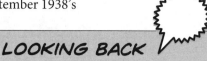

LOOKING BACK

"Jack was a little fellow," recalled Will Eisner. "He thought he was John Garfield, the actor! (laughter) Very tough, very tough. Everything you see here (Will points to the cover of *The Jack Kirby Collector* #13) was inside him. But he was a very little fellow; a very good fellow, but very tough. When we moved to a new office in a nice office building, we had a towel service for the artists to wash their hands, and we would buy a towel for each of the artists so they could wash up. The people who supplied the towels, however, were Mafia! (laughter) They were charging more and more money, so my partner Iger said, 'Look, let's find another towel service (that's) cheaper,' because at that time we had ten to fifteen artists and it was beginning to cost money. So I called them and said, 'Look, we would like to find another towel service.' So I get a visit from their salesman. (laughter) He had a white tie, a black hat, a broken nose, y' know? Scarface! (laughter) And he came in and said, 'Are you really not happy with the service?' I said, 'Well, we want to find another . . . ' He said, 'There is nobody else that can service this building.' (laughter)

"We were beginning to talk loud, and from the other room, in comes Jack Kirby. He says to me, 'Will, is he giving you a problem? I will beat him up.' (laughter) This is little Jack Kirby, and this big guy! (laughter) I said, 'Jack, go inside!' Jack says, 'No, no.' He says to the fellow, 'Look, we don't have to take your towels! We can take other people's!' The guy looked at me and said, 'Who is he?' And I said, 'He's my chief artist. Don't get him angry . . . ' (laughter) So this fellow said, 'Look, we want to do this friendly. We don't want to have any trouble.' And Jack said, 'If he comes to see you again, call me and I'll beat him up!' (laughter)."[66]

built awareness of the line through constant crossovers and aggressive appearances by characters in each others' titles—misunderstandings and fistfights and eventual team-ups that made the work of a few talented individuals look like a considered house style, and a collection of scattered titles seem like one long, continuous, heroic story."[71]

In fact, college students would later compare Stan's epic tales to such classics as the *Iliad* and *Odyssey.*

"By 1965, Stan was the most entertaining dialogue man in comics by a wide margin," observe Raphael and Spurgeon. "Then he began to do something even savvier. Lee's writing started to become more solicitous to the readers, pointing out various fourth-wall absurdities or even speaking to them directly. The tone always flattered the readers, praising them for their intimate knowledge of past adventures and the high standards they brought to the work in front of them. It was the same tone of voice that he brought to the letters and commentary pages he had instituted in the new titles, that of the kindly 'with-it' uncle.

"It added another layer of enjoyment to Marvel's superhero titles, and it spoke to an older, hipper readership who delighted in the comic books' genre-bending qualities without taking their content seriously. Lee's showy writing also helped him transcend the traditional writer and editor roles to become Marvel's host, the man responsible for bringing the readers the entertainment, a kind of comic-book Ed Sullivan who was never too far away from the side curtains. Stan Lee was offering front-row seats to the Greatest Show in Pulps, and young readers were lining up in droves."[72]

Stanley Lieber has been wearing the mask of "Stan Lee" for so long, he personifies the Kurt Vonnegut dictum of "We are what we pretend to be, so we must be careful what we pretend to be."[73]

As blogger Ray "!!" Tomczak puts it, "Stan Lee's real gift was for self-promotion and his greatest creation was Stan Lee himself."[74]

FOOTNOTE

"Our most recent poll asked on which deceased comic creator would you use the super power of re-animation so that you could talk about comics with him for a night," announced Comic Treadmill. "Unsurprisingly, Jack Kirby was an overwhelming winner, capturing 43% of the votes. We suspected a Kirby landslide would be the result, but ran it anyway to see what happened."[70]

KIRBY VERSUS LEE

"With his family ties and managerial position, Lee became the public voice of Marvel Comics," notes Jeet Heer of the *National Post.* "In innumerable interviews with journalists, Lee often made it sound as if Marvel comics sprang spontaneous from his imagination, with artists like Kirby and Ditko serving merely as hired hands who carried out his vision. Equally galling was the fact that Lee would receive a sizable

salary, comparable to that of a top CEO, while most of the artists who worked with him drew a meager freelancer's salary, often without health benefits or a pension.

"Lee's credit-hogging and relentless self-promotion proved too much for Kirby, who left Marvel Comics for greener pastures in 1970, the very year that the Beatles broke up.

"The two men became such bitter foes that when Kirby died in 1994, Lee wasn't sure whether he would be welcome at the funeral. Only a personal request by Kirby's widow convinced Lee to attend, although he stayed in the back and quickly slunk out."[75]

> **INTERVIEWER:** If you could have one superpower for just one day, what would it be?

> **STAN LEE:** Mind reading.[76]

FLASHBACK

So I'm standing there in the Marvel booth at the San Diego Comic-Con talking with Stan Lee and actor David Hasselhoff about an upcoming *Nick Fury* movie when suddenly a television crew approaches. *Flash!*—the TV lights come on. And like Dr. Jekyll transforming into Mr. Hyde, Stan goes from a quite normal conversation to a showman's glaring grin followed by a loud, "*HI!—HOW ARE YA?*" Yes, Stan the Man is the consummate showman—turning it on like flipping a switch. And the amazing thing is, you feel like he means it each and every time.

"Now, how Jack Kirby was treated during his long & illustrious career . . . the recounting of *those* lovely tales might drive you to big-gulp the Pepto," carps Mike Allred in a Silver Bullet Comics column. "Jesus Christ! I could have written the *Cliff Notes* for this book: 'And Kirby worked here, and he was screwed. Then he went there, was promised the moon, and got screwed again. Then he went back to the first place and got screwed some more. Then, because he had a family to support, he went to the place he was screwed at before he got screwed at the same place for the second time and was screwed again. Meanwhile, the first place set out to continuously screw him. Somewhere along the way, those busybodies at *Comics Journal* got involved, and then everybody knew just how much he got screwed. He died a hero. The end.'"[77]

DC'S SAFE APPROACH

"According to Bradford Wright (*Comic Book Nation,* 2001), DC comics were grounded in the culture of consensus and conformity, thus making them the comics best representing the values of the Establishment," reports *ImageTexT,* a journal about comics and related media published by the English Department at the University of Florida. "The superheroes championed high-minded and progressive American values and were always victorious in their struggles. They all could be held up as decent role models for children; they all held respected positions in society. When they were not in costume, most of them were members of either the police force or the scientific community.

"The characters put forth by DC stressed the importance of the individual's obligation to the community, even at the expense of their own individualism. Therefore, most if not all of the DC heroes spoke and behaved in a similar fashion, were in control of their emotions, and rose above the usual failings of the human condition. Their world was also under control: they resided in clean green suburbs, modern cities with shining glass skyscrapers and futuristic unblemished worlds. The DC heroes of the Silver Age exuded American affluence and confidence.

"However, the 'squeaky-clean' DC superheroes proved to be vulnerable to the challenge posed by the 'flawed' heroes and antiheroes of Marvel Comics. During the 1960s, anti-establishment figures such as Spider-Man, the Incredible Hulk, and the Fantastic Four meshed well with emerging trends in contemporary youth culture and were popular with readers, young and older."[78]

According to *St. James Encyclopedia of Popular Culture,* "By the late 1960s, DC recognized their dilemma and clumsily introduced some obvious ambiguity and angst into their superhero stories, but the move came too late to reverse the company's fall from the top. By the mid-1970s Marvel had surpassed DC as the industry's leading publisher."[79]

Then over the next thirty years the two behemoths would play nip-and-tuck for the top spot.

LOOKING BACK

"Sure, I read *Superman, Batman* and all the comics," admits Stan Lee when asked about his teenage reading habits. "But I also read all the books I could get my hands on. . . . Now that I think of it, I read everything. Mark Twain, H. G. Wells, O. Henry, Edgar Allan Poe, Dickens, Shakespeare, everything. It's not only science-fiction and fantasy that turn me on; it's anything of any type that's high-concept, unusual and imaginative."[80]

BATMAN REVISITED

DC's editor Julius Schwartz presided over drastic changes made to a number of its comic book characters, including Batman in 1964's *Detective Comics* #327. Schwartz attempted to make Batman more contemporary and return him to his detective roots. He brought in artist Carmine Infantino to help with this makeover. This included a redesign of Batman's equipment, the Batmobile, and his costume. Schwartz created Aunt Harriet to live with Bruce and Dick. The space aliens and several characters of the 1950s such as Batwoman, Ace the Bathound, and Bat-Mite were dropped.[81]

This makeover became known as the "New Look Batman." It influenced the campy Adam West *Batman* TV series, which ran 1966 to 1968.

BIGGER IS BETTER

In 1964, *Superboy Annual* #1 was added to the giant issue schedule. A month later DC reconfigured all its annuals as a separate comic series

called *80-Page Giant* in an attempt to increase sales in Canada. There was a financial advantage, in that Canada taxed annuals at a lower rate as if they were books.

NICK FURY— AGENT OF MARVEL

Jim Steranko—a former stage magician and musician who had performed with Bill Haley and the Comets—brought his artwork up to the Marvel offices. "I was sent out . . . to look at his work and basically brush him off," recalls Roy Thomas. "Stan was busy and didn't want to be bothered that day. But when I saw Jim's work . . . on an impulse I took it in . . . to Stan. Stan brought Steranko into his office, and Jim left with the *S.H.I.E.L.D.* assignment. . . . I think Jim's legacy to Marvel was demonstrating that there were ways in which the Kirby style could be mutated, and many artists went off increasingly in their own directions after that."[84]

Steranko's take on *Nick Fury, Agent of S.H.I.E.L.D.* "soon became one of the creative zeniths of the Silver Age, and one of comics' most groundbreaking, innovative and acclaimed features."[85] Particularly noted for his use of surrealism, op art, and psychedelic design, Steranko was inducted into the Comic Book Hall of Fame in 2006.[86]

LOOKING BACK

DC's Brooklyn-born president Paul Levitz remembers his first comic book experience: "It was reading them out of boxes the older kids on the block had when I was around six. The earliest very clear memory I have is my babysitter bringing *Action Comics* #300, 'Superman Under the Red Sun,' and somehow I managed to scam my mother into letting me get a subscription based on the coupon from the ad in that."[82]

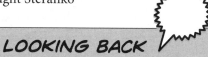

LOOKING BACK

Marvel's former editor in chief Bob Harras recalls that he was introduced to comics as a kid by his brother when home sick from school. "*Raggedy Andy* was the first comic I remember," says Bob. But he quickly graduated to superheroes when he came across an eighty-page *Superboy*.[83]

QUESTION: What comic book convinced you that comic books were awesome, and made you want to enter the comics world??

MIKE BARON: Steranko's *Nick Fury, Agent of S.H.I.E.L.D.*

TONY C. CAPUTO: Steranko. *Nick Fury, Agent of S.H.I.E.L.D.*, Miller's *Daredevil*, Claremont/Cockrum/Byrne *X-Men*, Matt Wagner's *Mage*, and recently, while researching Visual Storytelling, Terry Moore's *Strangers in Paradise.*

TIM TRUMAN: Steranko. *Nick Fury, Agent of S.H.I.E.L.D.*[87]

HUP, ONE, TWO, THREE . . .

One nostalgic fanboy recalls Stan Lee's early promotions: "Merry Marvel Marching Society (often referred to by the abbreviation M.M.M.S.) was a fan club of sorts for Marvel Comics started by Marvel editor Stan Lee in 1964. For the contribution of one dollar to start and a yearly contribution of 75 cents each year afterward, members received a button, a newsletter, and a recording featuring the Marvel staff including Lee, Jack Kirby and others. The M.M.M.S. folded in the mid-1970's."[88]

WEREWOLVES AND VAMPIRES

In 1965 a hard-driving entrepreneur named James Warren flooded the market with a trio of magazine-sized black-and-white comics that would become classics of the horror genre: *Eerie, Creepy,* and *Vampirella.* Warren Publishing featured magnificent Frazetta covers and interior artwork by such luminaries as Neal Adams and Gray Morrow, with a writing assist from editors Archie Goodwin and Joe Orlando.

Although featuring vampires and horror themes, not to mention an occasional touch of nudity, the magazine format allowed Warren to avoid the restrictions of the Comics Code Authority.[89]

Later, in the 1970s, when the CCA relaxed its restrictions against werewolves and vampires, other publishers jumped into the market. Marvel launched titles like *Tomb of Dracula, Man-Thing, Brother Voodoo,* and *Epic Illustrated.* And DC tried *Swamp Thing* as well as pitting Superman against the occasional werewolf or vampire.

DC's Carmine Infantino had this to say about his horror publishing lineup:

> **INTERVIEWER:** Did you want to go up against the Warren books?
>
> **CARMINE:** The reason we did those books was because we thought that there was more profit margin in those, frankly. With those, the break-even was at about 35 percent—which wasn't bad— but sales came in at 22 percent so that was the end of that.[90]

Jim Warren's health—combined with business problems—led to bankruptcy in the early 1980s. Harris Publications acquired the assets at auction, although a 1998 lawsuit gave the rights to *Creepy* and *Eerie* back to Warren.[91]

In 2007 it was announced that Submarine and Grand Canal Film Works acquired all rights to Jim Warren's classic horror comics magazines. A new entity, New Comic Company, was formed to handle licensing, development, and production.

"These properties represent one of the last remaining and single largest great libraries of horror content available. We've had our eye on this for a long time," said Grand Canal's Craig Haffner. "It was worth the wait."[92]

CHECKERED PAST

Following Harry Donenfeld's death in 1965, Jack Liebowitz took over the reins of National Periodical Publications, Inc.—serving as president of the now-public company that included DC Comics, Independent News, *Mad* magazine, and Licensing Corporation of America.[93]

Harry's son Irwin oversaw many of DC's day-to-day operations, eventually becoming publisher. Irwin Donenfeld had come up with a few good ideas in the past, in particular a try-out comic called *Showcase* that allowed DC to test new concepts. Hadn't that led to the rebooting of the Flash and the return of superheroes?

Now in 1966 he had another brainstorm: with DC's sales dropping and Marvel's rising, Irwin came up with the idea of topping every DC cover with a checkerboard pattern to make the books stand out more on the newsstands. He called them "**go-go checks**."[94]

"What a ridiculous thing," Carmine Infantino fumed. "It was the stupidest idea we ever heard because the books were bad in those days and that just showed people right off what not to buy."[95]

Go-go checks? "[T]hey were the ugliest thing anyone ever did to the front of a comic book," opines Mark Evanier of POVonline.[96]

DC'S COVERS GET ATTENTION

"One of the interesting things that happened to DC Comics in the late sixties and early seventies was that the covers got much, much better in terms of artwork and the design of the scenes in them," says Mark Evanier. "Carmine Infantino, who may have been the best 'designer' of cover scenes that comics have ever had, became Cover Editor—a job he retained throughout his subsequent promotions to Publisher.

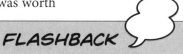

FLASHBACK

I was a big fan of Warren's horror titles. I'd collected every single issue of *Creepy*, *Eerie*, and *Vampirella*—a quest that had sent me into basements of New York City magazine dealers where old issues of *Look*, *Life*, and *Saturday Evening Post* were stacked as high as my shoulders and narrow pathways wended their way through mountains of dog-eared copies of *Time*, *Saturday Review*, and *Playboy*. I felt like I'd entered the domain of the legendary Collyer Brothers, two turn-of-the-century eccentrics who died when stacks of newspapers and rare collectibles collapsed on them in their Fifth Avenue brownstone. The most difficult Warren publications to find were those featuring Frank Frazetta covers—particularly *Vampirella* #5 with the Frazetta painting of an ax-wielding caveman and his half-naked female companion facing a snarling dinosaur. But find them I did, one by one.

Previously, DC's covers had been primarily supervised by editors who weren't artists and didn't draw. They could come up with an interesting situation but often, not an interesting, punchy visual. Infantino changed that, aided by the arrival of Neal Adams as DC's most prominent cover artist."[97]

> **INTERVIEWER:** You achieved the [DC art director] position on the strength of the covers that you designed?
>
> **CARMINE:** Julie Schwartz would tell me to go home and design covers which they would write stories around. I would come in with a series of covers starting with The Flash and later on Batman, Adam Strange, and others. Apparently, every time my covers came out, they connected and sold very well, so Donenfeld suggested that I should become Art Director. I said I wasn't sure at the time but I would give it a try. I took the job, Irwin left, and I was designing most of the covers. That was about the time that Kinney National, later Time-Warner, came in and took over.
>
> **INTERVIEWER:** As Art Director you designed all of the covers?
>
> **CARMINE:** Yes. The editors would come to me and I would create their covers. They would then go off and edit the rest of the books. That's how it began.
>
> **INTERVIEWER:** Did you work closely with Neal Adams on the cover designs?
>
> **CARMINE:** Yes . . . I found that it was always best to give him a layout and let him embellish it. He would do a helluva job once you gave him a layout.[98]

DC'S NEW OWNERS

In reviewing Gerard Jones's *Men of Tomorrow,* Robert J. Rosenberg of *BusinessWeek* commented that "My beef with Jones, though, is not what he put in, but the story he wanted to tell but couldn't—the tale of the very private Jack Liebowitz, who was the real man of tomorrow. He turned a seat-of-the-pants outfit into a powerhouse, extending distribution, building a licensing arm, taking the company public, and selling it finally to (future) Time-Warner chief Steve Ross—all this from a man

who began as a socialist. In a world filled with would-be Supermen, he was the one man who would be Clark Kent."[99]

At the time, DC Comics had been feeling the impact of Stan Lee's new brand of superheroes. Before sales fell too far, Liebowitz and the Donenfeld family sold their interest to Kinney National Company, the corporation which eventually morphed into today's Time-Warner.

Jack Liebowitz served on the board of directors for Kinney National and its subsequent entities from 1967 to 1991.[100]

Irwin Donenfeld had expected to remain on the job after the sale, co-managing DC with Carmine Infantino, the artist he'd promoted into management. But when the dust cleared, Irwin had been squeezed out of the company his father founded. He retired to a quiet life of running a marine shop in Westport, Connecticut. Although wealthy from the sale, he remained bitter about this unwelcome turn of events.[102]

Today, DC Comics is part of the Warner Bros. division of Time-Warner, the largest media company in the world. Time-Warner's 2006 annual report showed total corporate revenues of $44.2 billion (up 4 percent from $42.401 billion in 2005).

As Time-Warner chairman Richard D. Parson describes it, "DC Comics, wholly owned by the Company, publishes more than 50 regularly issued comics magazines featuring such popular characters as Superman, Batman, Wonder Woman, and The Sandman. DC Comics also derives revenues from motion pictures, television, product licensing and books. The Company also owns E.C. Publications, Inc., the publisher of *Mad* Magazine."[104]

Not bad for a comic book company started by a couple of Jewish hucksters from the Lower East Side.

TRUE FACT

Kinney National Company was originally a New Jersey funeral parlor business before expanding into New York parking lots, office cleaning firms, and construction companies. Kinney National further diversified its holdings by buying National Periodical Publications (DC Comics) in 1967, Panavision in 1968, and Warner–Seven Arts in 1969—then renaming itself Warner Communications before merging with Time, Inc., in 1989 to form Time-Warner.[101]

COMICS TRIVIA

Up until his death in 2004 Irwin Donenfeld liked to boast to friends that at twelve he was the "first kid ever to see a Superman comic."[103]

FANZINES

Sometimes simply known as **'zines**, these are nonprofessional publications created by fans to communicate with others who share a common interest.

The origin of **fanzines** can be traced back to nineteenth-century literary groups who formed amateur press associations. These publications were often produced on small tabletop printing presses by stu-

dents. Today, the advent of personal computers and desktop publishing has put self-publishing within almost everyone's reach.

Superman first appeared as a story in a 1933 fanzine called *Science Fiction,* published by Jerry Siegel and Joe Shuster.

The very first comic book fanzine was *The Comic Collector's News,* started in 1941. Many others followed, devoted to EC Comics, Harvey Kurtzman's humor magazines, superheroes—you name it![105]

Alter Ego, a fanzine about costumed heroes, was launched in 1961 by Jerry Bails. Later on, under Roy Thomas's editorship, it was converted into a slick magazine by TwoMorrows Publishing.[106]

Other early fanzines included *Comic Art, Fantasy Comics, Xero,* and *Hoo-Hah!* These 'zines were instrumental in creating the culture of comic fandom: conventions, collecting, and so on.

Paul Levitz, now president and publisher of DC Comics, started out editing a fanzine called *The Comic Reader* before actually working inside the comics industry.

Rik Offenberger's Silver Bullet Comics interview explored Levitz's early fanzine days:

> **INTERVIEWER:** In the early days of fandom you were associated with *The Comic Reader,* can you tell us what you did there and give a little bit of explanation about what *The Comic Reader* was to fans who may only be familiar with publications like *Wizard?*

> **PAUL LEVITZ:** Through a circuitous history going back to fandom founding father Jerry Bails, *The Comic Reader* was the first comics fanzine focusing on news of the field. It passed from editor to editor, and wasn't being published when Paul Kupperberg and I started our news-zine *Etcetera* in early 1971. After a couple of months, Paul dropped out of co-editing, and the previous editor of *The Comic Reader* gave the accumulated subs and the name to me.
>
> In those days, many comics still didn't carry credits, and no publisher announced a publication schedule in advance. *TCR* was the first fanzine to fill in those gaps and so served as a monthly "*TV Guide*" for fans of the period. At its peak in my run (1971–73), we had about 3,500 circulation . . . the largest number of any 'zine you had to pay for and slightly larger than the attendance of the largest con at the time. When I gave up, I sold the 'zine to the editors of the *Menomonee Falls Gazette* (a leading strip 'zine of the period), who continued it for many years.

It all looks very quaint and childish in the era of the Internet and desktop publishing programs, but at the time, it was a solid resource for fans and pros alike, and got me acquainted with both communities, making friends I've worked with ever since.[107]

UNDERGROUND COMIX

The late 1960s and early '70s saw an upsurge of **underground comix.** These independently published comics reflected the youth counterculture of the time. With their uninhibited, irreverent style, they certainly didn't adhere to the Comics Code!

In 1968 Robert Crumb began selling his *Zap Comix* #1 out of a baby carriage in San Francisco. This self-publishing entrepreneurship is usually considered the start of the adult underground comix movement.

R. Crumb created such zany characters as Fritz the Cat and Mr. Natural. His work was "striking for its grotesque, cartoon style satirizing American culture."[108] He has been described as "the cantankerous, misogynistic godfather of underground comix."[109]

Crumb moved to Cleveland in 1962 to work as a greeting card artist for Hallmark. He sent some drawings to Harvey Kurtzman's *Help!* magazine. Encouraged by Kurtzman, Crumb moved to New York to work for *Help!,* but the magazine folded. He stayed in New York for a while, drawing comics trading cards for Topps, but eventually returned to Cleveland.[110]

Todd Gitlin, a professor of culture and communications at New York University, has described Crumb as "both the darling of the counterculture and one of its secret critics."[111] Certainly, Crumb's comix work paved the way for Art Spiegelman's *Maus.*[112]

The spelling "comix" was adopted to differentiate these publications from mainstream comics. The notion of comic books outside the mainstream was suggested by the headline "Comics Go Underground" on the October 1954 cover of *Mad.*[113]

Vaughn Bode's *Cheech Wizard* was also a popular underground strip. Gilbert Shelton's *Fabulous Furry Freak Brothers* was another favorite—along with his send-up of the superhero genre with *Wonder Warthog.*

Familiar underground titles included *Anarchy Comics, Bijou Funnies,* and *Skull Comics.* Additionally,

FLASHBACK

When I was consulting with *Mad* magazine, I asked editor John Ficarra if he'd known Harvey Kurtzman. "I met him somewhat late in his career (1985)," confirmed Ficarra. "He was a quiet-spoken, small man, nothing like I envisioned. However, Freelancer Harvey was much different than Editor Harvey. Al Jaffee still has a job he did for Harvey when Harvey was an editor at *Esquire,* I believe. It has sixteen overlays by Harvey, who kept sending Jaffee back for revision after revision. Harvey the freelance artist was, shall we say, a bit reluctant for any revisions and editor input on his own artwork. I remember him going on and on to me about how much he loved Howard Stern. He loved that Stern was pushing the boundaries of taste on the radio."[114]

Crumb produced *Homegrown Funnies, Despair,* and *Big Ass Comics.* Even mainstream's Wally Wood and Bill Pearson took a turn, publishing a celebrated underground comix called *Witzend.*[115]

These publications were mainly distributed though a network of head shops that also sold underground newspapers, psychedelic posters, rolling paper, and bongs. In the mid-1970s, as sales of drug paraphernalia was outlawed in many places, the distribution network dried up. The underground comix movement is considered by most historians to have ended by 1980. It was replaced by **indie comics**.[116]

END OF THE SILVER AGE

Several events are associated with the ending of the Silver Age of Comics:

> » Jack Kirby's departure from Marvel Comics in 1970 to do *Fourth World* titles at DC.
> » The retirement of Mort Weisinger, DC's longtime editor of the Superman titles, causing them to be divided up among several editors.
> » The advent of darker superhero stories, with Batman recast as a vengeful vigilante.
> » The death of Peter Parker's girlfriend Gwen Stacy in *Amazing Spider-Man* #121 ("The Night Gwen Stacy Died," 1973).
> » An "All-New All-Different" version of the X-Men in *Giant-Size X-Men* #1 (1975), restarting a franchise that would dominate subsequent decades.
> » The updating of the Comics Code, unleashing an onslaught of new horror comics such as *Ghost Rider* and *Tomb of Dracula.*[117]

If I had to call it (and for the purposes of this history, I do), the breakup of Jack Kirby and Stan Lee—"arguably the most important creative partnership of the Silver Age"[118]—was the defining moment that marked the ending of the Silver Age.

QUESTIONS FOR FURTHER THOUGHT

1. Was Stan Lee a genius? Or just lucky? A self-promoting hack? Or a self-deprecating talent? Share your opinions.

2. Compare and contrast the two team-ups: Simon and Kirby versus Lee and Kirby.

3. Was Martin Goodman showing nepotism when he made his
 wife's cousin editor? Or just being expedient? Did he recog-
 nize Stan Lee's talent? Or did Goodman simply see Stan as a
 get-it-out-the-door factory worker?

4. Was it okay that publishers cribbed ideas from each other and
 followed successful trends? Plagiarism? Trademark infringe-
 ment? An homage? Does it happen today?

5. Were Simon and Kirby poor businessmen or victims of unscru-
 pulous publishers? Hotheads or martyrs for the comic book
 industry?

KIRBY IS HERE! MAR. NO. 1

WHEN THE OLD GODS DIED--THERE AROSE THE

NEW GODS

DC

THE NEW GODS

15¢

AN EPIC FOR OUR TIMES

READ "ORION FIGHTS FOR EARTH!"

THE BRONZE AGE

THE RETURN OF SUPERHEROES

Fourth World . . . is some of my favorite Jack Kirby work. I'm just a huge admirer of the original work Jack did on all four titles back in the early '70s. I thought it was a beautifully structured, multi-layered work filled with wonderful characters, a wealth of incredible concepts, and a Wagnerian sense of drama. And the stories were ABOUT something. Dysfunctional families for one. But there was thematic material all through the original *Fourth World* work; free will vs. slavery, nature vs. nurture, fathers vs. sons, love vs. hate . . . the original books were a real exploration of thought. I believe that's one of the reasons people keep coming back to them. . . . Jack was a little ahead of the curve and the *Fourth World* work really demonstrated that.[1]

—Walter Simonson, noted artist who took up the pencil on *Fourth World*

AND so a third period of superheroes began. This period is commonly referred to as the **Bronze Age of Comic Books.** It usually is said to run from the early 1970s to the mid-'80s.

The collaborative partnership of Stan Lee and Jack Kirby had ended, drawing to a close that creative wellspring that had produced a new kind of superhero. "Previous comic book heroes were icons, perfect in motive, unquestioned in society," observes columnist Alex Ness. "Marvel heroes were moral, but filled with questions, angst filled, and considered to be criminals at least at first. In Lee's world, society assumed that if you wore a costume and had powers you were a menace. A mask meant that you had something to hide. . . . Marvel Universe was more like our world and reality than any previous comic universe."[2]

UP-AND-COMERS

During this new age, Young Turks like Neal Adams, Bernie Wrightson, Steve Englehart, Gerry Conway, Mike Kaluta, and Mike Ploog took the comic art form to a new level. Their comics mirrored the social upheaval that the country was experiencing. As the historians at Heritage Auctions elucidate, "It was an exciting time, when both successes and failures could be equally spectacular."[3]

Although superheroes remained the mainstay of the industry, this era is marked by more mature storylines, and real-world issues such as drug abuse. Horror made a comeback. And in addition to the superheroes there was an onslaught of "nonsuperhero heroes" such as Conan, Kamandi, Swamp Thing, and Dracula.

A NEW WORLD

"If you're old enough to remember the excitement of Kirby leaving Marvel to come to DC, that was an astounding thing," says Paul Levitz. "The reality was that Jack had only been at Marvel for about a decade. It wasn't a big body of his career, but a decade felt like forever. The ripple effect of change was much greater at that point."[4]

KIRBY WRITES HIS OWN TERMS

In 1970 DC's editorial director Carmine Infantino made Jack Kirby an unprecedented offer, one that gave him complete creative control over his work.

INTERVIEWER: . . . Jack Kirby came in. Did you fly out to California to talk to Jack?

CARMINE INFANTINO: We knew each other very well from the old days. I knew him and Simon very well. I don't remember who called who one day—I honestly don't remember—but I said to him, "Jack, I'm going to be out there on some business and how would you like to have a drink?" He said, "Absolutely." We met in my hotel room. He brought with him some things and he told me how unhappy he was over at Marvel. He then trotted out these three pieces, *The New Gods, Mister Miracle* and *Forever People*. He said, "These I want to do but I won't do them for Marvel," and I said, "Do you want to come to DC? Would you like to?" and he said, "I'd love to." I said, "Okay." And he wrote a contract by hand right there and we signed it. We were in business. It was that simple.[5]

Kirby took over the struggling *Superman's Pal Jimmy Olsen* with issue #133. This and the three other titles—*Forever People, Mister Miracle,* and *The New Gods*—became the basis of Kirby's *Fourth World* saga.

"I felt that we ourselves were without a mythology. Even the Saxons had their own mythology, and I thought that there was a new mythology needed for our times," Kirby explained. "So I created that. Darkseid and Orion [are like] Zeus and Hercules, a father and son. And it has been that way with all mythology."[6]

However, Kirby's *Fourth World* saga was told with a complexity that exceeded what comic readers were accustomed to. Sales were poor, and as a result the books were discontinued in 1973.[7]

Kirby then turned his attention to the postnuclear world of Kamandi, before finishing out his time at DC with six issues of a new version of *The Sandman*.[8]

CARMINE INFANTINO: Jack decided to leave. He came in and he said that he was going back to Marvel. I wished him well! We were still friends when he left.

INTERVIEWER: Why were his books cancelled?

CARMINE INFANTINO: Bad sales. What most people don't realize is that we had to be concerned for our distributors. They were part of our company—Independent News. The distributor is advancing money to you all of the time. When you put out a book they advance you the money. They came to us and told us that these books after a certain point started to lose money

and we should consider dropping them! That didn't only go for Jack's books but some other titles as well. It's a business![89]

ROUND AND ROUND IT GOES

Marvel's founder Martin Goodman sold his publishing businesses in 1968 to Perfect Film and Chemical Corporation for approximately $15 million. The new owner grouped these businesses in a subsidiary called Magazine Management Co., with Goodman remaining on as publisher.

When Goodman finally retired in 1972, he was succeeded as publisher by Stan Lee.[10]

"I was made the publisher," recalls Stan the Man. "From then on, I hired other writers and editors to do most of the work. I spent most of my time traveling around the country—around the world, really—lecturing about Marvel, about comics. I probably lectured in more colleges than anybody, because for a period of 10 years, I never went less than once a week to some college somewhere—and I'm talking 52 weeks a year for all that time. I don't think there's a school in America that I haven't been to a couple of times, at least . . . and some in Canada and others in England. I was like the advance guard—always talking about Marvel wherever I could go. I did newspaper interviews and a lot of radio and TV interviews . . . I was sort-of the spokesman for Marvel."[10]

According to biographers Raphael and Spurgeon, "Lee took to his new role as if he had been rehearsing for it his whole life. Gone were his 1950s-era suits and ties, replaced by hip attire—open-neck shirts, casual slacks, Gucci shoes, a heavy-link silver bracelet. He bought hair, a toupee at first and later a transplant. He grew a moustache. He completed his look with the tinted prescription glasses that have since become his trademark prop. Following a trajectory begun in the late 1960s, Lee reinvented himself in the 1970s as a public figure every bit as colorful as his comic book characters. Stanley Lieber was a distant memory. The skinny Jewish kid who once aspired to literary greatness had been shunted aside in favor of a persona that traded on showmanship and an endearing arrogance: Stan the Man."[11]

At one point he was made president of Marvel. "I had been president for awhile back in New York, sometime in the '70s, and I gave up that title. I had it for maybe a year, but I found that I had to go to financial meetings and discuss five-year plans and three-year plans. . . . Hell, I'm a guy who doesn't know what he's going to eat for dinner tonight. I had to plan ahead?"

"I realized that I was doing things that a million people could do better than I do—or as well, certainly—and I'm not doing the thing that I think I do best, which is working on the stories or dealing with the public. I guess I'm one of the few people who quit being the president and went back to being the publisher. Even publisher was kind of a misnomer, because I didn't function as a real publisher—I was never involved in the business decisions."[12]

In 1973, Perfect Film and Chemical Corporation changed its name to Cadence Industries, and renamed Magazine Management Co. as Marvel Comics Group.[13]

NEW MANAGEMENT

ROY THOMAS: That's when Al Landau, not one of my favorite people, succeeded you as president of Marvel. His company, Trans World, had been selling Marvel's work in other countries.

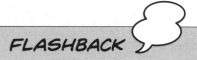

FLASHBACK

Marvel's president du jour David Schreff has just completed the negotiation of hiring me to run the comics division—a process that started two presidents back. "I want you to be publisher," he confirms, but the corporate attorney speaks up: "We can't give him that title," she says apologetically. "It's in Stan's contract that he retains the title for life." So they agree I'll be the de facto publisher, but put my other title of executive vice president on the business card. Stan later agreed to officially give me the title of publisher..

STAN LEE: He came in because Martin knew him and dealt with him for years; they had been friendly. But then Martin and he had a falling out—I don't know. I always got along fine with Al. He leaned on me a lot, so I helped him when he was president—he came to me for everything. I know that he wasn't all that popular. . . .

ROY THOMAS: Al Landau was president a couple of years; then Jim Galton took over . . .

STAN LEE: Al was a very strange guy.[14]

UP AGAINST THE COMICS CODE

As it turned out, *Amazing Spider-Man* was the first comic book to challenge the rigid Comics Code. In 1971 Stan Lee had been approached by the U.S. Department of Health, Education, and Welfare (now called the Department of Health and Human Services) to do a comic book about drug abuse. Stan agreed, writing a three-issue story arc for *Amazing Spider-Man* #96–98 that illustrated the dangers of drug abuse. However, the CCA refused to approve the story, because it was against

the rules to depict drug use in any manner. Undaunted, Stan published the story without the Code's seal of approval.

The issues met with such critical acclaim that Marvel encountered no repercussions. This defiance by a major publisher brought about a loosening of the CCA rules later that year.[15]

ROY THOMAS: Did you feel strongly at that time that the Code needed to be changed?

STAN LEE: As far as I can remember—and I've told this to so many people, it might even be true—I never thought that the Code was much of a problem. The only problem we ever had with the Code was over foolish things, like the time in a western when we had a puff of smoke coming out of a gun and they said it was too violent. So we had to make the puff of smoke smaller. Silly things. But as far as ideas for stories or characters that we came up with, I almost never had a problem, so they didn't bother me. I think the biggest nuisance was that sometimes I had to go down and attend a meeting of the [CMAA] Board of Directors. I felt that I was killing an entire afternoon.

ROY THOMAS: Do you think that there were any bad feelings on the part of the Code over the Spider-Man drug issues?

STAN LEE: That was the only big issue that we had. I could understand them; they were like lawyers, people who take things literally and technically. The Code mentioned that you mustn't mention drugs and, according to their rules, they were right. So I didn't even get mad at them then. I said, "Screw it" and just took the Code seal off for those three issues. Then we went back to the Code again. I never thought about the Code when I was writing a story, because basically I never wanted to do anything that was to my mind too violent or too sexy. I was aware that young people were reading these books, and had there not been a Code, I don't think that I would have done the stories any differently.

ROY THOMAS: The only difference was that, technically, you could not do a vampire or werewolf story.

STAN LEE: We couldn't do vampire stories?

ROY THOMAS: No, they had been forbidden since the mid-'50s when the Code arrived. The Morbius story was done in the vein

of just like any other supervillain—we even gave him primary costume colors of red and blue, just like Spider-Man. Very soon after that, we began the whole gamut of those creatures: Werewolf by Night, Man-Thing, Frankenstein. Many of these concepts flowed from you. Man-Thing was a sentence or two concept that you gave me for the first issue of *Savage Tales*.[16]

THE HORROR OF IT ALL!

"I'd done up a western, and I took it in to Marvel," recalls artist Mike Ploog, noted for his Man-Thing pencils. "They looked at it and said, 'No way. We don't do books that look like this.' But I'd met Roy Thomas there, and I went on home, trying to figure out what I was going to do next. A couple of days later, they called me up and said, 'How'd you like to do monsters?' Obviously they'd seen what I'd done for [Warren Publishing], because I'd done some werewolf stuff. I said, 'Sure, I'll do anything.' . . . Marvel Comics at that time was magical. There was magic around that place. . . . Everybody there were great people."[17]

HOWLING AT MIDNIGHT

Of course a man named Wolfman would have to become famous for his work on horror comics. Marvel's *Tomb of Dracula* was a seventy-issue series (April 1972–August 1979) featuring a group of vampire hunters who fought Count Dracula and other supernatural menaces. Various writers handled the first half-dozen issues, but the book hit its stride when Marvin Wolfman became permanent scripter with the seventh issue.

> INTERVIEWER: Your work on the character Blade and title *Tomb of Dracula* pegged you for some as a horror writer, but would you rather they think of your work as spanning genres?

> MARV WOLFMAN: I think of myself as a writer who can do a great deal of material in many different genres.

> INTERVIEWER: I think *Tomb of Dracula* is great, mind you, but is it a writer's fear to be pigeonholed as a certain kind of writer, as a TV actor fears replaying the same character for the rest of their career?

MARV WOLFMAN: In comics I am probably more well known for my superhero work. And to some it's my humor writing in animation that I'm known for. I have no problem with anyone liking any part of my work.[18]

Marv co-created *Blade,* the story of a vampire turned vampire hunter. This character became the basis for three popular Wesley Snipes action-thriller movies and a TV show.

KUNG FU FIGHTING

During this uncertain period, publishers jumped onto the growing martial arts craze. It was hot. David Carradine was starring in TV's *Kung Fu* (1972–1975). Bruce Lee had graduated from playing Green Hornet's sidekick Kato to starring in chop-socky movies like *Fists of Fury* (1972) and *Enter the Dragon* (1973).

No surprise when Marvel launched *Shang-Chi, Master of Kung Fu* (1973) and *Iron Fist* (1974). It also produced a magazine-format comic called *Deadly Hands of Kung Fu* (1974). And Silver Samurai made his debut in *Daredevil* #111 (1974).

DC followed with *Richard Dragon, Kung Fu Fighter* (1975). Bronze Tiger appeared in the first issue. And Lady Shiva had showed up by issue #5.[19]

Kii-eeee!

But comic book readers were looking for something more.

. . . AND THEN THERE WERE SIX

It was an uphill battle. By 1974, there were only six comic book publishers left—the fewest since 1936.[20]

PROFESSOR STAN

During the 1970's, Stan Lee spent more time touring college campuses than writing comics. He was basking in a new-found cult status, talking to the kids who grew up on Marvel comics.

"The Silver Surfer is the one that the college kids would talk about the most, and that made me happy, because I really was fond of the Surfer, and I always tried to put as much of my own corny philosophy in the Surfer's dialogue as I could," says Stan.

"Another thing that gave me a kick is that they would refer to the three issues of *The Fantastic Four* that introduced and featured Galactus

and the Silver Surfer as 'The Galactus Trilogy.' They would refer to them that way in every school. That sounded so impressive to me. . . . It sounded like 'The Harvard Classics.' . . . 'The Galactus Trilogy.' I loved that. . . . I mean, one of the most embarrassing things was that *Esquire* did an article, and they quoted one college kid as saying, 'We think of you as this generation's Homer.' Man, I pinned that up in my room. . . . My hat didn't fit me after that!"[21]

RETURN OF THE X-MEN

With the publication in 1975 of a one-shot called *Giant-Size X-Men* #1, Marvel Comics successfully revived the series about a team of mutant superheroes. After a half decade's hiatus, writer Len Wein and artist Dave Cockrum conceived a story that linked the old X-Men team with a new one that Professor Charles Xavier assembles in a mutant rescue effort.[22]

The following year, Chris Claremont started scripting *Uncanny X-Men,* the beginning of a highly successful seventeen-year run. By the early 1990s, the X-Men franchise had become the most popular in the entire comic book industry. "If Stan Lee is the father of the X-Men, then Chris Claremont is their godfather," declares John C. Snider, editor of the Scifidimensions website. "No other writer has had as much influence on Marvel's popular franchise. . . . His multilayered storytelling and vivid characterizations defined Marvel's mutants."[24]

"The advantage of working with the X-Men in the '80s was that the characters weren't as developed as they are today," Claremont recently mused. "We had a free hand, could pretty much define the field we were playing on. It was wide open territory."[25]

During the 1980s the growing popularity of *Uncanny X-Men*—along with the rise of comic book specialty stores—led to the launch of several spin-off series (nicknamed "X-Books"). Notable among them were *The New Mutants, X-Factor, Excalibur,* and *Wolverine.*

COMICS TRIVIA

X-Men #1 still holds the record as the best-selling comic book of all time, with a staggering 8 million copies of the first issue sold.[23] *X-Force* #1 sold close to 4 million units. Today, *Astonishing X-Men* sells about 125,000 copies per issue.

> **INTERVIEWER:** If you could have the mutant powers of any one of the X-Men, which would you choose?

> **MARK PANICCIA:** I've been involved with several X-related books fer sure, so I'd say it's a toss up. I'd love to have Wolverine's healing factor but dang if it wouldn't be cool to fly like Angel![26]

This plethora of X-Men titles engendered a number of crossover storylines, plots that overlapped from one X-Book to another. These "X-Overs," as they were sometimes called, usually created a spike in sales.

THAT '70S SHOW

Carmine Infantino was made publisher of DC during a time of declining circulation for comics. His attempt to revamp several older characters such as Superman, Batman, Wonder Woman, Green Lantern, and Green Arrow saw mixed results.[27]

"The printer came to me in 1974 saying that there could be a paper shortage for next year and Marvel was going to put out 60–70 books," recalls Infantino. "They could knock us off the stands, so I matched them book for book. I had to cover my rump. Of course, we lost money, and they lost money, but I wouldn't relinquish my space on the stands. That's what got the guys upstairs upset, because I covered myself that way. But I feel that I did the right thing then and I do so now. Once you lose your rack space, you're dead. I stand by my decision."[28]

In a desperate effort to bolster revenue, Infantino raised the cover price of DC's comics from 15 to 25 cents. At first Marvel met the price increase, then dropped back to 20 cents. Infantino stubbornly stayed at 25 cents, a decision that cost DC overall sales. And ultimately cost Infantino his job.[29]

"I was ordered upstairs and was informed they no longer were happy with my efforts," Infantino recalls. "I wasn't too happy with their less than thrilling attitude towards comics."[31]

THE DC IMPLOSION

Times were tough. DC tried to attract readers by adding more pages, releasing more titles. This growth strategy was heralded as "the DC Explosion."

Later, when DC underwent a large cutback, dropping dozens of titles overnight, it was redubbed "the DC Implosion." All in all, sixty-five titles were cancelled, some before they were even published, leaving the company with eight fewer titles than before the "Explosion" started.[32]

FOOTNOTE

The X-Overs reinforced the concept of a unified Marvel Universe. As we used to say at Marvel, "If it rains in one book, you'll see thunderclouds in all the others."

LOOKING BACK

"It took a fair amount of your lunch money to keep up to date," reminisces fanboy and collector Burl Burlingame. "I recall the widespread horror when the cover price went from 15 to 20 cents, and then to a quarter. (Hey, minimum wage then was less than two bucks an hour!)"[30]

THE WRATH OF KAHN

In January 1976 Jenette Kahn became the new publisher of DC Comics. It befell her to clean up the mess. She was the one who had to shut down titles, pick a new direction, recruit new talent. Certainly a thankless job.

On the DC message board a blogger named kmadden5 poses the question: "When did DC jump the shark?"

Blogger kmadden5 goes on to answer his own question:

"In my opinion, DC Comics jumped the shark as early as 1976 when Jenette Kahn was hired as publisher. From that point on, DC began a deliberate attempt to be more like Marvel Comics. This continued over the next decade until it finally culminated in 'Crisis on Infinite Earths.' At the time DC jumped the shark, it wasn't even noticeable. The decline wouldn't become noticeable until a few years later. The first thing you notice after she becomes publisher is that multiple issue stories start to be the rule, rather than the exception (which is what they had been up to that time.) In my opinion, this is the BEGINNING of the decline."

FOOTNOTE

The phrase "jump the shark" refers to a defining moment when a television show peaks. It harkens back to an episode of *Happy Days* when Fonzie jumped over a shark while waterskiing. Supposedly, the show went downhill thereafter.

Another blogger named gardnergrayle replies, "Not sure what you're getting at here, but you sound like a Marvel fan who sees the beginning of the end for comics as you knew them. Marvel and DC have been on a quality roller coaster since the early seventies. Both companies have waxed and waned over the decades. . . . As to your question, DC hasn't jumped the shark that I'm aware of, unless the 'Implosion' counts, but I think Marvel is about halfway across the tank. They just might land in it. And I'll laugh my ass off when they do."

Kmadden5 responds, "No, I'm a DC fan. I never liked Marvel Comics. I think DC started going downhill when they started to try to be like Marvel."

Then a blogger known as themac adds, "Since you asked . . . I think Jeanette [sic] (why does this picture look like Mary Tyler Moore) Kahn, and then Paul Levitz after her have done the exact opposite of what you're suggesting."[33]

Paul Levitz chuckles at the reaction to his predecessor's arrival at DC. "'A woman?' A fairly outrageous proposition at the time. 'A young person?' Neither of those were things that had been sighted running a comic company. There was Helen Meyer over at Dell, but she was basically invisible to the world."[34]

"There were very few women in the field when I joined," recalls Jenette Kahn with a wry smile. "And, of course, anxiety and horror washed through the DC halls when it was known that I'd been hired. After all, I was in my twenties, from outside the industry and (shudder) a girl. The perception—and I'm sure it was equal part wish—was that I'd be gone in a year. But, of course, I stayed."[35] For twenty-six years.

KAHN DO ATTITUDE

"Despite the fact that my arrival fostered fear and loathing, almost everyone tried to win my favor," says Kahn. "After all, I was the boss and I held the power of life or death over my almost exclusively male employees. We had no guidelines or human resources department then and, if I wanted, I could more or less fire at whim. This certainly was not my plan, but no one believed it. I was an untried and unknown quantity. So I witnessed grown men scurrying around like rabbits in a warren, trying to anticipate what I'd like to hear. No one, save Paul, had an opinion that contradicted mine. I realized that my staff lived in fear by day, then went home to muster a brave front that would reassure their wives and families. There is an inherent injustice in the hierarchies of corporations. The injustice for me was inescapable. And it humbled me."

As she describes it, "Even in my first five years at DC, the most difficult of times, I found wonderful people to work with: Joe Orlando, Dick Giordano and Paul Levitz, then a 19-year-old part-time assistant editor and for years . . . my most valued colleague. There were people, like Karen Berger, whom we hired during that time, for whom I have not only the greatest respect but deep, abiding affection. People like Andy Helfer, always on the hip tip and a topnotch editor who cheerfully refuses to be domesticated.

"I'm the resident optimist whereas Paul is the resident cynic. It makes us a wonderful team. I'm positive and encouraging but not afraid to take unpopular positions. . . . And I'm much better at raising the bar on good material than I am at putting a floor under mediocre efforts."[36]

> INTERVIEWER: If you could have any superpower, which would you choose?
>
> PAUL LEVITZ: (Declined to answer, maintaining his secret identity.)[37]

HAPPY BIRTHDAY, SUPERMAN

"Years of devaluing our talent had left deeply imbedded veins of mistrust," Kahn admits. "We might have instituted far more enlightened procedures, but that didn't mean that we could suddenly overturn the emotional backlash that came from years of inequitable behavior."[38]

Artist Neal Adams spearheaded a campaign to force National Comics (DC, that is) to recognize Joe Shuster and Jerry Siegel as the creators of Superman. It was a difficult battle, but in 1975 a settlement was negotiated that restored Shuster and Siegel's creator credits and provided them with a pension and health benefits for life.

Then National held a three-day convention at the Commodore Hotel in New York City to celebrate Superman's birthday—with Jerry Siegel and Joe Shuster as its headliner guests.[39]

MUSICAL CHAIRS

In the three years between Roy Thomas's leaving Marvel in 1974 and Jim Shooter's succession in 1978, there were four editors in chief (counting the three weeks of Gerry Conway): Len Wein, Marv Wolfman, Gerry, and then Archie Goodwin.[40]

ROY THOMAS: Did that musical chairs of editors bother you?

STAN LEE: Yeah. I wish that any one of those guys would have stayed for a while. But it didn't affect me that much; I just thought it didn't look good for the company—that we didn't know what we were doing. But they were all good. I was disappointed that Gerry didn't stay, because I always liked him and thought that he would do a good job.[41]

SHOOTING FROM THE HIP

In 1978 a whiz kid named Jim Shooter took over the editor-in-chief reins at Marvel Comics from Archie Goodwin.

As Michael David Thomas sums it up in a *Comic Book Resources* interview, "Jim Shooter's name carries with it many stigmas. Writer. Editor. Publisher. Megalomaniac. Pariah. These are probably the most associated descriptions of the tall man who became a household name among comic book fans in the late 70s and most of the 80s. Whether they're deserved is really about who you talk to."[42]

Shooter had started writing for DC Comics at the tender age of thirteen, most notably the Legion of Superheroes in *Adventure Comics* and a run on *Karate Kid.*

After his stint at DC, he began writing for Marvel in the early 1970s, then became an editor. In 1978 he was offered one of the most prestigious jobs in the industry: editor in chief of Marvel Comics. Predictably, he accepted.

"He spent the next decade or so building up the run-down mess it had become to a juggernaut that commanded close to 70 percent of the comic book market at its peak," notes Thomas. "Not bad for someone in his mid-20s when he took over at Marvel."[43]

However, all was not well at the House of Ideas. Because Shooter had been made editor in chief over more tenured staffers, several key people defected to DC. No—being a tough, controlling, perfectionist, do-it-my-way boss wasn't going to win Shooter any friends.

DC GOES SHOPPING ABROAD

"Comics Sucked. By the end of the '70s Silver Age, Marvel and DC were churning out dredge on a weekly basis," opines The Skinny Website. "Long boring storylines and flat character-arcs were hurting Superman more than Lex Luthor ever could. So Jenette Kahn, then president/editor of DC, began to search for a cure.

"Her first step was to go abroad, and in London she found Alan Moore and Neil Gaiman. These two Brits jumped at the promise of a wider audience and greater creative freedom. Gaiman respected readers' maturity and wrote *The Sandman,* an existential story of myth and horror, which became a pop culture in its own right. Moore, however, was the stronger writer, and it showed.

"What Orson Welles did for cinema, what Shakespeare did for theatre, Moore did for comics. His run on *Swamp Thing* created the 'sophisticated suspense' genre; *V for Vendetta* was social satire of *1984*'s stature; and *Watchmen,* his magnum opus, is regarded as the most important comic ever published."[44]

Moore was followed by Grant Morrison, whose first major work was his bizarre take on DC's *Doom Patrol* and Warren Ellis, whose recent *Planetary* is "an intricate postmodern conspiracy adventure that recontextualizes a century of pop-culture tropes, idioms and clichés."[45]

USHERING IN THE 1980S

The Micronauts—a Marvel series based on a line of Mego toys—began its seven-year run in 1979. Despite skepticism about a comic book based on toys, The Micronauts outlived the toy line on which it was based by six years. The early issues were notable for the pencils by Michael Golden.[46]

A fanzine about popular comics, Amazing Heroes, was launched by Fantagraphics Books in 1981. In addition to the reviews and interviews, its special swimsuit editions featured sexy pinups of female comics characters as drawn by various artists.[47]

By the early 1980s, Charlton Comics was in serious decline. The comic book industry was in a sales slump, struggling to reinvent a profitable distribution system.

Marvel was not immune to the economic pressures. "We had been losing money for several years in the publishing," admits Jim Shooter.[48]

FLASHBACK

As publisher I was determined to bring defected talent back to Marvel. Michael Golden was one of my first successes, luring him back to the House of Ideas as its art director. His hands were so gnarled with arthritis he could barely hold a pencil. But, boy, could he art direct!

Chris Claremont took longer, an endless negotiation based on his "unpaid royalties" on toy sales before he agreed to sign on as senior editorial director.

Steve Ditko was polite over the phone but preferred to continue his quiet lifestyle residing at the YMCA rather than return to what he called "the scene of the crime."

THE DIRECT MARKET

The **Direct Market** came about as a response to the declining newsstand market for comic books. Fan convention organizer Phil Seuling approached publishers asking to purchase comics directly from them, rather than going through the traditional periodical distribution system. Comic shops, willing to take the merchandise on a nonreturnable base for a slightly better discount, wanted to get in on this approach.[49]

The newsstand channel distributed magazines and comics on what might be described as a consignment basis, with unsold copies being returned for credit. "Returns had become a very big deal in the early 1970's, as comics were no longer selling in the percentages of previous decades," explains Chuck Rozanski of Mile High Comics. "During World War II, when comics were very popular, it was not unusual for sell-through percentages to be in the high 60% range. A few comics were reported to have even sold entirely out of stock. This is a critical number, because comics are a unit-

FOOTNOTE

Fanboys lust after sexy drawings of comic book superheroines the way other guys peruse supermodels in the annual Sports Illustrated swimsuit issue. And sexy original artwork is a prized collector's item. John Romita, Sr., told me that he'd only done one nude sketch of Spider-Man's Mary Jane (and he knew exactly who had it). In my own collection I have a nude Omaha the Cat Dancer, a topless Lara Croft, a nude Little Annie Fanny, a nude Cherry Poptop—all by the original artists. Not to mention, a naked Asian woman by Wally Wood. Yes, we fanboys do live in a fantasy world!

driven business. What I mean by this is that the majority of the cost of publishing any given comic book is in the editorial production (i.e., plot, pencils, inks, colors, and editorial staff costs). Once you've paid for the cost of creating the comic, the cost of printing/paper/ink per issue is negligible. This is why it was economically viable for the publishers to flood the newsstands with far more copies than they could realistically sell of any given issue. Even if half of the copies remained unsold after 30 days, and subsequently had their covers stripped off, the effort was still worthwhile. With low unit production costs, the critical marketing issue for the comics publishers was maximizing the total unit sale by putting as many books out on the newsstand as possible. . . .

"By the early 1970s, however, the numbers were beginning to turn against newsstand sales. One important factor was the overall decline in the number of outlets willing to carry comics. Another critical factor was the decline in reading among America's youth, with television dragging away a larger and larger percentage of potential readers. The comics publishers started seeing their overall sales numbers plummet, and sell-through figures started becoming dismal. That was the period when comics seemed to increase in price every year, with the price quickly escalating from 12 cents, to 25 cents, in just four years," says Rozanski, a lanky ex-hippie with a long gray ponytail.

"It was within the context of this early stage in the disintegration of the newsstand market that Phil pitched his idea of a new distribution system to the publishers. Even though his initial order numbers were tiny, everyone was happy with Phil's new arrangement, as it at least provided a possible alternative to newsstand distribution. Little did they know at the time that this new system would ultimately revolutionize the entire marketing of comic books within just ten years."[50]

‹ MILESTONE #6: THE DIRECT MARKET IS DEVELOPED.›

This new Direct Market caused a major shift away from the corner drugstores and five-and-dimes of yesteryear to a loose network of comic book stores mostly operated by fanboys and geeks.

Now, customers had to get used to new buying patterns. "I think where someone used to buy comics in those pre–Direct Market days is just as important a memory as the comics themselves," self-professed "Innocent Bystander" Gary Sassaman waxes nostalgically. "I can't tell you, chapter-and-verse, issue-by-issue, where some of them came by, but I remember buying *Amazing Spider-Man* #3 at York's Drugstore, a day or two before it showed up at my regular haunts. I know I bought

Nick Fury, Agent of S.H.I.E.L.D. #1 at Moser's, because that's the day my friend Bert picked to try and shove two or three other comics in his geography book, when we went there after school. Needless to say, he got caught. . . .

"We're spoiled in this day and age," Sassaman concludes. "I can pretty much get anything I want, comics-wise . . . just by pre-ordering it. The world of comics is controlled by one company—Diamond—and it's a world that reaches every shop every month, providing you can convince the owner to order something for you (not always the easiest task)."[51]

By the early 1990s there were some twelve thousand accounts (six thousand true independent comic book specialty stores at that time, estimates DC's Bob Wayne[52]) spread across the United States. The good news and bad news—these comic book stores provided a highly targeted buying audience but at the same time tended to marginalize comics in the public eye.

Moms weren't comfortable going into them. It was like visiting a head shop or pool hall—perceived as a slacker's domain. A bunch of geeky guys standing around arguing over whether Thor could beat up the Hulk.

> **AND THE ANSWER IS?** Let's go directly to the source: "I would have to guess that Thor is stronger," muses Stan Lee, "only because he is a god and probably can't be killed. Again, I don't know how the guys have been writing him lately, but I thought of him as invulnerable. I would think that with his hammer and everything, he'd probably beat the Hulk. But what's interesting with the Hulk is, the more he fights and the more he's beaten, the stronger he gets, so maybe it would be a draw."[53]

A lot of comic book stores were located in inconvenient side-street locations and looked about as unkempt as a frat boy's dorm room. You felt like you needed to know a secret password to gain uncontested entrance.

What's more, these shops weren't very kid friendly for the most part. Few comic products for youngsters.

Comic Book Guy, one of the characters on *The Simpsons* TV show, is a parody of the prototypical comic book store owner. It's not far off the mark.[54]

Now, a quarter century later, the comics industry has missed out on reaching nearly two generations of potential readers. That left it up to Saturday-morning cartoons and movies based on superheroes to introduce the characters to kids.

Today, the dominant Direct Market distributor is Diamond Comic Distributors, Inc., located in Timonium, Maryland. Smaller alternatives are Cold Cut and Last Gasp, the latter a tiny operation in San Francisco that specializes in counterculture fare.

Diamond was established in 1982 to provide comic book specialty retailers with wholesale, nonreturnable comic books and related merchandise.[56]

With this shift, publishers began to produce material specifically for this market, series that probably wouldn't sell quite well enough on the newsstand, but did okay on a nonreturnable basis to the more targeted readers of the Direct Market. With continuing declines in newsstand sales, the Direct Market has evolved into the primary market for Marvel and DC.

As the popularity of collecting grew, many new comic shops opened, and existing retailers such as gaming and trading card shops added comics as a side business.

This rapid growth (due partially to "speculation" by people investing in the future value of comic books) proved unsustainable, with the market contracting in the mid-1990s. This led to the closing of many comic book shops. By the late 1990s there were only 6,500 comic book stores in America. Today, that number has dwindled to about 2,500 specialty outlets.[57]

NOT SO HEROIC

During this early-1990s period Marvel purchased a regional distributor called Heroes World with the intention of exclusively self-distributing its own products. That caused other distributors to seek exclusive deals with publishers to compensate for the loss of Marvel's business. DC Comics, Image, Dark Horse, and several smaller publishers made exclusive deals with Diamond. This pincer movement forced Capitol City Distribution and other small distributors out of business.

Then, as the market shrunk, Marvel's attempt at self-distribution became too costly, so it closed down Heroes World and signed its own exclusive distribution deal with Diamond.

The further development of the Direct Market is commonly credited with restoring the comic book industry to profitability after the infamous crash of the 1990s.[58]

DO NOT PASS GO

Michael Z. Hobson started his fifteen-year run with Marvel in the 1980s. With the title of executive vice president, he was an experienced publisher, having spent a baker's dozen years at Scholastic Books.

Mike Hobson went on to run Marvel's international business as managing director of Marvel Europe, including its companies in the UK and Italy. "He looks just like the Monopoly Man," his friend and onetime co-worker Jim "Ski" Sokolowski describes him.[59]

FOOTNOTE

What is it about Scholastic and comic book publishers? Mike Hobson worked at Scholastic before joining Marvel. Jenette Kahn worked at Scholastic before going to DC. And Shirrel Rhoades (yours truly) was a group publisher at Scholastic prior to becoming EVP at Marvel.

MINI AND MAXI STORYTELLING

Meanwhile DC began to publish "some of the most exciting material in the history of comic books," as Jenette Kahn put it. "Our initial foray was small but critical. We published *The World of Krypton* by E. Nelson Bridwell. It was remarkable not so much for its content but for its format. *The World of Krypton* was the first miniseries in comics. The sales spiked. A contained story with a beginning, middle, and an end had tremendous appeal. And if that worked, why not a maxiseries, an epic saga told over not three or four issues but twelve?"[60]

COMICS TRIVIA

Ski named his dog after Mike Hobson. He sometimes brought his dog to work. Hobson piddled on the carpet outside the old Marvel conference room, leaving a big stain on the floor. The dog, we mean. Not the man. *Shhhh,* don't tell anybody!

The result was *Camelot 3000* (1982–1984), written by Mike Barr and drawn by Brian Bolland. A retelling of the Arthurian legend in modern terms, this watershed book received a 1985 Jack Kirby Award nomination for Best Finite Series.[61]

BIG EVENTS

In 1984 Marvel unveiled its first large crossover epic, *Secret Wars.* A year later, DC tried its first large-scale crossover *Crises on Infinite Earths,* which had long-term effects on the DC Universe continuity. For the next dozen years big events were regular fare of Marvel and DC, a sure-fire means of generating bigger sales.

INTERVIEWER: If you could have any superpower what would you choose?

JIM "SKI" SOKOLOWSKI: Complete control of the electromagnetic spectrum. You didn't think I'd go for anything small, did you?[62]

Why do crossovers? A self-described "chatterbox fangirl" named Felicity offers these three raisons d'êtres:

1. Buy More Titles: The underlying purpose of any crossover is to get you to buy more books, hoping that the fan who buys every Gotham book BUT Bats's four will buy in "just for this storyline" and stay hooked. But some are basically just an excuse for the writers to have fun mixing characters up and boost cross-readership.

2. House Cleaning: When a comic book company promises "NOTHING WILL EVER BE THE SAME AGAIN!" what they really mean is, "Dear god, we have cluttered up this place." On a small scale, what you get is War Games; huge numbers of mob bosses, henchmen and hitmen created for one-offs or color in the various Batbooks are lined up and shot for the good of the poor overworked continuity editor. On a large scale, you get Crisis on Infinite Earths, the gigantic reset event that attempted to create continuity in the DC Universe in the first place. The whole point is to make the crazy spiderweb mythology hang together for just a few years more.

3. Dixie Cup Elseworld: This kind is my FAVORITE. Rather than put out a wacky concept as an Elseworld book and try to get people to notice it by squandering advertising space, you just build the thing into ongoing books and press "reset" at the end.

"So there you have it, my first crack at a unified theory of comic book crossovers," says Felicity. "Why do you care? I don't know. What does it mean? That I'm a big big geek and DC Comics gets all my money."[63]

A NEW UNIVERSE

To celebrate Marvel Comics' twenty-fifth anniversary, editor in chief Jim Shooter made an attempt to launch a New Universe line of comics in 1986. The New Universe was intended to be a distinctly separate world from the traditional Marvel Universe, with its own characters and stories in a more realistic setting. There would be few superheroes—and no aliens, gods, mythological beings, or magic. This limitation of fantasy

elements was meant to give it the sense of being "the world outside our window."

The New Universe was heavily marketed but faced substantial problems. Top talent was lost when budgets were reduced. Sales were poor, and the imprint was abruptly discontinued in late 1989.[64]

Jim Shooter took the blame. "So he's created a few more universes, buried them and lived to tell about it all," shrugs a cynical industry insider.[65]

FOOTNOTE

Characters from the New Universe—Star Brand, Justice, and Nightmask—popped up in 2005's *Exiles*, and again in 2006's *Untold Tales of the New Universe*. The latter was a series of one-shots leading to *newuniversal*—a single-title reboot of the New Universe by Warren Ellis and Salvador Larocca.[66]

SHOOT-OUT

"What goes up must come down," writes Michael Dean Thomas in *CBR*. "The details of Jim Shooter's fall from grace in the late '80s at Marvel have as many sides to them as Sybil had personalities. Everybody has submitted their two-cent stories as to why Shooter was canned.

"Oh, it was Kirby not getting his art back."

"Shooter was a megalomaniac."

"Shooter was a dictator. . . ."

"Regardless of the whys, the end result was, Shooter was not only fired from Marvel but his reputation besmirched with tales of horror and degradation from those he had allegedly wronged."[67]

John Romita, Sr., remembers it this way: "Shooter took over and that was, for about six or seven or eight years, a golden age for us. For about three or four years when he was a positive force, he expanded the line. He sold books, they were happy with him upstairs, the artists were gaining stature . . .

"Then—I don't know if the New Universe was the only resort, but after the New Universe failed—it may have been an economic thing, it may have been a combination of things—but I think they started to snipe at Shooter from upstairs. And as he took grief, he started to give grief to the people below him. He started to become a very hard guy. . . . It was a rough time. From wonderful moments to some very bad moments."[68]

ARCHIE'S FAMILY

During the 1980s Michael Silberkleit and Richard Goldwater—sons of the founders—took over the reins of Archie Comics. They had been apprenticing for that day: "Richard and I started off getting lunch for our fathers—for quite a long time—then we worked in the warehouse,"

says Silberkleit. "It's pretty much automated now, but in the old days we ran the labels through a glue machine."[69]

The future? "We expect our kids to take over the business," says Silberkleit. "Maybe we should start them off in the warehouse. A family tradition!"[70]

A DARK HORSE ENTERS THE RACE

Mike Richardson had founded a chain of successful comic book shops in Portland, Oregon, upon graduating college. But by 1986 he decided to do something to improve the standards of comics and invested his profits in launching Dark Horse Comics. In July of that year he published his first title, *Dark Horse Presents* #1.[71]

One of Dark Horse's early titles was Paul Chadwick's *Concrete*—which went on to earn an unprecedented twenty-six awards and nominations within two years of its debut and "continues to win awards to this day."

Dark Horse has published respected comics like Frank Miller's *Sin City,* Mike Mignola's *Hellboy,* Neil Gaiman's *Murder Mysteries,* Stan Sakai's *Usagi Yojimbo,* Sergio Aragonés's *Groo,* and Michael Chabon's *The Escapist.* A leading publisher of licensed comics, its popular properties include *Star Wars, Buffy the Vampire Slayer, Conan, Aliens,* and *The Incredibles.*

Premiere magazine described Dark Horse as "the largest bite any independent publisher has ever taken out of the DC-and-Marvel dominated business."[72]

MUSICAL CHAIRS

In 1986 Marvel was sold to the movie studio New World Entertainment, which within three years sold it to billionaire Ronald O. Perelman's MacAndrews and Forbes holding company. Perelman took the company public on the New York Stock Exchange.[73] (See the chapter on the Comic Wars.)

STEADFAST STAN

"At some point a few years ago—probably in the early '80s—I got the title 'chairman,'" Stan Lee recalls. "But again, I didn't function like a real chairman. . . . It was more of an honorary title. Even now, I'm chairman emeritus. . . . I'm not sure what 'emeritus' means. . . . I've got to look it up some day."[74]

QUESTIONS FOR FURTHER THOUGHT

1. Was the Comics Code too stringent? Was it effective? Does it serve a purpose today? Share your opinion.

2. What made Chris Claremont's *Uncanny X-Men* tales so popular? Discuss his dialogue and writing style. Was his *X-Men* better than Stan Lee's originals? If so, how?

3. Was Jim Shooter a good editor? A bad manager of people? Misunderstood? A stand-up guy who took the rap for Marvel in the controversy over Jack Kirby's artwork? Where does he stand in the pantheon of Marvel editors in chief?

4. Did DC's Jenette Kahn change comic book history by bringing British writers Alan Moore and Neil Gaiman to American audiences? If so, in what ways?

5. How accurate is *The Simpsons*' caricature of Comic Book Guy in your experience?

THE MODERN AGE

DARKER KNIGHTS

In explaining how he came to write *Watchmen*—called by *Time* magazine one of the "100 Best Novels Ever Written"—British magician and writer Alan Moore says, "Well, I mean, it's a fairly minor fact but what originally happened was that me and Dave [Gibbons] had got an idea for a kind of a superhero story which we figured needed a whole continuity of characters, not a big continuity but a whole continuity of characters, like we figured that if there were any superhero characters from old defunct comic companies lying around, that we could take a whole bunch of them wholesale and then tell this story starting with the murder of one of them, that would take these kind of familiar old-fashioned superheroes into a completely new realm. Now, at that time Dick Giordano was working for DC Comics. Now, Dick had previously been working for a company called Charlton Comics. Now, while he was at Charlton he had overseen the creation of a number of characters that are still remembered with vague nostalgic affection by comic readers and comic fans. . . . Yeah, so it was just taking these ordinary characters and just taking them a step to the left or right, just twisting them a little bit."[1]

THE exact ending of the Bronze Age is fuzzy. In fact, some do not believe it ended at all. Nonetheless, the **Modern Age of Comics** (sometimes referred to as the **Copper Age**) is generally considered to extend from the mid-1980s until present day. I'd place its beginning with the 1986 publications of Alan Moore's *Watchmen* and Frank Miller's *The Dark Knight Returns.*

"In this period, comic book characters generally became darker and more psychologically complex, creators became more well-known and active in changing the industry, independent comics flourished, and larger publishing houses became more commercialized," an encyclopedia entry describes the Modern Age.[2]

COMICS GROW UP?

A Harvard study explained it this way: "Before 1986, most people in America thought comic books were just bad entertainment about superheroes: men and women who fight crime with extraordinary powers and methods. People thought comic books only appealed, and could only appeal, to children, entertaining adults secretly and unintentionally, if at all. Then, in a flurry of news articles, the mainstream media announced the existence of adult comic books and adult comics fans. Some news stories focused on the collectors who invested in comics hoping for a big payday. Others focused on the content of these comic books. Headlines amounting to 'Wow! Comics about holocaust victims and psychopathic superheroes' topped newspapers. People were surprised by the new comics' adult content, i.e., sex, violence, and strong political opinions. These comics also had a largely overlooked adult sensibility: depth, seriousness, and complexity. They presented complicated topics using complex narrative forms that are open to multiple interpretations. The media declared 1986 the year comics finally 'grew up.'

"But that is not quite true. . . . What the mainstream press actually saw was a turning point for the superhero genre."[3]

WATCHFUL EYES

"In 1986 everyone was watching *Watchmen,* which won enthusiastic notices in publications from *The Nation* to *Newsweek,* from *Time* to *Rolling Stone.* A comic book that seemed to transcend the form, *Watchmen* remains a landmark and made celebrities out of writer Alan Moore and artist Dave Gibbons," writes comics historian Les Daniels.[4]

"*Watchmen* was designed to be read on a number of levels," Moore says. "To a certain degree all interpretations are true. . . . All of these different little threads of continuity are effectively telling the same story from different angles."[5]

As Daniels concludes, "In its moral and structural complexity, *Watchmen* is the equivalent of a novel, and it remains a major event in the evolution of comic books."[6]

A DARK AND STORMY KNIGHT

Frank Miller "postulated a dystrophic future"[7] in his landmark *The Dark Knight Returns* (1986), returning Batman to his "psychotic vigilante"[8] roots in a fresh new way.

"Miller, who felt that superheroes had become too humanized in recent years, saw Batman as 'god of vengeance,' and wanted to restore some of the mythic power he felt had been lost," notes Les Daniels.[9]

THE STORY: Pushing fifty and a near-alcoholic, Batman comes out of retirement to take on a gang terrorizing Gotham City in a battle that stops "just short of slaughter."[10]

"No story in the Batman world is probably more important than Frank Miller's *The Dark Knight Returns*," observes Batman maven Patrick Furlong. "This story was released in 1986, and was responsible for the rejuvenation of Batman as a dark character, and [of] the comics industry as a whole."[11]

"*The Dark Knight Returns* is an awesome work, breaking the mold that stifled Batman for many years. It brought a change in the public attitude to what Batman and superheroes in general are all about," concludes the editor of Grovel.com.[12]

FORETELLING DARKER DAYS

DC's *The Dark Knight Returns* and *Watchmen* "so thoroughly deconstructed the superhero genre that for several years all superhero comics seemed like nothing more than bad parodies of themselves."[14]

These two phenomena had another profound impact on the American comic book industry: they encouraged publishers to shift their comics to a "darker" tone, often described as "grim and gritty."[15] This change was underscored by the growing popularity of anti-heroes

FOOTNOTE

As Jenette Kahn recalls it, "Frank Miller was over at Marvel doing spectacular things with *Daredevil*. His work felt modern in a way that few people's had since Neal Adams', Denny O'Neil's and Jim Steranko's had some fifteen years before. Frank's was the kind of daring we wanted to encourage at DC. I asked him to lunch and said: 'Tell me what it is that you would really like to do. I don't care how offbeat it is or if it's never been done before. Whatever it is, we'll try to make it happen.' And so it was that Frank proposed what was to become *Ronin*. . . . [It] was bursting with new ideas and breathtaking art, and set the stage for *The Dark Knight Returns* and the modern era of comics."[13]

such as Wolverine and the Punisher. Soon the pages of mainstream comics were filled with brooding mutants and erratic vigilantes.

‹MILESTONE #7: WITH DARKER KNIGHTS, COMIC BOOKS BECOME LITERATURE.›

"These dark characters began to appear in superhero comics (especially those published by Marvel, but also with increasing frequency by DC) during the mid-1970s, but it was not until the mid-1980s that they became ubiquitous and almost *de rigueur* for any comics publisher who wanted to remain in favor with the fan base," observes Matt Povey of Matt's Notepad. "The source point for this more violent, antiheroic motif was probably Frank Miller's *The Dark Knight Returns,* a familiar, but paradoxically unprecedented reinterpretation of the Batman mythos that was worlds apart from the bright, colorful, innocuous super-heroic adventures of the Silver Age Batman. *The Dark Knight Returns* achieved both massive sales and critical acclaim, and dozens upon dozens of imitators soon arose in its wake. Miller's reinterpretation of the Batman mythos in *The Dark Knight Returns* was nothing less than revolutionary, but what was revolutionary was soon to become crass and trite. Among the spawn of this era (which included a dark hero named Spawn) were Cable (of X-Men fame), a murderous antihero in the vein of his fellow X-Man Wolverine, and Coldblood—another dark antihero in the Cable mold who never achieved enough popularity to support his own title."[16]

This nihilism was also found in DC's "A Death in the Family" in the *Batman* series (1988–1989), in which Batman's sidekick Robin is murdered by the Joker. And at Marvel it led to dark storylines like "Mutant Massacre" (1986) and "Acts of Vengeance" (1989–1990).[17]

OF MAUS AND MEN

As if meeting the challenge, in 1986 Art Spiegelman published the first volume of *Maus: A Survivor's Tale,* a memoir in the guise of a graphic novel recounting his father's struggle to survive the Holocaust as a Polish Jew and Spiegelman's own attempts to connect with him.[18] The second volume was published in 1992.[19] By late 1993, both had been combined to form a complete novel.[20]

Todd Gitlin, a professor of culture and communication at New York University, has aptly called *Maus* "at once the most horrific of all horror comics, the most graphic of all history comics."[21]

Maus signified that the medium was capable of telling stories about subjects other than superheroes—that in fact this heretofore lowbrow entertainment might just be literature. The work won a Pulitzer Prize Special Award in 1992, the first comic book to do so. According to the *New York Times,* "The Pulitzer board members . . . found the cartoonist's depiction of Nazi Germany hard to classify."[22]

Did this signify that comics were starting to gain respectability?

PERELMAN'S PLAY

Financial mogul Ronald Perelman acquired Marvel in 1989, "seeing it as more than a comic book company. The idea was that Marvel would be the foundation of a media play."[23]

To make it happen, Perelman hired William C. Bevins, Jr., an executive with the desired entertainment background, having been chief financial and administrative officer of Turner Broadcasting System, Inc. prior to joining Perelman's various enterprises (Andrews Group, MacAndrews Holdings, and so on).[24]

As CBS News correspondent Dan Raviv reported, "In the late 1980s, financier Ronald Perelman, worth billions and riding high after his hostile takeover of the cosmetics firm Revlon, bought Marvel Entertainment—legendary creator of Captain America, the Incredible Hulk, Spider-Man, the X-Men, and other superheroes—and he had big plans. He not only began churning out more comic books, he also acquired sports cards and other subsidiaries, impressing Wall Street so much that after he took the company public, Marvel's market value ballooned to over $3 billion."[25] Yes, he was indeed the "Wizard of Wall Street."[26]

INTELLECTUAL PROPERTIES

Meanwhile, comic book companies—DC and Marvel, at least—were coming to a more sophisticated understanding that they were in an **intellectual properties** (IP) business, their characters having a value greater than simply as content that sold a few comic books.

‹MILESTONE #8: COMICS ARE LEVERAGED AS INTELLECTUAL PROPERTIES.›

DC may have come to the realization more quickly, due to its affiliation with Warner Bros. They produced the first high-quality comic book movie franchises with Batman and Superman. It has long been

rumored that DC operates more as an R&D lab for Warner Bros. than as a publisher.

Sure, there had been Superman lunchboxes and Batman Thermos and Mickey Mouse toys, Red Ryder air rifles, and other comics memorabilia around for decades—but slowly and surely DC and Marvel were coming to understand that there was more money in the ancillary uses of the properties than in publishing itself.

THE SPECULATOR BOOM . . .

There have always been fanboys who saved all their comic books, but in the mid-1980s more serious collectors began to emerge. Some collected for love of comic books (for example, Diamond's Steve Geppi owns all the old *Uncle Scrooge* comics by his favorite artist, Cark Barks), but others began collecting them simply for their future value. These hoping-to-get-rich collectors became known as **speculators.**

‹ MILESTONE #9: THE SPECULATOR MARKET RISES AND FALLS.›

This boom period began with the publication of *The Dark Knight Returns* and *Watchmen*. Their critical success focused mainstream attention on the comic book industry. This was reinforced by the 1989 *Batman* movie, and then again by the 1993 "Death of Superman" publishing event.[27]

This frenzy increased with reports of old comic books selling for big bucks at auction.

> » *Detective Comics* #27, in which Batman made his debut, was valued at $80,000 in the early 1990s. (It would go for about $300,000 in today's market.)
> » *Action Comics* #1 brought $82,500 at a Sotheby's auction in 1992. (In 2006, a 6.5 CGC-grade copy sold for $250,000.)[28]

Comic book publishers took advantage of this trend, using numerous marketing techniques to hype the collectibility of their books. These gimmicks included variant covers, foil-embossed covers, hologram covers, even glow-in-the-dark covers. Some smaller publishers even issued nude covers, featuring their superheroines *au naturel.*

Another technique was polybagging. When a comic was polybagged, the collector had to choose between reading the comic or keeping it in pristine condition for future collectible value. Better still, buying two copies—one to read, one to keep.[29]

Although speculators "investing" in multiple copies of a single comic caused a temporary increase in sales, it ultimately created a collectibles glut.

. . . GOES BUST

The speculator market reached its high point in the early 1990s, then collapsed between 1993 and 1997 as collectors came to realize their *Shadowhawk* #1s would never be worth more than a buck or two. Fans were disillusioned by the gimmicks and high prices. People who had been buying comics like frenzied shoppers at a January white sale stopped. Two thirds of all comic book specialty stores closed during this period. Several publishers—including Defiant Comics, Triumphant Comics, and Malibu Comics—were forced out of business.

"When Ronald Perelman took over Marvel in 1989, his goal was to expand Marvel's business," says Chuck Rozanski, president of Mile High Comics. "He had his team start by increasing the number of titles being published, raising cover prices on a regular basis, and salting the monthly output heavily with special issues that could derive extraordinary profits through such inexpensive means as enhanced covers. At first, it looked like his plan was succeeding brilliantly. Sales and earnings soared as fans purchased huge numbers of these higher-priced books. What we heard in the stores, however, was an accelerating stream of complaints against the high cost of comics. Initially this criticism was focused on the higher-priced enhanced comics, but it quickly became apparent that the higher cost of collecting was forcing many fans out of their chosen hobby.

"Calculating the math in this scenario is fairly easy. In 1985, comics were 60 cents. With 40 regular Marvel titles being printed, it cost a typical fan $24.00 to purchase every Marvel comic book being printed. That left plenty of disposable income left over for trade paperbacks, toys, and other related Marvel goods. Even for collectors of modest means, it was possible to be a 'Marvel Zombie' for only $6 per week.

"By early 1993, Marvel prices were a minimum of $1.25 per copy, with several enhanced issues each month. With well over 100 titles being printed each month, the monthly cost for a dedicated fan to purchase the entire Marvel line was approximately $150.00. It was at this point that the comics market started falling apart at the seams. We noticed it first in our retail stores, as the number of monthly subscribers we were servicing started to fall precipitously.

"Fans who had been purchasing every Marvel title were frustrated that they could no longer afford to purchase the whole line, and were

even more frustrated that they didn't have the time to read them all. Rather than cut back to what they could afford, this substantial portion of the comics collecting community simply chose to quit collecting altogether."[30]

Valiant Comics—at one point the third largest comic book publisher—did not survive. *Deathmate* (a six-part crossover between Valiant and Image Comics) is considered to have been the "final nail in the Speculator Market's coffin." Although highly anticipated when it was initially solicited, the series shipped so many months late that reader interest had disappeared by the time it finally arrived. That left many retailers holding hundreds of unsellable copies. As a result, you can find *Deathmate Prologue* (with the foil cover) going for a mere $1.89 on eBay.[31]

"Today most Valiant Comics are easy quarter-bin fodder, especially easy-to-find issues when Valiant was publishing 400,000 copies of each title a month," notes Ryan McLelland on the Valiant website.[32]

In a study titled "The Comic Book Apocalypse," this was described as "a period in comic-book history where the industry almost committed suicide through greed, arrogance, and stupidity."[33]

THE REAL COLLECTORS MARKET

Veteran collectors point out a key factor that was largely overlooked by the speculators: original comic books from the Golden Age were genuinely *rare*. Most of these comics had been thrown in the trash by parents or recycled along with other publications during the paper drives of World War II. Comic books of interest to fans from the 1940s through the 1960s (such as an original issue of *Superman, Captain America,* or *Challengers of the Unknown*) were difficult to find—and thus highly valued by collectors.

That's why very few comics produced in the early 1990s have retained their value in the current market. With tens of thousands of comics printed (or in some cases, 10 million), there is no rarity, and the appreciation in value of these more-recent books is all but nil. (See the chapter "Collecting Comic Books for Fun and (Maybe) Profit.")

FOOTNOTE

Comic book valuation is similar in concept to coin collectors seeking an 1856 Flying Eagle cent. Only six hundred regular strikes were made, plus one thousand proof sets for members of Congress. Due to its rarity, a 1956 Flying Eagle cent sold for $29,325 in 2001—while coins from the more plentiful 1957 edition might go for a mere $8 to $10 each. Simple supply and demand![34]

SPEAKING UP!

Artist Chris Ware says, "Comics are a disposable, inherently low-rent visual medium. Any innate value they offer is within the beauty of the story and the book itself, not bestowed by rarity, art galleries, outside experts or art historians."[35] Although Ware describes comics as "low-rent," his own graphic novel *Jimmy Corrigan, the Smartest Kid on Earth* sells for a healthy $35 in hardcover. And his own artwork is displayed in such high-end venues as the Chicago Museum of Modern Art. Go figure.

POSTBUBBLE SPECULATION

"Since 1997, comic book sales have fallen to a fraction of early-90s levels, with print runs of many popular titles down by as much as 90% from their peaks," according to industry reports. "Currently, most of the hype generated around the major companies' comics involves changes to the characters, well-known creators writing or illustrating a title, and buzz surrounding an adaptation to another media such as film or television. The one remaining bastion for comic speculation remains in online auction sites such as eBay; but even there, comic books remain a buyer's market."[36]

Dang! There goes my retirement plan.

POSTMODERNISM

"Established superheroes such as Batman and Green Arrow gained new life as violent vigilante characters and were soon joined by a new generation of surreal postmodern superheroes like the Sandman and Animal Man," notes the *St. James Encyclopedia of Popular Culture*. "Such innovative and ambitious titles helped DC to reclaim much of the creative cutting edge from Marvel. Although DC's sales lagged behind Marvel's throughout the 1990s, the company retained a loyal following among discerning fans as well as longtime collectors, remaining highly respected among those who appreciate the company's historical significance as the prime founder of the American comic book industry."[37]

SUPERSTARS

Here was a new phenomenon: fans focusing on their favorite artists and writers rather than a specific character or comics franchise. Publishers were starting to discover that attaching a hot creator to a project sold copies in the same way a big-name movie star sells tickets to a movie. Marquee appeal.

Certainly, big names had existed from the past—Stan Lee and Jack Kirby, for example. But here was a brash new breed of creators, artists and writers who behaved more like rock stars than comic book geeks! Artists Todd McFarlane, Rob Liefeld, and Jim Lee, writers Neil Gaiman and Alan Moore, and writer-artist Frank Miller became very well known, with dedicated fans who followed their work closely.

‹MILESTONE #10: CREATORS BECOME SUPERSTARS (AND IMAGE COMICS IS FORMED).›

FLASHBACK

Here I am having lunch with Stan Lee at a restaurant near his office in Santa Monica. "Look, over there," he nudges me. "It's Steadman." "Who?" I whisper. "Oprah's fiancé," he clarifies, sounding like a child who has just sighted Santa Claus. It was amusing to note that Stan Lee—a man who hobnobs with presidents and movie stars as casually as he does with college students—sounded in awe of the Mighty O. Yes, money talks!

This changed the comics industry. In a scramble to lock down popular talent, publishers sometimes found themselves in a bidding war. The Adam and Andy Kuberts, the George Pérezes, the Kurt Busieks—we were signing them to what came to be known as **"superstar contracts."** Some of these guys were suddenly making big bucks—really big!

IMAGE EMERGES

Several popular Marvel artists became pissed that their artwork and characters were being heavily merchandised—T-shirts, animated TV shows, even bed sheets—and they were getting only page rates and a modest incentive. These creators were essentially freelancers doing work-for-hire assignments. Technically, they didn't even own their own artwork, although it was Marvel's practice to return pages so they could sell them to a secondary market of collectors. And what about all those action figures based on their characters they saw in Kay-Bee's and Toys R Us? Where were the fat royalty checks?

"The first person to be confronted with the question . . . was perhaps Terry Stewart, who was president of Marvel Comics at the time," reports *The Comics Journal*. "Stewart was in his office after hours one December night in 1991, surrounded by the bric-a-brac of Marvel-licensed products—a Hulk gumball machine and the like—when he looked up to find virtually all of Marvel's top artists entering his door *en masse*. He didn't know it at the time, but he was looking at Image Comics on the march. Present by all accounts were Rob (*X-Force*) Liefeld, Jim (*X-Men*) Lee, Todd (*Spider-Man*) McFarlane, and McFarlane's wife, Wanda, who reportedly sat in a corner nursing the McFarlanes' newborn baby, Cyan, as one of the most momentous meetings in recent comics history unfolded."[38]

The meeting had an edge to it: it just wasn't fair, they told Marvel's president. They demanded that the company give them ownership and creative control over their work. But big business doesn't easily budge. Marvel stuck to its guns.[39]

"They wanted a significantly better deal," Terry recalled recently. "We couldn't meet their demands. There just wasn't any wiggle room."[40]

All in all, seven creators—big names that sold copies—walked. This departure was called the "X-odus," because four of the penacilers were famous for their work on the X-Men franchise.[41]

Okay, so the publicity was lousy. The fans were mad. People started wearing those rude "Marvel Sucks" T-shirts. And to add insult to injury, those seven upstarts—Todd McFarland, Rob Liefeld, Jim Lee, Marc Silvestri, Jim Valentino, Erik Larsen, and Whilce Portacio—announced they were going to start up their own company. The very nerve!

"Image exists in large part as a thumb to the nose of Marvel—'Don't want to treat us good? So there!'" observes *The Comics Journal*.[42]

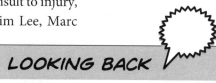

Image Comics, this new company, would be creator owned, each artist forming his own publishing entity under the corporate umbrella. The rules were simple—and idealistic:

» Image does not own a creator's work; the creator does.
» No Image partner would ever interfere, creatively or financially, with any other's work.[44]

"It's unlikely that Image would've happened if not for the militant atmosphere the Creator Bill of Rights had helped cultivate among artistic nonentities working in mainstream comics," Gary Groth assessed in *The Comics Journal*.[45]

Each founding member of Image Comics would maintain his own studio, autonomous from any central editorial control. Image would own no intellectual property other than its own logo. Because Whilce Portacio opted not to be a full partner, there were only six imprints under the new Image banner:

» Todd McFarlane Productions, owned by McFarlane;
» Extreme Studios, owned by Liefeld;
» Wildstorm Productions, owned by Lee;
» Top Cow Productions, owned by Silvestri;
» ShadowLine, owned by Valentino; and
» Highbrow Entertainment, owned by Larsen.

Thus, Image Comics launched in 1992, using the star power of its owners/creators to instantly become the biggest competitor to Marvel and DC in thirty years.

The first Image comic books out of the gate were Liefeld's *Youngblood*, Lee's *WildC.A.T.s*, and McFarlane's *Spawn*. Propelled by the artists' star

power and a still-hot collectors' marketplace, these titles sold in quantities no publisher other than Marvel or DC had seen since the market's drastic decline in the 1970s. The company experienced lesser successes with Larsen's *The Savage Dragon,* Silvestri's *Cyberforce,* Valentino's *Shadowhawk,* and Portacio's much-delayed *Wetworks.*[46]

"Boys and young men were enthusiastically attracted by its unrestrained depictions of impossibly thin, big-breasted women (in porn-star poses) and angry, gun-toting 'heroes' with layers and layers of anatomically incorrect bulging muscles," comments comic book historian Claude Lalumière.[47]

CAUSE AND EFFECT

"It looked like events were spinning out of anyone's control," Gary Groth adds. "The domino effect of events—the formation of Image, which prompted Marvel to buy Heroes World, which prompted DC to go exclusive with Diamond, which prompted the exclusivity wars, which resulted in Diamond absorbing Capitol, which turned Diamond into a *de facto* monopoly—had about it the air of historical inevitability, huge forces moving of their own accord."[48]

MONKEY SEE . . .

Other creators attempted to follow Image's lead, using their own star power to launch series they would control. Chris Claremont, famous for *Uncanny X-Men,* created *Sovereign Seven* at DC. Joe Madureira, also known for *Uncanny X-Men,* launched *Battle Chasers* under the Cliffhanger imprint. Kurt Busiek and Alex Ross, the team responsible for the popular limited series *Marvels,* came up with *Astro City* under the Image banner.

The results were mixed.

THAT WAS THE YEAR THAT WAS

"Looking back it can easily be said that 1992 was a rather big year for comics," observes columnist Michael Bailey. "Image Comics made its debut with the release of Rob Liefeld's *Youngblood* in April and solidified its hold on fandom with Todd McFarlane's *Spawn* in May. Not to be outdone Marvel Comics began a new horror line based of the success of *Ghost Rider* with a storyline called 'Rise of the Midnight Sons.' Marvel also placed its stake in the future with the world of *Marvel 2099* and pumped up its mutant line with the two-month *X-Cutioner's Song*

crossover. Marvel also made its return to Saturday morning with the first two episodes of the *X-Men* animated series. It was the second year of the Bat as well with the release of *Batman Returns,* a new ongoing series titled *Batman: Shadow of the Bat,* and an animated series of his own that changed the look of superhero cartoons forever.

"How does a year like this end?

"You end it with the death of a legend.

"You end it with the death of Superman."[49]

DEATH AND RESURRECTION

In *Superman* #75 (November 1992), DC's editorial team killed off the Man of Steel in a battle-to-the-death with a supervillain called Doomsday. Both fans and the general public alike were shocked. Newspapers headlined the event. Collectors and speculators rushed into comic stores to buy out the stock at inflated prices.

But was this truly the last of Superman? "No one ever stays dead in comic books," is the wry observation of Jim "Ski" Sokolowski, DC's director of publishing operations and circulation. "We can always find a way to bring 'em back. Hey, it's comics!"[50]

From planning to production to publication took roughly one year.[52] The storyline—a massive eleven-issue crossover among four different series (*Superman, Superman: The Man of Steel, Action Comics,* and *Justice League of America*)—was devised by Mike Carlin and the writing team of Dan Jurgens, Roger Stern, Louise Simonson, Jerry Ordway, and Karl Kesel.[53]

First, you had "Death of Superman." Then crossover stories depicting the world's reaction to Superman's death with "Funeral for a Friend." Followed up with the eventual return of Superman in "Reign of the Supermen!"

As Dan Jurgens says, "From the first page to the last, I think the entire 'Death and Return of Superman' story truly entertained our readers, and that's what it's all about, isn't it?"[54]

LOOKING BACK

"This isn't the first Superman meeting where somebody said, 'Let's kill him off,'" says DC's Mike Carlin. "At the meeting we had planned to do another story, but due to extenuating circumstances we had to push that back a little bit and then we had to fill the gap. So somebody said, 'Let's kill Superman.' . . . This, obviously, we thought, would be a big deal. We didn't just say, 'Let's kill him,' and say, "Let's go home.' Someone said, 'Let's kill him,' and then we said, 'OK, then what?'"[51]

No, maybe not. The move was deemed a clever response to underperforming sales. Amazon described it as "a 1992 stunt that turned out to be DC's bestselling *Superman* comic ever."[55] The Superman titles gained international exposure. Overnight they hit the top of the comics sales charts.

"A total sell-out," as one comics insider put it. Not clear on how the double entendre should be taken.[56]

. . . AND NEAR-DEATH

It was hard to argue with the sales. Initial printing of *Superman* #75 was some 3 million copies. When that sold, DC went back to press for a newsstand version with a new cover featuring a torn piece of Superman's cape flapping in the wind. Additional printings followed, with the book selling 6 million copies all told.

By contrast, Rob Liefeld's *Youngblood* #1 sold over a million copies, while Todd McFarlane's *Spawn* #1 sold 1.7 million.

There seemed to be a "feeding frenzy." Other publishers pumped out comics with variant covers, huge press runs, trumped-up events.

"All those readers coming into comic shops was great for retailers," observes writer-fanboy Michael Bailey, "but the good times were nearly over. In 1993 the bottom fell out of the comic market as the supply seriously outweighed the demand."[57]

The value of comic books depends on rarity. When the speculators realized these were valueless comics, they quit buying. This coincided with the departure of the Average Joe consumers, fanboys who felt frustrated by high prices and poor stories and slick marketing gimmicks. "This brought the comic book industry to a grinding halt," laments retailer Helgi Davis.[58]

"Frankly, I view that particular marketing event as being the greatest catastrophe to strike the world of comics since the Kefauver Senate hearings of 1955," says Chuck Rozanski of Mile High Comics. "While there were certainly a plethora of other reasons why the American comics market began falling apart in 1993 (including higher cover prices, overproduction, and deteriorating art/story quality), in my opinion the 'Death of Superman' promotion inadvertently exposed to the general public (many of whom ignorantly bought into the prevailing delusion that all comics were collectibles that infinitely rose in value) the 'Ponzi Scheme' reality of the market for recent back issue comics."[59]

TEETHING PAINS

Meanwhile, Image Comics was having its own problems. With limited business experience, many of the Image partners found themselves overwhelmed by the responsibilities of managing their respective studios. The company became notorious for falling behind its publishing schedule. Comic shops cut orders to reduce their risk. This hurt the studios, each being responsible for its own cash flow and profitability.[60]

So in 1993 Image hired Larry Marder as its executive director. A veteran of the advertising industry, he brought a better financial dis-

cipline to the company and had modest success in getting creators to meet deadlines.

By the mid-1990s, Image titles such as *Spawn* and *The Savage Dragon* had proven themselves as lasting successes, while new series such as Wildstorm's *Gen13* and Top Cow's *Witchblade* showed promise. Image had established itself as a strong competitor in the comic book arena.[61]

HEROES REBORN

During the mid-1990s, Jim Lee and Rob Liefeld patched up their differences with Marvel and contracted to do a series called *Heroes Reborn,* based on key Marvel characters—Captain America, Iron Man, the Avengers, and the Fantastic Four.

"It was my goal to rebond with those guys who had dropped out," Jerry Calabrese recently said, recounting the "shuttle diplomacy" involved in doing the *Heroes Reborn* deal. "They had every reason not to trust Marvel. But I got them rights, a limited take on merchandising, et cetera." As the Marvel president following Terry Stewart, he had a "clean slate" with the Image creators.[62]

Heroes Reborn was a "closed arc," only loaning the characters out to other storytellers. Sales were great, but the Image guys were a pain to administer. Sour feelings lingered on both sides of the editorial divide.

"As I've often said, it's not what I would have chosen to do," observes writer Kurt Busiek. "I can't argue that it worked—it boosted sales on all four books, kept them quite high, and let Marvel bring them back at a higher level than they'd left at. So in financial terms, which is what it was all about, it worked—and it brought in more readers to try those books.

"In aesthetic terms, it didn't interest me a whole lot. I thought *Iron Man* was the best-crafted of the bunch—*Fantastic Four* was well-drawn but rushed, and the other two were enthusiastically sloppy. . . . The main thing I appreciated about the whole *Heroes Reborn* experiment, aside from the clean slate and the sales boost it gave us guys who came along afterward, was that it happened off in its own world, and had an entry point and an exit point. The characters could come back as they had been without a big to-do, once the experiment was over. So they did it, they got a benefit out of it,

FLASHBACK

Rob Liefeld was a brash young artist with a style all his own. I admired his *chutzpah*. But he was always running late on the *Heroes Reborn* project. To complicate matters, the only way he'd give Marvel the pages of each issue was by flying a guy to New York with instructions not to turn over the disk of finished material until we physically handed him a check—something like a hostage exchange. I would hold out the check, he would hold out the disk. A pain in the @$$, in comic book-speak.

they put it away, and we got the real guys back. Not much to complain about, from where I sit."[63]

"*Heroes Reborn* certainly had its controversy as the first 'out-sourced, packaging' deal of its kind," recalls Liefeld. "It was terribly politically charged, but there's almost no one left from that era at Marvel and they've re-emerged from all their troubles, roaring back to the forefront of the industry."

Liefeld adds, "Ultimately, the Marvel heroes returned to the Marvel Universe in 1997's *Heroes Reborn: The Return,* and things returned to where they were, albeit, noticeably recharged."[64]

IMAGE'S IMAGE PROBLEM

Some of the Image studios used freelancers to write and illustrate series owned by the partners, leading to criticism that they had reproduced the very system they had rebelled against.

"Image's principles have clearly been demonstrated to be coterminous with Marvel's, DC's or any corporation for whom the bottom line trumps anything so airy-fairy as art or morality," declared Gary Groth in *The Comics Journal.* These were "the same traits they had implicitly or explicitly objected to on the part of Marvel and DC: the empire-building mentality, of shamelessly trying to buy creators' loyalty, of engaging in work-for-hire practices, of outsourcing their books to other creators, etc."[65]

IMAGE'S DYSFUNCTIONAL FAMILY

A clash between the strong-willed partners was inevitable. Several of them complained that Rob Liefeld was using his position as CEO of Image to further his own publishing interests. As a consequence, Marc Silvestri's Top Cow withdrew from the partnership in 1996. Later that year, Liefeld—the universally acknowledged "bad boy of comics"—was forced out of the company by a unanimous vote of the partners. Silvestri then returned his studio to the Image fold.[66]

DC EXPERIENCES VERTIGO

Vertigo is an imprint of DC Comics. Because Vertigo publishes content aimed at a more mature audience, the line carries a separate name to differentiate it from the more mainstream, family-friendly image of

DC. (Sort of like the difference between Touchstone and Walt Disney Pictures, both Disney imprints.)

Vertigo was based on DC's success with mature comics themes in the late 1980s, beginning with *Saga of the Swamp Thing* and continuing with *Watchmen, Hellblazer,* and *The Sandman.* In 1992, DC editor Karen Berger proposed moving DC's mature readers titles to a specialized imprint where they would be allowed even greater freedom.

Vertigo has proven influential in the comic book industry, particularly because of its experiments with graphic novels. A critical success, the line has pursued good writers over flashy art. Many of its stories contain violence, sexual situations, and substance abuse—controversial topics not deemed appropriate to carry a Comics Code seal.

Part of Vertigo's success stems from its willingness to take on creator-owned projects, where it doesn't control all the rights to the characters, but can get better stories. Proof in fact is *The Sandman* by Neil Gaiman, *Preacher* by Garth Ennis, *Transmetropolitan* by Warren Ellis, and *The Invisibles* by Grant Morrison.[67]

> **INTERVIEWER**: What superpower would you want to have?

> **NEIL GAIMAN**: Multiple bodies or time stretching. I'm now at the point where there isn't enough time to do everything I want to.[68]

MARVEL'S GROUP GROPE

In the early 1990s, Marvel management tried a bold experiment: instead of one editor in chief, it would have five! The comic titles were divided up into groups, each with its own editor. The lineup: Bob Harras heading the X-Books, Bob Bodiansky on Spider-Man, Mark Gruenwald on Marvel Heroes, Bobbie Chase on Marvel Edge, and Carl Potts handling General Entertainment.

"That was a weird concept," comments former president Jerry Calabrese, who inherited the structure. "How well do you think that worked?"[69]

The arrangement proved unwieldy, requiring too much coordination between groups. In 1995, it was disbanded in favor of a more traditional structure, with Bob Harras emerging as Marvel's editor in chief.

> **INTERVIEWER**: If you could have any superpower, which would you choose?

BOB HARRAS: Oh, God—can I be boring and say flying? Although for some reason stretching powers always seemed like they would come in handy.[70]

INDIES AND ALTERNATIVES

Comic specialty stores encouraged several waves of independent-produced comics. The term **alternative comics** is a label applied to a range of comics that have appeared since about 1980. Typically, these are authored by a single creator, aimed at adult readers, and tend to be experimental. The works in question have variously been labeled "postunderground," "independent," "indie," "small press," "new wave," or "art comics." Many self-published "minicomics" also fall under the alternative umbrella.[71]

Alternative comics present (as the name implies) an alternative to the mainstream comics that dominate the U.S. comic book industry (for example, the superhero-themed comics of Marvel and DC, the light comedy of Archie Comics, and manga-related works).

FOOTNOTE

The term **minicomic** used to refer to a format, a comic about half the size of a digest. However, today it usually refers to the handmade, independently produced nature of the comic—that is, one that's not "mainstream."

A recent Wikipedia entry put it into perspective: "Those [mainstream] comics are typically produced by a team of workers operating on tight deadlines: a writer, a penciler, an inker, a letterer, a colorist, and an editor. The subject matter and style . . . is in large part dictated by their publisher, who hires the personnel to produce the comics according to well-established conventions of a genre.

"By contrast, alternative comics are often independently authored and drawn by a single creator and they are published when deemed complete by the author, with little regard for regular distribution schedules. Where the content of 'mainstream' comics is influenced by corporate managers attempting to maximize sales, 'alternative' comics are often published in small numbers for specialized audiences, which allows for the publication of material that many in a more general readership would likely find obscure or offensive. In all of these ways, 'alternative' comics build directly on the precedent set by underground comix."[72]

Satisfying, but can it pay the rent?

MAKE MINE MALIBU

Marvel bought Malibu Comics in 1994, at the same time acquiring the rights to *Men in Black* by first-time writer Lowell Cunningham.

MIB would be turned into two highly successful movies starring Will Smith and Tommy Lee Jones, as well as an animated TV series. Malibu was founded by Scott Michael Rosenberg, an entrepreneur who now heads Platinum Studios, a company devoted to comics-to-film adaptations.[73]

STRIKING GOLD

The Golden Age was "a taut McCarthy-era conspiracy thriller" that revisited DC's 1940s costumed adventurers, "imbuing them with fragile personalities." James Robinson and Paul Smith helmed this effort. The four-issue limited series was considered to take place in Elseworlds, outside normal DC Universe continuity.[74]

FLASHBACK

One of the neat things about being publisher of Marvel was free comics! There was a bin a few steps from my office door where editors tossed comics that were cluttering up their files, the box being a virtual grab bag for anyone to take one (or more). I fished out a complete run of old Malibu titles like *Mantra* for my collection. Who said working at Marvel didn't have perquisites? A similar perk was bundles. Not only did staff get a weekly bundle containing every title Marvel released, we also had bundle exchanges with DC and others. So every day of the year was "Free Comic Book Day" to the publishing team!

MARVELS-OUS

In 1994, a four-issue limited series written by Kurt Busiek and painted by Alex Ross followed an Everyman in the form of a news photographer whose mundane life is constantly affronted by the larger-than-life exploits of Marvel's superheroes. Titled *Marvels,* the complete series was collected into a graphic novel the following year.

Winner of multiple awards, this brilliant effort was instrumental in launching the sizable careers of Busiek and Ross.[75]

> **INTERVIEWER**: What superpower would you pick if you could have one?

> **JIM MCCANN**: Assuming there were other super-powered people, I'd love to have Rogue's powers; that way I could "sample" other powers.

> **INTERVIEWER**: Ask John Dokes what superpower he'd choose.

> **JIM MCCANN**: I can't seem to find John anywhere! So I guess his power is invisibility![76]

DC'S MANY KINGDOMS

Drawing heavily on Biblical imagery and the Book of Revelation, Alex Ross and writer Mark Waid came up with *Kingdom Come* in 1994,

a four-issue limited series published by DC Comics. Set in the future, it described a conflict between aging superheroes (Superman, Wonder Woman, the Justice League) and vigilantes backed by Lex Luthor, while Batman and his "outsider" friends try to head off an apocalypse. Painted in acrylics and watercolors by Ross, it was highly acclaimed for its artwork as well as daring theme.[77]

Alex Ross had planned a prequel, but due to a falling out with Waid it was never produced. Waid, however, did his own version in 1999, a two-issue limited series crossover called *The Kingdom*. This was followed by several related one-shots that fell short of *Kingdom Come*'s success.[78]

All of the *Kingdom* books form an Elseworlds story arc, not part of regular DC continuity.[80]

SPEAKING UP!

"The Kingdom was a well-intended fiasco," admits Mark Waid, "but at least it gave us Hypertime . . . of which I'm particularly proud. As far as *Kingdom Come* goes, I'm thrilled that fans have embraced it so warmly over the years; it's hard to go wrong working with someone as talented as Alex Ross."[79]

MR. ROCK 'N' ROLL

Terry Stewart had been made president of Marvel back in 1990, having joined the company a year earlier on the strength of his comics knowledge and business acumen. He was a casual guy with receding reddish hair, an avid collector of old 45-rpm records, neon clocks, and jukeboxes.

"I was a lawyer, engineer, a banker, a very sordid background," chuckles Terry, now president of the Rock and Roll Hall of Fame. "But Perelman wanted a guy who had a business sense plus a feeling for the product. I have over 100,000 comics in my collection, 200,000 vinyl records."[81]

As noted, Terry was the man in charge when Todd McFarlane and six other high-profile artists walked—and expensive "superstar" contracts were becoming all the rage. "Guaranteed deals," as Terry describes them.[82] Speculators were buying anything with #1 on it. Newsstand was tanking, the Direct Market distributors were duking it out.

About then, Marvel's chairman Bill Bevins and Terry brought in a publishing veteran named Jerry Calabrese to consult on advertising. Next thing you knew, Terry had been bumped "upstairs" with the new title of vice chairman, and Jerry became president of Marvel Comic Group.

FLASHBACK

Terry Stewart sticks his head in my office and says, "Let's go get some sliders." "Sliders?" I reply. "You know, belly bombers," he says, referring to those tiny onion-laden burgers like you find at White Castle. He takes me to a greasy hole-in-the-wall café that requires a roadmap to find. "I'm celebrating," he says. "Just bought a Porsche Boxter." He knew that I had a classic 911 and would appreciate his new acquisition. Another toy for a man who has twenty-eight jukeboxes, numerous neon clocks, loads of Buster Brown memorabilia, and a giant Shoney's Big Boy statue in his collection.

LONG LIVE THE KING

Jerry Calabrese was a big-picture guy—a consummate dealmaker. He had revitalized Marvel's advertising and licensing business before taking his turn as president. A dark-eyed Italian-American, he'd had a rough-and-tumble career in the magazine industry before joining Ron Perelman's Marvel empire.

Looking back, he's proud of the progress he made. "We turned advertising and sponsorships from $3 million a year to $100 million by 1995."[83]

He thrived on solving problems and making hard decisions, barking his orders around the conference table. Afterward, he'd grin and say, "It's good to be king."

Jerry initiated *Heroes Reborn,* although he preferred to call it "Unfinished Business." "This was my attempt to rescue comics. I reached out to the guys at Image. It was shuttle diplomacy, me trying to regain their trust. They were mad at Terry, not me. But they were rightfully wary of Marvel executives."

Jerry chuckles, "You can think I'm a suit, although that's funny, given I've never worn one!"[84]

Marvel's then corporate vice president of human resources Rick Pogue described Jerry Calabrese this way: "He's the kind of guy who can fly into Chicago, look at the skyline, and say we need a building over there, then get on a plane and fly out. And he'd be right, but he needs people around him who know how to build a skyscraper." He nodded at me and said, "That's why we hired you."[85]

FLASHBACK

I first met Jerry Calabrese back in the late 1970s, when I was associate publisher of *Harper's* magazine and he'd been a young pup looking for a job in publishing. We kept in touch as he climbed up various corporate ladders, eventually owning *Games* magazine. I learned a very valuable lesson from Jerry: be casual at work, but keep a suit hanging behind your office door.

FLASHBACK

Jim Sokolowski—better known as "Ski"—was Marvel's VP of editorial planning. For some strange reason Jerry Calabrese is convinced that Ski and I already knew each other before I joined the company. We didn't. The misassumption seems to be based on the fact that Ski and I graduated from the same small college . . . about fifteen years apart.

MY BRIEF CLAIM TO FAME

Aside from being a comic book geek, I am a professional publisher. After all, I've spent forty years in the magazine and book industries, holding executive positions with such respected publishing entities as *Harper's, Ladies' Home Journal,* and *Redbook,* Scholastic, and Reader's Digest. And I have consulted for companies ranging from Time, Inc. to Microsoft.

That's why Jerry Calabrese recruited me. "The skill set needed to get the most out of Marvel Comics was resident in real publishing," he recently reemphasized. "The idea was to run the publishing business like a publishing company."

Heroes Reborn, Heroes Return, Flashback with its minus issues, those *Amalgam* crossovers with DC, the Thunderbolts/Masters of Evil switcheroo, *Battlebooks* with Billy Tucci, the *Strange Tales* line, *X-Men Manga*, new titles like *Spider-Girl* and revival of old titles like *Ka-Zar*—plus the *Marvel Knights* project with Joe Quesada and Jimmy Palmiotti—my team and I were determined to "publish our way out of it." Ignoring the chaos of ever-changing upper management, the continuing industry slump, the hold-up of movie deals by the bankruptcy judge, the nose-dive of sister companies Fleer and Skybox, the dip in advertising pages, and disappearance of licensing deals, we kept the comics coming. That almost-three-year period I was publisher of Marvel was like bailing water in a boat with the seacock open . . . but we kept it afloat against all odds.

Despite our ownership problems, Marvel Comics continued to dominate the industry with a 37 percent market share. And during my tenure we produced sixteen of the twenty top-selling comics on a monthly basis.

What's more, we moved the publishing division's bottom line back into the black!

But that wasn't the greatest accomplishment. The fact that we held the business together during those turbulent times (see the next chapter, on "The Comic Wars") was a very significant achievement. The collapse of Marvel might have pulled down the entire comic book industry.

FLASHBACK

"Hey," said Gerry Gladstone of Midtown Comics when I recently introduced myself to him, "you're part of comics history. You helped save the industry." Yeah, well . . .

REVOLVING DOORS

The transition from Terry Stewart to Jerry Calabrese had just been the warm-up act. After that, the changeovers in Marvel management came like the *rat-a-tat-tat* of machine-gun fire.

Calabrese didn't see Scott C. Marden coming, blindsided by Marden's side-door approach of heading up Marvel Interactive. "He's good," said my old pal, referring to his replacement's political instincts. The king had been toppled.

"It was an attempt to position Marvel as an Internet company," says Calabrese. "Perelman knew that the multiples on high-tech companies were double those on publishing-only companies."[86]

Scott Marden looked like a tall version of Marvel's owner Ron Perelman. He'd headed up a division at Phillips before coming to Marvel. But we knew he'd been a rock 'n' roll performer in his youth—and for an off-campus editorial meeting we dug up a song he'd recorded along with a photo of him when he still had hair. Writer Scott Lobdell

parodied David Letterman's Top Ten for the opening of the retreat, one of them being: "Don't worry if you haven't met the new president of Marvel. Just wait two weeks and there will be a new one." Marden took the joke in good style. A few weeks later there *was* a new president brought in to displace him.

Marden moved over to head up Marvel Enterprises, a business unit comprised of the company's trading card, sticker, online, and interactive software businesses . . .

THE LAST BOY SCOUT

. . . and in came David J. Schreff, a former president of marketing and media for the NBA. He'd been introduced to the Perelman camp by onetime Apple CEO John Scully. Schreff's compensation as Marvel's new president was "not less than $900,000," escalating up to $1 million over three years. (Hey, I'm not telling tales out of school: his contract was posted on the Internet.[87]) Rumor had it that Perelman and Bevins later argued over who had picked him for the role. One of those "I thought *you* wanted to hire him" conversations.[88]

A trim, bespectacled man with neatly combed hair, Schreff was described by his co-workers as a "Boy Scout." Many found him to be a very nice guy, but miscast as head of a wild-and-wooly comic book empire. He thought educational venues held great opportunity, an idea that sent shivers through the editorial department. They *knew* comics were somewhat "subversive," a harmless rebellion from parental authority and educational approvals.

SASSY SASSA

In late 1996, Jerry Calabrese foretold the hiring of Turner Network exec Scott Sassa as the next chairman and CEO. Bill Bevins was stepping down due to a serious heart problem (yes, apparently he had one!).

"What makes you think they'll hire Sassa?" I asked.

"Because he's available," replied Jerry, knowing Perelman's taste in execs.[89]

FLASHBACK

This was during the time a repetitive Brazilian rhyme called "The Macarena" dominated the hit parade. Word leaked out that David Schreff had been meeting with choreographers to invent "The Marvel Macarena," a dance with movements "like Spider-Man might perform." This became the joke of the editorial department, with sniggers coming from the bullpen and new gems of sarcasm plastered on Ralph Macchio's office door. Finally, Schreff called me to his office to ask if it was true, that his Macarena idea was turning him into a companywide laughing stock. I painfully admitted it was true. That was the last we heard of the Marvel Macarena.

FLASHBACK

We're in a limo—me, Marvel president David Schreff, and vice chairman Terry Stewart—going to visit a company we might want to do a distribution deal with. Schreff as usual looked corporate in his suit and tie, while Terry and I were dressed in black with colorful Marvel superhero neckties. Schreff asks how many black shirts we each owned (about two dozen apiece, it turned out), puzzled that two grown men might dress like characters out of a comic book. Later that year Marvel's *Men in Black* movie would gross $441 million worldwide.

Sassa came with a big rep: reputedly having started out washing Ted Turner's cars, he'd risen to the top, becoming president of Turner Entertainment Group and launching a number of cable networks, among them Turner Classic Movies and Cartoon Network—brilliant moves that allowed Ted Turner to take advantage of having acquired the MGM/UA movie library and the Hanna-Barbera cartoon archives.

"He was Perelman's attempt to position Marvel as a true entertainment company," says an insider. "A Disney play."[90]

Unlike politically correct Schreff, Sassa enjoyed peppering his no-nonsense conversations with expletives. Schreff was somewhat taken aback at having a new hands-on boss. The Marvel staff thought the tough little Asian American was cool—kind of like an *Enter the Dragon* drama with our very own street fighter.

SWIMMING WITH THE SQUID

One day Sassa was there in the center of the bullpen assuring the publishing staff that Perelman would prevail over the "Barbarians at the Gate," the next day he'd disappeared, never to be seen in the Marvel offices again. Takeover mogul Carl Icahn had assumed control of Marvel Entertainment and—on the strength of an unsolicited letter of application—hired a former Marvel exec named Joseph Calamari to be his new president.

Calamari couldn't wait to tell me about his plans to launch *two* new Universes, a feat that Jim Shooter had failed to make stick back in the 1980s. Marvel's entrenched editorial staff tended to resist any publishing plans that strayed from Stan Lee's "canon."

Thus, Calamari would fail to launch any new Universes—that success coming nearly ten years later under the auspices of Joe Quesada and Bill Jemas.

FLASHBACK

Everybody called Joe Calamari "the Squid" behind his back. Turns out, he not only knew about it, but liked the nickname. One day I walk into his corner office to find him huddled with one of our artists, designing a personal letterhead that pictured a writhing octopus-like creature with the words "The Squid" emblazoned underneath. "Joe," I say, "don't you know that a squid is a slimy bottom-feeder with no backbone?"

MARVEL BECOMES A BATTLEGROUND

The story of "How Two Tycoons Battled over the Marvel Comics Empire . . . and Both Lost!" has been told in Dan Raviv's book *Comic Wars*. Admittedly he only got half the story, the financial struggle that plunged Marvel Entertainment into bankruptcy. The internal power struggles and the valiant efforts by staff to keep comic books shipping remain largely untold.

QUESTIONS FOR FURTHER THOUGHT

1. What was so wrong with the speculator boom? Don't people speculate on stocks, oil wells, and antiques?

2. Discuss the morality of Batman. A noble knight? A psychotic vigilante? Should he be jailed or honored? How did Frank Miller's *The Dark Knight Returns* handle these moral issues?

3. Was "The Death of Superman" great storytelling? A brilliant marketing strategy? A bad idea all around? Dishonest in returning him from the dead? Argue your point of view.

4. Why do you think there was such a turnover of Marvel presidents under Ron Perelman's ownership? Why do you think there's been so little turnover of DC presidents under Time-Warner's ownership?

5. Is *Maus* great literature? A comic downer? A too-obvious allegory? A compelling memoir breaking new ground?

COMIC WARS

THE BATTLE OVER MARVEL

Well, I had both Marvel and DC comics as a kid, and I was aware of Stan Lee and his corny sense of humor—which I still love!—but until 2000 I never gave a thought to how those businesses were run. I'm glad now that I found out![1]
—Dan Raviv, author of *Comic Wars*

OKAY, this chapter isn't about comics—it's about dollars and sense. The battle for ownership of Marvel was never about superheroes and fans.

Ron Perelman doesn't read comics. Neither does Carl Icahn.[2] For that matter, neither did most of the presidents who paraded through the hallways of Marvel—from Jerry Calabrese to Scott Marden to David Schreff. Not even hip Scott Sassa. As for Joe Calamari, an obvious sufferer of ADD, there were arguments among the staff as to whether he could even read, comics or not.

Perelman would turn up at Marvel's offices once a year on Bring Your Daughter to Work Day to show young Samantha the empire that Daddy owned. Today, she probably gets to visit Revlon, his mega-successful cosmetics company.

For Perelman it was never about the comics; it was about the money. He'd made his billions by taking over companies and selling junk bonds.

PROFILE

Ronald Owen Perelman (born January 1, 1943) is a wealthy American investor and businessman who made his fortune buying beleaguered corporations and selling them later for an enormous profit. Despite his wishes to the contrary, Perelman has constantly found himself in the headlines because of his billion-dollar businesses and million-dollar divorces. His collection of businesses has included such household names as Revlon, Nephros, Technicolor, and Hummer, to name a few.[3] Today, he is 94th on *Forbes's* World's Richest People list, with an estimated wealth of $6.1 billion. He ranks 40th in the United States.[4]

He has been described as "America's richest short, bald . . . chain-cigar-chomper"[5] and a "pit-bull corporate raider."[6] In the Townhouse headquarters of his MacAndrews and Forbes holding company, he displays paintings by Roy Lichtenstein and Andy Warhol along with pillows stitched with mottos like "Love Me, Love My Cigar" and "Happiness Is a Positive Cash Flow."[7]

Riding high after his hostile takeover of the Revlon cosmetics firm, he decided to tackle the entertainment industry. After all, he had "a terrific eye for spotting undervalued companies, taking them over, giving them new management, and often breaking them up so that the pieces could be sold for an easy profit."[8] As was said about him, "That is what corporate raiders do for a living."[9]

"In 1989 Perelman . . . surprised the investment world by outbidding a number of rivals to buy Marvel."[10]

New World Entertainment was the seller. The Hollywood production company had squeezed television programming out of the Incredible Hulk and other Marvel characters and was now ready to move on. "So Marvel was on the auction block, and when Perelman saw that half a dozen companies were making bids he hardly needed to check his credit line. He simply outbid the others at $82.5 million."[11]

As one observer commented, "Meet Dr. Doom!"[12]

FLASHBACK

Back in 1988 I'm sitting at the Marvel conference table with the Warburg Pincus investment banking group. We're there to buy Marvel, our offer of $75 million on the table. But we've just been told we'll have limited access to the due diligence information, only one day to examine the documents. "It's all in a room, the financial history, the records," says their representative. "Anything else you want to see, you can ask but we don't guarantee we'll show it to you." We look around at each other, then stand up en masse and walk away from the deal, the money people grumbling, "For $75 million we expect to see more than that!" A dumb decision, as it turned out.

MARVEL'S NEW OWNER

Perelman had created Andrews Group, Inc., from the corporate shell of the former Compact Video, so he used this private holding company to purchase Marvel Entertainment Group in January 1989.[13] A master of OPM, Perelman put up only $10.5 million from his own pocket, the

balance provided by a syndicate of banks led by Chase Manhattan. No big deal for the financial institutions; this was chump change compared to the billions that Perelman represented to them in other business dealings.[14]

Perelman described his new purchase as "a mini-Disney in terms of intellectual property."[15] And the ensuing boom in comic book sales allowed him to repay the loan out of cash flow in a few short years.

Was Perelman smart like a fox? You bet, but he was also lucky. He'd bought the comics company just as speculators began investing in comic books. The *Batman* movie made comics hot. "The Death of Superman" sold more than 6 million copies. Fans were buying multiple copies to sock them away for their "future value."

"Marvel was a pawn in a much larger game that was being played by big boys with big toys and big egos," observes J. R. Fettinger, who maintains a website devoted to Marvel Comics. "Neither the product nor the customer were even as remotely important as the game itself. Financier and corporate raider Ron Perelman . . . used the company to generate short-term cash in order to inflate its value so he could take it public, which explained some of the increases in both (cover) prices and the number of titles. But his other use of the company, leveraging (i.e., borrowing money) to the hilt, nearly destroyed it. For one, none of the borrowings actually went to improve the quality of the product. Rather, the money went into two places: (1) buying more companies and (2) his own pocket."[16]

In July 1991 Marvel sold stock to the public for the first time, the IPO providing $40 million cash to Perelman while he retained 60 percent of the shares.[17] The stock offering was underwritten by Merrill Lynch and First Boston Corporation.[18]

Following the rapid rise of this immediately popular stock, Perelman issued a series of junk bonds that he might use to acquire other entertainment companies. Many of these bond offerings were purchased by Carl Icahn Partners.[19]

FLASHBACK

Perelman's chairman at the time is William C. Bevins, Jr., a former Turner Broadcasting exec from Atlanta. Not fully trusting "those crazy comic book guys," Bevins sends a couple of his cronies down to the Marvel offices to play watchdog—brash Joe King and good ol' boy Bobby Jenkins. King is known for his huge expense accounts that itemized limos and lap dances. Bobby is smooth as magnolias, but sharp with numbers. Former president Jerry Calabrese described them as "an ensemble cast of scholarship players." Joe settled into the office next to Jerry's to help make deals and do acquisitions. "Let's go buy something," he says to me with a wide grin.

During this expansion binge, Marvel spent more than $700 million— again borrowed from a bank syndicate led by Chase Manhattan—to acquire the Fleer Corporation and SkyBox International (two trading card companies), the Panini Group (an Italian sticker maker), Welsh Publishing (a producer of kids' magazines based on licensed characters), Malibu Comics (a small comic book competitor), and Heroes World (a distribution company).[20]

TOYING AROUND

Perelman also cut an unusual deal with Isaac "Ike" Perlmutter and Avi Arad, two Israeli immigrants who ran a small company called Toy Biz. In 1990 Toy Biz exchanged equity for an "exclusive, perpetual, royalty-free license" to make toys based on Marvel's characters.[21] "A Master License," as former Marvel vice chairman Terry Stewart describes it.[22]

What did Marvel get in return? "Control," says Stewart. Although Marvel owned only 27 percent of Toy Biz's stock, the shares carried super-voting rights equivalent to 78 percent.[23]

Funding Universe explained it this way: "This strategic alliance was mutually beneficial. For Toy Biz, it eliminated royalties that would otherwise have cost the company anywhere from 6 to 12 percent of its sales of Marvel character toys. Marvel's top-ranked comic books and animated television shows amounted to free advertising for the action figures and other playthings marketed by Toy Biz. Harry De Mott II, an analyst with CS First Boston, told *Forbes*' Suzanne Oliver that 'The cartoons are like a half-hour infomercial for Toy Biz products.' And Marvel's stake in Toy Biz gave it much higher returns than it would have made from mere royalties."[24]

Perelman was indeed a "Wizard"[25] at selling these grandiose expansion plans to Wall Street. Marvel stock (MRV) jumped to $34, seventeen times its initial price, ballooning the company's market value to over $3 billion.[26]

"Using the sky-high shares as collateral, Perelman forms holding companies to sell Marvel 'high yield notes' (junk bonds) in three tranches. He personally nets over $500 million. When the bonds come due in five years, he can repay the investors or—if MRV stock collapses—he can just hand over the shares and walk away."[27] Meanwhile, Marvel's bank debt rose to more than $600 million.[28]

"Unfortunately, his luck was not to last. Marvel's attempt to distribute its products directly through Heroes World led to a decrease in sales and aggravated the losses Marvel suffered when the comic book bubble popped and the 1994 Major League Baseball strike massacred the profits of both the Fleer and Panini divisions."[29]

J'ACCUSE!

"I believe that Ronald O. Perelman caused more harm to the comics industry than anyone in history, including Fredric Wertham," asserts comics retailer Chuck Rozanski. "When he took over ownership of Marvel Comics in 1989, Marvel was coming off of a series of record

years of both sales and earnings. . . . Sadly, Perelman severely aggravated this problem by raising prices by another 100% over the next seven years. . . . Had Ronald O. Perelman not been the owner of Marvel at this time, then perhaps the damage of the implosion of 1993 could have been mitigated. Instead of acknowledging that their price increases and title inflation were a significant part of the problem, however, Marvel's management chose to believe that their ills were being caused by a lack of proper marketing of Marvel products by the Direct Market distributors. This led them to make the incredibly stupid decision to buy one of the smaller Direct Market Distributors (Heroes World) and start distributing their comics on their own."[30]

These events shook the entire comics industry. "It is, in fact, the sheer scale of the numbers involved which has, at times, made the Marvel story seem remote, a battle of financial giants whose interest in the comics medium is strictly a sporting one," notes *Comic Buyer's Guide*. Marvel's debt was at that time "more than the entire comics industry's sales in 1997 combined."[31]

PERELMAN'S NEMESIS

Meanwhile, corporate raider Carl Icahn had been investing heavily into Marvel's bonds, one of his standard takeover methods. Even wealthier than Perelman, he made a worthy opponent. According to *Forbes*, Icahn's current worth is $13 billion, ranking him forty-second among the World's Richest People—more than twice as rich as Perelman. He's the twenty-fourth richest man in America, again well ahead of Perelman.[32]

Because Marvel's expansions were so expensive, it was hard for the company to keep up with its debt repayments to the banks. But fortunately the comics industry was booming.

Then the unthinkable happened: the comic book market collapsed. In milking the "collectors' craze," publishers had flooded the market with schlocky product—too many #1's, too many variant covers, too many copies. Supply-and-demand theory at work, the collectors learned that Modern Age comics were only worth the price on the cover—or less. It was those rare Golden Age and Silver Age comics that carried the high price tags. They came to realize they weren't going to put their kids through college on all those *X-O Manowar* #1 comics they had been buying up.

To make matters worse: the Major League Baseball strike in 1994 shattered the enthusiasm of fans, causing baseball card sales to plummet. Basketball cards weren't selling well either, and Marvel had agreed

to pay the NBA a high royalty fee unrelated to sales levels.[33] All of a sudden Fleer and SkyBox were losing $700,000 a week.

As a result, "Marvel went into a nosedive, and the following year it lost $464.4 million."[34]

Perelman offered to rescue the company by infusing it with $350 million, but there's no such thing as a free lunch. In return he wanted bondholders to dilute their shares by 80 percent. However, Carl Icahn had acquired a 25 percent stake by buying up bonds at 20 cents on the dollar. That afforded him some say-so. And he refused to be diluted by Perelman's self-serving money-raising scheme.[35]

WAR IS DECLARED

Thus began the turbulent period known as the **"Comic Wars"** (so dubbed by Dan Raviv in the title of his book about this battle for control of Marvel.) Raviv describes it as being "as ferocious and outlandish as any of Marvel's tales of good vs. evil."[36]

Perelman admittedly is not a sympathetic character. "Mega-investor Ron Perelman has all the traits of a comic book supervillain," observes D. Smithee, a self-professed fan of comic books. "He is massively wealthy and powerful. More to the point, he exudes enough vanity and overreach to make Lex Luthor and Dr. Doom seem like a couple of Girl Scouts. So it's not surprising to see Perelman slugging it out with rival billionaire corporate raider Carl Icahn."[37]

At first Icahn looked like a White Knight but soon "revealed his true colors in attempting to buy the company on the cheap by buying the distressed bank debt, bankrupting the company and wiping out the debt, converting his bonds to a controlling interest and selling the post-bankruptcy Marvel for a tidy profit."[39] He was proud of his fabled takeover of TransWorld Airlines. His office displays numerous commemorative photographs of DC-3's and 747's on its walls. He has been called one of "Wall Street's most successful predators."[40]

"'A large number of companies in this country are badly run," Carl Icahn has said. "Terribly run. That's one of the reasons I'm successful."[41]

PROFILE

"Carl Icahn, raised in Queens, New York City, earned a reputation as a corporate raider after his hostile takeover of TWA in 1985," notes The Stock Idea Network. "He was educated at Princeton University (A.B., Philosophy, 1957) and New York University School of Medicine, where he dropped out before graduation. Carl Icahn, like many others in the 1980s, made his billionaire fortune in large part because of financier Michael Milken's junk bonds."[38]

FIGHTING BACK

Ron Perelman wasn't going to be bullied by Icahn. Calling his bluff, Perelman had Marvel file for chapter 11 protection in U.S. Bankruptcy Court in Wilmington, Delaware.[42]

No one at the operating level saw the bankruptcy coming. Sure, Marvel had missed a couple of bank covenants, but that sort of thing is usually worked out with the bank. "We had no idea until that December meeting at Chase Manhattan where Howard Gittis made the announcement that he was throwing the company into Chapter 11," recalls Paul Crecca, who was Marvel's CFO and general manager at the time.[43] Gittis was Perelman's chief deputy, a Townhouse insider who helped devise MacAndrews and Forbes's financial strategies.

The news release was short and not so sweet. It sent ripples of fear throughout the comics industry— sort of a "Say it ain't so, Joe" reaction. Did this mean Marvel was going out of business? No, it was merely a way of forcing Carl Icahn and other bondholders to go along with the plan.

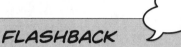

FLASHBACK

We Marvel execs are advised about the bankruptcy filing and told to be in the office a few days after Christmas to field any calls from vendors or licensees when the news hits. I am scheduled to go on vacation to St. Croix, my family and a group of friends having planned the rendezvous for months, nonrefundable deposits put down, airline tickets booked. When I remind then-president David Schreff of these plans, he offers to reimburse me for all costs if I stay behind. A good soldier, I agree and cancel my vacation. Marvel has to cough up close to $7,000. And how many phone calls do I get from outside vendors when the announcement is made? Not a one!

NEW YORK, N. Y., December 27, 1996—Marvel Entertainment Group, Inc. (NYSE: MRV) today announced that, in order to implement a proposed $525 million recapitalization that will enable Marvel to pursue its new strategic initiatives and achieve sustained profitability, Marvel has filed a voluntary petition for reorganization in the U.S. Bankruptcy Court for the District of Delaware in Wilmington. The filing will ensure that Marvel can continue all business operations without interruption while it obtains necessary approvals of its financial restructuring plan. The filing was necessitated by the failure of the holders of bonds issued by Marvel's holding companies to reach agreement regarding any alternative plans for the Company's future.[44]

"Under Marvel's Chapter 11 proposed plan of reorganization submitted to the Court, Andrews Group Incorporated, which is controlled by Ronald O. Perelman, will invest $365 million in new equity in Marvel which will be used to make Toy Biz, Inc. a wholly-owned subsidiary. In turn, Marvel's lender group has agreed to provide a total of $160 mil-

lion to finance Marvel's new strategic investment program and working capital requirements."[45]

"We would have preferred to re-capitalize Marvel without having to seek the aid of the court," said Scott Sassa, chairman and CEO of Marvel, "but the actions and positions taken by the bondholders prevented that approach."[46]

Carl Icahn was quick to respond: "We find it unconscionable that the Andrews Group Inc., which controls Marvel (NYSE: MRV), should attempt to use the bankruptcy process to wipe out its shareholders and its public bondholders from whom it borrowed over $800 million in good faith only a few years ago. We find it especially reprehensible that Marvel has adopted this course, and completely ignored a far more equitable alternative that had been presented and remains available."[47]

"We are taking steps that are not typical in this situation," responded Sassa. Standing firm.[48]

Should vendors worry? No, insisted Sassa. "We intend to pay all of our bills, including those submitted prior to the filing, on time and in full, and maintain normal credit terms with our suppliers and licensors."[49]

Did this mean there would be no more comics? Marvel's president David Schreff weighed in with this assurance: "There will be absolutely no interruption of our publishing schedule or our development plans for TV and feature film, interactive products and services, licenses and sponsor partnerships, themed restaurants and theme park attractions. *X-Men* and *Spider-Man* on the Fox Kid's Network continue to be top rated animated series on television."[50]

Comics Buyer's Guide put it like this: "Indeed, the people working at 387 Park Ave. South continued to release a full slate of comic books in 1997, although with some difficulty and ever-mindful of the ownership tribulations. Shirrel Rhoades, executive vice president of publishing, put his best spin on it: 'The good news is that people are fighting over who gets to put money into Marvel and grow Marvel, and make it a much stronger business. It's like a custody fight where both parents love the child and want to nurture it.'"[51]

Nevertheless, my publishing staff—some eighty people—was nervous. Would they get their next paycheck? Scott Sassa made an appearance in the bullpen and read his news release to us: "We expect to continue doing business with our customers and licensees under normal business terms. We will fund and move forward with all of our new strategic investments, and employees will be paid in full and on time."[52]

FOOTNOTE

An old publishing mentor once told me that everyone thinks the law of the jungle is "Survival of the Fittest," but that's wrong—it's really "Don't Scare the Animals." He was really talking about managing your staff during a tough situation.

"Easy for him to say," muttered one of the bullpen artists. "He's got a fat contract with a severance clause."

Nonetheless, Marvel's staffers liked the brash style of the hip young exec. They *wanted* to believe him. And he made victory sound like a sure thing: that he and Perelman "had it under control." The bankruptcy was just a "poison pill" to stave off those barbarians at the gate, he assured us.

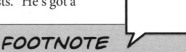

FOOTNOTE

Shortly after the bankruptcy announcement, an ill-timed squib in a local newspaper reported that Perelman's AGI Corporation was purchasing a $10 million townhouse in New York City for Marvel CEO Scott Sassa. Plus Sassa's contract provided him with a $2 million "base salary" along with $1 million in annual bonuses.[53]

WHO'S ON FIRST?

Despite the pep talks by Sassa, rumors were rampant: Speculation that Perelman was not going to refinance Marvel, leaving it unable to meet its obligations. Or that Icahn was going to demand that Perelman cash out his bonds, draining the company's coffers. Or that hoards of buyers were poised to take over the embattled comic book company. Or that Fleer and Skybox were going to collapse, taking Marvel down with them. Or . . .

What was really going on? Sassa wasn't talking, aside from his canned public statements. Schreff didn't seem to be plugged in. Terry Stewart looked worried. Perelman's minions—guys like Joe King and Bobby Jenkins—were strangely absent.

However, information was trickling in from all sides. One of my VPs was getting the scoop from an outside headhunting firm. A senior member of my editorial staff started receiving clandestine phone calls from former Marvel exec Joseph Calamari, hinting that changes were imminent. A steady stream of info was flowing from the Townhouse via the lawyers and financial staff. Everybody seemed to have his own Deep Throat.

The situation wasn't good. Licensing and advertising had dried up. The trading card companies were a cash drain. Publishing was still making money, but I wondered how long I could support the entire enterprise.

"Should I be working on my resume?" Ski asked me.

"No," I lied.

We had to keep pumping out the comics every week. Without that, the company would be dead in the water.

FLASHBACK

Marvel is in bankruptcy, but excesses abound. Prior to a business trip, one of Perelman's financial types is heard yelling down the hall to his secretary, "Hey, Laurie, is my helicopter ready? And I want a limousine waiting to pick me up. It better not be a Lincoln, it better be a Mercedes. You got that, a (blank)ing Mercedes!"[54]

GOTCHA!

Bankruptcy—it was a clever move, Perelman thought. Little knowing that he'd walked into a trap: the bondholders, led by Icahn, claimed

this bankruptcy as a default—for Marvel's stock had been pledged as collateral for the bonds—and in a stunning court decision Perelman was forced to give up the company.

MARVEL BONDHOLDERS REPLACE BOARDS OF DIRECTORS OF BOTH MARVEL ENTERTAINMENT AND TOY BIZ

NEW YORK, N.Y., June 20, 1997—The Board of Directors of Marvel Holdings, Inc., which was previously elected by the Marvel Bondholders' Committee, announced today that it has voted its majority of Marvel Entertainment Group, Inc.'s (NYSE:MRV) equity to elect a new Board of Directors for Marvel Entertainment. The new Marvel Board consists of nine members, seven selected by the Marvel Bondholders Committee and two selected by Marvel's Equity Security Holders (the "Equity Committee").

The new Marvel Entertainment Board has named Joseph Calamari, former Executive Vice President and owner of Marvel Entertainment, as interim President of Marvel Entertainment. Calamari will head a transition team that will begin immediately to address Marvel's problems and work to restore the Company to profitability.[55]

"This is a great day for Marvel Entertainment and those of us who want to help this once-great company emerge from Chapter 11 and make the most of its superb characters and still-strong franchise for the benefit of Marvel's owners, customers and employees," said Carl Icahn, who had been elected chairman of the board of Marvel Entertainment. "It has been a long, complex battle, but the bondholders have now been vindicated. The new Board is committed to restoring Marvel to financial and operational health and Joseph Calamari's experience and knowledge of Marvel's businesses will help us get the company back on track and position it to pursue a growth strategy."[56]

Joe Calamari had been hired based solely on a letter he'd written to Icahn "offering to help." (Joe showed me the letter.) Icahn told me that Joe's experience as a former Marvel exec would "reassure the banks." But in truth the bankers complained that Icahn had presented no "concrete

FLASHBACK

So here I am, sitting next to Carl Icahn, an intimate little tête à tête, just me and him—and some 150 of his closest confidants—at a conference table that's about a mile long. People are standing along the walls and in front of the windows in his high-rise office, trying hard to pretend they're not listening as I explain to him how the comic book business works. Ol' Carl is spending more time glancing at the pretty blonde by the window than listening to me. A future wife, I was told. Oh well, I thought, it's his money.

turnaround strategy . . . or a management team capable of executing one."[57]

EXIT STAGE LEFT

Throwing in the towel, Perelman walked away with his profits. Based on thousands of pages of court filings and other documents, Dan Raviv concluded that—thanks to cleverly timed sales of junk bonds—Perelman netted a profit of $280 million from his eight years of running Marvel.[58]

Other opinions differ as to Perelman's booty. Comics retailer Chuck Rozanski estimates that Perelman made off with $200 to $400 million, while *Forbes* thinks he made nothing.[59] Bets are on Rozanki's version.

TOYS R THEM

Toy Biz was in total panic. Ike Perlmutter and his partner Avi Arad knew that under bankruptcy law a new owner could cancel the unlimited license for Toy Biz to make Marvel toys without paying fees. Over half their toy line consisted of Marvel action figures, webslinger devices, comics-based games, and superhero gizmos.

"The fight over Marvel became a battle of egos between Perelman and Carl Icahn, with Toy Biz wading in to protect their no-royalty license with Marvel. . . . From billionaires Perelman and Icahn, to multimillionaires Avi Arad (creative director at Toy Biz) and Ike Perlmutter (the largest shareholder at Toy Biz), there are colorful personalities that often clash."[60]

"No one is tougher than Carl Icahn," notes Raviv. "Ike Perlmutter and Avi Arad try hard to get along with him, but decide they can't. The battle is long and multi-sided, featuring huge egos and all-night arguments." Icahn was confident that "the roughshod tactics he used at TWA, U.S. Steel, Texaco, and Nabisco would work at Marvel."[61]

WRESTLING WITH A SQUID

The relationship between Joe Calamari and Icahn's camp grew contentious. The new owners found it difficult to control the headstrong president they had put in place. Calamari wanted to make movies—now! Nobody uptown wanted to spend the money while bankruptcy was being negotiated. The telephone conversations between the Marvel offices and Icahn's headquarters were filled with expletives.

The conference calls between the factions were often long and profane. I sat in on many of these conference calls, listening to the telephonic shouting matches. A censored version would have sounded something like this:

ICAHN'S PEOPLE: No, Joe, you (beep)ing (beep). We (beep)ing told you not to (beep) with that (beep).

CALAMARI: I'll (beep)ing do what the (beep) needs to be done. And you (beep) (beep)s don't know (beep).

ICAHN'S PEOPLE: (Beep) you, Joe. You work for us and you'll (beep)ing do what the (beep) we tell you.

CALAMARI: (Beep) (beep) (beep)ing (beep)!

"On the other hand, from another perspective, all of this detail makes you realize what a living hell it must have been to have worked for Marvel Comics during this time period," observes *Spider-Man* chronicler J. R. Fettinger. "How anyone even remotely focused on their jobs when rich, overpaid stuffshirts and corporate raiders who cared NOTHING about the comics, or the people whose livelihood depended on them, who underneath their pretense of sophistication and wealth, often behaved like spoiled, selfish children whose dialogue with each other actually sank to the point of repeated 'F**k you!' 'F**k you too!' . . . is amazing."[62]

Joe Calamari and his CFO Augie Liguori were under the delusion they could convince the bankruptcy court to turn Marvel over to them. They felt the bankruptcy judge should favor them because as hands-on managers they offered a better shot at turning the company around. Icahn smelled a rat. Calamari began seeking support among Marvel's senior staff. Bob Harras was polite but cautious in his responses. I was skeptical. Some of the guys in advertising and licensing laughed at the idea.

"With the legitimacy of everyone's control at issue, with restructuring plans coming from every direction, and with a bankruptcy court judge opting to retire before spending any more time in this morass," it was a mess. Judge Helen Blalock of the U.S. Bankruptcy Court, District of Delaware, stepped down and Federal District Judge Roderick McKelvie took over the reins. But everyone—lawyers representing Icahn, the lenders, Toy Biz, and even Perelman (though no longer a party to the negotiations)—continued to do battle.[63]

"By December 1997, the Marvel case was transferred out of federal bankruptcy court in Delaware to U.S. District Court. Judge McKelvie felt

the future direction of Marvel would be best determined by a trustee."[64] After all, Icahn wasn't making progress in satisfying the creditors. In a surprise move, McKelvie appointed a federal trustee named John J. Gibbons, Esq., to replace Icahn.[65]

Suddenly Joe Calamari was left in charge of day-to-day operations, reporting to a court-appointed magistrate who knew very little about publishing comic books.

TOY BIZ ENTERS THE FRAY

The new Marvel management asserted that "Toy Biz improperly obtained its worldwide, exclusive, perpetual, royalty-free license to manufacture and sell a wide variety of toys based on Marvel's characters from Marvel's former management." [66]

Joe Calamari announced, "These contracts make no business sense. We would be obligated to pay out moneys—that we are otherwise in short supply of—to production companies while Toy Biz can continue to sell toys royalty-free. Management is currently in the process of reviewing each of these contracts in an effort to reduce the costs that Marvel must incur."[67]

To make the point, Calamari fired Avi Arad as head of Marvel Studios.[68]

Uh-oh. Dependent on Marvel's comic characters, Perlmutter and Arad realized that Toy Biz's fate was at risk. As one observer put it, "The prospect of losing their license caused them to become passionate about purchasing Marvel. Perlmutter arranged his own financing group, and ultimately bid over $400 million for Marvel."[69]

Thus, Toy Biz won "approval from U.S. District Judge Roderick McKelvie for its plan to reorganize Marvel Entertainment Group Inc., clearing the way for Marvel to emerge from bankruptcy protection."[70]

"Judge McKelvie rejected objections by investor Carl Icahn and unsecured creditors, who had argued that the settlement would result in losses. Under the plan, Marvel would merge with Toy Biz Inc., and secured lenders would receive a portion of equity in the new company and be paid 70 cents on the dollar for their $617 million of Marvel-related claims. In addition, equity holders would receive 12 million warrants, exercisable in several ways."[71] The takeover was completed in October 1997.[72]

Both Perelman and Icahn lost this war. The winners were Ike Perlmutter and Avi Arad, little guys besting two of the most ruthless financial tycoons in the United States—a classic David and Goliath story!

POCKET CHANGE

A follow-up article in the *New York Times* focused on the "events that led to bankruptcy of company and delisting of Marvel on New York Stock Exchange . . ." The article went on to say that "fighting between financiers Ronald O. Perelman and Carl C. Icahn for control of company has left behind little of lasting value for investors, employees or comic book fans to show for their time in control of company." It concluded that "their original stakes in Marvel—about $10 million for Perelman, about $40 million for Icahn—represented pocket change to these billionaires."[73]

FLASHBACK

Because Wildstorm was technically a creditor (Marvel owed them moneys related to *Heroes Reborn*), John Nee received bankruptcy papers listing the executives who were being cut back. My name is on the list. Apparently, I made too much money for the penurious new owners-to-be. John tweaks me to the impending doomsday, so as the takeover gets under way I go on vacation to Scotland. Only Ski knows where to find me, but he promises not to tell. I'm following the mantra of an old friend who said, "If they can't find you, they can't fire you." I phone in every now and again to get Ski's report: "They came down to the editorial floor looking for you again today." And so I keep on touring Loch Ness (never did see the monster, dammit!). When I return, all the other execs have been fired. When they finally get to me, I've gained two extra weeks' pay. And had a nice holiday to boot!

BYE BYE, AMERICAN PIE

As Perlmutter's team took over, there came the expected housecleaning—largely based on high salaries. Jerry Calabrese—my buddy who had recruited me—was brought back to do the dirty work. Execs were falling like flies.

"I think it's safe to assume that you've all probably heard about the recent layoffs at Marvel," wrote Ian Johnson in his *The Final Word* column. "Two of Marvel's top executives, Shirrel Rhoades and Joseph Calamari, have been fired along with a host of editors. These moves may or may not have been necessary, but they definitely hurt Marvel in the long term."[74]

"A lot of good people lost their jobs in the battle itself," complained a Marvel stockholder.[76]

HERE TODAY, GONE TOMORROW

In early November, Jerry Calabrese abruptly resigned as the president of Marvel. He explained, "After only a little less than two months, it's clear to me that it would be impossible for me to make the kind of positive impact and difference I believed possible when I accepted the task."

As *CBEM* saw it, "Given his previous tolerance of difficult situations (and owners) under the Perelman regime, this is quite a statement."[77]

Calabrese was replaced by Eric Ellenbogan, former head of Golden Books and a member of Marvel's board of directors.

FOOTNOTE

"The sacking of president Joseph Calamari is more than it seems," reported Rich Johnson in his *Ramblings 98* column. "Avi Arad, best known for his work for Marvel animation, had been acrimoniously sacked by Joseph in the past. Avi moved to Toy Biz where he is now part of the ruling Marvel class. So guess why Joseph was one of the first to go? Revenge is best served cold at Marvel."[75]

AFTERMATH

"In 1998, after years of mismanagement by financier Ronald Perelman had left the company bankrupt, toy executive Isaac Perlmutter bought Marvel and put Arad in charge of getting Hollywood to base blockbuster films on its characters," reported the news network CNN. "The results speak for themselves: Under Arad, the first seven Marvel-based films—from the low-budget vampire-hunting epic *Blade* to the first Spider-Man and X-Men movies—each hit No. 1 at the box office. All told, the 12 Marvel-character films made during Arad's tenure have grossed $3.6 billion worldwide."[78]

AVI'S VISION

Avi Arad's belief in Marvel was a key factor in Perlmutter's decision to buy the company. "In late 1997, Arad had given an impassioned presentation to a group of about 40 bankers and lawyers that is widely seen as having swung support to the Perlmutter bid over a competing offer from Icahn."[79] Avi convinced them of the value of Marvel's characters as movie properties!

As Reasonline's Jeremy Lott analyzes it, " . . . Perelman is a remarkably unperceptive man who never understood exactly what he was buying or what to do with it. Yet Perelman's comparison of Marvel to Disney has turned out to be more apt than he knew. Though a nearly unparalleled entertainment powerhouse today, Disney went through years so lean in the '70s and '80s that its imminent demise was taken for granted. It was only with the massive success of *The Little Mermaid* (1989) that Disney rejuvenated its film division and fully reversed its long-slumping fortunes . . .

"That's a lesson that the new owners of Marvel, Ike Perlmutter and Avi Arad, seem to have learned. While its comic book sales continue to putter along, Marvel has scored critical and commercial successes with films . . ."[80]

"Had Perelman remained in charge of Marvel, we would never have seen *Spider-Man,* the movie with a $700 million to date box office gross," asserts D. Smithee. "Perelman was only interested in generating hype about a movie and cashing in on that."[81]

TURNING POINT

"1999 was a milestone year in which Marvel was freed from Chapter 11," points out a forty-five-page study titled *Marvel Comics Turnaround.* "Management continued to streamline its capital structure, sell non-core assets, and improve operations of the core business. But more

importantly, 1999 was the first time that the company began slowly shifting its focus away from addressing bankruptcy issues to building the company for the future."[82]

‹MILESTONE #11: MARVEL EMERGES FROM BANKRUPTCY AND THE INDUSTRY REBOUNDS.›

So, is the new Marvel succeeding? "It looks that way," says Dan Raviv. "It doesn't own the baseball card or sticker companies anymore, and a pretty conservative management—hand-picked by silent and publicity-shy Ike Perlmutter—vows to decrease debt, rather than borrow and expand as Ron Perelman used to do. The stock, MVL, has quintupled . . . as the fear of another bankruptcy fades."[83]

"From a purely financial standpoint, the turnaround was a runaway success," concludes one study. "Nevertheless, Marvel still has problems of the kind mentioned earlier in the paper looming on the horizon, such as industry cyclicality, future decreasing returns from the licensing model, and potential problems with international expansion."[84]

USA Today adds, "But even superheroes have weaknesses. . . . [There is] a danger of a few superflops, which would cool Hollywood off in a hurry. And there's always a danger of moviegoers getting tired of superheroes."[85]

"Either way, it is clear that Marvel's reinvention is what will keep it relevant into the 21st century. What an interesting turn of events for a company founded to produce cartoon books for Depression-era children."[86]

WHO ARE THESE "NEW" GUYS?

These days Ike Perlmutter is a Florida-based investor who prefers to stay behind the scenes, but is constantly on the phone concerning himself with every detail of Marvel's operations.[87] He is known for his thrifty nature. Stories abound about his complaining because people Xerox on only one side of the paper or expect free coffee in the workplace.

Perlmutter's partner Avi Arad was a successful toy designer when they met during a haggle over royalties. They have been called "the ultimate Odd Couple."[89] The diminutive Ike always in suit and tie, Avi constantly garbed in black, most comfortable while riding his motorcycle. Ike a notorious cheapskate, Avi flashy. Ike thrives on creative financing, Avi's bored by numbers. Ike doesn't know much about the Marvel characters, Avi's a fanboy at heart. Both were veterans of Israel's Six Day War in 1967

PROFILE

Isaac Perlmutter, a businessman who made his money in discount or "dollar-store" merchandising, and who bought collapsed companies like Remington, found himself owning the near-collapsed Toy Biz—a toymaker with the license to make Marvel Comics character action figures.[88]

and came to the United States three decades ago with little but their big dreams. Some say the similarities end there.[90]

HEROES AND VILLAINS

Who were the heroes and who were the villains in the Comic Wars? "Dan Raviv's book takes a clear position," notes a reviewer on Amazon.com, "borrowing from comic books a habit of making his characters larger than life and designating them good guys or bad guys. The good guy in Raviv's version of this true story is Isaac 'Ike' Perlmutter, and we know we are supposed to identify best with him because, unlike the other major parties, Raviv always refers to Ike by his first name. Meanwhile, Perelman and Icahn are referred to by their last names, except in chapter titles, which refer to them by the names of Marvel Comics villains Dr. Doom and The Vulture. The good guy versus bad guy idea makes this a simple book to read, and that makes the business education go down more easily, but it undoubtedly grossly oversimplifies the true situation."[92]

PROFILE

Avi Arad is an Israeli-American toy designer who became the CEO of Toy Biz in the 1990s. When that company took over Marvel, he was instrumental in getting the comic book publisher out of bankruptcy and expanding its profile through licensing deals and movies. On May 31, 2006, Arad resigned his many Marvel positions (including head of Marvel Studios) to form his own production company, Avi Arad Productions.[91]

"Right away the author places businessman Ike Perlmutter and toy designer Avi Arad . . . as heroes, giant killers, inspirational figures, when in most cases they were simply acting in their own enlightened self-interest," adds Marvel-watcher J. R. Fettinger.[93]

"Late in the book we see that good old Ike, who's worth half a billion dollars, won't spring twelve hundred bucks for an office Christmas party to improve Marvel's wounded morale," says the Amazon reviewer. " . . . he's no superhero, and I imagine Perelman and Icahn aren't quite supervillains, either."[94]

Another reviewer notes that: "Dan Raviv's retelling of the Marvel Entertainment bankruptcy is one of the most riveting business books to come through the book publishers in a long time. . . . I never knew how close to the brink they came to non-existence."[95]

Still another has this praise, "Taking topics such as Zero Yield Bonds, Distressed Debt & Corporate Bankruptcies that would confuse most readers or put them to sleep Raviv does the unthinkable. He writes the most entertaining business book I have ever read."[96]

However, one former president of Marvel describes the book as "a self-serving piece of crap."[97] Another ex-president scoffs at it, noting that his name appears only once in the entire treatise.[98] And still another one-time exec says, "It told the story from 30,000 feet. Maybe it documented the financial tug-of-war between Perelman and Icahn, but it told nothing of the staff's struggle to keep the business going."[99]

"What this book does not cover is the stories of the people who had been with Marvel for over thirty years and had lost their jobs during the bankruptcy process," says an irate Marvel stockholder. "They were writers, artists, and editors who were told one day to clean out their desks and that was it. They have never worked again at Marvel or at any other company, and their loss was also a loss for comics in general. They were among the losses that Marvel went through as Avi Arad and his partners both at Toy Biz and in Hollywood saved the company."[100]

"Although Arad seems to clearly and genuinely love the characters, Perlmutter can barely name any of them, never read a comic book, and knows next to nothing about cultivating the creative spirit necessary for an entertainment based company to succeed," says observer J. R. Fettinger.

"After all, it was Perlmutter who risked further alienation of the Marvel faithful by cutting Stan Lee's salary (blatantly reneging on a deal made earlier by one of his own cronies), who seemed to care nothing about the morale of Marvel employees, doing petty things like taking away free coffee from the Bullpen (I can't tell you how many times I have seen this inexplicable pennywise and pound foolish behavior, even from people far more intelligent and financially savvy than me—not that that's saying much), who refused to sanction funds for a Christmas party (thinking $1,200 was too much—in New York City, in a company with dozens, if not hundreds of employees, that seems pretty modest), and who was just as guilty of buying companies, shuttering them, and liquidating them as the other corporate magnates, although not on the same scale."[101]

THE DUST SETTLES

"It isn't a tale of big business versus the little guy who really cares, but of the rich fighting the richer over an object that is little more than a commodity in most of their eyes," observed an online pundit. "The winners are clearly the lawyers in this case (to the tune of over $30 million) and prior Toy Biz owners, even though the merger is arguably not the only path to settling the bankruptcy of Marvel Comics. The losers were Marvel bondholders, the banks and the fans who had to suffer through this case. If there is any real moral to this story, perhaps it is that if you create something and truly love it, never sell it to the money men."[102]

QUESTIONS FOR FURTHER THOUGHT

1. In your opinion, who were the "good guys" and "bad guys" in Marvel's so-called Comic Wars? Who were the victims—and why?

2. What is a "hostile takeover"? Who seems to be more successful at taking over companies—Ron Perelman or Carl Icahn?

3. Did Marvel's bankruptcy and ownership battles really damage it in the long run? After all, its share of market is higher today than ever and its sales are nip-and-tuck with DC's. Argue your point of view.

4. Of all the contenters to own Marvel, who in your opinion would have been the best "caretaker" of the comic book empire?

5. Has the transformation of Marvel (and other comic book companies) from simply being a publisher of entertaining stories to a multimedia intellectual property licensing machine been a good thing or bad thing? Argue first on behalf of the fans, then from the viewpoint of owners and stockholders.

THE POSTMODERN AGE

A NEW DAY FOR COMICS

We're still in what many consider the Modern Age. Whether another Age will enter the picture remains to be seen.[1]

—Heritage Auction Galleries

I'D make the argument that Marvel's emergence from bankruptcy (ending the so-called Comics War and the industry slump) marks the beginning of a new age for comic books. History will tell, but for the moment let's refer to this current period as the **Postmodern Age of Comics.** (Someone else may later designate it as the Titanium Age or the Adamantium Age or whatever.)

PINCHING PENNIES

"In late 1998, Marvel emerged from bankruptcy under the ownership of its former licensing partner Toy Biz," observes Michael Dean in his *Comics Journal* column. "Toy Biz owner Ike Perlmutter, having worked his way up from his days as a junk dealer, had a reputation as a penny-pincher, and, according to *Comic Wars* (Dan Raviv's history of the Marvel bankruptcy), he was appalled to find that [Stan] Lee, who no longer even wrote for Marvel, was guaranteed an annual salary that escalated by 2002 to $1 million. Perlmutter ordered the lifetime contract to be voided, offering Lee a two-year contract at an annual salary of $500,000."[2]

FOOTNOTE

According to some insider sources, Stan Lee was actually receiving $2 million a year at one point, $1 million as his contractual compensation from Marvel and another $1 million from "the Townhouse," as Ron Perelman's MacAndrews and Forbes headquarters was called. Nobody complained; Stan was considered "a living Walt Disney."

"Well, what happened was a couple of years ago, Marvel—as you may know—went into bankruptcy," says Stan Lee. "At the time they were in bankruptcy, they did what most companies do that are in that situation—they rejected everybody's contract . . . which you can do when you're in bankruptcy. My contract had been a lifetime contract, which I've had for a million years, and suddenly—for the first time since joining the company—I was free to do anything at all."[3]

One of the things Stan was free to do was a project with Marvel's longtime rival, DC Comics.[4]

FLASHBACK

Okay, it was un-PC, but we had a "Death Pool" at Marvel—staffers laying wagers as to which celeb might die next. It was something we picked up from Howard Stern, that early-morning shock jock being staffers' favorite radio host. The rules were simple: you picked the name of an aging or ailing celebrity, and if he or she croaked first, you took the entire pot of money. Oh yes, there was one unspoken rule: nobody was allowed to pick Stan.

STAN LEE'S DC PROJECT

In September 2001 DC Comics announced "the coolest collaboration in the history of comic books." Stan Lee was teaming up with longstanding rival DC Comics to present Lee's alternative interpretations of Superman, Batman, Wonder Woman, Green Lantern, and other popular DC characters in a series called *Just Imagine Stan Lee Creating . . .*

"Will Superman work at the Daily Planet? Will Batman have the Batmobile? Will they even be heroes?" taunted DC's publicity. "The imagination of comic-book lovers everywhere will run rampant as they wait to read the adventures of the DC Universe through the eyes of Stan Lee—the comic book world's most prized and beloved storyteller."[5]

Stan joined the hype: "Man! Talk about fun! If ever there was a dream assignment, it's the one I lucked into doing the *Just Imagine . . .* series," he gushed. "How much would you pay for that privilege? Naturally, that was the first thing I asked DC—how much would it

cost me? And y' know what? They actually said that they would pay me! Wow!"

Stan continued with a polite dig at his old alma mater: "I wanna sincerely thank all you dynamic DC'ers for welcoming a fella from the other side of the street and making him feel so at home."[6]

Just Imagine . . . ran for a dozen or so issues, having reimagined favorite DC characters ranging from Superman to Catwoman, Green Lantern to Sandman.

"It was difficult," chuckles Stan. "These were great characters and I didn't want to make it look like I was going to show them how they *should* have done them. They were so beautiful in their original form. For the series I changed them as much as I could. Batman was the story I enjoyed doing the most. I made him an African-American. And I liked The Flash as a teenage girl. What fun!"[7]

STAN'S RETURN

Some saw this cancellation of Stan Lee's contract as a loophole for Stan to reclaim ownerships of the characters he'd created—Spider-Man, X-Men, Hulk, et al. One was a former lawyer named Peter Paul, Stan's partner in a new website. "Paul saw this as an opportunity and he seized it," reported *The Comics Journal.* "Part of what Marvel got for its money under the old contract was a disavowal on Lee's part of any rights to the many characters he had helped to create while working at Marvel. As Paul saw it, the contract had, in effect, licensed Lee's characters to Marvel. 'When they voided the contract, they voided the license.'

"Understanding the risks they were facing, Marvel's Hollywood liaison Avi Arad and others prevailed upon Perlmutter to authorize negotiation of a new contract that was more generous to Lee than the voided contract had been. Not only was the million-dollar salary back in place, but Lee was, for the first time, allowed to initiate his own ventures outside of Marvel as long as he continued to put in a certain amount of hours representing Marvel to the public." [8]

> INTERVIEWER: What is your official status with Marvel right now?

> STAN: I'm the Chairman Emeritus, and according to my contract with them now—which is, again, a lifetime contract—I am supposed to devote 10% of my time to working for Marvel . . . and the rest of my time, I can do anything that I wish. Even if it means competing with Marvel, which I have no desire to do.

INTERVIEWER: How did Marvel feel when they heard about your recent deal to re-invent the DC characters?

STAN: Oh, they probably weren't happy about it. I couldn't say no when I received that offer. . . . How can any writer say no to the opportunity of redoing every one of DC's top superheroes?[9]

BRAVE NEW WORLD

How did the decline of the comics industry in the late 1990s affect creators? "It made me braver," says artist Darick Robertson. "I thought comics were going out entirely so I chose to do *Transmetropolitan* and go down swinging and laughing. I've been fortunate in my tenacity that I have always had work when I needed it, but '95 to '97 were gloomy years. I learned a lot in taking chances and believing in my vision for what good comics are and what I can achieve as an artist."[10]

After twenty-plus years in the industry, Robertson can be termed a seasoned veteran, having worked for Marvel, DC, Vertigo, and a few now-defunct companies such as Malibu, Acclaim, Eclipse, and Innovation. He was picked as one of *Wizard*'s top ten creators.[11]

Transmetropolitan was published by Vertigo, the "mature" part of the DC Comics empire. The storyline deals with a gonzo journalist named Spider Jerusalem, a (sometimes) voice of reason in a wacky futuristic "world gone slightly mad." Launched in 1997, it was the collaboration of Robertson and writer Warren Ellis. It reached its planned conclusion with issue #60.

"In a small way, I think *Transmetropolitan* contributed to some readers finding their way back into an industry that had alienated them," muses Robertson. "Many folks who meet me at cons tell me how they had stopped reading comics, but *Transmetropolitan* was a reason to start collecting again and that makes me so proud. I never saw comics for their collectible value as much as their content value and was lost in those years trying to fit in to the mainstream while my heroes like Alan Moore, Frank Miller and David Mazzuchelli were leaving it."[12]

AN IMAGE PROBLEM

In 1999, Jim Lee sold Wildstorm to DC Comics, allowing him to drop his responsibilities as a publisher and concentrate on creative work. More Jim Lee art? The fans rejoiced.

"Any moral pretense was shattered conclusively when Lee threw up his arms and sold out to DC," declared Gary Groth in *The Comics Journal*, "somehow securing the compliance of Alan Moore—who had sworn in 1987 never to work for DC again—in the scam. (In a way, Lee was following in the ignoble footsteps of Malibu, whose slogan, plastered on millions of advertising impressions, was 'Independent. Very Independent,' and who subsequently sold out to Marvel.)"[13]

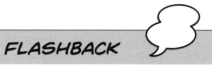

FLASHBACK

I'm consulting with DC Comics but space is tight at the 1700 Broadway offices, despite five floors, so they stick me in the Wildstorm office, a singular room reserved for Jim Lee when he's in New York. I leave a note on the desk, thanking Jim for the loan of his office. Next time I come to town, I find a playful message from Jim—"Please don't let John Nee steal my chair"—lying on the plush leather seat of the most comfortable desk chair in the entire building.

IMAGE ALL OVER AGAIN

In 1999 Larry Marder left his post with Image to become president of McFarlane Toys. ShadowLine's Jim Valentino assumed the role of business manager for "Image Central," then in 2004 handed over the reins to Highbrow's Erik Larsen.[14]

In an attempt to diversify, Image now publishes a number of "indie" titles by other creators. Dubbed the "nonline" because of their lack of commonality, this practice offers outsiders the same total-ownership terms the partners have enjoyed.[15]

One of these nonstudio productions—Robert Kirkman's *The Walking Dead*—emerged to become the most successful black-and-white comics of recent years, its sales surpassing many of Image's own titles. Nonetheless, McFarlane's *Spawn*, his toy line, and Silvestri's Top Cow titles remain a substantial portion of Image's total sales.

As of this writing, Image retains its position as the third largest publisher in the North American Direct Market—after Marvel and DC—with Dark Horse and Dynamic Forces nipping at its heels, but the creators co-op has lost sales momentum compared to its early years.[16]

CROSSOVERS GALORE

"Notwithstanding McFarlane's passionate denunciation of Marvel and DC," Gary Groth asserts, "when the opportunity arose, he jumped right back into bed with DC in order to draw a Spawn/Batman crossover."[17]

As a matter of fact, Image did crossovers with a number of publishers, including Marvel, DC, Dark Horse, Archie, Harris, and Mirage. In particular, *Spawn* has crossed over with *Batman*. *ShadowHawk* has crossed over with *Vampirella*. *Savage Dragon* has crossed over with *Superman*, *Hellboy*, the *Teenage Mutant Ninja Turtles*, and *The Atomics*.

Top Cow's characters (including *Witchblade*) have crossed over with *Wolverine, Silver Surfer, Shi,* and *Darkchylde.* And all of the above Image characters have appeared in crossovers with *Sonic, the Hedgehog.*

TODD GETS TAGGED

"One character in the *Spawn* comics got Todd in serious trouble," reported a law firm specializing in bankruptcies. "When Todd created the mobster villain Antonio Twistelli, it was alleged that his inspiration was hockey player Tony Twist who was then with the Quebec Nordiques, and later played with the St. Louis Blues. Twist sued and in 2000 a jury in the St. Louis Circuit Court where the suit had been filed awarded him more than $24 million for unauthorized use of his name. The judge set aside the award saying that the 'verdicts in this case are against the manifest weight of the evidence.' An appeal to the appellate court sided with [Todd McFarlane], but that was not the end of the episode. The Missouri Supreme Court found that the use of Twist's name was driven more for money than artistic value, and ordered a new trial. In July 2004 a jury awarded Twist $15 million. Although Todd vowed to appeal the new judgment, his company Todd McFarlane Productions Inc. was forced to file Chapter 11 Bankruptcy. Todd's toy company was not a part of the bankruptcy, but it was listed as the production company's largest creditor. We will all have to wait for the next issue to see how [Todd] emerges from this threat."[18]

STAN LEE BECOMES A WEBSLINGER

Stan the Man was looking for new things to do. Teaming up with his friend Peter Paul, he became the figurehead of his own web-based entertainment company, Stan Lee Media (SLM). In the midst of the dot-com boom, this proved to be a magnet for investment capital. In 1999, SLM went public in a reverse merger with Boulder Capital Opportunities, an investment-shell holding company that was already established on the stock exchange. Unlike his former employer, SLM published no comics, manufactured no toys, and produced no movies. What it generated was intellectual property—concepts for development in all kinds of media and all over the world. As *The Comics Journal* reported, "Its one essential asset was Stan Lee—or more precisely, his then 77-year-old brain, from which a fountain of commercial ideas promised to flow."[19]

INTERVIEWER: Stan, if you could have any of your characters' powers, what would it be?

STAN LEE: Aw, I've got enough superpower now. Couldn't handle any more![20]

THE DAY MICHAEL JACKSON TRIED TO BUY MARVEL

"At its peak, SLM was better capitalized than Lee's sometime boss, Marvel Entertainment. Which caused Paul's and Lee's minds to turn again to the possibility of purchasing Marvel and its inventory of products from Lee's imagination," reports *The Comics Journal.*

Stan says, "At that time, it looked as though our stock was high and that we had—I thought we had some money in the company, and—whether it was Peter's idea or mine, but the point is we both discussed: Gee, wouldn't it be something if we could actually buy Marvel. And yes, we did. We did discuss that. I remember I said, I hope it can be a friendly takeover. I—I hate the expression 'a hostile takeover.'"[21]

"The prospect of acquiring Marvel was so much on Paul's mind that SLM employees remember seeing him bounce through the halls one day wearing a Spider-Man costume. But that sight was no stranger than the one that greeted them the day Paul's new potential Marvel-purchasing partner came by to look over the SLM facilities and turned out to be pop-star Michael Jackson. Jim Salicrup, a former Marvel editor who was then a writer-editor for SLM, told the *Journal,* 'Up close, he seemed surprisingly normal looking. His nose was still attached and everything back then.'"

Turns out, the connection to Jackson came not via Paul's vast network but through an SLM artist who knew someone in the Jackson camp. According to Paul, "After we built SLM into a public company with a market cap almost twice Marvel's, we talked with Michael Jackson about teaming up to buy Marvel. I have a videotape of Michael in our offices for over two hours, seeing what we were doing."

"Jackson, who was an avowed fan of Lee's work at Marvel, was reportedly interested and sat down with Lee and Paul to discuss the possibilities. Salicrup, who was also present, recalls Jackson saying to Lee, 'If I buy Marvel, you'll help me run it, won't you?' According to Salicrup, Lee responded, 'Sure. I'll be here.'

"Jackson retained the services of investment banking firm Wasserstein-Perrella to negotiate with Perlmutter, but according to

Paul, the Marvel owner was unwilling to take less than $1 billion for the company, and Jackson's zeal eventually faded."[22]

DOT-COM IMPLOSION

At the end of the year, Stan Lee Media ran out of money. Following the company's collapse, it was discovered that Peter Paul had illegally tried to support the stock's price by attempting to buy 1.6 million shares of the company's stock with bad checks. He blamed the company's failure on Bill and Hillary Clinton, claiming they had caused a major investor to back out. In December 2000, as SLM prepared to file bankruptcy, Paul fled to Brazil.

He was later extradited and pled guilty to stock fraud. In 2005, he settled related civil charges, but pled poverty to avoid paying fines.

U.S. District Judge A. Howard Matz described Paul as "a con artist" and "a thoroughly discredited, corrupt individual."

When asked about Paul's role with the company, Stan Lee in his deposition said, "I was never sure what his title was, but he was the— you know, he and I were the two biggest stockholders, and Peter really did everything."[23]

FLASHBACK

Turns out, I'd known Bill Jemas's wife for years, a popular recruiter for the publishing industry. After a tour at Fleer/Skybox, he had been asked to report to me at Marvel. He was working on the prototype for a kids' line aimed at mass-market outlets like Target and Wal-Mart. The centerpiece was a horror series (think: *Goosebumps*) featuring Marvel characters. A lawyer by training, he liked this switch to a more creative role. But poor sales of the *Chillers* books and thwarted ambitions led him to leave . . . biding his time until he could return as publisher.

THE JEMAS REPORT, PART I

Bill Jemas left his position with Madison Square Garden in 2000 to become president of Marvel's Consumer Products, Publishing, and New Media. This was a second time around at Marvel for Jemas, but this time it would be on his terms. He took an aggressive stance in the comic book industry, unmindful of making enemies. His efforts helped pull Marvel out of its dip back into unprofitability.[24]

ULTIMATE MARVEL

"Early on, Jemas made one excellent decision," opines Franklyn Harris in his *Pulp Culture* column. "He hired Joe Quesada as editor in chief. Quesada, an artist who had run his own smaller imprint, ushered in a new era of creativity. He lured name writers and artists from rival DC Comics, independent publishing, and Hollywood." Among these luminaries were J. Michael Straczynski (*Babylon 5*), Brian Michael Bendis (*Powers*), and Grant Morrison (*The Invisibles*). Quesada then

gave them latitude to tell the stories they wanted, with little editorial interference.

"With a stable full of talent, Jemas launched new initiatives. He was the driving force behind Marvel's Ultimate line, which created a new, streamlined Marvel Universe populated with modern versions of the company's characters. *Ultimate X-Men, Ultimate Spider-Man* and *The Ultimates* (a hardcore take on *The Avengers*) soon outsold their old-school counterparts."[25]

"Stan Lee's stories were the basic formula for the original stories and the writers accompanied by artists set out to consider the same characters while using the values and ethical considerations of the present. In this world Tony Stark makes use of martinis to brace himself for the dangers he faces as Iron Man. Hank Pym, Ant Man, is a wife beater. Captain America is a flawed but still true warrior. Hulk is a mess. And Thor seems to be either a Norse God, or a sufferer of delusions. Spider-Man as reimagined is less of a dork, more troubled by real world issues."[26]

While a new universe was a landmark event, it wasn't without its detractors. "The title *The Ultimates* and *Ultimate Spider-Man,* along with many other Ultimate universe titles stirred a great deal of debate in the comics community . . . over the need for such books, and debate over the whether the Ultimates were 'too adult' or were 'offensive to the legacy of Stan Lee.' All of that debate is rich in opinion, and demonstrates the love people have for the setting of the Marvel Universe as the Architect Stan Lee created."[28]

How did Stan Lee react to this reinvention of his original universe?

SPEAKING UP!

When asked about including a character that looked like actor Samuel L. Jackson in the *Ultimate* series, penciler Bryan Hitch replied, "I understand from those who know that Sam Jackson is flattered. He's the only one really based on someone real, though it does occasionally help to visualize somebody playing the characters just to get a feel for how they would act. Samuel Jackson was and is the perfect Nick Fury, better than Mark's original choice of Bette Midler anyway."[27]

> **INTERVIEWER**: Now, do you have time to keep up with the current comics scene? We talked before about this, but do you read the Ultimate titles?
>
> **STAN LEE**: Well, I don't have time to keep up, but I have looked at the Ultimates. I think they look great.
>
> **INTERVIEWER**: Retelling your stories for a new generation . . .
>
> **STAN LEE**: Yeah, I've looked through them, they really are great.[29]

Stan Lee remains a showman—some say, a lovable huckster. For nearly seventy years he has "sold Marvel superheroes like a carnival barker sells glimpses of a bearded lady."[30] And back under a lifetime contract with Marvel, he cheerfully hawks the Ultimate universe.

X-FACTOR

Avi Arad saw movies as Marvel's salvation. What's more, he "adored living in Los Angeles, being far away from the old issues of bankruptcy, the Townhouse, Ike, Joe, Larry, Carl Icahn, the secured lenders, and all the rest. The artist in him had been set free. He was an executive producer for all movies based on Marvel characters. By late 2000, there were over a dozen in the production pipeline."

‹MILESTONE #12: COMICS BECOME VALUABLE MOVIE PROPERTIES.›

As Dan Raviv explains: "The first did well. *X-Men: The Movie* was somewhat rushed by Twentieth Century Fox in the summer of 2000, released a few months ahead of schedule. But ticket sales, worldwide were [strong] and videocassette and DVD sales were far greater than anyone had expected."[32]

The *X-Men* movie is widely credited as being "the patriarch of the current 'Comic Book Movie Age' that Hollywood is currently experiencing."[33]

"Believe it or not, *X-Men* was very tough to get made. It was prodding and pushing—it's scary," Avi Arad says of his $296 million movie about Marvel's mutants. "Obviously, X-Men was always a huge book of ours, but no one knew X-Men from a hole in the head."

He continues, "Okay, as you know, I'm a lifelong fan with a very high opinion of our properties, and my assessment was that the world still doesn't understand. . . . No one bothered reading the books and understanding—and again, I'm not being high-falutin' about it—but I think our books are great literature with great metaphors of real life dealing with fears and hopes."[34]

THAT'S THE WAY THE CODE CRUMBLES

Marvel's rebellious new spirit was exemplified in its decision to pull out of CMAA, the organization that administers the Comics Code Authority.

"I remember the last CMAA meeting Marvel attended," chuckles Joe Quesada. "Paul Levitz of DC was there, Michael Silberkleit of Archie, the usual gang. Silberkleit had a big black portfolio with him and inside were these yellowed transcripts from the senate hearings back in the '50s. I wasn't interested in reading them. That just depresses me. He started talking about funding a joint spinner rack program, but I said, 'I'm more interested in sentinels than spinners.' That was the end of the meeting. Marvel pulled out shortly after that."[35]

MARVEL'S OWN CODE

After resigning from the CMAA in 2001, Marvel implemented its own coding system on its comics. In July 2003, Marvel modified this code to avoid any conflicts with the Motion Picture Association of America (which held a trademark on the "PG" designation).

Marvel Comics Rating System

» ALL AGES
 8+ years old
 Carrying no cover label, these titles are appropriate
 for readers of all ages.
» MARVEL PSR
 ("Parental Supervision Recommended")
 12+ years old
 Though appropriate for most readers, parents are
 advised they may want to read before or with younger
 children.
» MARVEL PSR+
 15+ years old
 Similar to Marvel PSR, but featuring more mature
 themes and/or more graphic imagery. Recommended
 for teen and adult readers.
» PARENTAL ADVISORY/EXPLICIT CONTENT
 18+ years old
 Most Mature Reader's books will fall under the MAX
 Comics banner (created specifically for mature content
 titles), and some may fall under the new EPIC Comics
 imprint. These titles could contain content similar to
 an R rated movie—including harsh language, graphic
 violence, mature themes, nudity, and sexual situations.
 MAX and Mature-themed EPIC titles will be designed
 to appear distinct from mainline Marvel titles, with the

"Parental Advisory/Explicit Content" label very prominently displayed on the cover. Any Parental Advisory/Explicit Content title (whether MAX or EPIC) will NOT be sold on the newsstand, and they will NOT be marketed to younger readers.[36]

FLASHBACK

We're all at the Abbey Tavern, the one-time hangout for the Marvel staff. Editor in chief Bob Harras is tending bar with the help of Andy Ball. Terry Stewart, vice chairman of Marvel, is there. Creators like Andy and Adam Kubert have shown up, along with former Marvelites Sven Larson and Danny Fingeroth. The place is crowded with Marvel staffers. Ski is holding court, standing out like a bear surrounded by cubs. A pretty blonde comes up to me. "Hi, don't you remember me?" she says. I don't. "I posed for a character with you in *Code of Honor*." As a minor tribute, the editors had asked artist Vince Evans to paint me into the four-issue limited-series comic book—a "cameo appearance." I squint at her, picturing her as she'd appeared in the comic: "Oh," I apologize, "I didn't recognize you with your clothes on!"

How does Marvel choose its ratings on individual titles? "It's somewhat subjective," editor in chief Joe Quesada admits. "But we try very hard to use good judgment."

Would Marvel ever consider rejoining the CMAA? "No way!" exclaims Quesada, shaking his head indignantly. "We were spending $150,000 a year for that?"[37]

CONTINUING THE STANDARD

DC Comics and Archie still belong to the CMAA, dutifully submitting each issue for approval in order to display the Code's seal on the comic's cover.

Dan DiDio shakes his head. "I try to make DC's comics acceptable according to what 8 o'clock prime time is," says the former children's television programmer.[38]

DC'S SUCCESSION

In February 2002, *Savant*, a weekly comics magazine with an activist bent, noted a change in management at DC Comics. Editor Dave Potter and staff writer Paul Riddell speculate on Paul Levitz's rise to power:

POTTER: A lot of news has been breaking while putting *Savant* to bed of late—it was announced that Jenette Kahn, longtime president and editor-in-chief of DC Comics, is leaving the company, marking a true end of an era. She has held that position for over 20 years, and joined the company as publisher in 1976. But does the end of an era mean any tangible change at DC that fans will see?

RIDDELL: Even if someone starts freebasing Preparation H and hires Rob Liefeld to take over, you're still going to see about six to twelve months where the projects she oversaw will continue to trickle out. You can be reasonably assured, however, that she's already taken this into consideration, and that she's

already trained and briefed Paul Levitz to step in without that much trouble.

> **POTTER**: While I think Kahn leaving is certainly a milestone occurrence, I have a sneaking suspicion that history won't judge it to be the end of an era for DC.[39]

"Paul Levitz is the best person they could have at the head of DC," observes Stan Lee. "He knows comics!"[40] Not a bad endorsement from the man who led the competition for lo-so-many years.

NEW EDITORS

About the same time, Paul Levitz brought in a TV exec to help him rethink DC. Dan DiDio was also a fanboy who had written for comics, fanzines, and *Wizard* magazine. As senior vice president and executive editor, he's putting his stamp on the DC Universe while bringing fast-paced television programming techniques to the comic book company.

DiDio has "a more aggressive/edgy style," says *Newsarama* blog master Arthur Pendragon. But he adds that "Quesada is much more visible than DiDio, and because of his trash talk he's a lightning rod for controversy."[41]

> **INTERVIEWER**: If you could be a superhero, what would you call yourself and what would your power be?
>
> **JOE QUESADA**: Hyperbole! 'Nuff said![42]

Joe's answer: short but sweet and speaks volumes!

On *Newsarama,* a blogger known as ttroy says, "I think the biggest difference in the way DC and Marvel do business is DC has the long term effect and goals in the industry to reach . . . with Marvel 6 month(s) in the future is tops to them—no long term goals only short term successes . . .

"DC is looking years in the future down the road while staying on the path ahead . . . Marvel is ahead of them on the path but blind to what is going to happen down the road."[43]

TELLING THE TALE

In 2002, Marvel decided to include an editorial page "that will describe recent storylines and provide character information to make the books new-reader friendly."

"Turns out fans dig the recap pages like we've been doing in the Ultimate books and books like *Alias*," says Joe Quesada. "What the recaps do is allow our writers to get into the story without having to deal with the weird and unnatural expository dialogue that introduces characters and their powers."[44]

Some creators complained about this loss of a page, a reduction in story length from twenty-two pages to twenty-one pages. "Obviously it is a good idea to make the books new-reader friendly, but you think that Marvel could have found a better way to do this?" grouses the *CBEM* newsletter. "Freelancers are frustrated because that's 12 pages, or roughly half an issue of income lost per year. One artist has remarked that this change will cost him roughly $3,500 dollars in lost income. Let's face it, comic creators aren't exactly the richest people on earth."[45]

Perhaps the best ideas are old ideas. A 1997 news release announed the first time this concept had been used. I have to admit I thought it was one of my better ideas!

NEW YORK, June 10, 1997—Marvel Comics, the world's #1 comic book publisher, will establish a new milestone in publishing history with the introduction of a new format for all of its monthly titles, beginning June 12, it was announced today by Shirrel Rhoades, Executive Vice President, Publishing, Marvel Comics Group. Central to the redesign is the exclusive addition of gatefolds to each front cover. The gatefolds provide a foldout enhancement that features an extra two pages inside each comic book. The inside left page provides an index of the books' key characters, each with a concise biography and relevant editorial references. On the right is the 'story-so-far,' a short synopsis of the last few issues, highlighting plot developments and story summaries. . . .

"The gatefold cover is designed to provide . . . a shared starting point or frame of reference to each issue," stated Rhoades. "This is Marvel's answer to the opening credits found in television dramas, which allow viewers to jump right into the existing storylines."

Marvel's monthly publications have been likened to graphic soap operas, depicting super heroes with human challenges and frailties. The vulnerabilities and the soul-searching complexities of the characters in the Marvel Universe have historically been the signature trait of its super heroes and the key to their evergreen popularity. The intent of the comic book redesign is to balance dynamic, fresh elements that appeal to new readers, while remaining mindful of the heritage and tradition recognized by Marvel's loyal fans.[46]

Alas, the gatefold disappeared following the Comic Wars, a victim of tightfisted cost controls. But the recap approach solves many problems for serialized storytelling by providing new readers with an easy "jumping-on point."

UNRAVELING A TANGLED WEB

Marvel's *Spider-Man* movie hit theaters in May 2002, the biggest movie of the year. Avi Arad, head of Marvel Studios, was suddenly one of the hottest producers in Hollywood.[47]

But the road to box-office success was long and difficult to traverse. The rights to a movie version of Spider-Man were tangled up in a series of bankruptcies, byzantine licensing agreements, and acrimonious lawsuits.

Variety summed it up like this: "The tortured journey of Spider-Man's trying to get to the silver screen begins in 1985 when Marvel granted The Cannon Group rights, which would revert to Marvel if a movie wasn't made by April 1990. Cannon—then in its heyday—was run by Menahem Golan and Yoram Globus.

"But a few years later, a nearly bankrupt Cannon was acquired by Pathé Communications, a company financed by Credit Lyonnais and headed by Giancarlo Parretti. After a much-publicized split between Golan and Globus, Golan formed 21st Century Film Corp., while Globus remained at Pathé. In April 1989, Parretti and Globus conveyed the Spider-Man rights to 21st Century."

"Years later, MGM would claim Parretti, Golan and Globus defrauded it of the Spider-Man rights by that transfer. In July 1989, Marvel and 21st Century made a new agreement under which rights would revert to Marvel if a movie wasn't made by January 1992."[48]

Unfortunately, Golan couldn't find financing for the film, so he sold off television rights to Viacom and home video rights to Columbia Pictures. Theatrical rights went to Carolco Pictures for $5 million. Budgeting *Spider-Man* at $50 million, Carolco attached director James Cameron to the project.[49] Cameron was paid $3 million to come up with a script treatment.[50]

"In 1991, Carolco Pictures revised the original agreement between 21st Century and Marvel so Carolco would revert the rights to Marvel if the studio did not make a film by May 1996. In April 1992, production of *Spider-Man* ceased due to a tight budget at Carolco Pictures," notes a Hollywood insider.

FLASHBACK

The buzz around the Marvel offices was that James Cameron's treatment for the Spider-Man movie was "brilliant" and "awesome." There was even a commemorative keychain that said "Coming to theatres . . . Summer '92." Of course Ski has one.

"Litigation over the film rights began in 1993 when Golan's 21st Century sued Carolco for disavowing its obligation to give Golan a producer credit if the studio ever made *Spider-Man*. Eventually, Carolco sued Viacom and Columbia for the television and home video rights, and the two studios countersued. The studio 20th Century Fox, though not part of the litigation, contested rights to the film indirectly by presenting an exclusive contract with director Cameron, having transferred from Carolco.

"In 1996, Carolco, 21st Century, and Marvel went bankrupt. The studio MGM acquired 21st Century's position during its bankruptcy and also purchased Carolco's rights to Spider-Man, entitling itself to them under Marvel's previous agreements with 21st Century and Carolco. MGM also sued 21st Century, Viacom, and Marvel Comics, alleging fraud in the original deal between Cannon Pictures and Marvel."[51]

"In 1998, Marvel re-emerged from bankruptcy with a new reorganization plan that merged the company with Toy Biz. The courts determined that the original contract of Marvel's rights to Golan had expired, returning the rights to Marvel. Marvel settled its lawsuits with MGM and Viacom, and in 1999, the company sold Spider-Man rights to Sony in a merchandising joint venture for a reported $7 million."[52]

By all accounts, James Cameron had "pursued the Spidey project for years, even preparing a treatment some time ago that generated quite a bit of noise among Industry *playas*." He described it as his "dream project."[53] But it was not to be. In April 1999, Sony announced that James Cameron would not be attached to write or direct. Instead, the studio hired director Sam Raimi and screenwriter David Koepp (who would reportedly "incorporate parts of the legendary Cameron treatment in the new script").[54] After two drafts, the studio hired Scott Rosenberg to rewrite Koepp's screenplay.[55] "The script reportedly went through a dozen rewrites (an ongoing lawsuit by some of the screenwriters claims they were improperly stripped of credits on the final product)."[56]

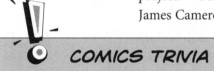

COMICS TRIVIA

Even the *Spider-Man* movie's promotion hit snags. After the 9/11 terrorist attacks, Sony recalled posters showing a close-up of Spider-Man's face with the World Trade Center reflected in his eyes. Not all the posters were recovered, however, and the ones still at large are now highly prized collector's items. "The movie's original trailer, released in 2001, featured a group of bank robbers on their getaway in a helicopter, which Spider-Man catches in a giant spider-web between the two towers of the World Trade Center."[58] The trailer was pulled but can still be found on the Internet.

"Of course, the problems weren't over," reports Ronald Grover of *BusinessWeek*. "Sony wanted Leonardo DiCaprio to play the superhero, then Freddie Prinze Jr., before finally settling on fresh-faced, 26-year-old Tobey Maguire."[57]

To date, *Spider-Man* has chalked up an impressive $821 million in worldwide sales.[59] As Grover puts it, "Not bad for a movie that took 17 years to get to the big screen."[60]

THE JEMAS REPORT, PART 2

Over at Marvel, Bill Jemas's controversial style and tendency toward micromanagement led to him being stripped of his presidency in late 2003. As reported by *Newsarama:*

JEMAS OUT OF MARVEL BY JANUARY?

A changing of the relatively new guard will be taking place at Marvel. According to numerous sources, current Marvel Publishing President Bill Jemas will be leaving his position in January if not earlier. Jemas' replacement, currently said to be coming in under the "Publisher" is reportedly a former Marvel employee.

The departure of Jemas from Publishing will perhaps bring to a close a period where Marvel saw coverage for both controversial statements said by Jemas, as well as controversial comics Jemas championed. While Jemas' style quickly drew the ire of many long-time Marvel Comics fans, Marvel's upper management apparently finally grew tired of the Publishing President's style as well as reports have leaked out that Marvel's Avi Arad found Jemas' take on Marvel characters made it more difficult for him to sell the properties in Hollywood, and retailers finally took their complaints over Marvel's policies to Jemas' superiors earlier this year. . . .

UPDATE: 11:38 A.M.: According to sources, former Fleer/Skybox product director Dan Buckley will take the position of Publisher at Marvel shortly. While Buckley was a Marvel employee, he was also employed by Fleer and worked extensively on Marvel-related products, such as *OverPower* and Marvel cards published by Fleer.[61]

ROAD TO RECOVERY

"Coming out of bankruptcy is like finishing chemotherapy," says Peter Cuneo, vice chairman of Marvel Entertainment, Inc. "You are theoretically 'cured' but also very weak. Since then, films made with Marvel characters have had a great track record—eleven out of twelve have been successful, with a cumulative box office of over $2 billion—so we're in a much stronger bargaining position. By producing our own films instead of licensing the rights to a studio, we will keep a much higher percentage of a film's revenues and be able to choose a release date that will enhance our sales of toys and other merchandise."

Marvel's recovery from "the company's near-death experience . . . didn't come without its share of pain, of course. Quiet but intense, Cuneo leaves little doubt as to his role in creating the new Marvel," notes the *HBS Alumni Bulletin*. "When asked to pick a superhero he relates to the most, Cuneo mentions a tireless vigilante: The Punisher."[62]

STRIPPERELLA

INTERVIEWER: What projects are you working on now?

STAN LEE: My new company, POW!, which stands for Purveyors of Wonder, is doing movies, television shows, animated shows, and I'm busier than I've ever been.

INTERVIEWER: I did hear a rumor about you getting a lap dance in Florida somewhere.

STAN LEE: That's all untrue. One of my new projects is the animated show *Stripperella*, which features the voice of Pamela Anderson. A few months ago, we got a letter from some exotic dancer in Tampa, Florida, and she accused me of stealing the idea from her while she was giving me a lap dance. I have never had a lap dance in Tampa or any other part of Florida. If I ever did have a lap dance, I don't think I would be discussing television ideas with the girl that was giving it to me. In fact, nothing more has come of it. I think it might have been a publicity stunt on her part.[63]

The animated series made its debut on Spike TV in June 2003.[64]

PLAYBOY OF THE WESTERN WORLD

That same year, Stan Lee announced plans to collaborate with Hugh Hefner on a similar superhero cartoon featuring *Playboy* Playmates.

Animation Magazine reported, "*Hef's Superbunnies,* a joint venture between Lee's POW! Entertainment and *Playboy*'s Alta Loma Entertainment division, will feature *Playboy* magazine's founder and editor-in-chief as the leader of a sophisticated, worldwide crime-fighting organization comprised of his famed beauties of the month."[65]

Did this require Stan to interact with the famed *Playboy* Bunnies? "Oh, I have trouble keeping them away already," he confesses, tongue firmly in cheek.[66]

Although a pilot was ordered by MTV, the animated series has not aired as of this writing. "It hasn't happened yet, but it will," Stan is quick to say. "These things take time. Hef and I are in agreement about the show. The holdup is just the usual legal stuff."[67]

YEAH! YEAH! YEAH!

"And POW! has a number of DVDs being released," Stan says proudly. "We've produced one called *Mosiac* about a female superhero. That's followed by *The Condor*. He's a Hispanic superhero 'cause I thought it was time for one.

"And a third DVD will be called *Ringo*. Ringo Starr will do the voice." Then Stan shifts into his puckish mode, "I promised I'd do my best to make him famous."[68]

SUPER TV

Another Stan Lee project hit the airways in 2006—a program called *Who Wants to Be a Superhero?* In this televised competition judged by Stan, hopefuls create their own superhero alter ego such as Creature, the Iron Enforcer, and Fat Momma. The show allows ordinary people to discover whether or not they have the stuff that makes a hero. The winners are to be immortalized in a new comic book published by Dark Horse Comics.

"I'm going to be playing the same type of role as Donald Trump," Stan chortles. "But instead of saying, 'You're fired' . . . at the end of every episode I'll say something like, 'Turn in your costume.'"[69]

Who Wants to Be a Superhero? debuted on the Sci Fi Channel and was picked up for a second season.[70] Starting with six episodes for the first season, even more were ordered up for the next go-round.[71]

"After all these years as a writer, I never thought I'd be on the other side of the camera starring in a far-out TV series," says Stan. "But, now that I've had a taste of it, there's no stoppin' me! The great guys at the Sci Fi Channel have unleashed us to cook up ten new, wilder-than-ever episodes. So, Heroes, hang on to your Spandex, 'cause the best is yet to come!"[72]

LOST ISSUE RESURFACES

"Just imagine if someone at Abbey Road Studios came across a lost Beatles song," writes Michael Sangiacomo of Newhouse News Service. "The equivalent has happened in the world of comics: A lost issue of

Fantastic Four, drawn by the late Jack Kirby and written by Stan Lee, has been found."[73]

The story was intended for issue #102 of *Fantastic Four* in 1970. This was during a particularly tempestuous time at the end of the Lee-Kirby partnership. Kirby submitted the penciled artwork—along with his letter of resignation. He left Marvel to begin his *Fourth World* series for rival DC Comics.

Unhappy with the work, Stan Lee shelved it. Parts appeared as flashbacks in a different story in *Fantastic Four* #108, but the original was lost—until now.

When Marvel editor in chief Joe Quesada approached Stan Lee about the pages, Stan didn't remember them, but agreed to write a new story to go with Kirby's pencils. So Marvel paid top dollar to the Kirby estate for the rights to publish these pages in a special edition.[74]

INTERVIEWER: If you could have any superpower, which would you choose?

DAN BUCKLEY: Telekinesis.[75]

GRAPHIC NOVELS

"The whirlwind of New York Comic-Con (2007) kicked off yesterday with the ICv2 graphic novel conference," reported *Publishers Weekly.* A blog added, "The one truly momentous announcement made during the show: industry analyst Milton Griepp's assertion that the graphic-novel market was now larger than the comics-pamphlet market, news that met with silence from news-sites far more obsessed with writer Stephen King's tenuous connection to a licensed comic book than an epoch-changing event almost certain to determine what the comics industry will look like ten years from now."[76]

‹MILESTONE #13: GRAPHIC NOVELS AND MANGA ENTER THE MEDIA MIX.›

Charles McGrath of the *New York Times* reports: "Some of the better-known graphic novels are published not by comics companies at all but by mainstream publishing houses—by Pantheon, in particular—and have put up mainstream sales numbers. *Persepolis,* for example, Marjane Satrapi's charming, poignant story, drawn in small black-and-white panels that evoke Persian miniatures, about a young girl growing up in Iran and her family's suffering following the 1979 Islamic revolution,

has sold 450,000 copies worldwide so far; *Jimmy Corrigan* sold 100,000 in hardback."[77]

Recent graphic novels have ranged from Frank Miller's *300* ("*Gladiator* Meets *Sin City*"[78]) to *Chicken with Plums* by *Persepolis* author Marjane Satrapi, serious fare like *Cancer Vixen: A True Story,* by Marisa Acocella Marchetto, and *The Pro,* by Garth Ennis with pencils by Amanda Conner and inking by Jimmy Palmiotti.

> **INTERVIEWER**: If you could have any superpower, which one would you choose?

> **JIMMY PALMIOTTI**: Invisibility. Access to everything in the world when I want it and the idea that I can be somewhere and not be there—the possibilities are endless![79]

> **AMANDA CONNER**: A toss up between flying, teleportation, and multiplying myself.[80]

NEW PARADIGMS EMERGE

In 2006, Tokyopop and HarperCollins announced a copublishing agreement that transferred all of Tokyopop's bookselling and distribution rights to HarperCollins. The agreement also allows Tokyopop to turn HarperCollins books into manga format. Beginning in 2007, they planned to release up to twenty-four titles a year.[81]

A NEW ECONOMIC ENGINE

"In the last few years, Japanese comics became the economic engine which made the viability of the graphic novel look less like the result of a few isolated works and more like a steady stream of saleable product," observes *The Comics Journal.*

"Driven by the popularity of televised Japanese anime among both children and young adults alike, manga volumes have gone on to sell in respectable numbers even after the floodgates were opened and the new releases began piling up. It's hard to overestimate the success of these books—at the end of [2002], manga volumes comprised 23 of the top 25 bestselling titles on BookScan's graphic novels sales charts; the fifth volume of the popular series *Chobits* became the first manga book to appear on BookScan's Adult Trade Fiction list.

"Buoyed by this success, manga publishers have all but abandoned the 'pamphlet' format preferred by an inexplicably hostile Direct

Market—Dark Horse [decided] that its latest comics would appear directly in paperback, while VIZ has stopped publishing traditional comic books altogether."[82]

GULP! GASP!

"Hey folks," announced *Ain't It Cool News* in May 2006, "word has come in from all over the place that Avi Arad has left Marvel."[83]

A press release from Marvel Entertainment announced that "the company has entered into a new arrangement with Avi Arad to independently produce films for Marvel under his own production company banner, Avi Arad Productions. In this new capacity, Mr. Arad will remain actively involved in Marvel's upcoming film slate, including Iron Man and Hulk, the first two films anticipated to be financed and produced by Marvel under its new film financing slate."[84]

"I have helped to build Marvel into a very special company," said Avi, "and on the heels of the tremendous success of *X-Men: The Last Stand,* I felt like it was the right time for me to move away from the day to day corporate responsibilities in order to focus on what I love best—creating and producing. I am leaving behind a great team to run the studio, and I expect to remain actively involved in the development and production of many Marvel films in the years to come."[85]

Already a millionaire thanks to royalties on toys he designed, Avi lives in Beverly Hills. And having made his mark with a spate of blockbuster movies based on Marvel superhero characters, he executive produced a movie based on the Bratz toy line as the first project on his own.[86]

BETTY AND VERONICA GET A MAKEOVER

Archie Comics now publishes *Sabrina the Teenage Witch* in a manga format. But forget manga for the moment. Even more drastic: Archie's girlfriends Betty and Veronica got updated in 2007, "drawn in a new dynamic art style by artist Steven Butler." In addition to this "more realistic look," *Betty & Veronica Double Digest* #151 introduced longer serialized stories.[87]

Not everyone was thrilled with the change: "The physiognomy of Betty and Veronica is timeless: two large doe eyes surrounding a crescent tipped and nostril-less nose, under which a strawberry mouth containing one gigantic, undivided tooth plumply rests. The design of Archie's girlfriends hasn't significantly changed in almost half a century, ever since cartoonist Dan DeCarlo created the modern look for Archie and the Riverdale gang in the 1950s," rants John Brownlee of *Wired's* Table of Malcontents. "Now, it's changing again . . . all thanks to artist

Steven Butler, whose clumsy line work should be familiar to anyone who has ever seen a children's coloring panel on the back of an IHOP place mat."[88]

A blogger named ray responds, "If you only know Steve Butler's work from an IHOP placemat, then maybe you should check out his work on some of these little known titles [*Spider-Man, X-Men, Avengers*]."

Another blogger with the handle Archie Phan points out, "The classic Archie character designs are by Bob Montana, not Dan DeCarlo."

"jeez. the new looks suck. talk about moving backwards," writes dinnie.

"Yuck," echoes Dave.

Eelface scolds, "The New Archie is way better! Stop being so smart!"

Chris says, "I worked at a comic store for 5 years, and this sort of 'character redesign' isn't that uncommon."

The ironically named Don't Panic! replies, "It's Sacrilege I tell ya."

Finally, following this long tirade, Rik Offenberger (one of the Archie editors) sets the matter straight: "Over the years we have tried to present Archie and his pals in new and exciting ways. Some of them have worked well, such as *Manga Sabrina, Little Archie,* and *Katy Keene,* others have not been as successful, such as Archie with a mullet. Josie wasn't always a Pussycat, but that was a change that the fans really embraced. This new style is going to be featured in only one 4-part story mixed with classic tales in *Betty & Veronica Double Digest* #151–154. Classic Archie will be in every other story we publish. We will see what the fans think and if it is well received we may do another, if the fans don't like it we will never do another story with this style. We are going to listen to how our fans respond. So I thank you for your initial response. However, could you wait to see the comic itself and let us know what you think of both the story and the art? We really do value your comments. While we do try new things from time to time, Archie and his pals always stay true to their values and nothing ever has or will replace classic Archie. I do want you to be assured that at no point were we ever considering a change to the entire line, we are only talking about one story done in a different style."

However, the last word must go to a blogger named Taylor: "my dad (richard goldwater—owner of archie comics) didnt even tell me about this and i happened to be watching the news one day and saw this and called him immediately and told him that they are UGLY. well, they wanted to get alot of press, and i guess thats a good thing for them and this was a good way to get it because i have seen them quite a bit on TV."[89]

There you have it. Straight from Riverdale!

RETURNING TO THE POCKET UNIVERSE

"It's a return that, well, let's be honest, you probably didn't see coming," reports comics industry watchdog *Newsarama*—Rob Liefeld's return to the Marvel fold.

In 2006, Jeph Loeb and Rob Liefeld teamed with Marvel for a five-part miniseries that returns to the *Heroes Reborn* universe, and brings along the villain who got the whole *Heroes Reborn* ball rolling. The title? *Onslaught Reborn.*[90]

LOOKING BACK

Recalling his 1992 X-odus from Marvel, Rob Liefeld has said, "I was 21 years old and I figured if I fell on my face, I could always go back to Marvel."[91]

"Dan Buckley brought up that *Heroes Reborn* was having the 10th anniversary and Dan—among others at Marvel—had been a fan," says Loeb. "Say what you will, there's a *lot* of people who came to Cap and the FF because of Rob and Jim who had never read those books before."[92]

> **INTERVIEWER**: If you could have any superpower, what would you want it to be and why?
>
> **JEPH LOEB**: I'd bend time like HIRO and go back to be with my son.[93]

"*Onslaught Reborn* represents an opportunity to complete a job that was left unfinished storywise," Rob Liefeld says. "Everything here is brand spankin' new. This is a sequel in every sense of the word. It's ten years later, Onslaught is angry and powerful and ready to exact revenge on everyone. Onslaught is a terrific villain, and he's been restrained for a very long time."

And yes, Liefeld is aware of the double meaning that some may read into his "unfinished" comment, given that he didn't complete his full twelve-issue run of *Captain America* ten years ago. Liefeld was fired after just six issues, with Marvel citing low sales. The remainder of the series was finished by Jim Lee's studio.

"As for the past history, the previous politics of *Heroes Reborn*, it may come as a surprise to any and all that I have only fond memories of that era, that work, everything," Liefeld says.[94]

Right.

IN LEAGUE WITH LITERARY HISTORY

The League of Extraordinary Gentlemen began as two six-issue comic book limited series written by Alan Moore and illustrated by Kevin O'Neill. Published under the America's Best Comics imprint, it was collected into graphic novel format (with the addition of a prequel story called "Allan and the Sundered Veil"). The story takes place in a fictional 1898 world in which all of the characters from Victorian-era adventure literature actually exist.[95]

The League of Extraordinary Gentlemen was adapted into a 2003 Warner Bros. film of the same name starring Sean Connery.[96]

ONE IN A HUNDRED

Time magazine picked *Watchmen* by Alan Moore and Dave Gibbons as one of the one hundred best English-language novels from 1923 to the present.

Andrew Arnold writes in the TIME.comix column, "Moore, who has become one of the most successful graphic novelists of the age (*From Hell; League of Extraordinary Gentlemen*), first broke out with this, his deconstruction of the superhero. Working with UK compatriot Gibbons, Moore created a complex murder mystery with intense, unforgettable characters that explored the themes of absolute power, love and the medium of comic books. It is the only graphic novel to also be included in the All TIME 100 Novels list."[97]

AMAZING ADVENTURES IN COMICS

Although not a comic book, Michael Chabon's novel *The Amazing Adventures of Kavalier & Clay* is noteworthy in any discussion of comic books. Winner of the 2001 Pulitzer Prize for fiction, it was also nominated for the 2000 National Book Critics Circle and the PEN/Faulkner awards for best American fiction that year. It is a roman à clef about the early days of comic book publishing, as close to the "feel" of the early days as you'll get without sitting at the feet of, say, Joe Simon.

The Amazing Adventures of Kavalier & Clay follows the lives of the title characters, a Czech artist and a Brooklyn-born writer during the early days of the comic book industry. The characters are based on actual comic book creators, including Jack Kirby and Stan Lee, Jerry Siegel and Joe Shuster.

The novel focuses on the prominent role of Jewish writers and artists in the development of pop culture. Chabon posits that comic books

and pulp fiction were "crucibles for a uniquely American mythology that allowed outcasts and immigrants to dream of heroism," and that aspects of Jewish tradition fit well with this mythology.[98] In the novel's epigram, Will Eisner describes this as "impossible solutions for insoluble problems."[99]

Chabon's impressive list of novels includes *The Mysteries of Pittsburgh, Wonder Boys, A Model World and Other Stories, Summerland,* and *Werewolves in Their Youth.* His work has appeared in the *New Yorker, Harper's, Esquire,* and *Playboy,* and in a number of anthologies such as *Prize Stories 1999: The O. Henry Awards* and *Best American Short Stories 2002.*[100]

> **INTERVIEWER**: What superpower would you rather have, flight or invisibility?
>
> **MICHAEL CHABON**: Well, if you were invisible, you would be blind. So I guess I choose flight.[101]

Query: Was Chabon's decision to undertake a comic book series for Dark Horse another example of "big pond" writers migrating to comics? Or simply a fanboy coming home?

BOOK WITHIN A BOOK

Debuting in February 2004, *Michael Chabon Presents: The Amazing Adventures of the Escapist* was a quarterly anthology based on fictional superheroes who had appeared in Michael Chabon's novel *The Amazing Adventures of Kavalier & Clay.* Chabon personally supervised all of the stories and also contributed a few originals of his own.

Chabon says his goal was "simply to produce a character and a cycle of stories that can stand, on their own, with the best of them."[102]

He summarizes it this way: "The Escapist is the greatest living champion of the League of the Golden Key, a secret global brotherhood dedicated, from ancient times, to the furthering the cause of liberation and freedom from oppression and slavery, whether physical or psychological. He has been trained in the ancient art of escape and is a master of locks, chains, ropes, ties, knots, and fastenings of all kinds. Prison walls, iron bars, steel restraints, such things are child's play to him. In addition, thanks to the mystic power of his Golden Key, he has greater than normal strength and agility."[103]

A critical success, it won both the 2005 Eisner and Harvey awards for Best Anthology and Best New Series.[104]

However, declining sales caused Dark Horse to cancel *The Amazing Adventures of the Escapist* in January 2006. This created a major dilemma.

Plans were already in motion to publish an ongoing series of stories written by Brian K. Vaughan, and the first of them had already appeared in issue #8—which was now scheduled to be the last in the series.

Not to give up! "With this week's issue #8, *Michael Chabon Presents: The Amazing Adventures of the Escapist* heads into new waters with its first on-going storyline," announced the Amazing Website of Kavalier & Clay. "Set in the world of Joe Kavalier and Sam Clay rather than the world of heroes, the new plot will focus on two independent comic book creators' attempt to revive The Escapist. And behind this tale of creative struggle stands writer Brian K. Vaughan (*Ex Machina, Runaways, Y: The Last Man*)."[105]

THE ESCAPIST BREAKS FREE AGAIN

The Escapists #1 hit comic book shops in July 2006, featuring the art of Steve Rolston (*Queen & Country*) and Jason Alexander (*Gotham Central*).

Chabon had personally tapped Brian K. Vaughan to write the storyline. As Vaughan tells it, "Imagine my shock when I came home to a message on my machine from him, which said, 'Brian, I'm calling with urgent League of the Golden Key business.'"[106]

Cleveland-based Vaughan admits he jumped at the chance to write the new series. "Not to blow my own horn, but I turned down some really cool gigs at Marvel and DC to work on this, not just so I could constantly annoy my wife with the fact that I'm working with her favorite author— although that's a big part of it—but because I felt that the world Michael Chabon has created gave me an opportunity to really push myself, and to hopefully tell stories that are completely different from anything else on the stands right now.[107]

"Yeah, as a former magician who used to perform his own half-assed straitjacket routine, I love the *Escapist*," Vaughan continues, "but my favorite chapters from *Kavalier & Clay* weren't about the costumed hero, they were about his creators. Taking a page from Mr. Chabon's novel, our story will balance the fictional adventures of the Escapist with the 'real world' drama of the new creators behind the character's modern-day return."[108]

Chabon has called Vaughan "the best young writer in mainstream comics." Among Vaughan's accomplishments by age thirty were a sci-fi series for Vertigo; a political drama for Wildstorm; and *Runaways,* a superhero story with a new twist for Marvel.[109]

> ### FOOTNOTE
>
> *Runaways* has an interesting premise: a couple of kids discover that their parents are supervillains. "Most teenagers go through a part of their life where they think their parents are the most evil in the world," Vaughan says. "I thought, what if that was true?"[110] Do Vaughan and his wife (playwright Ruth McKee) have any kids to run away? "Nope, none yet," he responds when I pose the question.[111]

Wizard magazine voted Vaughan "Writer of the Year" in 2006.[112]

BATMAN BEGINS . . . AGAIN

Audiences loved the 2005 Warner Bros. movie *Batman Begins*. This take on DC's popular character was much closer to Frank Miller's *Dark Knight Returns* than previous films. With worldwide sales of $372 million, Warner Bros. had pulled off a successful reboot of the *Batman* movie franchise. And here was a movie to match Marvel's spate of comic-based films.[113]

"DC Comics president Paul Levitz, director Christopher Nolan and screenwriter David S. Goyer worked as a team to draw ideas from thirty years' worth of Batman comics. Nolan's personal 'jumping off point' was 'Batman: The Man Who Falls,' a short story about the death of Bruce Wayne's parents and Bruce's travels throughout the world. The early scene in *Batman Begins* of young Bruce Wayne falling into a well was directly adapted from 'The Man Who Falls.'"[114]

> QUESTION: So, Paul, you had *Batman Begins* open well . . . taking comic book films to a new level. . . . What other properties are you developing?

> PAUL LEVITZ: There's a ton in development. We'll have a *Wonder Woman* script in momentarily from Joss Whedon. *Flash* with David Goyer working on it. We've had a lot of discussions on *Green Lantern,* although not a definitive plan. *Shazam* is over at New Line . . .

> QUESTION: Having been a part of the DC family for as long as you have, how personally rewarding has it been for you . . . to see DC properties back at the top of their game again today after the success of *Batman Begins* and . . . *Superman Returns?*

> PAUL LEVITZ: Given my life, to sit there in a movie theater and watch the DC symbol come up at the front of a film that's as good and as true to the character as *Superman Returns* or *Batman Begins* or for that matter *V for Vendetta* or *Constantine* is an enormous thrill. I have the privilege, which is very rare in life, of running a company whose projects have been important to me since I was four or five years old, of seeing it grow to new heights. When you look at DC today—it's not only that last year we had three motion picture successes across a wide range, we had six television shows in production—if you look through the history of creative companies, not to take anything

away from any other business, but I'm not sure you can find another creative institution that has spawned as wide a range of projects in as short a period of time. We've had everything on the air . . . from *Krypto* for pre-school audiences on Cartoon Network, on up to *Mad TV* running Saturday nights at 11 on Fox for obviously a very college, young adult audience, to things like *V for Vendetta* and *Constantine* with hard R ratings. We've really been showing that comics as a medium in America can be a source material for any kind of story.

QUESTION: I realize you may be prejudiced, but you're also the guy who can answer this question—why is (a character like Superman) worthy of all these films, cartoon series, TV series, comic books and everything else?

PAUL LEVITZ: I think there's a prejudiced and an objective answer. If you look back over the last 65 years or so . . . I think there have been about 15 where there hasn't been a new Superman creative work in whatever was the dominant medium of the time. He was a radio show for 11 or 12 years, he was a television series for about nine, there were the serials, the theatrical cartoons. Objectively speaking, you have at least three generations that loved Superman when he was done well and we're starting on a fourth. I think when you look at anything that has been able to transcend the time in which it was born—most creative properties are of a moment; they capture something in the zeitgeist, it works with that moment and it disintegrates fairly quickly in the culture. No matter how important "I Dream of Jeanie" was at the moment it was there, it was of that moment and of that actress and probably that writer and all of those things together—Superman has transcended the people who worked on him, the people who played him. There is something about it that lives on.

QUESTION: So, what is it?

PAUL LEVITZ: To me, I think there's an intrinsic power to that basic formulation that says, "You look at me as Clark Kent, but hidden in me is Superman." I think there is a very fundamental human moment there. I can't speak for the other half of the human race, but certainly the male half of the human race, no matter how successful you are, if you are the Superman side of success, you're sitting there saying, "I wish she would see me for the dopey Clark that I am, and not just love me for the fact

that I've got the Black American Express card and the super-charged car and all the mortal versions of superpowers." And if you're Clark, you're sitting there saying, "There is some Super-man in me, won't you look?" I think that humanity has been a vital part of why people continue to care about the character.[115]

CAP DIES . . . AGAIN

FLASHBACK

Not long ago I'm speaking with Tom DeFalco who writes *Spider-Girl*. We're catching up on the old gang. "I'm having lunch with Bob Harras and Ski in a few weeks," I tell him. "Ahhhh," chuckles DeFalco, "the *Masters of Evil* united, again!"

Captain America was presumed dead at the end of World War II, his plane blown up by the Evil Axis. But fortunately he landed in an ice floe that cryogenically preserved him. Now—in issue #25 of *Captain America,* Marvel's famed superhero is downed by an assassin's bullet. Is he dead for good . . . or is this another "Death of Superman"–style story arc, in which the flag-draped hero will eventually return from the dead?

Entertainment Weekly announced it this way in its March 23, 2007 issue:

> Captain America Dead
> With troops stretched thin, we must now extend the tours of Sgt. Slaughter and Beetle Bailey.[116]

An upcoming *Captain America* movie argues for resurrection.

STAN'S NEW VENGEANCE

And in mid-2007, Stan Lee once again picked up his mighty Marvel pen to write a new Avengers story that kicked off an all-new series for the super team. Featuring the art of Kevin Maguire, Stan's lead story in *Avengers Classic #1* (June 2007) told how the Avengers *really* got together.[117]

As the battle cry goes, "Avengers assemble!"

DAWN OF A NEW AGE

"No doubt about it," opines Peter Vinton, Jr., in his insightful review of Geoff Klock's *How to Read Superhero Comics and Why,* "the super-hero comic book genre is in a period of fundamental transition. The safe, juvenile realm of the 1940's Superman, the 1960's Spider-Man, or even the angstsy teen drama of Chris Claremont's mid-1980's X-Men have given way to something deeper and far more relevant. No longer is the genre simply about escapism into fanciful tales of Spandex-clad

mortals with extraordinary powers who choose to fight for all that is good and just; this new generation of stories lay bare the most primal of Jungian archetypes and allow their readers to examine themselves and their place in the real world."[118]

GOLDEN AGAIN?

"I think we are in the middle of a new Golden Age for comic books," says Steve Mortenson, a California-based comics retailer.[119]

WHAT BECOMES A LEGEND?

Stan Lee turned eighty-five on December 28, 2007.

INTERVIEWER: What kind of superpower would you want to have if you could pick one?

STAN LEE: I used to say "immortality," because I have so many things I want to do, but now I keep forgetting people's names, so I'd like to say a super memory. When someone comes over and shakes my hand I used to say, "Pleasure to meet you," and they would tell me we just had lunch the day before, so now I say, "It's a pleasure to see you," just in case I forgot that I've seen them before. So I don't say "immortality" anymore.

INTERVIEWER: You don't need it, you're already immortal.[120]

QUESTIONS FOR FURTHER THOUGHT

1. How would you rate Stan Lee's creative ventures outside the Marvel fold? Which was the best idea? The worst?

2. Was Image Comics a successful idea? Argue pro or con. Bonus points if you break your analysis down studio by studio.

3. What makes *Watchmen* one of the one hundred best novels? In fact, what makes it a novel?

4. Was Todd McFarlane unduly punished for using a hockey player's name for a comic book character? Or did he get exactly what he deserved? Why do you think so?

5. What do you make of manga? Why does it appeal to girls? Will it replace the American comic book?

COLLECTING COMIC BOOKS FOR FUN AND (MAYBE) PROFIT

"CAN you tell me how much my comics are worth?" is one of the most common questions that novice collectors ask.[1]

Maybe it's a stack of #1s you've bought over the years, a hedge against future financial needs. Or a box of yellowed comic books you found in the attic. Or that complete run of *Iron Man* you've had since childhood. Or Frank Miller's *Sin City* you've collected since its 1991 debut.

Don't bother writing to the comic book publisher. "Dark Horse doesn't keep track of the secondary market value of our comics," publisher Mike Richardson says on the Dark Horse website. "Your best bet would be to check out the price guide located in the back of *Wizard* magazine (a monthly magazine devoted to comics) or, better yet, the *Overstreet Price Guide* (a yearly publication with prices on just about every single comic book ever published). You should be able to pick up both *Wizard* and *Overstreet* at any comic book shop. In fact, your local comic book shop could realistically tell you what your comics are worth because they deal with that every day!"[2]

There you have it, the best sources for pricing your prized comics.

But before we talk about the art of collecting, comic book values, or *how* to collect, let's examine *why* you collect.

AN ACQUISITIVE PERSONALITY

There are three kinds of comic book collectors:

1. **Fanboys**: Those geeks who want to keep up with the soap-opera storylines of X-Men or Savage Dragon. (*Geek,* by the way, is not necessarily a derogatory term in the comic book world. It merely denotes someone with a fervent passion for the subject.)

2. **Nostalgia Buffs**: Those who fondly remember comics of their youth and want to rekindle that connection by collecting old favorites. (Fanboys and nostalgia buffs *can* sometimes be the same people.)

3. **Speculators**: Those who collect comics for their future value, like playing the stock market. (Yes, fanboys and nostalgia buffs *can* also be speculators—or not. However, the onus is on the speculator to know comics as well as those in the first two categories, in order to make wise investments.)

So the first step is to determine which category best describes your motives for collecting. That will determine *what* you should collect.

> For example, a fanboy might buy the next issue of *Witchblade* simply to follow the ongoing storyline about Sara Pezzini, the woman with a mystical glove that turns her into a sexy super-heroine. And at a cover price of $2.99, *Witchblade*'s a darn good read—but it's probably not destined to increase in value anytime soon.

> A nostalgia buff might be looking for a copy of *Spawn* #1, where Al Simmons makes his deal with the devil—a favorite story from the past—but valued by *Overstreet* at a mere $10.

> The speculator may be looking for EC's *Crypt of Terror* #17 (first of the "New Trend" horror comics), a near-mint copy currently valued at $4,300 by *Overstreet,* and sure to increase even more over time.

INTERVIEWER: Were you an avid collector as a kid?

JIM WARREN: *(founding publisher of Creepy, Eerie, and Vampirella)* You bet! Not only comic books but anything on paper that interested me. The first issues of *Life* magazine, *Look, Boy's Life, Popular Mechanics,* cereal boxes with interesting stuff on the back, baseball program books, college football pictures, model airplane plans, you name it. The day I came home from the Army I discovered my mother had thrown out my comic book collection. Now, we're talking *Action Comics* #1 to about #15. We're talking *World's Fair Comics—New York World's Fair Comics* (1939 and 1940). We're talking the first issues of *Human Torch, Sub-Mariner, Captain America;* we're talking an almost complete collection of *The Spirit* from the Philadelphia *Record* newspaper. Shall I go on? It wasn't my mother's fault. Dim-witted lout that I was, I forgot to tell her what these cardboard boxes of magazines meant to me. Excuse me, I think I'll cry now.

INTERVIEWER: (laughs) Did you eventually forgive your mother?

JIM WARREN: Of course not. I still remind her of it. Each year on her birthday, I consult the comic book price guides and total up how much the collection would have been worth. I write the dollar figure on a piece of paper and enclose it in her birthday card. Then, when she opens the card, she cries. It's been a running gag in our family for almost 50 years.[3]

TO EACH HIS OWN

All three categories of collectors might search comic shop bins for *Amazing Spider-Man Annual* #21 (1987)—the issue in which Peter Parker marries Mary Jane Watson. But all for different reasons.

The fanboy could be a completist who missed that particular issue in his *Spider-Man* run. The nostalgia buff perhaps thought it was a boffo issue, one that reminds him of when he was courting his own MJ. And the speculator finds the issue a bargain at $12, thinking it's likely to increase in value because it depicts a historic event in the Spider-Man canon.

"I've never been into having partial collections of things," says DC's president Paul Levitz. "I told the story when we launched *The Spirit*

Archives that I had managed to put together about half the *Spirit* sections when I was collecting them and just really couldn't move the mark very much for about two years, so I sold them because I couldn't stand having half of them. It was bothering me much too much."[4]

com·plet·ist (n.) A person who obsessively gathers the complete collection of a particular set of items (such as a musician's recordings or an author's books).[5]

FLASHBACK

Ski looks up from his computer, where he's playing FreeCell while he smokes a Marlboro and cradles the phone to his ear to negotiate an agreement with an inker. Multitasking as usual. "Here," he says, at the same time tossing me a bundle of comics. "You'll want to add these to your collection." "Why these?" I ask, thumbing through the so-so titles. "Because you're a completist, one of them collectors who's gotta have the whole run, nothing missing." He's right.

In comic book terms, we're talking about a collector who does not limit his or her collecting to specific issues but tries to acquire complete runs of a comic book series.

APPRECIATION IN VALUE

"In *The Great Comic Book Heroes*—a great comic and, in its way, heroic book—Jules Feiffer describes the odd spectacle of middle-aged men 'who continue to be addicts, who save old comic books, buy them, trade them, and will, many of them, pay up to fifty dollars for the first issues of *Superman* or *Batman*.'

"He wrote this in 1965. Since then, the comic-book collectibles market has exploded. In 2005, according to the *Wall Street Journal*, 'A near-perfect *Action Comics* No. 1, the book that launched Superman, lists for $485,000, up from $200,000 five years ago.' That's nearly a 5 *million* percent markup from the 1938 street price of 10 cents."[6]

"You won't hear it from your local stockbroker," says Shawn Langlois of CBS *Market Watch*, "but the vintage comic book market can be an enriching, though risky, alternative investment."[7]

Ben Smith, director of marketing at Metropolitan Collectibles, agrees. "Lots of our customers are taking their money out of the stock market and putting it into comic books because the returns are much better," he reports. "Many comic books often outperform the very company that prints them."[8]

For instance, a near-mint copy of *Detective Comics* #27, in which Batman made his debut, was valued at $80,000 in 1992 and would return about $300,000 in the current market. Conversely, the same amount invested in . . . Time-Warner, the owner of the Batman franchise, would have returned less than half that of the comic book over the same period.

"Similar results could be found in relationships between Mickey Mouse/Walt Disney, X-Men/Fox Entertainment, and Incredible Hulk/Vivendi Universal.

"Over the past 20 years, the S&P 500 has failed to keep pace with the performance of one of the more popular books, *Action Comics* #1—Superman's debut."[9]

FLASHBACK

My ten-cent copy of the *Amazing Spider-Man* #1 (1963) was listed in the *Wizard* price guide as being worth $40,000 when I donated it to the Savannah College of Art and Design in 2003. Today, the 2006 *Overstreet Comics Guide* lists a CGC NM+ 9.6 grade *Amazing Spider-Man* #1 as selling at $97,750.[10]

DANGERS OF SPECULATION

Nonetheless, most comic book publishers will tell you that speculation is not the best reason to get involved in comic book collecting. During the early 1990s, many people got burned by buying up the plethora of faux #1s, titles that were cranked out to satisfy a misguided get-rich-quick collecting binge. These would-be speculators thought they were going to put their kids through college on these "investments," only to discover that a decade later Rob Liefeld's *Fighting American* #1 and *Youngblood* #1 (second printing) are worth a mere $2.50 each.

MONITORING THE MARKET

"With the resurgence of superheroes like Spider-Man and Superman on television and the silver screen, it's hard to believe that until recently these comic book legends verged on extinction," comments Kate Lohnes of *The Monitor*. "Like the classic supervillain whose brilliance proves to be his downfall, the comic book industry came very close to self-destruction.

"In 1993, DC Comics presented the public with two sensational story arcs involving its biggest superheroes, Superman and Batman. In 'The Death of Superman,' Superman faces off with Doomsday, a seemingly unstoppable villain, and dies. In 'Knightfall,' a new character named Bane breaks Batman's back, forcing him to pass the Batman mantle to another person. These story arcs garnered intense media and fan reaction, leading some people to speculate these characters would disappear from comics forever, making the comic books collector's items and increasing their value."[11]

"Comic book 'speculators' began buying quantities of 'The Death of Superman' and 'Knightfall.' People would walk in and sweep armfuls of the issues off a shelf and buy them," recounts Helgi Davis, owner of Myth Adventures. "Instead of making a finite number of popular comics, publishers flooded the market with more. The increase in comics

led to a decrease in their value. When the speculators realized they were selling valueless comics, they quit buying them. Their disappearance coincided with the departure of average consumers, who felt frustrated with high prices. This brought the comic book industry to a grinding halt."

The result? "When the speculators jumped ship, it was horrible," Davis recalls. "Comics had gotten more and more expensive, and then people stopped buying. I ended up donating $13,000 worth of comics to the RGV Children's Home."[12]

NEST EGG

That's not to say some speculators haven't made out well.

You should be so lucky. Or so good at collecting.

"For Mark Zaid, what began as a stack of memories has become a hefty nest egg," reports the *Wall Street Journal*. "The Washington, D.C., lawyer began collecting when he was about seven, buying copies for 20 cents each. He returned to collecting in adulthood and today he has an insurance policy on his comics, stores most of them in protective casings, and keeps the priciest copies, worth more than $100,000, in a safe-deposit box. When Mr. Zaid wants to read about the Green Lantern in *All-American Comics* No. 16, he doesn't turn to his $30,000 copy, but a book of reprints he bought for $20. 'It's not just collecting,' he says. 'It's investing.'"[13]

Steve Geppi, chief executive of Diamond Comic Distributors and publisher of Gemstone Publishing, adds, "I've been an investor in the comic book market for 30 years, and I can tell you nothing has come close to the return I have experienced."[14]

SAMPLE PRICES

Actor Nicolas Cage, whose movies have raked in a billion dollars, proved himself to be the consummate collector of comic books when his collection of 141 lots was auctioned off for $1.68 million. Had Cage lost interest in comics? No, he sold his beloved collection to make then-wife Lisa Marie Presley happy. (After the divorce he stated that she was "too demanding.")

Cage selected Heritage Auction Galleries and Jay Parrino's The Mint, two of the biggest names in comic book auctioning. Prior to the auction, the books were graded and encapsulated by Comics Guaranty

LLC (CGC). The auction took place on October 14, 2002, a weekend concurrent with the Dallas Comic-con.

Here are a few sample prices from Cage's collection:

» $86,250 for an *Action Comics* #1 (1938), the first appearance of Superman;

» $126,500 for an *All-Star Comic* #3 (1940), which introduced the Justice Society of America;

» $120,750 for a *Detective Comic* #38 (1940), Robin's debut.[15]

Not bad, eh?

But don't get your hopes up too quickly. These were near-mint books from the Golden Age. Your bagged copy of Jim Lee's *Deathblow* #1 with the red foil logo sells for only $2.99. Once-hot comics like *X-Men* #1 and *Terminator* #1 can easily be purchased on eBay for under two bucks apiece these days.

SCARCITY

This brings us to one of the cornerstones of comic book values: scarcity!

Scarcity increases the value of most anything. And comic books are no exception. Simple supply and demand: comic books from about 1980 onward were printed and collected in large quantities. In economic terms, the supply of these comics is much greater than the demand.

What creates scarcity? Limited editions. Low print runs. Older comics that weren't saved, thrown out as worthless scrap by tidy mothers or donated to World War II paper drives.

A lot of early comics didn't survive. They were considered a disposable form of entertainment back in the 1930s and '40s. In these cases, the demand is now larger than the supply.

» More recent comic books from the Modern Age are worth little, if anything. At least at the moment.

» Bronze Age books tend to be a bit more valuable. Certain books from this period—such as *Giant-Size X-Men* #1, *X-Men* #94, and *Incredible Hulk* #181—are extremely collectible and can bring thousands of dollars each at auction.

» Books from the Silver Age are highly prized by collectors, especially when in good condition. Not considered collectible at the time of publication, they tended to get folded, spindled, and otherwise mutilated, making it all the harder to find near-mint

(NM) copies these days. For example, a 1960 *Richie Rich* #1 is valued at $3,200 today versus a 1991 issue of *Richie Rich* #1 which goes for a modest $2.50.

» And Golden Age books are like . . . well, gold.

FLASHBACK

A few months ago, a local yard-sale guy called me to say he had a stack of old comic books he thought I might want, having heard I used to be in the business. I wanted them, all right. For a hundred bucks he sold me a stack of Golden Age comic books preserved in plastic sleeves—mostly *Prize Comics*, with *Crackerjack Funnies*, *Spy and Counterspy*, and various early issues of *Zap* thrown in for good measure. The *Overstreet* guide values them at nearly four grand.

RARITY BY DESIGN

"I'm going to jump right into the snakepit by defending Marvel's recent decision to limit their print runs to orders actually received from retailers," writes Mile High retailer Chuck Rozanski. "For a variety of good reasons, this is a topic that has created more controversy within the comics retailing community than any other publisher policy put into effect in the past five years. . . .

"For those of you who are not aware of the basics, comics publishers experienced a massive shift in their operating dynamics over the past twenty-five years. Until the mid-1970s, comics were published in huge quantities, and then placed for sale to consumers almost exclusively into mass market retail outlets (such as newsstands and drugstores). Those outlets purchased comics from local magazine distributors, typically at a 30% discount off of cover price, but with the right to return any unsold copies for full credit.

"This sale-and-return policy had been in effect since the mid-1930s, and worked quite well for many years. In fact, during the years of World War II, sales were running at a very high percentage, with only nominal unsold copies being returned. After the end of the war, however, sell-through percentages began to decline. . . .

"By 1979, comics publishers were at a crossroads. Either a new methodology had to be discovered for retailing comics, or the industry was doomed. It was at this point that publishers began paying serious attention to the Direct Market. . . . The key to this market, at least as far as the publishers were concerned, was that the sale-and-return aspect was eliminated. Comics retailers were allowed to purchase from Direct Market distributors at discounts as high as 55% off, but in exchange for that enhanced discount, they agreed to take on the entire risk of ordering. No returns were allowed."[16]

Rozanski adds that "the Direct Market was based on the assumption that comics retailers would buy comics from the publishers at enhanced discounts, in exchange for taking on the risk of ordering non-returnable. . . .

"Right from the beginning, some savvy retailers realized that they could limit their risks by ordering lightly on their initial new comics order, and then quickly placing reorders for issues that sold well. This may have worked out well for comics retailers, but gradually acted to shift more of the risk burden back on to comics publishers. To return the risk back to retailers, Marvel . . . announced that they would only guarantee to ship initial orders from comics retailers, and would minimize print overruns.

"Marvel's actions have led to the greatest improvement in Direct Market operating margins in over a decade. Specifically, there is now a vibrant and energetic market for recent back issues, especially Marvel comics. This contrasts sharply with the past ten years, when back issue comics (especially from the previous couple of years) were almost unsellable.

"Why are back issues so important? Because, quite simply, that's where the earnings flow from in most comics shops. . . . There are very few comics shops that can generate sufficient operating earnings to prosper without the high margin sales from back issues. . . .

"With practically all recent back issues hard to find, there is actually some possibility that the old saw about 'I'm going to put my kids through college with my comics collection' may actually have a chance of being valid. That certainly turned out to be the case for collectors from the 1960s and early 1970s, and print runs were vastly higher back then. I'll bet that in 20 years comics from today will be flat-out impossible to find."[17]

RARITY BY ODDITY

Sometimes comic books contain "bloopers"—errors that make them valuable—like that 1918 postage stamp known as the "Inverted Jenny," a misprinting that depicted an upside-down biplane (it has an estimated value of $300,000).[18] These comics are hard to find, having been snapped up for the curiosity value. Or because the comic book publisher recalls it and reprints a corrected copy.

Among the legendary comics in this vein is the *Captain America* with the outline of a penis faintly extending from Cap's sidekick Bucky, like one of those find-the-hidden-animals puzzles. Or the *League of Extraordinary Gentlemen* copy that contained a "Marvel douche" ad in it. Or the *Wolverine*

FLASHBACK

As part of Marvel's deal with Paramount, we published the comic book version of Tom Cruise's *Mission Impossible* movie. Somehow, Cruise didn't see the book until after it came off press. The actor had approval of his image—and he didn't like it. Paramount insisted we redraw a couple of panels and reprint the book. Expensive, but we did it. The reason for Cruise's displeasure? We were told he thought it made him look "too gay." I still have a couple of these never-distributed first printings tucked away in my comics collection. Very rare indeed!

with an ethnic slur that caused quite a stir as Marvel was being taken over by Israeli-born Ike Perlmutter and Avi Arad.

COLLECTIBILITY BY SUBJECT MATTER

Comics featuring important characters (like Superman, Batman, or Spider-Man) are more actively collected than books featuring lesser-known characters (say, Hardcase or Bloodshot).

Comics with key events are often collected ("The Night Gwen Stacy Died," "Death of Superman").

First appearances are highly collectible (Batman's appearance in *Detective Comics* #27, Spider-Man's debut in *Amazing Fantasy* #15). And "Secret Origins" might be either first appearances or flashbacks, but collectors love them.

Some puerile fanboys like to collect swimsuit issues. (These are comic book versions of the famous *Sports Illustrated* issue, but featuring sexy versions of, say, She-Hulk or Storm.) Along this same line are variant nude covers featuring Cavegirl or Avatar's Hellina.

Other collectors pick up oddities such as *Sergio Aragonés Destroys DC* or *Punisher Kills the Marvel Universe*.

And still others like crossovers such as *Shi/Vampirella* or the *Amalgam* series from Marvel and DC. Also the improbable *Archie Meets the Punisher* and its corresponding *The Punisher Meets Archie* are popular with some collectors.

COMICS TRIVIA

Some four thousand copies of Dark Horse's *Conan* #24 were printed with a variant nude cover and distributed through the *Diamond Dateline* retail newsletter, shrink-wrapped in black plastic.[19]

FLASHBACK

I'm a diehard Wally Wood fan, ever since I saw his artwork in old EC Comics and early issues of *Mad*. I had to have them all. And later on I added his Steve Canyon spoof called *Cannon*, the World War II sexcapades of *Sally Forth*, even his pornographic Disney parody published in *The Realist*. What's more, I purchased his personal reference file—a collection of girlie photos used to draw his sexy babes. Hooboy!

FAVS

Many fanboy collectors look for comics penciled by a particular artist or with wordsmithing by a favorite writer. Needless to say, anything by Jack Kirby is highly prized. Some fans like the early *Micronauts* by Michael Golden. Others want to read every single issue of Chris Claremont's legendary run on *Uncanny X-Men*.

Specific books like Jack Kirby's *Fourth World* saga are big. Or Stan Lee's "Galactus Trilogy." Some go for obscure titles (the original Aircel *Men in Black* comics created by Lowell Cunningham or the confusing array of *Red Sonja* titles).

WHAT'S YOUR COMIC REALLY WORTH?

Determining the value of your comics can be tricky. There are many things to consider in pricing a comic. However, these simple guidelines should help you figure out how much your comic books are truly worth:

1. Consult a price guide.
2. Check with your comic book store.
3. Look at eBay (and other online sources).
4. Refer to current auction results.
5. Peruse classified ads.

Let's take them one at a time . . .

I. PRICE GUIDES.

Comic book price guides usually list the title and a suggested value based on condition. There are several reliable guides to choose from, but *Wizard* magazine and *The Official Overstreet Comic Book Price Guide* are among the more popular.

Keep in mind, the listed prices are only guidelines. The true value of a comic book depends on how much someone is willing to pay for it. That's the acid test.

The Official Overstreet Comic Book Price Guide *(House of Collectibles) is "widely considered the primary authority on the subject of American comic book grading and collection values in the industry."*[20] *Begun in 1970 by Robert M. Overstreet as a guide for fellow fans of Golden Age comics, the Overstreet price guide has expanded to cover the entire history of American comic books. Its thirty-seventh edition was published in 2007.*[21]

Overstreet also publishes a monthly magazine for serious comic book collectors called *Comic Book Marketplace.* You can find it at most comic shops.

The Standard Catalog of Comic Books (Krause) is another excellent reference. Compiled by John Jackson Miller, Maggie Thompson, Peter Bickford, and Brent Frankenhoff—the editors of *Comic Buyer's Guide* and *Comicbase*—this book is known as "the world's largest book about comic books."[22] Weighing over five pounds, it not only includes pricing info, but also creator credits, reviews, sales figures, and more for over 165,000 comic books.[23]

Comics Values Annual 2006 is another comic book price guide from the prolific Krause division of F + W. This tome features "95,000 listings for classic and contemporary comics that allow collectors to quickly evaluate and price collections."[24]

Wizard: The Guide to Comics is a monthly magazine devoted to comics fandom. Published by Wizard Entertainment (formerly known as Wizard Press), it carries articles about the comics industry, interviews with comic book creators, and a collectors' price guide in each issue.[25]

Founded by Gareb Shamus when he was a college student, *Wizard* began as a newsletter supporting his parents' comic book store. By issue #7, it became closer to the magazine it is today, printed in color on glossy paper. Wizard Entertainment is publisher of several fan-based magazines: *Toyfare, Inquest Gamer, Toy Wishes,* and *Anime Insider,* in addition to *Wizard.*[26]

2. COMIC BOOK STORE

Your local comic book guy will be more than happy to help you sell your prize EC Comics collection or your complete run of *Fantastic Four.* But he won't be too interested in that *Dr. Giggles* #1, for he probably has a bin full of them himself.

Keep in mind, he's running a business (sort of) and has to make a profit too. He'll either offer you a low-ball buyout price and take them into his own inventory—or he'll take them on consignment, negotiating with you for a cut of the sales price. He'll likely want 25 to 35 percent, depending on the circumstance.

3. EBAY

EBay auctions are a great way to see how much people are actually willing to pay for a comic book. Like any auction, final results depend on the pool of bidders. Sometimes a valuable item languishes. Other times, a mediocre piece gets caught up in a bidding war. But either way, checking auction sites will give you a good idea of what the comic book is going for right now.

And you can use a search engine like Google or Yahoo to find out more about the comics you own. Just type in the title of the comic book and see what information it turns up.

Also check to see what online retailers such as Mile High Comics or Fantasy Comics are selling their comics for to get an idea about the competition.

4. AUCTIONS

Check what comics are going for in big auction houses like Sotheby's or Heritage Auction Galleries. The comics they list may be pricier items than your humble collection, but you never know what will turn up. These are real sales, not theoretical valuations.

Other auction houses include Jay Parrino's The Mint, All Star Auctions, and MasgtroNet.[27] Also active with collectibles are Hunt Auctions, Leland.com, and Russ Cochran.[28]

5. CLASSIFIED ADS

Checking classified ads to see what other people are willing to sell their comics for will give you an idea of what yours might bring. There are several places you might find such ads: classified sections of newspapers, local shoppers, comic industry trade magazines such as *Comic Buyer's Guide.* In fact, when you subscribe to CBG, you sometimes get a free ad as a sign-up bonus. You could even advertise your comics to see what someone might offer you.

GRADING YOUR COMICS

Prices are partially based on the "grade" of your comic. A grade reflects the physical condition of a comic—rated on a scale of 0.5 (Poor) to 10 (Mint).

The abbreviations used for the various grades are as follows: mint (commonly abbreviated as MT or M), near mint (NM), very fine (VF), fine (FN), very good (VG), good (GD or G), fair (FR), poor (PR).

Many different factors are involved in the grading. Is the cover creased, torn, or unattached? Are the pages faded or yellowed? Have coupons been cut out of pages? However, even a comic book that is relatively worn can still be valuable if it's rare, very old, or features the first appearance of a character.

Comics Guaranty LLC is the primary company that provides third-party grading of comics. Located in Sarasota, FL, CGC's fees range from $15 to $1,000.

FOOTNOTE

Comics that show signs of restoration are issued a purple label, a designation that can severely reduce its price. Collectors sometimes call this the "purple label of death."[29]

Its grading system assigns numbers up to 10. Latex-gloved inspectors working in a humidity-controlled room assess the condition of the comic, checking for damage or restoration. After grading, the comic is sealed in a clear plastic case (sometimes called a "slab"). A label is then affixed indicating its official grade.

INSTANT INFO

"Comic book collectors, investors and dealers now have a real-time reporting system providing invaluable market data on CGC comics!" says the promo.[30]

GPAnalysis for CGC Comics enables collectors to determine current and past prices realized for specific comic books. This tool will even provide graphs of a given book's performance.

GPAnalysis provides subscribers with twenty-four-hour online access to its database. "By tracking, recording, and averaging all online auction results, GPAnalysis does the work for you," the promotion continues. "Want to know what a *Fantastic Four* #25 in 9.0 has been trading for? GPA can tell you. Want to know how much you can safely pay for an *Amazing Spider-Man* #129 in 9.4 condition? Piece of cake."[31]

SLABBING

This is the practice of encasing a graded comic book in plastic so that it is both well-preserved and tamper-proof after grading.

People interested in the value of a comic book applaud the practice for it avoids fraud, accidental damage, or any change in the comic after grading. Other mourn the fact that it's impossible to read or enjoy the "slabbed" book.

PRESERVING YOUR COMICS

Maybe you're not sending your comics off to be graded by CGC. Hey, it's costly. So forget "slabbing." But you still want to make sure your prized comics are preserved against damage or deterioration. Here's what you need to do:

Buy packages of Mylar sleeves and acid-free backing board at your local comic book store. Or order it online from companies like Mile High Comics or Bud Plant. Make sure you choose the right size. The dimensions of comic books have changed slightly over the years. Modern comics are not as wide as Silver Age books.

Place each comic in a Mylar sleeve that covers the book like a clear envelope. Insert an acid-free backing board to keep it straight. Make sure the treated

SPEAKING UP!

"During my 32 years in the world of collecting comics, I don't think I've ever witnessed a phenomenon that has ignited as much controversy as 'slabbing' comics," says Chuck Rozanski of Mile High Comics. "Ever since Comics Guarantee Corporation first appeared on the scene . . . there has been an ongoing heated debate as to the propriety of having comics graded by this ostensibly disinterested third-party company. Of particularly intensity has been the debate as to their policy of sealing graded comics in hardcase plastic holders, which cannot be opened without voiding the grading guarantee. I have to admit that my first reaction to CGC's proposal for endorsement at the 1999 Overstreet Advisor's Conference was immediate hostility. I have always been an advocate of reading the comics you buy, even if you've purchased them as an investment. The idea of sealing rare comics in a hardcase holder . . . was an anathema to me. What swung me around to accepting, but not endorsing, CGC's participation in the comics market, was their agreement (under pressure from conference attendees) to make their hardcases reasonably easy to open, and their willingness to reseal and certify those cases for a reduced fee. To me, that seemed like a reasonable compromise."[32]

side is facing front. Place the comic's back cover on the backing board's glossy side and slide both into the sleeve, cover facing out.

Store your comics in short or long comic book boxes with the bagged and boarded comics standing up (not stacked atop each other). The short-length boxes hold about a hundred comics, the long-lengths about three hundred. The short ones are far easier to handle in an average closet.

Keep the boxes in a low-light-level, humidity-free environment. Avoid smoke and extreme ranges in temperature. Replace the boards every five years or so.

"Does it work?" posits Burl Burlingame of the *Honolulu Star-Bulletin*. "I pulled a short box of comics out of my attic, where they've resided for nearly two decades. . . . Other than some discoloration of the box itself, and a fingerprint-like pattern worked into the outside of each bag, the comics look pretty much like the day they were read once and then carefully stored away. Great. Now what do I do with a complete run of *Dagar the Invincible?*"[33]

TIP

Yes, you can buy cheap plastic sleeves. But if you want to keep your books as an investment for more than five years, don't be stupid. Use a high-quality long-term backing board made from acid-free paper and high-quality Mylar sleeves.

NOT JUST COMIC BOOKS

Comics fanboys and kindred collectors sometimes go beyond those thin periodicals featuring their favorite superheroes or funny animals or cowboys or old EC horror. These fanboys often collect original artwork, toys, trading cards—you name it.

ORIGINAL ARTWORK

"Collecting comic art is a very simple task, and in the end can be unusually satisfying," advises one collector. "All that you really need to begin is a mild understanding of the creation of the actual artwork, and an interest in a particular character or an artist's work. From there it becomes startlingly easy to find and purchase (or trade for) original comic art."[34]

Original artwork is usually a page used in the making of a comic book. These 11-by-17-inch Bristol boards are 150 percent the size of the printed page. The lead artist draws the scenes in pencil (the "penciler"), which is gone over in ink by a second artist (the "inker") to add definition, shadowing, depth—although with the advances in computerized coloring this second step is increasingly skipped these days.

This artwork is used to produce a particular issue of a comic book, then is traditionally returned to the artist. There's a formula for how

many pages of a specific book go to the penciler and how many to the inker (usually two to one). These artists sometimes supplement their incomes by selling off those pages to collectors and fans.

Obviously, price depends on a willing buyer and a willing seller. If Brazilian comic book artist Mike Deodato, Jr. (real name: Deodato Taumaturgo Borges Filho) offers to sell a page from a recent issue of *Thunderbolts,* it's up to you to accept his price or politely decline. But usually you're dealing with a middleman—agent, online gallery, comic book shop. (Deodato's agent, Glass House Graphics, offers original artwork by its stable of artists on its website.)[35]

There is a supply-and-demand side to this. Artists who don't make a practice of selling their art may be in more demand—and more pricey—than guys who dump it by the carload.

Also vintage can play a role in pricing. Golden Age art will most often sell for more than, say, Bronze Age art.

There's also a name thing. You can expect to pay more for an A-list artist like Jim Lee than a B-list artist like Bart Sears. Or more for an original Frank Frazetta than even a Gene Colon or Alan Davis.

FLASHBACK

I was always a Harvey Kurtzman fan. I collected every *Mad* he edited, every *Humbug,* every *Help!,* even those two rare issues of *Trump* that were backed by *Playboy.* Imagine my delight when I learned a computer designer I knew used to assist Kurtzman—and that she had a stack of his old sketches. I talked her into selling me a tracing-paper drawing from *Little Annie Fanny,* which hangs framed on my kitchen wall. A prized possession.

Some people collect the color guides that are used in coloring a comic book. Others buy original sketches. Even doodles.

What's it cost? The average price for superhero pages is $100 to $500. Hal Foster's *Prince Valiant* comic strips "from the 1960's might sell as low as $1,000 today, but originals from the earlier years trade for as much as $20,000. And sometimes even more."[36]

Keep in mind that each piece of art is unique, even if it's from the same comic book as another piece. A splash page featuring the titled superhero in a dramatic action pose will likely fetch a better price than an inside page filled with humdrum establishing scenes.

Where can you find this original art?

> » At comic conventions (called "comic-cons"). The San Diego Comic-Con each July is the largest—and a great place to find art being sold by dealers and artists alike. The Wondercon is second largest. Followed by Wizardworld. Not to mention a number of regional conventions such as the New York Comic Convention or Heroes Con in Charlotte.
> » In comic shops. Catch as catch can, but I've found sketches by George Pérez and Marie Severin, pages from old *Batman* comics, even rare animation cels. "We used to carry them, but

not lately," says Gerry Gladstone, owner of New York City's Midtown Comics.[37]

» Direct from the artist—if you can make the connection. Most of them use brokers these days to sell their art. Brokers frequently create web pages for that purpose, so try Googling your favorite comics artist.

» Other collectors. But they can be stingy about letting go of prized artwork. Or looking to make a fat profit.

» On eBay. Recent listings included a Frezetta pencil sketch priced at $2,700, Steve Ditko pages at $310, and a John Romita, Jr., Spider-Man drawing at $300.[38]

» At auction. Heritage Auction Galleries, Jay Parrino's The Mint, All Star Auctions, and MasgtroNet specialize in selling comics collections. Even the lofty Sotheby's auctioned off items from the Marvel Comics collection in the early 1990s.

FLASHBACK

Collecting is where you find it. On my walls I have painted pages from *Code of Honor* (purchased directly from the artist), a sketch of Captain America signed by Jack Kirby (purchased from a comics dealer), two cels from the *Heavy Metal* movie (purchased at the San Diego Comic-Con), a page from *Preacher* (purchased at a comic book shop), a drawing of Lara Croft by Dave Finch (purchased on eBay), a pencil of Little Annie Fanny by Harvey Kurtzman (purchased from his former assistant), a page from the Marvel Knights *Daredevil* #1 (a gift from Joe Quesada and Jimmy Palmiotti), and a poster by Adam Kubert (a gift from the artist). Not to mention dozens of other drawings by Jim Lee, Adam Pollina, Marie Severin, and George Pérez. Okay, you may not get gifts from your favorite comic artists, but you can purchase artwork from comic dealers and eBay as easily as I can!

Comic book publishers do not sell art to the general public, so don't bother to write to DC to buy the splash page from the latest *Birds of Prey*. "However, we will forward the letter to the artist," says DC's David Hyde. Same is true at Marvel and Archie.[39]

Several museums, including the Cartoon Art Museum in San Francisco, sell art as part of the maintenance of their museum.[40] And some artists donate artwork to charities, which in turn auction it off to raise money for a good cause.

Since its inception, the Hero Initiative (formerly known as ACTOR) has helped "more than 30 different creators, paying out more than $200,000 worth of aid," says Jim McLauchlin, who is president of this nonprofit organization dedicated to helping comic book veterans with emergency medical aid, financial support for life essentials, and an avenue back into employment. Setting up at most conventions, the org brings in top talent to sign books and sketch for fans in exchange for donations. It also auctions off artwork and memorable experiences, such as lunch with a favorite creator.[41]

The Comic Book Legal Defense Fund is another. For instance, CBLDF uses Sketch Cards as a fundraiser activity! These high-quality drawing cards are available at the CBLDF booth for you to use to get great sketches from fund-supporting artists.[42]

GOOD ART

You need to know what you're buying—good art or bad art. "One example might be the work of the late, great Milton Caniff," explains Comic Art and Graffix Gallery. "Caniff was the artist and creator of *Terry & the Pirates* from 1934–46, and latterly *Steve Canyon*. His *Terry* daily strip originals from the period 1936–38 are highly sought after and sell generally in the $300–500 range. But the dailies dated 2–6–36 and 10–7–39 recently traded for $2,000 and $3,000, respectively. The example from 1936 is said by some to be the finest single example of the chiaroscuro technique Caniff employed."[43]

AUTOGRAPHS

Some folks like to collect the John Hancock of a John Buscema.

Comic-cons are a great source for autographs. There you can get comic books, posters, and sketch cards signed. Even have a favorite creator sign your arm (which you'll never wash again!). Comic book publishers often have creators do signings at their booth.

TOYS

Tom Conboy is a comics insider who has worked for Marvel and now handles the circulation and distribution for *Wizard*, the comics fan magazine. For years Tom has collected comic-related toys—not to play with, heaven forbid, but for their future value. In fact, he's careful not to remove the toys from their packaging, for an unopened Transformer Bumblejumper is worth $400 versus $40 for the loose toy. Quite a spread!

Got an action figure collection? You can always check current pricing with *ToyFair*, the toy collectors' fan magazine published by those *Wizard* folks.[44]

TRADING CARDS

Topps is tops. Fleer and Skybox used to be owned by Marvel. Fleer (incorporating Skybox) is now part of the Upper Deck Company. Upper Deck has exclusive agreements to produce memorabilia with such sports superstars as Michael Jordan, Tiger Woods, and Ken Griffey, Jr.[45]

A **trading card** (or **collectible card**) is a small card intended for trading or collecting. Originally they were premiums distributed with tobacco products but later became popular as inserts in bubblegum

packs. Eventually, the cards became more desirable than the gum, with today's trading card packs containing only cards themselves.

Trading cards have been traditionally associated with sports, particularly baseball, to the extent that other cards dealing with other subjects are known as **editorial trading cards** (or simply **nonsports trading cards**). These often feature cartoons, television personalities, or comic book superheroes.[46]

COLLECTOR MENTALITY

"Just after Davis Crippen's death . . . at age 75, his son dusted off the 11,000 comic books in his father's collection to get them ready to be sold," reports the Associated Press. "Expecting to get about $50,000 from the four-month-long task, he was surprised to find that the collection his father had amassed in the 1930s and 1940s—known as the 'Golden Age' of comics—was worth about $2.5 million . . .

"Tom Crippen said his father's books were in such good condition because he hardly ever read them.

"'This man who built one of the great collections—he was not that interested in comics,' Tom Crippen said. 'He liked the idea that he had thousands and thousands and thousands of vintage comic books tucked around the house, but he didn't really think about it day to day.'"[48]

BEGINNER'S ADVICE

"When I started collecting comics I knew only that I had read *The Crow* and loved the *Daredevil* movie and wanted to read those books," recalls Gareth Atha. "I went off one day to my local shop and asked the guy behind the counter what titles he recommended. He gave me *Watchmen, The Dark Knight Returns* and *Sandman Vol. 1: Preludes and Nocturnes.* I bought them and off I went, loving every page I read. I later learned that all comics collectors seem to worship these titles as building blocks for a collection. These books are good. No. They're great, some of the best examples of comic book storytelling there is, but they may not necessarily be the right titles to start your collection off on. You need to find your own feet in this, like everything else. So, if you know you want to start collecting comics for good stories, try some of the more famous titles such as *Batman, X-Men* and the like, and then move onto the more obscure titles later. . . . One thing is for certain, you are starting out in a wonderful hobby that will bring you years of pleasure."[49]

INTERVIEWER: Your collection is frequently the subject of discussion or rumors in the business. How big is it?

PAUL LEVITZ: I guess I have about 30,000 comics, or something like that. It's not one of the larger collections of the working professionals of my generation.

INTERVIEWER: What do you think of collecting at the moment? Are there too many things being produced, not enough, just the right amount?

PAUL LEVITZ: Collecting is a matter of personal passion. I had a friend, one of the pioneers of the direct sales business, who collected rabbits, ceramic rabbits, stuffed rabbits, etc. I have a lawyer friend who collects stuffed cows. I think people collect what moves them, what strikes them, and I don't think you can have too much variety in the world for people to decide what it is they would like to collect.

INTERVIEWER: Do you think collecting seems to be more socially accepted now?

PAUL LEVITZ: I think the challenge in collecting now is deciding what to collect, and in finding your path and pattern to it. It's really a case of what moves you emotionally. . . . It's wonderful to collect stuffed cows, if that's what makes your day, give 'em each a name, and you know each one's story, God bless you. If you're interested in collecting comics because they're more fun than stuffed cows because you can actually read them, pick a run of something. Follow the evolution of it. There's so much great stuff, going way back, that's inexpensive to collect as a place to start. Find something wonky. Collect all the gorillas, collect the year of go-go checks, collect the year Marvel was Marvel Pop Art comics, collect every comic from the month the art changed in paper size and see what that did to the artists' work in the transformation, collect all of a favorite writer or artist. Follow whatever trail moves you.[50]

QUESTIONS FOR FURTHER THOUGHT

1. What does CGC do?

2. Which is a magazine—*Wizard* or *Overstreet*? And what is the other?

3. What's "slabbing"?

4. What's the difference between a collector and a packrat? Or is there any?

5. Name four things that might make a particular comic book scarce (and thereby valuable).

COMICS IN EDUCATION, EDUCATION IN COMICS

STEVE GEPPI

THE role of comics in education has changed drastically over the years, and now it's changing even more. From the stereotype of the teacher taking comics away from children, which dates approximately from the 1940s or 1950s, things have turned 180 degrees.

With local media well represented on Thursday, May 3, 2007, at Geppi's Entertainment Museum, the Maryland State Department of Education (MDSE) announced that teachers piloting the state's unique Maryland Comics in the Classroom Initiative rate the program an effective, enjoyable education tool that enhances student interest in reading and produces positive results.

Maryland State Superintendent of Schools Nancy S. Grasmick was among the officials on hand, with area teachers, principals, parents, and students at the museum for the announcement. According to MDSE, the still relatively new Comics in the Classroom program uses classic Disney comics in ten active lessons for the third and fourth grades. Working with Disney Publishing Worldwide and Diamond Comic Distributors, MSDE

developed materials for several grade levels that are being piloted at various schools throughout the state.

MSDE's broader graphic literature program, the Comic Book Initiative, began in September 2004 to explore the use of comics and graphic novels in classroom settings. It was developed by a creative team that includes award-winning teachers, reading specialists, educational administrators, library specialists, comic book authors, and publishers. This unique statewide project does not mandate comic books or replace traditional classroom materials. Rather, the program provides options for teachers as they seek to encourage reading in students of all ages.

This, of course, is not the first time comics have been used in the classroom. If you go back to Texas in the late 1920s, teachers were the main reason that installments of the popular *Texas History Movies* daily comic strip were collected into a textbook. Various versions of that collection were used for subsequent decades before briefly fading from view.

In most places, though, the image of the teacher as the opponent of comics took hold and was popularized as a commonly shared experience. What would those teachers think of today's movement? Certainly some of them would complain, but I'd like to think that most of them could be persuaded by the notion that giving students the gift of reading is more important initially than the choice of reading material.

The development of this field is by no means finished, either. Who can say what the future of the medium and its role in education holds? It will be fun to speculate, though. Based on the growth of insightful publications like this book, one might even expect that path to that future to be lined with the four-color, well-educated world of comics.

COMICS AND EDUCATION

Here is a reading list culled from the syllabus of a proposed course to teach American Studies through the medium of superhero comic books by University of Maryland professor D. Snyder.

Comics Defined

Understanding Comics: The Invisible Art, Scott McCloud

Superheroes: A Modern Mythology, Richard Reynolds

Superman

Superman: Archives, Volume 1, Jerry Siegel & Joe Shuster

Myth/Symbol

Captain America: The Classic Years, Joe Simon & Jack Kirby

Gender

Wonder Woman #1, Charles Moulton

Wonder Woman #162 [The Authentic Origin of Wonder Woman's Secret Identity rewritten in 1966] Charles Moulton

Wonder Woman: The Once & Future Story, Trina Robbins

Race

Icon, Dwayne McDuffie

Sexuality

Chasing Amy, Kevin Smith

The Enigma, Peter Milligan and Duncan Fegredo

Multiculturalism

X-Men: The Dark Phoenix Saga, Chris Claremont, John Byrne and Terry Austin

Disability

Daredevil: Born Again, Frank Miller

Postmodern Comics

Marvels, Kurt Busiek and Alex Ross

The Watchmen, Alan Moore

Vigilante Justice

Batman: The Dark Knight Returns, Frank Miller with Klaus Janson and Lynn Varley

Batman: No Man's Land, No Law and a New Order, Bob Gale, Alex Maleev and Wayne Faucher

The Many Lives of Batman: Critical Approaches to a Superhero and his Media, Eds. Roberta Pearson and William Uricchio

Cultural Landscapes and Whiteness Studies

Astro City: Life in the Big City, Kurt Busiek and Brent Anderson

Cyberculture and Cyborg Theory

Ronin, Frank Miller

Ghost in the Shell, view the movie or read the magna (comic book)

Dark Minds, Pat Lee, Adrian Tsang and Alvin Lee

Comic Futures of America

Kingdom Come, Mark Waid and Alex Ross

Earth X, Jim Krueger, Alex Ross, John Paul Leon and Bill Reinhold

COMICS MILESTONES

A NO-BRAINS-REQUIRED SUMMARY

THROUGHOUT this wild-and-wacky history, I've identified thirteen milestones that have played a role in making the comic book industry the way it is today. You can argue whether these milestones were positive or negative—but you cannot deny their impact on comics.

Here I restate them for your easy reference (just in case you suffer from a short attention span):

» **Milestone #1:** The Comic Book Format Is Invented.
 Maxwell C. Gaines invents a new format for comics; Major Malcolm Wheeler-Nicholson adds original content.

» **Milestone #2:** DC and Marvel Comics Emerge.
» The beginnings of the two comic book publishers that will come to dominate the industry.

» **Milestone #3:** The Superhero Genre Is Introduced.
Joe Shuster and Jerry Siegel come up with Superman, establishing the superhero genre, which will become the dominant content of comics.

» **Milestone #4:** *Seduction of the Innocent* is Published and Launches a Witch Hunt That Begets the Comics Code.
The industry survives a challenge that makes it stronger and self-policing.

» **Milestone #5:** Stan Lee and Jack Kirby Create a New Kind of Superhero.
Two legendary creators reinvent the superhero concept by humanizing the characters.

» **Milestone #6:** The Direct Market Is Developed.
A "network" of specialized comic book retailers allows publishers to sell comics on a nonreturnable basis.

» **Milestone #7:** With Darker Knights, Comic Books Become Literature.
The Dark Knight Returns, Watchmen, and *Maus* prove that comics can be literature as well as entertainment.

» **Milestone #8:** Comics Are Leveraged as Intellectual Properties.
The industry finds a new economic model that does not depend entirely on selling comics.

» **Milestone #9:** The Speculator Market Rises and Falls.
Comics become important collectibles, but the industry abuses the concept.

» **Milestone #10:** Creators Become Superstars (and Image Comics Is Formed).
Fans recognize the importance of creators, imbuing them with more power.

» **Milestone #11:** Marvel Emerges from Bankruptcy and the Industry Rebounds.
The comics industry survives another threat and shows signs of recovery.

» **Milestone #12:** Comics Become Valuable Movie Properties.
The movie industry embraces comics as source material for blockbusters.

» **Milestone #13:** Graphic Novels and Manga Enter the Media Mix. New formats change the way comics are sold—and read.

These are the key events—milestones—that have created the comic book industry as we know it today. However, there are more milestones to come as this unique American art form morphs and grows. Will sequential art storytelling go away? No. Will we lose the modern mythology of our superheroes? No more than we've lost tales of Zeus and the gods of Olympus. Will comic books as we know them disappear? Who knows—that chapter hasn't been written yet.

COMICS INDUSTRY PROFILES

FANBOYS WHO MADE IT HAPPEN

A select alphabetical listing of artists, writers, publishers, packagers, marketers, owners, and various hangers-on in the comic book industry. Apologies to any names inadvertently left out!

Neal Adams—A comic book artist who helped create the definitive imagery of such DC Comics characters as Batman and Green Lantern.

Ross Andru—Penciler who succeeded John Romita, Sr., on *Amazing Spider-Man*.

Jim Aparo—The artist best known for his 1970s *Batman* series.

Avi Arad—The Israeli toy designer who scaled the heights of Hollywood as head of Marvel Studios. Now runs Ari Arad Productions.

Sergio Aragonés—A cartoonist familiar to *Mad* readers for his wordless marginal contributions. Although known for his *Groo the Wanderer* series, comic book fans chuckled

over *Sergio Aragonés Massacres Marvel* and *Sergio Aragonés Destroys DC*—his comical interpretation of Marvel's and DC's superheroes.

Frank Armer—A 1930s pulp magazine publisher whose racy titles—*Pep, La Paree,* and *Spicy Stories*—were taken over by Harry Donenfeld.

Everett M. "Busy" Arnold—An early comic book entrepreneur and publisher of Quality Comics. With a degree in economics from Brown University, he saw a financial opportunity in giving Depression-era audiences "established quality and familiar comic strips for their hard-earned dimes."

Chris Bachalo—An artist known for his "quirky, cartoon-like style." He illustrated several of Marvel's X-Books, including *Generation X,* which he helped to create.

Mark Bagley—The artist who drew Marvel's *Thunderbolts,* which included one of "The 25 Greatest Comic Moments Ever." He broke into comics by entering his work in the *Marvel Try-Out Book* contest. He drew *Ultimate Spider-Man.*

Cark Barks—A Disney Studio illustrator best known for his series of Scrooge McDuck comics. Will Eisner called him "the Hans Christian Andersen of Comic Books."

Adolphe Barreaux—The artist who created "Sally the Sleuth," a comic strip that began appearing in *Spicy Detective Stories* in 1934.

C. C. Beck—The Fawcett Comics artist who drew the Captain Marvel character created by writer Bill Parker. The popularity of Captain Marvel allowed him to set up his own studio to ensure that the comic books maintained his clean, simple style.

Allen Bellman—Golden Age artist who was part of the Timely stable.

Brian Michael Bendis—A writer and sometime artist noted for his "wordy" scripts and protracted story buildup. A manga influence is seen in his use of decomposition in *Ultimate Spider-Man.*

Dave Berg—A cartoonist known for his "Lighter Side" strips in *Mad.* In his early days he worked with Stan Lee at Timely Comics on such titles as *Combat Kelly.*

Karen Berger—The DC editor who came up with the Vertigo concept. She has won the *Comics Buyer's Guide Award* for Favorite Editor every year since 1997.

Jack Binder—The man who ran a studio that produced comics for publishers.

Steve Bissette—Artist best known for his *Swamp Thing* work.

Tex Blaisdell—An artist known for his work on *Little Orphan Annie*. He teamed with Joe Orlando on several projects.

Vic Bloom—The writer who scripted perpetual teenager Archie Andrews's first appearance—in *Pep Comics* #22.

Vaughn Bode—An underground comix artist, best known as creator of *Cheech Wizard*.

Bob Bodiansky—One of Marvel's group editors, in charge of the Spider-Man titles.

Joe Brancatelli—Journalist who published the short-lived *Inside Comics* and the one-shot *Phase*.

Tom Brevoort—Worked his way up from intern to executive editor at Marvel. Handles such titles as *New Avengers, Fantastic Four,* and *Civil War.*

E. Nelson Bridwell—A writer for *Mad* and various comic books such as *Shazam!* and *Superman*. He created the famous punchline "What you mean we, white man."

Raymond Briggs—The British artist whose graphic novel *Ethel and Ernest* won Best Illustrated Book in the 1998 British Book Awards.

June Brigman—An artist best known for co-creating *Power Pack* with Louise Simonson. She has drawn the newspaper strip *Brenda Starr* since 1996.

Dan Buckley—The sports marketer who came back to Marvel as its president and publisher.

Carl Burgos—The artist best known for creating the Human Torch in *Marvel Comics* #1.

John Buscema—An artist noted for his work on *The Avengers*. Produced the first regular *Wolverine* series with Chris Claremont.

Kurt Busiek—The writer has a long string of credits, ranging from a celebrated run on Marvel's *Avengers* to his self-titled *Kurt Busiek's Astro City.*

Steve Butler—The artist who took a turn at redesigning Archie's girlfriend's Betty and Veronica.

John Byrne—A British-born writer-artist, noted for his work on *X-Men* and *Fantastic Four,* as well as rebooting the *Superman* franchise in 1986.

Jerry Calabrese—The former *Playboy* publishing exec who served two separate terms as president of Marvel. He is now the president of Lionel Trains.

Joseph Calamari—An interim president of Marvel Comics under Carl Icahn's brief ownership and the court-appointed bankruptcy receiver. His plan was to launch new universes. His nickname was "Joe Squid."

Eddie Campbell—The Scottish-born artist who published and illustrated the *From Hell,* a graphic novel written by Alan Moore. His artwork is known for its scratchy pen-and-ink style.

Milton Caniff—Comic strip artist known for his *Terry & the Pirates* and *Steve Canyon* creations.

Al Capp—a grumpy, one-legged genius famous for his *Lil Abner* comic strip and *Fearless Fosdick* parody.

Mike Carlin—A top editor at DC Comics, noted for devising the "Death of Superman" event. He started out as a writer and artist on Marvel's *Mad* wannabe, *Crazy* magazine.

Jackie Carter—The Scholastic editorial director brought to Marvel to create a kids' line.

Michael Chabon—Pulitzer Prize–winning author of *The Amazing Adventures of Kavalier & Clay,* a novel about the early days of the comic book industry. He is the creator of *The Escapist* comic book, based on elements of his novel.

Paul Chadwick—Provided art for Marvel's *Dazzler* before he created his own character called Concrete.

Bobbie Chase—One of the five group editors in Marvel's early-1990s experiment, heading up the Marvel Edge titles. She is noted for editing Peter David's *Incredible Hulk,* Larry Hama's *G.I. Joe,* and a solid run of *Fantastic Four.*

Howard Chaykin—Noted artist-writer whose *American Flagg* redefined comics for readers in the 1980s.

Harry "A" Chesler—The first comic book packager, he created complete comics for other publishers. The "A" being an affectionate nickname rather than a true initial, he quipped that it stood for "Anything."

Chris Claremont—The writer best known for his seventeen-year stint on Marvel's *Uncanny X-Men.* With a highly descriptive writing style, he is regarded for his strong female characters.

Becky Cloonan—An artist recognized for her manga-influenced *East Coast Rising*. Her best-known work is the twelve-issue series *Demo* with Brian Wood.

Daniel Clowes—The writer and cartoonist best known for the movie *Ghost World*, which he adapted from some of his stories.

Dave Cockrum—Along with Len Wein, he revitalized the *X-Men* franchise as well as co-creating such characters as Storm, Colossus, and Nightcrawler.

Jack Cole—The artist who created Plastic Man. He was also a popular *Playboy* cartoonist.

Max Allan Collins—The mystery writer who wrote the graphic novel *Road to Perdition*, invented the comic book private eye *Ms. Tree*, and took over the *Dick Tracy* comic strip from creator Chester Gould.

Ernie Colón—An artist who has worked on titles ranging from Marvel's *Damage Control* to DC's *Arak*. In 2006, he released the *9/11 Commission Report* with writer Sid Jacobson.

Gene Colon—His photorealistic approach was well suited to a series of war comics and *Hopalong Cassidy*. He had long runs on Marvel's *Daredevil* and DC's *Batman*, and applied his shadowy style to Warren's *Eerie* and Marvel's *Dracula Lives!*

Amanda Conner—The artist known for her work on Harris Comics' *Vampirella*. She has worked on titles ranging from DC's *Birds of Prey* to Marvel's *Excalibur*, as well as the creator-owned *The Pro* with Jimmy Palmiotti and Garth Ennis for Image.

Gerry Conway—The seventh editor in chief of Marvel. Best known for co-creating the Punisher with artist Ross Andru. He also wrote the death of the character Gwen Stacy during his long run on *The Amazing Spider-Man*.

Richard Corben—The artist best known for his fantasy strips in *Heavy Metal*.

Maurice Coyne—An accountant who was one of the founders (the "M") of MLJ, the company that would become Archie Comics.

Paul Crecca—The big redhead who was Marvel's CFO and general manager during the Marvel bankruptcy.

Robert Crumb—An underground comix artist, best known for creating *Zap Comix* and *Mr. Natural*. He was the subject of Terry Zwigoff's documentary *Crumb*.

Lowell Cunningham—The writer who created the alien-infested *Men in Black* comic books, the basis for the hit movies.

Terri Cunningham—DC's current director of editorial administration. The ultimate scheduler of talent.

Peter David—A marketer turned writer, he is known for adding emotional depth to the *Hulk* series. Also a popular columnist ("But I Digress . . .") who comments on the comics industry.

Jack Davis—The artist who freelanced for EC Comics' horror titles, eventually finding his place with Harvey Kurtzman's *Mad*.

Dan DeCarlo—Longtime Archie artist who created *Josie and the Pussycats*.

Nicholas De Crecy—A French graphic novelist known for such works as *Glacial Period, Leon the Junkie,* and *Salvatore*.

Tom DeFalco—A longtime editor in chief of Marvel. He created over three dozen characters, including Spider-Girl. His better-known work includes the *Spider-Man* series and *Dazzler*.

George Delacourte—Founder of Dell Publishing. His company published the first retail comic book, Max Gaines's *Famous Funnies* #1, in 1934.

J. M. DeMatteis—A writer who bridged DC Comics' *JLA* and *JLI*. Also known for his work on Marvel's *The Spectacular Spider-Man*.

Mike Deodato, Jr.—A pseudonym for a Brazilian artist named Deodato Taumaturgo Borges Filho. He gained recognition for his work on *Wonder Woman*. His other work includes *The Incredible Hulk, Squadron Supreme,* and *Amazing Spider-Man*.

Dan DiDio—The ABC network exec who became senior vice president and executive editor of DC Comics. He was chosen by *Wizard* magazine as its first-ever "Man of the Year" in 2003.

Ed Dietze—Business manager for the Marvel publishing division during the Comic Wars era.

Dick Dillon—Longtime artist on DC's *Justice League of America*.

Steve Dillon—British comic book artist known for his run on DC's *Hellblazer* and *Preacher*.

Steve Ditko—The reclusive artist who co-created Spider-Man with Stan Lee.

John Dokes—Marvel Comics marketing executive. Also known for his fine singing voice, acting skills, and penchant for swing dancing. A mainstay at the Marvel booth during San Diego's Comic-Con.

Harry Donenfeld—The hustler who built a small pulp magazine business into DC Comics. He published *Action Comics* #1, the first appearance of Superman.

Irwin Donenfeld—Son of Harry Donenfeld. He became editor and later publisher of DC Comics.

Max Douglas—An artist who invented the term "likemoviesonpaper" for sequential art storytelling.

Will Eisner—The artist who coined the terms "sequential art" and "graphic novel" as well as creating the Spirit. He was an early comic book packager and the namesake of the industry's Eisner Awards.

Will Elder—The artist known for his *Mad* magazine work, the satirical *Goodman Beaver* strip, and *Playboy*'s Little Annie Fanny—all with Harvey Kurtzman.

Warren Ellis—The British writer of comic books and graphic novels. He is known for *Transmetropolitan*, the Vertigo title he did with artist Darick Robertson.

Steve Englehart—A writer known for his complex style and handling of philosophical issues with such Marvel titles as *Defenders* #1–11 and *Captain America* #153–186.

Garth Ennis—An Irish writer best known for Vertigo's *The Preacher*, which he co-created with artist Steve Dillon.

Vince Evans—An artist known for his painterly style. His realistic artwork has been featured on *Spider-Man* posters, *Captain America* covers, *Code of Honor* limited series, and the *Matrix* comic book line.

Bill Everett—The artist who created Namor the Sub-Mariner while working at Funnies, Inc., and co-created Daredevil with Stan Lee.

Vince Fago—The editor who filled in for Stan Lee at Timely during World War II.

Al Feldstein—The EC editor who launched *The Vault of Horror* and *Tales from the Crypt*. Working with Bill Gaines, he enjoyed a lengthy career as editor of *Mad*.

John Ficarra—Current editor of *Mad* magazine. A protégé of Madman Bill Gaines.

Joe Field—The California comic shop retailer who originated Free Comic Book Day.

Louis Fine—A Golden Age artist known for his draftsmanship on projects such as the *Blue Beetle* #1 cover. He cranked out comics for such early entities as Eisner & Iger, Fiction House, and Fox Feature Syndicate.

Bill Finger—A writer who was the uncredited co-creator of Bob Kane's Batman. Finger also claimed to have come up with Batman's sidekick Robin.

Danny Fingeroth—The comics veteran who wrote an insightful book about superhero archetypes called *Superman on the Couch.*

Max Fleischer—The animator who brought *Popeye, Betty Boop,* and *Superman* to the silver screen with his 1940s cartoons.

Michael Fleisher—Probably best known for writing DC's *Jonah Hex.* Unsuccessfully sued sci-fi writer Harlan Ellison and *The Comics Journal* for calling him "crazy" in print.

Hal Foster–A comic strip artist acclaimed for the realistic style of his *Prince Valiant* comic strip.

Gardner Fox—The writer credited with creating the concept of the DC Universe.

Victor Fox—An early publisher who ran Fox Feature Syndicate. An indicted stockbroker, some say he was an accountant for DC before launching his own publishing house.

Frank Frazetta—An artist known for his heroic paintings of Conan, warriors, and luscious damsels in distress. One of the most influential fantasy and sci-fi illustrators.

Neil Gaiman—The British writer of sci-fi and fantasy, well known for his *Sandman* work for DC.

Maxwell C. Gaines—Creator of the first American comic book. He partnered with Jack Liebowitz on All-American Comics, then launched EC Comics. Father of *Mad* publisher Bill Gaines.

William M. Gaines—Son of Max "Charlie" Gaines. Following his father's untimely death, he took EC Comics in a "New Trends" direction that included horror and crime comics. Launched *Mad,* a mainstay humor magazine, following implementation of an industry-wide Comics Code that banned graphic horror.

Jim Galton—An early president of Marvel Comics. A character was named after him, "Big Jim" Galton, one of the Enforcer's henchmen in *Ghost Rider.*

Dave Gantz—An artist known for his work as a newspaper cartoonist.

Steve Geppi—The former postman who transformed the comics industry by establishing the Direct Market with his Diamond Comic Distributors and related companies. He is also founder of the Geppi Entertainment Museum, devoted to pop culture.

Steve Gerber—The creator of Howard the Duck, a cantankerous quacker in a people-filled world.

Dave Gibbons—The British artist who illustrated Alan Moore's twelve-issue limited series *Watchmen.*

Alison Gill—DC's current vice president of manufacturing. With a clipped British accent, she "keeps the trains running on time."

Richard "Dick" Giordano—An inker known for his work with Neal Adams, he was also an editor at Charlton Comics, helped establish Adams's Continuity Comics, and served as managing editor at DC under Jenette Kahn, helping establish its "new look."

Howard Gittis—One of Ronald Perelman's chief deputies, a "Townhouse insider."

Gerry Gladstone—President of New York's Midtown Comics and an industry booster.

Leverett "Lev" Gleason—An early publisher of such titles as *Crime Does Not Pay, Captain Battle,* and *Daredevil* (not the Marvel version).

Michael Golden—An art director for Marvel, particularly known for his artwork on the *Micronauts.*

John L. Goldwater—One of the three MLJ founders (the "J"). The publisher who came up with a teenage character called Archie. The company would be renamed after the popular redheaded teen.

Richard H. Goldwater—Son of one of the founders, he took over as president and co-publisher of Archie Comics in the mid-1980s.

Martin Goodman—Founder of Timely Comics, the publishing company that became Marvel Comics. Married to Stan Lee's cousin.

Archie Goodwin—The eighth editor in chief of Marvel. But Goodwin is best known for his editorship at Warren Publishing, where he helped invent the *Vampirella* mythology.

Victor Gorelick—The top editor at Archie Comics. He has worked at "Riverdale" since he himself was a teenager. He took over as managing editor when Richard Goldwater became president and co-publisher.

Ron Goulart—The sci-fi writer who is also a comics and pop-culture historian. He wrote the popular *TekWar* series of books credited to the actor William Shatner.

Chester Gould—Comic strip artist famous for his *Dick Tracy* creation.

David S. Goyer—A popular Hollywood scriptwriter who also writes comics.

Alan Grant—A Scottish writer best known for his work on *Judge Dredd.*

Devin K. Grayson—Writer responsible for such titles as *Batman: Bruce Wayne, Fugitive* and *X-Men Evolution.* She's best known for her work on *Nightwing.*

Milton Griepp—The director of ICv2.com, a trade news website focusing on comics and pop-culture merchandise.

Mark Gruenwald—The Marvel editor who created *The Handbook of the Marvel Universe.* His magnum opus was the twelve-issue miniseries *Squadron Supreme.* One of the group editors, overseeing Marvel Heroes.

Paul Gulacy—The artist who created *Sabre: Slow Fade of an Endangered Species,* the first graphic novel produced especially for the Direct Market.

Larry Hama—A one-time assistant to Wally Wood, he made his mark as writer on *G. I. Joe* and *Wolverine.* A martial arts expert, he had a bit part in the Walter Hill movie *The Warriors.*

Jens Harder—A German artist who has produced such graphic novels as *Électricité Marseille, ALFA,* and *Leviathan.*

Bob Harras—A former editor in chief of Marvel Comics. Was one of the group editors at Marvel, before taking the lead role in 1995. He made the best of the executive-ordered *Heroes Reborn* event, returning the characters smoothly to the Marvel Universe at the end of its run. His hands-on guidance of the X-Books kept them as best-selling titles in the industry at the time. He now works for DC Comics as group editor for collected editions.

Irwin Hasen—A Golden Age artist who worked on such titles as *The Green Hornet, Secret Agent Z-2, Bob Preston, Explorer,* and *Cat-Man.*

Don Heck—The artist who co-created Iron Man with Stan Lee.

Andy Helfer—The DC editor known for his Big Book imprint.

Robert Nazeby Herzig—Known for the graphic novel *Angel Skin* with Christian Westerlund.

Byran Hitch—A penciler known for his work on Marvel's *Ultimate* series.

Michael Z. Hobson—Executive vice president of Marvel for fifteen years. He'd held senior positions at Scholastic and the William Morris Agency. Later on he served as president of Parachute Publishing (packager of R. L. Stine's *Goosebumps* series).

David Hyde—Current corporate communications guru at DC Comics.

Carl C. Icahn—The takeover mogul who battled Ron Perelman for ownership of Marvel Entertainment.

Samuel Maxwell "Jerry" Iger—Ran a comic book packaging company with Will Eisner in the late 1930s and early '40s.

Carmine Infantino—The artist who became editor and later publisher of DC Comics. He ushered in the Silver Age in 1956 with an updated version of the Flash in *Showcase #4*.

Sid Jacobson—A writer who created the graphic novel version of the *9/11 Commission Report* in 2006.

Bill Jemas—President of Marvel at the turn of the millennium. A controversial figure, it is said he deliberately stirred up the fan community and published ghostwritten stories under his byline.

Bobby G. Jenkins—A good ol' boy from Atlanta, one of Bill Bevins's best financial people.

R. Kikuo Johnson—Creator of the graphic novel *Night Fisher*.

Gerard Jones—A comic book writer acclaimed for his brilliant look at the early days of the comics industry in *Men of Tomorrow: Geeks, Gangsters, and the Birth of the Comic Book*.

Carl Gustav Jung—The Swiss psychiatrist noted for his theories on archetypes and the collective unconscious.

Dan Jurgens—A noted writer and artist who worked on the "Death of Superman" storyline.

Jenette Kahn—President of DC Comics for twenty-six years, she also took on the role of editor in chief. Kahn is credited for the 1980s revitalization of DC.

Mike Kaluta—An illustrator in the pulp style, he worked for Charlton (*Flash Gordon*) and DC (Edgar Rice Burroughs's *Venus* tales), among others.

Jack Kamen—A sculptor by training, he began his career illustrating pulp magazines. Later he worked for EC Comics, becoming one of its most prolific artists, drawing crime, horror, suspense, science fiction, and humor stories.

Bob Kane—The artist who is credited with creating Batman. Writer Bill Finger and inker Jerry Robinson made uncredited contributions.

Gil Kane—Starting off in comics with Jack Binder's studio, his career spanned the 1940s through the '90s. His penciling of Marvel's *Amazing Spider-Man* in the 1970s included the three-issue arc that challenged the Comics Code and the landmark "The Night Gwen Stacy Died."

Robert Kanigher—A writer-editor whose work included *Blue Beetle, Justice Society of America, Wonder Woman,* and a host of DC's war titles. Co-created Sgt. Rock with Joe Kubert. Other creations included Black Canary, the Harlequin, and Poison Ivy.

Estes Kefauver—The anti-crime crusader whose Senate Subcommittee on Juvenile Delinquency investigated the comic book industry.

Karl Kesel—A writer and inker working mainly for DC, he created the modern-day *Superboy.*

Joe King—One of Bill Bevins's "Atlanta boys," assigned to be a Marvel dealmaker.

Jack Kirby—Known as "the King," this legendary artist co-created Captain America with his longtime partner Joe Simon. He co-created a number of characters with Stan Lee. His magnum opus was *Fourth World,* published by DC.

Robert Kirkman—A writer known for his Image Comics series *Invincible* and *The Walking Dead* (based on George A. Romero's zombie films).

Jay Kogan—Legal beagle at DC Comics.

Kazuo Koike—The Japanese artist known for his twenty-eight-volume samurai epic *Lone Wolf and Cub.*

Ed Konick—Longtime business manager of Charlton Publishing.

Adam Kubert—Son of Joe Kubert and brother of Andy. Among the superstar artists, Adam had a long run at Marvel on X-Books but is now trying his hand at DC.

Andy Kubert—Ditto.

Joe Kubert—Head of the Joe Kubert School of Cartoon and Graphic Art. Best known for his work on DC's *Sgt. Rock* and *Tor*. Father of artists Adam and Andy Kubert.

Harvey Kurtzman—The editor who created *Mad* magazine for EC, then went on to try a series of other humor magazines ranging from *Humbug* to *Help*.

Salvador Larocca—The Spanish artist broke into comics with Marvel's *Ghost Rider*. He went on to do a number of X-Books.

Erik Larsen—One of the founders of Image Comics in 1992. His Highbrow Entertainment imprint is noted for its creator-owned *The Savage Dragon*.

Jae Lee—The young Korean-born artist associated with a dark gothic style. Best known for his work on Marvel's *Inhumans* (for which he won an Eisner Award). His creator-owned *Hellshock* was published by Image. His penciling has made the Marvel spinoff *Stephen King's Dark Tower* an interesting series.

Jim Lee—One of the founders of Image Comics. The Korean-born artist created such teams as *WildC.A.T.s* and *Gen13* under his Wildstorm imprint before selling his company to DC Comics.

Stan Lee—The legendary Marvel Comics editor who co-created Spider-Man, X-Men, the Fantastic Four, Silver Surfer, and numerous other superhero characters. He revolutionized the comic book industry by creating superheroes with human flaws.

Paul Levitz—President and publisher of DC Comics. A one-time fanzine editor who rose through the ranks, taking over as head of DC from Jenette Kahn in 2002.

Corey Lewis—An artist known for his manga-influenced *Sharknife*, published by Oni Press. He has produced several video-game-themed comics such as *Street Fighters, Darkstalkers,* and *Rival Schools*.

Jack S. Liebowitz—The accountant who became the brains behind the publishing company that would become DC Comics.

Rob Liefeld—One of the founders of Image Comics but later kicked out. The brash "bad boy" artist is known for his exaggerated physiques and legal skirmishes involving *Fighting American*.

David Lloyd—The British artist who worked with Alan Moore on *V for Vendetta*. He has also worked on *Hellblazer* with Grant Morrison and Jamie Delano, *War Story* with Garth Ennis, and *Global Frequency* with Warren Ellis.

Scott Lobdell—A writer known for his work on Marvel's X-Books. His character-driven plots have opened doors in Tinseltown—he has scripted movies such as *Man of the House* starring Tommy Lee Jones.

Vincent Locke—The artist who co-created the graphic novel *History of Violence* with John Wagner. In addition to the cult-favorite *Deadworld,* he has worked on such mainstream titles as *Batman* and *The Sandman.*

Joseph "Jeph" Loeb III—A writer known for his Batman opus *The Long Halloween* and *Superman for All Seasons.* His television work includes being a supervising producer on WB's *Smallville* and ABC's *Lost,* and a co–executive producer on NBC's *Heroes.*

Jim McCann—Marvel's assistant manager of sales communication, also known for writing backup stories based on the *Guiding Light* soap opera.

Scott McCloud—Author of *Understanding Comics.* The artist is perhaps the industry's leading philosopher and visionary.

Todd McFarlane—One of the founders of Image Comics in 1992. The artist who created *Spawn* and founded a successful toy company.

Don McGregor—The writer who created *Sabre: Slow Fade of an Endangered Species,* the first graphic novel produced especially for the Direct Market.

Ralph Macchio—The Marvel editor long associated with the *Spider-Man* titles. Other editing assignments have included *Dazzler* and *Daredevil.*

Joe Madureira—An artist known for his manga-influenced *Battle Chasers,* as well as his work on Marvel's *Uncanny X-Men.*

David Maisel—An EVP who along with John Turitzin and CEO Ike Perlmutter formed Marvel's office of the chief executive.

Marisa Acocella Marchetto—Creator of a somber graphic novel called *Cancer Vixen: A True Story.*

Scott C. Marden—An interim president of Marvel Entertainment under Ron Perelman's ownership. His plan was to develop an online presence.

Larry Marder—The original executive director of Image Comics, he is also the artist who created *Tales of the Beanworld.*

William Moulton Marston—A psychologist who co-created Wonder Woman with his wife, Elizabeth Holloway Marston, as a role model

for girls. He wrote a number of *Wonder Woman* issues under a pseudonym.

Sheldon Mayer—The McClure Syndicate editor who rescued the Superman comic strip from the slush pile. Creator of *Sugar and Spike.*

David Mazzuchelli—An artist notable for his work with Frank Miller on *Batman: Year One* and *Daredevil: Born Again.*

Brad Meltzer—Author of several *New York Times* bestsellers such as *The Tenth Justice, Dead Even,* and *Book of Fate,* he also writes such comics as *Justice League of America.*

Mort Meskin—A prolific Golden Age artist, while working for Eisner & Iger he did the Sheena, Queen of the Jungle pencils for *Jumbo Comics* and cranked out MLJ/Archie material for packager Harry "A" Chesler. He also drew for National, Marvel, Gleason, Nedor, Spark, and Prize.

George Metzger—An underground comix artist, his most notable creation was *Moondog.* One of the first graphic novels, his *Beyond Time and Again* was published in 1976.

Mike Mignola—After doing a number of titles for Marvel and DC, the artist-writer created *Hellboy,* published by Dark Horse. The film version starred actor Ron Perlman as the demon detective.

Mark Millar—A writer noted for his well-crafted tales. He was the writer on several Marvel *Ultimate* titles.

Frank Miller—An artist-writer known for his *Dark Knight Returns* retelling of *Batman,* as well as *Daredevil, Elektra,* and *Sin City.* He co-directed the film version of *Sin City* with Robert Rodriguez.

Moebius (Jean Giraud)—The pseudonymous French artist has been a regular contributor to *Metal Hurlant* (a magazine he co-created) with such outstanding serials as the *Airtight Garage* and *Arzach.*

Shelton Moldoff—Golden Age artist who co-created *Hawkgirl* with Gardner Fox. Reputed to have ghosted for Batman creator Bob Kane.

Bob Montana—The original artist who drew Archie Andrews for *Pep Comics* #22. Many of Archie's friends at Riverdale High were based on the journals he kept about students and faculty at his own alma mater, Haverdale High in Massachusetts.

Jim Mooney—A Silver Age artist best known for his signature work on DC's *Supergirl.*

Alan Moore—The British writer known for such graphic novels as *The League of Extraordinary Gentlemen, From Hell, V for Vendetta,* and the acclaimed *Watchmen.* His literary references and experimentation with the comics form have set him apart from the typical comics creator.

Grant Morrison—The Scottish writer is known for nonlinear narratives and magical influences. Frequently published by Vertigo, his *The Invisibles* stood out. He made his mark on Marvel's *The New X-Men,* introducing numerous changes to the mutant series.

Lou Mougin—A fanboy who has written articles for *Amazing Heroes* and other fanzines as well as had stories published by Marvel, Eclipse, Heroic, and Claypool.

John Nee—The former business manager of Wildstorm who is now DC's vice president of business development.

Fabian Nicieza—Argentinean-born artist noted for his work on such Marvel titles as *X-Force, New Warriors, Thunderbolts,* and *New Thunderbolts.*

Anders Nilsen—In addition to his self-published *Big Questions,* Nilsen's graphic novel *Monologues for the Coming Plague* is the artist's longest and most ambitious work to date.

Irv Novick—An artist who started out working for packager Harry "A" Chesler, he eventually landed at DC Comics, where he had a long career on such titles as *Our Army at War* and later *Batman, Lois Lane,* and *The Flash.*

Denny O'Neil—A writer best known for his *Green Lantern/Green Arrow* work with artist Neal Adams and *The Shadow* with Mike Kaluta. As an editor his work on the Batman titles is notable, getting back to the Caped Crusader's darker roots, a move that influenced Frank Miller's *Batman: The Dark Knight Returns.*

Kevin O'Neil—The British artist who illustrated Alan Moore's *The League of Extraordinary Gentlemen.* He is also co-creator of *Marshal Law* and *Nemesis the Warlock.*

Rik Offenberger—An Archie editor and sometimes online interviewer.

Jerry Ordway—A writer-artist, he inked George Pérez's pencils on the *Crisis on Infinite Earths* miniseries and created *The Power of Shazam!* graphic novel.

Joe Orlando—From *Classics Illustrated* adaptations to Warren's *Creepy* and *Eerie,* he learned the business, eventually becoming a vice president of DC Comics and an associate publisher of *Mad.*

Katsuhiro Otomo—The Japanese creator of the manga comic *Akira*. He also directed the anime films based on the series.

Jimmy Palmiotti—The popular writer-artist who once partnered with Joe Quesada, the two co-creating *Ashe* and *Painkiller Jane*. He is known for his inking, especially on the *Daredevil* arc penned by movie director Kevin Smith. His writing includes *Hawkman* and *The Monolith* for DC and *21 Down* and *The Twilight Experiment* for DC's Wildstorm imprint. He and Garth Ennis scripted a *Ghost Rider* video game to accompany the *Ghost Rider* movie starring Nicholas Cage.

Mark Paniccia—A senior editor at Marvel, he was known for his manga work with Tokyopop and licensing line work at Malibu.

Bill Parker—The Fawcett writer-editor who co-created Captain Marvel with C. C. Beck.

Richard D. Parson—The chairman of Time-Warner. A former lawyer for Nelson Rockefeller and president of Dime Savings Bank, he brokered the deal between AOL and Time-Warner.

Peter Paul—The disbarred lawyer who partnered with Stan Lee on the web-based Stan Lee Media (SLM).

Bill Pearson—Publisher of the underground comic *Witzend,* founded by *Mad* artist Wally Wood. An editor for Charlton Comics, he also scripted for publishers ranging from King Comics to Gold Key.

Harvey Pekar—Cleveland-based writer of an underground comic book series called *American Splendor*. In 2003, an indie movie starring Paul Giamatti was based on his autobiographical comics. Vertigo has published his *The Quitter* as well as a five-issue miniseries.

Ronald O. Perelman—The Revlon tycoon who owned Marvel Entertainment. The story of his battle with takeover mogul Carl Icahn is told in the book *Comic Wars* by Dan Raviv.

George Pérez—Along with John Byrne, one of the most influential artists of the 1980s. Known for his group action scenes, he has worked on such team books as Marvel's *The Avengers* and *Fantastic Four,* as well as DC's *Justice League of America* and *The New Teen Titans.*

Ike Perlmutter—The Israeli toymaker who beat Ron Perelman and Carl Icahn at their own game. He is now the CEO of Marvel Entertainment, Inc.

Mike Ploog—An apprentice to Will Eisner, he is best known for his art-work on Marvel's *Man-Thing.* Also a movie storyboard artist, he has worked on such movies as *Ghostbusters, Little Shop of Horrors,* and *Michael Jackson: Moonwalk.*

Whilce Portacio—One of the original founders of Image Comics, this talented artist withdrew from the partnership due to family illness. He continued to publish through Jim Lee's Wildstorm imprint.

Carl Potts—Editor of Marvel's Epic imprint. One of the group editors, responsible for General Entertainment.

Mark Powers—Bob Harras's former assistant in the X-Office at Marvel.

Joe Quesada—The artist who became editor in chief of Marvel Comics in 2000. Founder of Event Comics with Jimmy Palmiotti, with whom he created *Ashe* and *Painkiller Jane*. In 1998, the team was hired by Marvel to create an imprint called *Marvel Knights*. The rest is (comics) history.

Dan Raviv—The CBS news correspondent who chronicled the battle between Ron Perelman and Carl Icahn over Marvel in a book called *Comic Wars.*

Alex Raymond—The classic comic-strip artist known for *Flash Gordon* and *Secret Agent X-9.* His realistic style and shading techniques have been an inspiration to many other artists.

Richard Piers Rayner—The artist who co-created the graphic novel *Road to Perdition* with Max Allan Collins.

M. R. Reece—General manager of Crestwood's Prize Comics. As its editors, Joe Simon and Jack Kirby created such titles as *Black Magic,* the creator-owned *Fighting American,* and the first romance comic title, *Young Romance.*

Shirrel Rhoades—Executive vice president of Marvel Entertainment and publisher of Marvel Comics in the late-1990s. His publishing background with Scholastic and *Harper's* and *Cricket* wasn't as important as his penchant for comic book collecting (he's "a completist"). He unwound the *Heroes Reborn* event that had been put into motion prior to his arrival and brought back Chris Claremont and Michael Golden. He recruited Joe Quesada and Jimmy Palmiotti to launch the *Marvel Knights* imprint and launched numerous new titles (*Thunderbolts,* the *Flashback* series, and so on). Holding the publishing business together during the battle for ownership between Ron Perelman and Carl Icahn, he turned around the money-losing publishing business, with Marvel Comics being the *only* profitable division when he left in 1999.

Mike Richardson—Founder of Dark Horse Comics. As owner of several comic book stores in Oregon, he decided to try his hand at publish-

ing. Dark Horse is known for licensed titles such as *Star Wars* and *Buffy the Vampire Slayer.*

Darick Robertson—The artist known for co-creating *Transmetropolitan* with Neil Gaiman. After a stint on Marvel's *Wolverine,* he went to Wildstorm to do *The Boys* with Garth Ennis.

Alex Robinson—Best known for his graphic novel *Box Office Poison*— which won the Prix du Premier Album at Angoulême International Comics Festival in 2005.

James Robinson—A British writer known for revitalizing *Starman.* Other notable works include DC's *The Golden Age* and *Legends of the Dark Knight.* He wrote the controversial screenplay for *The League of Extraordinary Gentlemen.*

Jerry Robinson—An inker who is the uncredited co-creator of Batman's nemesis, the Joker. He also suggested the name "Robin" for Batman's sidekick.

John Romita, Jr.—Son of John, Sr., the artist is sometimes referred to as JRJR. He took over his father's mantle with *Amazing Spider-Man* but is also noted for his work on *Iron Man* and *Daredevil* (particularly a collaboration with Frank Miller on a "Man without Fear" origin story).

John Romita, Sr.—The legendary Marvel artist known for his work on *Amazing Spider-Man.* He served as art director at Marvel for years when Stan Lee became publisher. He is the father of artist John, Jr.

Scott Mitchell Rosenberg—Chairman of Platinum Studios, an entertainment company that markets comic book characters. Founder of Malibu Comics, which was sold to Marvel in 1994.

Alex Ross—The artist known for his painterly *Marvels* and *Kingdom Come* opuses. The coffee-table book *Mythology: The DC Comics Art of Alex Ross* was published in 2004.

Chuck Rozanski—The ponytailed president of Mile High Comics who is an outspoken observer of the comics scene.

Joe Sacco—A Maltese artist whose nonfiction works include *Palestine* and *Safe Area Gorazde.*

Stan Sakai—Best known as a letterer until he created *Usagi Yojimbo,* the ongoing tale of a seventeenth-century Samurai rabbit. A spinoff series is the futuristic *Space Usagi.*

Jim Salicrup—A former *Spider-Man* editor at Marvel, an editor in chief and associate publisher at Topps, and now at Papercutz editing graphic novels based on *Nancy Drew, The Hardy Boys,* and *Zorro.*

Paul Sampliner—Co-founder of Independent News with Harry Donenfeld.

John Santangelo, Sr.—The Italian bricklayer who founded Charlton Comics. His Derby, Connecticut, empire also included a printing plant and distribution company.

Scott Sassa—The former Turner Network executive who served as chairman of Marvel Entertainment during the so-called Comic Wars. He returned to the world of television.

Marjane Satrapi—The creator of a Persian-inspired graphic novel called *Persepolis.*

David Schreff—A former NBA executive who served as president of Marvel Comics under Ron Perelman. His plan was to make comics educational.

Alex Schomburg—Known as a "cover maestro." While freelancing for Timely, he created classic covers for such titles as *Captain America, Sub-Mariner,* and *Human Torch.* He drew between five and six hundred covers during the Golden Age.

Julius "Julie" Schwartz—Originally the editor of All-American (which merged with DC Comics). In the 1950s, he oversaw the revival of such superheroes as the Flash, Green Lantern, and Hawkman—ushering in the Silver Age.

Bart Sears—A graduate of the Kubert School, he started off doing promotional work on properties like G.I. Joe until he broke into comics. After a long run at DC, he came to Marvel to work on titles such as *Blade* and *Peter Parker: Spider-Man,* before returning to DC for *Batman: Legends of the Dark Knight* and *Warlord.*

J. J. Sedelmaier—Animator for Robert Smigel's short parody films *The Ambiguously Gay Duo.*

Phil Seuling—The fan convention organizer who invented the Direct Market by coming up with a distribution system that cut out the wholesaler middlemen.

John Severin—An EC artist who later became associated with *Cracked* magazine. At Marvel, he worked on such titles as *Sgt. Fury* and *The Rawhide Kid.* Brother of Marie Severin.

Marie Severin—An artist and colorist noted for her work on such Marvel titles as *Dr. Strange, The Sub-Mariner,* and *The Incredible Hulk.* Sister of John Severin.

Gilbert Shelton—An underground comix creator, best known for his *Fabulous Furry Freak Brothers.*

Jim Shooter—The enfant terrible who became the ninth editor in chief of Marvel Comics. Also assuming the mantle of publisher, he became embroiled in the dispute with Jack Kirby over the return of his artwork.

Joe Shuster—The Canadian-born artist who co-created Superman with Jerry Siegel. They tried to launch a new character called Funnyman without success. Failing eyesight ended his drawing career before he'd again achieved a success that approached that of Superman.

Jerry Siegel—The writer who co-created Superman with Joe Shuster. He created superheroes for Charlton, Archie, and England's Lion, but never achieved the success engendered by Superman.

Louis Silberkleit—One of the three founders of MLJ (the "L"), the company that would become Archie Comics. Father of Michael Silberkleit.

Michael Silberkleit—Chairman and publisher of Archie Comics. His father was one of the founders.

Marc Silvestri—One of the founders of Image Comics. His Top Cow Productions publishes such popular titles as *Witchblade, The Darkness,* and *Fathom.* He came to fame as a penciler for Marvel's *Uncanny X-Men.*

Dave Sim—Canadian artist-writer best known as the creator of the six-thousand-page graphic novel *Cerebus the Aardvark.*

Joe Simon—The artist-writer who co-created Captain America with his longtime partner Jack Kirby. Other creations include the Cap-like Fighting American, Boy Commandos, the Newspaper Legion, Manhunter, and the Fly. He and Kirby also invented the romance genre.

Louise Simonson—Known as "Weezie." A former editor of *Eerie, Creepy,* and *Vampirella,* she went on to edit X-Books at Marvel. She and artist June Brigman co-created *Power Pack.* Wife of artist Walt Simonson.

Walt Simonson—An artist best known for his Marvel work on *Mighty Thor* and *X-Factor* (a collaboration with his wife, Louise Simonson). More recently he was writing DC's *Hawkgirl.*

Joe Sinnott—Considered to be Jack Kirby's best inker. He is credited with influencing a Jack Kirby trademark, the heavily inked cosmic bursts known as "Kirby Krackles."

Robert Smigel—The creator of the animated parody *The Ambiguously Gay Duo*.

Kevin Smith—The filmmaker responsible for such cult favorites as *Clerks, Mallrats,* and *Jay and Silent Bob Strike Back*. He not only owns comic book stores in New Jersey, but writes comics too.

Paul Smith—An artist who worked on a number of Marvel titles; his brief stint on *Uncanny X-Men* gained wide attention.

Jim Sokolowski—Better known as "Ski," he has worked both as a newsstand marketer and editorial planner, first at Marvel and then with DC.

Aaron Sowd—A designer with the now-defunct Stan Lee Media. His comic book credits include *X-Men, Batman,* and *Harley Quinn*.

Art Spiegelman—The artist-writer who created the Pulitzer Prize–winning graphic novel *Maus*. He started out contributing to such underground comix as *Real Pulp, Bizarre Sex,* and *Young Lust*.

Mickey Spillane—The author of bestselling Mike Hammer novels, he started out as a comic book writer.

Jim Steranko—An artist noted for his innovative use of surrealistic "zap art" styles, he made his mark with *Nick Fury, Agent of S.H.I.E.L.D.* He is also a skilled magician and escape artist, a bit of inspiration for Michael Chabon's *The Amazing Adventures of Kavalier & Clay*.

Roger Stern—Co-creator of Marvel's second Captain Marvel and Hobgoblin with John Romita, Jr., and co-creator of West Coast Avengers with artist Bob Hall. Later as a *Superman* editor, he helped invent the "Death of Superman" storyline.

Dave Stevens—The artist who created *The Rocketeer*. Best friend of legendary 1950s pinup model Bettie Page, an inspiration for much of his "good girl" artwork.

Terry Stewart—Former president and vice chairman of Marvel Entertainment, known for his pop-culture collections of jukeboxes, comic memorabilia, and 45-rpm records. He is now president of the Rock and Roll Hall of Fame.

Vin Sullivan—The DC editor who contacted Sheldon Mayer looking for filler material and came up with Superman.

Curt Swan—Primary artist on the 1960s *Superman* series.

Satoshi Tajiri—The Japanese creator of the Nintendo video game *Pokémon.*

Naoko Takeuchi—The Japanese artist famous for his manga series *Pretty Soldier Sailor Moon.*

Dr. Osamu Tezuka—A Japanese artist considered to be the father of story-based manga. He is sometimes called "the Japanese Walt Disney."

Roy Thomas—Stan Lee's first successor as editor in chief of Marvel (not counting Vince Fago's wartime stint). Best known for introducing Robert E. Howard's *Conan the Barbarian* to comics. Now editor of *Alter Ego.*

Craig Thompson—A graphic novelist known for *Blankets.* He had produced minicomics such as *Doot Doot Garden* and contributed short pieces to *Nickelodeon.* His graphic novel *Habibi* is based on Islamic mythology.

Frank Thorne—An artist known for his luscious women characters such as Red Sonja, Danger Rangerette, and Gita.

Herb Trimpe—The artist who co-created Psylocke with Chris Claremont.

William "Billy" Tucci—Founder of Crusade Comics, he is the creator of the marital arts heroine Shi.

John Turitzin—An EVP who along with David Maisel and CEO Ike Perlmutter formed Marvel's office of the chief executive.

Jim Valentino—One of the founder of Image Comics in 1992. His Shadowline imprint published such creator-owned titles as *ShadowHawk* and *Silver Age.*

Brian K. Vaughan—The writer who co-created the graphic novel *Pride of Baghdad.* Known for his works *Y: The Last Man* and *Ex Machina.*

Andy Wachowski—The comic book writer who co-created the *Matrix* movie trilogy. Brother of Larry Wachowski.

Larry Wachowski—The comic book writer who co-created the *Matrix* movie trilogy. Brother of Andy Wachowski.

John Wagner—The writer who created the graphic novel *History of Violence.* Living in Scotland, he revitalized British boys' comics in the 1970s and with his partner Alan Grant was part of the so-called British invasion of American comics in the 1980s.

Mark Waid—His work on DC's *The Flash* led to being recruited for Marvel's *Captain America*—only to have his highly praised work interrupted by the *Heroes Reborn* event. Among the highlights of his career is the stellar collaboration with painter Alex Ross on *Kingdom Come.*

Reed Waller—Creator of the anthropomorphic *Omaha the Cat Dancer.*

Chris Ware—Creator of the best-selling graphic novel *Jimmy Corrigan, the Smartest Kid on Earth.*

Chris Warner—The top editor at Dark Horse Comics. He was also one of the original creators of the Comics' Greatest World imprint, which morphed into Dark Horse Heroes.

James Warren—Founder of the publishing company of the same name, he's remembered for *Eerie, Creepy,* and *Vampirella.*

Bob Wayne—DC Comics' vice president of sales, the company's key contact with the Direct Market.

Len Wein—A writer-editor noted for co-creating DC's *Swamp Thing* and reviving Marvel's *X-Men.*

Clem Weisbecker—An Golden Age artist who worked for Jack Binder, such MLJ titles as *Black Hood,* and various Fawcett books.

Mort Weisinger—Best known as the editor of DC's *Superman* titles during the Silver Age. As a writer, he co-created Aquaman with Paul Norris, and Green Arrow with George Papp.

Steven Weissman—An artist best known for his *Yikes* series with Fantagraphics. Featuring an array of monster kids, perhaps the most notable graphic novel in the series is *Chewing Gum in Church.*

Fredric Wertham—The Austrian psychologist who wrote *Seduction of the Innocent,* a book that indicted the comic industry for "causing" juvenile delinquency.

Christian Westerlund—Known for the graphic novel *Angel Skin* with Robert Herzig.

Joss Whedon—The creator of *Buffy the Vampire Slayer.* Wrote a new Marvel title called *Astonishing X-Men.* Also a noted TV and film scriptwriter.

Malcolm Wheeler-Nicholson—Publisher of first comic book featuring original material. Although he would be squeezed out of his National Allied Publications by partner Harry Donenfeld, it would go on to become DC Comics.

Al Williamson—An artist who started out with EC Comics. He had a long run with Archie Goodwin on *Secret Agent X-9*.

Bill Willingham—Creator of *The Elementals*. Writes the respected *Fable* series.

Barry Windsor-Smith—A British painter who started his comics career drawing *X-Men*. He rose to fame as a painter of Marvel's *Conan* series and developed the Red Sonja character. At Dark Horse he created an oversized series, *Barry Windsor-Smith: Storyteller,* and is said to be working on a Marvel graphic novel about The Thing.

Ed Winiarski—A puckish artist who liked to caricature his co-workers in Timely's *Krazy Komics*.

David Wohl—A Top Cow editor-writer who co-created *Witchblade* and *The Darkness*.

Marvin A. "Marv" Wolfman—A former editor in chief of Marvel. The writer is known for his runs on Marvel's *Tomb of Dracula* with Gene Colon and DC's *The New Teen Titans* with George Pérez and others.

Basil Wolverton—An artist known for his exaggerated caricatures of ugly people. He described himself as a "Producer of Preposterous Pictures of Peculiar People Who Prowl This Perplexing Planet."

Wallace "Wally" Wood—The *Mad* artist who also created *Sally Forth* and *Cannon* for World War II troops. In addition to his regular comic book work, he also launched *Witzend,* one of the first alternative comics.

Bernie Wrightson—Known for his horror illustrations, he co-created the Swamp Thing with Len Wein. With Marv Wolfman, he also co-created Destiny, a character that would be developed by Neil Gaiman in the *Sandman* series.

CRANKING UP THE TIME MACHINE

A COMICS INDUSTRY TIMELINE

NOTE that the dates marking the beginning and end of Comics Ages are not precise and are often foretold by a series of events. Also, the milestones listed below are more often based on general trends than time-specific happenings. Acknowledging that dates can be sketchy and research sources contradictory, here is a handy reference that gives you a rough approximation of the comic book industry's "genealogy."

1933: BEGINNING OF THE PLATINUM AGE

» **Milestone #1: The Comic Book Format Is Invented.** Maxwell C. Gaines dreams up a new kind of publication; Major Malcolm Wheeler-Nicholson adds original content.

SPRING 1933: The brainchild of Max Gaines, *Funnies on Parade* is published. Proctor & Gamble uses it as a promotional giveaway.

MAY 1934: Another Max Gaines idea, *Famous Funnies* (Series I) is a sixty-eight-page comic distributed through department stores. It's a co-venture between Eastern Color and George Delacourte's Dell.

JULY 1934: With a ten-cent price tag on the cover, *Famous Funnies* #1 is sold on the newsstands. A bimonthly publication, it runs for 218 issues.

> » **Milestone #2: DC and Marvel Comics Emerge.** The beginnings of the two comic book publishers that will dominate the industry.

FEBRUARY 1935: *New Fun* is the first comic book published by National Allied Magazines—the company that will eventually become DC Comics. It is owned by a flamboyant character named Major Malcolm Wheeler-Nicholson. *New Fun* is the first comic to contain original content.

EARLY 1937: Due to debts, Wheeler-Nicholson is forced to take on printer Harry Donenfeld as his partner. The Major and Donenfeld's business manager Jack Liebowitz form Detective Comics, Inc.

MARCH 1937: The first issue of DC's *Detective Comics* appears. It will become the longest-running comic book series ever.

EARLY 1938: Donenfeld sends Wheeler-Nicholson on a cruise, then pushes Detective Comics, Inc., into bankruptcy during his absence.

MARCH 1938: Harry Donenfeld's Independent News acquires Detective Comics' assets at a bankruptcy auction. Wheeler-Nicholson goes back to writing for the pulps.

1938: THE BEGINNING OF THE GOLDEN AGE

> » **Milestone #3: The Superhero Genre Is Introduced.** Joe Shuster and Jerry Siegel come up with Superman, establishing the superhero concept, which will become the dominant content of comics.

JUNE 1938: DC's *Action Comics* #1 features the first appearance of Superman. (The strip had been rescued from the McClure Syndicate slush file by Max Gaines and Sheldon Mayer.)

JANUARY 1939: A *Superman* newspaper strip appears.

APRIL 1939: With Harry Donenfeld's funding, Max Gaines and Jack Liebowitz form All-American Publications. All-American will introduce such superheroes as the Flash, Green Lantern, and Wonder Woman.

MAY 1939: Batman first appears, in *Detective Comics* #27.

NOVEMBER 1939: MLJ Comics—the forerunner of Archie Comics—is founded by Maurice Coyne, Louis Silberkleit, and John L. Goldwater.

NOVEMBER 1939: *Marvel Comics* #1 is published by Timely. However, the company does not adopt the "Marvel Comics" imprint until the 1960s.

JANUARY 1940: *The Adventures of Superman* radio show goes on the air. Superman is voiced by Bud Collyer, future host of TV's *Beat the Clock*.

FEBRUARY 1940: Fawcett debuts a superhero called Captain Marvel in *Whiz Comics* #2. He outsells Superman.

APRIL 1940: A bullet saying "A DC Comics Publication" appears for the first time on a comic book cover.

JULY 1940: *All-Star* #1 is co-published by Detective Comics and All-American.

SEPTEMBER 1940: Western Publishing and Dell publish the first comic book based on Warner Bros. Looney Tunes characters.

OCTOBER 1940: Detective/All-American introduce an editorial advisory board made up of celebrities and educators to make sure their comics are "clean and wholesome."

LATE 1940: Seventeen-year-old Stanley Lieber starts working as a gofer for Timely, the comic book company owned by his cousin's husband Martin Goodman.

JANUARY 1941: The Justice Society of America is formed in *All-Star Comics* #3.

MARCH 1941: Joe Simon and Jack Kirby create Captain America for Timely.

MARCH 1941: Republic Pictures releases a movie serial titled *The Adventures of Captain Marvel*—the first superhero adapted to film.

MAY 1941: Young Stanley Lieber adopts the pen name of "Stan Lee" for scripting comics. He's saving his real name for "the Great American Novel."

JUNE 1941: National (DC) sends Fawcett a "cease and desist" letter regarding its Captain Marvel character.

AUGUST 1941: Jack Cole's Plastic Man appears in *Police Comics* #1, proving that superhero funny books can indeed be funny.

SEPTEMBER 1941: National (DC) files a lawsuit against Fawcett, alleging copyright infringement by Captain Marvel.

DECEMBER 1941: Wonder Woman first appears in *All-Star Comics* #8. She is created by psychologist William Moulton Marston as a positive role model for girls.

DECEMBER 1941: MLJ comes up with a teenage character called Archie Andrews in *Pep Comics* #22 after John Goldwater sees an *Andy Hardy* movie.

APRIL 1942: Stan Lee becomes editor of Timely (Marvel) when Joe Simon and Jack Kirby get fired for moonlighting with DC.

OCTOBER 1942: All-American launches Max Gaines's *Picture Stories from the Bible.* The bullet on the cover identifies it as "A DC Publication."

NOVEMBER 1942: Stan Lee enlists in the Army Signal Corps.

APRIL 1943: Columbia's fifteen-part *Batman* movie serial is released.

SEPTEMBER 1945: Tired of superheroes, Max Gaines sells his interests in All-American to Harry Donenfeld. But he holds on to his *Picture Stories* titles.

1946: BEGINNING OF THE ATOM AGE

SEPTEMBER 1946: All-American is merged with National Comics.

OCTOBER 1946: *Action Comics* #101 shows Superman observing an atomic bomb blast—a sign that the so-called Atom Age has commenced.

FALL 1946: EC Comics is started by Max Gaines with *Picture Stories from the Bible.* EC stands for "Educational Comics."

AUGUST 1947: Max Gaines is killed in a boating mishap, and his twenty-five-year-old son Bill takes over EC—promptly changing the focus from "Educational Comics" to "Entertaining Comics."

SEPTEMBER 1947: Joe Simon and Jack Kirby invent the romance genre with Prize's *Young Romance* #1.

DECEMBER 1947: Filthy-rich Scrooge McDuck is created by Disney artist Carl Barks in *Four Color Comics* (Series II) #178.

MARCH 1948: *Saturday Review of Literature* drama critic John Mason Brown describes comic books as "the marijuana of the nursery; the bane

of the bassinet; the horror of the house; the curse of the kids; and a threat to the future."

APRIL 1950: EC publishes its first horror comic, *Crypt of Terror* #1.

MAY 1950: Dr. Fredric Wertham is appointed consultant to Senator Estes Kefauver's committee to study the influence of comic books on juvenile delinquency.

JULY 1950: Columbia's fifteen-part *Atom Man vs. Superman* movie serial is released.

SEPTEMBER 1952: *The Adventures of Superman* TV series begins, starring George Reeves as the Man of Steel.

NOVEMBER 1952: *Mad* makes its debut as a zany comic book edited by Harvey Kurtzman. By issue #24 it switches to a magazine format.

JANUARY 1954: Fawcett settles the trademark lawsuit over Captain Marvel with National (DC) and closes down its comic book division.

> » **Milestone #4: *Seduction of the Innocent* is Published and Launches a Witch Hunt That Begets the Comics Code.** The industry survives a challenge that makes it stronger and self-policing.

EARLY 1954: Dr. Fredric Wertham publishes *Seduction of the Innocent,* asserting that comic books cause juvenile delinquency.

SPRING 1954: William M. Gaines appears before Kefauver's Senate Select Committee on Juvenile Delinquency to defend his horror comic books. The testimony is a disaster.

SEPTEMBER 1954: The comic book industry establishes the Comics Code Authority to self-censor content before publication.

FEBRUARY 1955: EC cancels its last horror titles after distributors refuse to carry them without a Comics Code seal of approval.

1956: THE BEGINNING OF THE SILVER AGE

SEPTEMBER 1956: DC's *Showcase* #4 successfully reintroduces the Flash, an updated superhero from the 1940s. The issue marks the beginning of the Silver Age.

DECEMBER 1956: Harvey Kurtzman quits *Mad* to start *Trump,* a *Playboy*-backed humor magazine that lasts only two issues. Al Feldstein takes over as editor of *Mad* with issue #30.

OCTOBER 1957: American News goes bankrupt. National's Independent News agrees to distribute Martin Goodman's comics but restricts him to only eight titles a month.

LATE 1958: Jack Kirby returns to Timely (Marvel) to work with editor-writer Stan Lee.

MAY 1959: Supergirl makes her appearance in DC's *Action Comics* #252.

AUGUST 1959: Joe Simon does *The Adventures of the Fly* for Archie Comics. Some claim this is the prototype for Spider-Man.

NOVEMBER 1961: National Comics (DC) becomes National Periodical Publications, a publicly traded corporation.

> » **Milestone #5: Stan Lee and Jack Kirby Create a New Kind of Superhero.** Two legendary creators reinvent the superhero concept by humanizing the characters.

NOVEMBER 1961: *Fantastic Four* #1 is the start of the so-called Marvel Age of Comics. These superheroes behave like a real family.

MAY 1962: *The Incredible Hulk* #1 bursts onto the comics scene with the title hero's characteristic rage. The cover blurb challenges, "Is he man or monster or . . . is he both?"

AUGUST 1962: An angst-ridden Spider-Man makes his first appearance in *Amazing Fantasy* #15.

SEPTEMBER 1963: Marvel's mighty mutants debut in *The X-Men* #1.

JUNE 1964: A National (DC) subsidiary buys *Mad* magazine. Bill Gaines stays on to run the popular humor publication.

DECEMBER 1964: James Warren begins *Creepy* magazine. *Eerie* and *Vampirella* are soon to follow. Like *Mad* they escape the *Comics Code* due to their magazine format.

JANUARY 1966: The *Batman* TV show debuts, starring Adam West and Burt Ward in a campy rendition of the Dynamic Duo.

JANUARY 1966: John Romita, Sr. leaves National (DC) to work with Stan Lee at Marvel.

FEBRUARY 1966: "Go-Go Checks" are added to DC covers to make them more noticeable on newsstands. This is an idea fostered by Harry Donenfeld's son Irwin.

MARCH 1966: Stan Lee and Jack Kirby begin the Galactus Trilogy in *Fantastic Four* #48.

JULY 1966: Thirteen-year-old Jim Shooter breaks into comics with his first story appearing in *Adventure Comics* #346.

JULY 1966: Black Panther—Marvel's first black superhero—appears in *Fantastic Four* #52.

AUGUST 1967: Kinney National's board approves the acquisition of National Periodical Publications (DC Comics). Kinney is a funeral parlor and parking lot conglomerate.

NOVEMBER 1967: Robert Crumb sells his twenty-four-page *Zap Comix* #0 for 25 cents out of a baby buggy. The printing is only five thousand copies, but it signals the beginning of the underground comix movement.

AUGUST 1968: Carmine Infantino becomes editorial director at National (DC).

FALL 1968: Martin Goodman sells Timely (Marvel) to Perfect Film and Chemical Corporation.

JULY 1969: Warner-Seven Arts is acquired by Kinney National.

OCTOBER 1969: Marvel moves the distribution of its comics from National's Independent News to Curtis Circulation. The number of comics titles increases.

1970: THE BEGINNING OF THE BRONZE AGE

OCTOBER 1970: In a dispute with Stan Lee over credit, Jack Kirby goes back to National (DC). He takes over *Superman's Pal, Jimmy Olsen* with #133, setting the stage for his *Fourth World*.

FEBRUARY 1971: Jack Kirby's *Fourth World* saga begins with *Forever People* #1, followed by *The New Gods* #1 and *Mister Miracle* #1 in March. It is called "the epic for our times."

MAY 1971: Stan Lee challenges the Comics Code Authority with an anti-drug message in *Amazing Spider-Man* #96.

AUGUST 1971: The Comics Code is revised to permit anti-drug stories.

SEPTEMBER 1971: Carmine Infantino becomes publisher of National (DC).

1972: Kinney National is renamed Warner Communications.

SEPTEMBER 1972: Learning that DC plans to publish Fawcett's Captain Marvel, Marvel revives its version of the character—claiming the trademark.

SEPTEMBER 1972: Stan Lee becomes publisher of Marvel Comics, and Martin Goodman retires shortly thereafter.

OCTOBER 1972: *Forever People* and the *New Gods* are cancelled, ending Kirby's "grand interlocking book experiment."

> » **Milestone #6: The Direct Market Is Developed.** A "network" of specialized comic book retailers allows publishers to sell comics on a nonreturnable basis.

LATE 1972: Phil Seuling sets up Seagate Distributing to sell comics on a nonreturnable basis to comic specialty stores. This is the proto-beginning of the Direct Market.

LATE 1972: High-school student Paul Levitz freelances on letters pages at DC Comics.

NOVEMBER 1972: Holt, Reinhart, and Winston publishes a hardcover collection of *Wonder Woman* with an introduction by Gloria Steinem. Seen as empowerment for women, Wonder Woman's superpowers are soon restored in the comics.

NOVEMBER 1972: Ex–DC editor Dick Giordano draws Carmine Infantino as the villain in *Wonder Woman* #203.

1973: Perfect Film and Chemical renames itself Cadence Industries.

MAY 1973: "The month that doesn't exist!" DC skips this month in its production schedule to increase the lead time between on-sale date and cover date.

MID-1973: Paul Levitz becomes an assistant editor at DC while still going to college.

JUNE 1973: Gwen Stacy's death in *Amazing Spider-Man* #121 shocks Spider-Man fans worldwide.

NOVEMBER 1973: Phil Seuling makes a deal with DC (and later Marvel) to distribute new comics to comic shops on a nonreturnable basis— giving legitimacy to the Direct Market concept.

NOVEMBER 1974: Wolverine joins the fray for the first time in *Incredible Hulk* #181. He will go on to become the breakout star of *The X-Men*.

JUNE 1975: The "DC Explosion" is launched, a marketing strategy to mask a price increase by increasing pages and adding new titles.

SUMMER 1975: Publication of *Giant-Size X-Men* #1 revives Marvel's series about mutant superheroes.

JANUARY 1976: Carmine Infantino is fired as publisher of National (DC). Jenette Kahn of Scholastic is named as his replacement.

MARCH 1976: Jim Shooter becomes an associate editor at Marvel.

APRIL 1976: Jack Kirby returns to Marvel to work on *Captain America,* the title he and Joe Simon created thirty-five years earlier.

MAY 1976: Iconoclast Harvey Pekar makes his autobiographical debut with *American Splendor* #1.

JUNE 1977: Paul Levitz becomes editorial coordinator at National (DC).

NOVEMBER 1977: National officially changes its name to DC Comics.

DECEMBER 1977: Dave Sim self-publishes three hundred copies of *Cerebus* #1, the story of a sword-swinging aardvark. Sim becomes a focus of the independent comics movement.

FEBRUARY 1978: Jim Shooter is promoted to editor in chief at Marvel Comics. Key editors defect to DC.

NOVEMBER 1978: Blaming low sales on snowstorms, the so-called "DC Implosion" is marked by staff cutbacks and mass cancellation of titles.

DECEMBER 1978: *Superman: The Movie* makes you believe a man can fly. And a star of Christopher Reeve.

JANUARY 1979: *Micronauts* begins its seven-year run as a series. It establishes Michael Golden's reputation as a penciler.

MARCH 1980: Gold Key pulls all its comics off the newsstand to sell them only as bagged items in toy stores.

OCTOBER 1980: Frank Miller takes over *Daredevil,* challenging the Comics Code with his ultraviolent storylines.

MARCH 1981: Marvel's *Dazzler* #1 is created exclusively for the Direct Market.

JANUARY 1982: DC begins paying royalties and returning artwork to creators.

MID-1982: Steve Geppi founded Diamond Comic Distributor to serve the comic industry's Direct Market.

DECEMBER 1982: DC produces *Camelot 3000* exclusively for the Direct Market.

JANUARY 1984: Alan Moore revitalizes DC's *Saga of the Swamp Thing*, turning it into a true horror title.

JANUARY 1984: DC buys Charlton's superhero characters. They will later be the basis for characters in Alan Moore's *Watchmen*.

MAY 1984: Marvel launches its first big crossover epic, *Secret Wars*.

APRIL 1985: DC publishes its first large-scale crossover, *Crises on Infinite Earths*.

1986: THE BEGINNING OF THE MODERN AGE (COPPER)

> » **Milestone #7: With Darker Knights, Comic Books Become Literature.** *The Dark Knight Returns*, *Watchmen*, and *Maus* prove that comics can be literature as well as entertainment.

MARCH 1986: Frank Miller offers up a "grim-and-gritty" new take on Batman with *The Dark Knight Returns*.

JULY 1986: Dark Horse publishes its first comic under the aegis of comic shop owner Mike Richardson.

AUGUST 1986: Art Spiegelman's *Maus* begins its horrific tale. A second volume will appear in 1991 to complete the set. The literary world is confused as to whether this is fiction or nonfiction.

SEPTEMBER 1986: Alan Moore and Dave Gibbons create *Watchmen* #1, the beginning of a twelve-issue series published by DC.

OCTOBER 1986: Marvel attempts to launch a New Universe, but it falters. All New Universe titles are canceled in June 1989.

NOVEMBER 1986: New World Entertainment buys Marvel for $50 million from Cadence Industries.

APRIL 1987: Jim Shooter is fired as Marvel's editor in chief. Tom DeFalco replaces him.

SEPTEMBER 1987: Spider-Man marries Mary Jane Watson in *Spider-Man Annual* #21.

JULY 1988: Bud Plant sells his distribution company to Diamond Comics Distribution.

DECEMBER 1988: *Watchmen* is issued as a trade paperback. It will be picked by *Time* magazine as one of the "100 Best Novels of All Time."

DECEMBER 1988: VIZ splits with Eclipse, offering up its own line of Japanese imports.

> » **Milestone #8: Comics Are Leveraged as Intellectual Properties.** The industry finds a new economic model that does not depend entirely on selling comics.

JANUARY 1989: Ron Perelman's Andrews Group buys Marvel for $82.5 million from New World Entertainment. Perelman declares, "It is a mini-Disney in terms of intellectual property."

APRIL 1989: Jenette Kahn takes on the title of editor in chief. Paul Levitz becomes publisher. Dick Giordano retains his spot as executive vice president for editorial.

> » **Milestone #9: The Speculator Market Rises and Falls.** Comics become important collectibles, but the industry abuses the concept.

JUNE 1989: Tim Burton's *Batman* movie sparks a renewed interest in comics, fueling the so-called speculator market, in which comics are bought as investments.

JANUARY 1990: Warner Communications merges with Time, Inc., to form Time-Warner. DC Comics is transferred to Time-Warner's motion picture division instead of its former location in Warner Publishing.

AUGUST 1990: *Spider-Man* #1 by Todd McFarlane sets a record with 2.6 million copies sold.

JULY 1991: Perelman's MacAndrews and Forbes sells 40 percent of Marvel to the public, pocketing $40 million in owner dividends.

AUGUST 1991: *X-Force* #1 by Fabian Nicieza and Rob Liefeld tops the record set by *Spider-Man* #1 with 4 million copies sold, thanks in part to a marketing gimmick in which collector's cards were bagged with the issue.

SEPTEMBER 1991: *Wizard* magazine is launched by fanboy Gareb Shamus.

OCTOBER 1991: *X-Men* #1 by Chris Claremont, Jim Lee, and Scott Williams beats the record set by *X-Force* #1 by selling 8 million copies. Marvel releases the issue in five editions with variant covers. It is still the bestselling comic book of all time.

DECEMBER 1991: A group of artists confront Marvel president Terry Stewart over creator rights.

1992: CONTINUING THE MODERN AGE (CHROMIUM)

» **Milestone #10: Creators Become Superstars (and Image Comics Is Formed).** Fans recognize the importance of creators, imbuing them with more power.

FEBRUARY 1992: Seven "superstar" artists walk out on Marvel to form their own imprint, Image Comics.

APRIL 1992: Rob Liefeld's *Youngblood* #1 is the first publication of Image Comics.

APRIL 1992: Art Spiegelman's *Maus* is awarded a Pulitzer Prize.

MAY 1992: Todd McFarlane produces Image's most successful character with the publication of *Spawn* #1.

JUNE 1992: Tim Burton's *Batman Returns* movie is released.

JULY 1992: Marvel announces it's acquiring the Fleer trading card business for $265 million.

JANUARY 1993: DC begins its "Death of Superman" story arc with *Superman* #75. The event brings new customers into comic book stores, but long-term fans feel "cheated" by his eventual resurrection.

MARCH 1993: Karen Berger launches DC's Vertigo, an imprint featuring more mature themes.

APRIL 1993: Ron Perelman swaps a perpetual Marvel toy license for controlling interest in Toy Biz.

MAY 1993: As the glut of new comic books reaches more than seven hundred titles per month, the speculator boom collapses, causing a massive decline in comics sales.

JULY 1994: DC publishes *Kingdom Come,* a futuristic view of its superheroes as envisioned by Mark Waid and Alex Ross.

JULY 1994: Marvel announces plans to buy Italian sticker maker Panini for $150 million.

OCTOBER 1994: Mike Carlin replaces Dick Giordano as executive editor of DC.

OCTOBER 1994: Marvel experiments with five group editors rather than a single editor in chief.

NOVEMBER 1994: Marvel buys Malibu Comics, getting the rights to *Men in Black* in the process.

DECEMBER 1994: Marvel buys Heroes World, the third-largest Direct Market distributor—and goes exclusive a few months later.

MARCH 1995: Marvel buys a trading card company called SkyBox for about $150 million.

MAY 1995: Jerry Calabrese succeeds Terry Stweart as president of Marvel Comic Group.

MID-1995: Following its awkward experiment with group editors, Bob Harras emerges as editor in chief of Marvel Comics.

AUGUST 1995: DC elects to sell its product through Diamond Comic Distribution. Shortly thereafter, Image and Dark Horse announce they too will be exclusive with Diamond.

SEPTEMBER 1995: Marvel and DC announce that their entire universes will cross over for the first time in a joint publishing project.

DECEMBER 1995: Marvel hires two Image founders (Jim Lee and Rob Liefeld) to reshape *The Avengers, Captain America, Fantastic Four,* and *Iron Man* in an event known as *Heroes Reborn.*

JUNE 1996: Shirrel Rhoades contracted as "acting publisher" of Marvel Comics by president Jerry Calabrese.

JULY 1996: Diamond buys Capital City, making DCD the last remaining major distributor for comic books to Direct Market comics shops.

MID-1996: Scott Marden replaces Jerry Calabrese as Marvel president.

SEPTEMBER 1996: David Schreff becomes president and COO of Marvel.

SEPTEMBER 1996: Rob Liefeld is forced out of Image. Top Cow returns a few months later.

OCTOBER 1996: Shirrel Rhoades becomes executive vice president of Marvel. Later, Stan Lee officially turns over publisher title to Rhoades.

OCTOBER 1996: Former Turner exec Scott Sassa becomes Marvel's chairman and CEO.

OCTOBER 1996: Superman marries Lois Lane in *Superman: The Wedding Album.*

NOVEMBER 1996: Ron Perelman offers to reinvest $350 million in Marvel, but bondholders led by Carl Icahn block his plan.

DECEMBER 1996: Marvel files for Chapter 11 bankruptcy protection.

FEBRUARY 1997: Marvel shuts down Heroes World and returns its distribution to Diamond.

MAY 1997: Icahn wins his bondholder challenge and replaces Perelman's board.

JULY 1997: *Men in Black* movie displays the Marvel logo.

AUGUST 1997: Marvel sues Rob Liefeld's Awesome Entertainment over Agent America, alleging trademark infringement with Captain America.

NOVEMBER 1997: Michael Golden becomes Marvel's senior art director.

DECEMBER 1997: Chris Claremont returns to Marvel as vice president and editorial director.

DECEMBER 1997: A federal judge ousts Icahn and appoints a trustee to administer Marvel.

APRIL 1998: The New York Stock Exchange delists Marvel's stock. It has fallen to $1 from a high of $30 in 1994.

JUNE 1998: Toy Biz's Isaac Perlmutter and Avi Arad win a federal judge's approval to take over Marvel, besting both Ron Perelman and Carl Icahn.

> » **Milestone #11: Marvel Emerges from Bankruptcy and the Industry Rebounds.** The comics industry survives another threat and shows signs of recovery.

OCTOBER 1998: Marvel emerges from bankruptcy under new Toy Biz ownership.

OCTOBER 1998: Jerry Calabrese returns as president of Marvel, with orders to "clean house."

OCTOBER 1998: Marvel president Joe Calamari and publisher Shirrel Rhoades replaced by new management.

NOVEMBER 1998: Jerry Calabrese resigns from his second round as Marvel's president. He's replaced by board member Eric Ellenbogan.

JANUARY 1999: DC buys Jim Lee's Wildstorm.

FEBRUARY 1999: Winston Fowlkes appointed publisher of Marvel by Ellenbogan.

JULY 1999: Peter Cuneo replaces Ellenbogan as president and CEO of Marvel.

NOVEMBER 1999: Publisher Winston Fowlkes among those fired by Marvel's new president.

1999: BEGINNING OF THE POSTMODERN AGE (ADAMANTIUM AGE?)

JANUARY 2000: AOL merges with Time-Warner.

FEBRUARY 2000: Bill Jemas is put in charge of Marvel's publishing unit.

> » **Milestone #12: Comics Become Valuable Movie Properties.** The movie industry embraces comics as source material for blockbusters.

JULY 2000: The first *X-Men* movie is released. It is considered by many to be the best superhero movie ever made.

AUGUST 2000: Joe Quesada replaces Bob Harras as editor in chief of Marvel Comics.

SEPTEMBER 2000: Michael Chabon's *The Amazing Adventures of Kavalier & Clay* is a roman à clef about the early days of the comics industry. It wins the 2001 Pulitzer Prize for fiction.

OCTOBER 2000: Marvel launches its Ultimate line with *Ultimate Spider-Man* #1.

MAY 2001: Marvel resigns from CMAA and creates its own comics rating system.

SEPTEMBER 2001: Stan Lee "reinvents" DC's superheroes in a series called *Just Imagine Stan Lee Creating . . .*

OCTOBER 2001: *Smallville* debuts on the WB Network, starring Tom Welling as a young Clark Kent.

DECEMBER 2001: Jim Shooter "returns" to Marvel to write *Avengers*.

JANUARY 2002: TV exec Dan DiDio joins DC as vice president for editorial.

JANUARY 2002: Allen Lipson becomes CEO of Marvel as Peter Cuneo retires.

FEBRUARY 2002: Upon Jenette Khan's retirement, Paul Levitz is named president and publisher of DC Comics.

MAY 2002: Free Comic Book Day marks the industry's first broad cooperative promotional venture.

MAY 2002: The *Spider-Man* movie wows fans. At long last, the web-slinger makes it to the screen!

NOVEMBER 2002: Stan Lee sues Marvel over movie profits.

FEBRUARY 2003: Mike Carlin turns DC's top editorial spot over to Dan DiDio.

JUNE 2003: Ang Lee's *Hulk* movie is a disappointment, despite its clever use of CGI to create the not-so-jolly green giant.

OCTOBER 2003: Dan Buckley becomes publisher of Marvel comics, pushing Jemas aside.

OCTOBER 2003: Marvel settles with Joe Simon over rights to Captain America.

JUNE 2004: The *Spider-Man 2* movie proves lightning can strike twice.

JULY 2004: A hockey player is awarded $15 million for unauthorized use of him as a character in *Spawn* comic books, causing Todd McFarlane Productions to file for bankruptcy protection.

SEPTEMBER 2004: Alan Fine becomes president and CEO of Marvel Publishing.

APRIL 2005: Stan Lee settles lawsuit with Marvel.

APRIL 2005: Frank Miller's movie version of *Sin City* is a successful marriage of film and graphic novels.

JUNE 2005: The *Batman Begins* movie gets high marks.

> » **Milestone #13: Graphic Novels and Manga Enter the Media Mix.** New formats change the way comics are sold—and read.

AUGUST 2005: The publishers of *Shonen Jump* introduce *Shojo Beat,* a manga digest targeted at older teens, particularly teenaged girls. (*Shonen* means "boy," and *shojo* means "girl.")

AUGUST 2005: Archie sues a singing group called the Veronicas. They will reach a settlement providing for joint promotions.

SEPTEMBER 2005: Marvel sets up $525 million debt facility to finance ten films.

JUNE 2006: *Superman Returns* marks the Man of Steel's return to the silver screen.

DECEMBER 2006: Graphic novel sales in the United States and Canada hit $330 million.

MARCH 2007: Captain America is killed by an assassin.

MARCH 2007: The movie *300,* based on a Frank Miller graphic novel, breaks records with a $70 million opening weekend. This is the biggest March opening ever, and the third largest R-rated movie opening to date.

MAY 2007: *Spider-Man 3* sets box-office record for an opening weekend. The movie's No. 1 debut for a 3-day weekend topped 2006's "Pirates of the Caribbean: Dead Man's Chest" in North America with $135.6 million and "The Da Vinci Code" internationally with $155 million.

NOTE: Some dates are approximate. Many are the cover dates from the comics themselves. These dates tend to be two months after the actual release date.

GADZOOKS

A COMICS GLOSSARY

Anime: Japanese animation. Noted for characters with big eyes.

Annual: A comic book published once a year, often related to a series.

Archetype: A recurrent symbol or motif in literature, art, or mythology.

Artist: The term usually refers to the illustrator of a comic. Artists are divided among three specific groups: pencilers, inkers, and colorists.

Ashcan Copy: A comic book or movie produced for legal reasons (such as protecting a copyright) with no intention of being distributed.

Backing Board: A piece of cardboard to keep comics flat during storage in a polypropylene bag. Also called **backer board**. Stored books are referred to as "bagged and boarded."

Backup Feature: A story or character not usually featured on the cover nor as the first story in the comic.

Bad Girl Art: Term coined in 1993 to describe an attitude as well as a style that portrays women in a sexually implicit way.

Balloon: The bubble above a character's head in which speech, sounds, or thought is conveyed.

Bimonthly: Published every two months.

Biweekly: Published every two weeks.

Bleed: Art that extends to the edge of the page (the trim). This is common on the cover, and sometimes for effect inside the book.

Book: In the trade, a comic book or magazine. Sometimes it also refers to an actual book or graphic novel.

Breakdown: Laying out a comic book story panel by panel.

Bronze Age: A period in comics history that follows the **Silver Age**. From 1970 (the breakup of Kirby and Lee) through the late-1980s (publication of Alan Moore's *Watchmen*).

Bullpen: The area where staff artists make corrections and adjustments to pages as part of a comic book's production.

Cap: A nickname often applied to Captain America.

Cape: A sleeveless cloak. A common costume accessory for superheroes. Example: "You don't tug on Superman's cape."

Caped Crusader: A description often applied to Batman.

Captions: Text-filled boxes that help narrate a comic's story.

CCA: See **Comic Code Authority**.

Cel: A transparent sheet used in animation to depict action over a background. Used cels from animated films are considered collectible.

CGI: See **Computer Graphics Imagery**.

CMAA: See **Comic Magazine Association of America**.

Collected Edition: A trade paperback or digest that collects individual issues of a comic book series into a bound volume.

Collective Unconscious: In Jungian psychology, that part of the unconscious mind derived from ancestral memory, common to all humankind as distinct from an individual's unconscious.

Colorist: The person responsible for adding color to a comic book page, either by hand or computer program.

Comic Book: A bound magazine containing a story or stories told by sequential art.

Comic Book Guy: A fictional comic shop retailer created by Matt Groening for *The Simpsons* TV series. A parody of fanboys who run comic book stores.

Comic Book Store: A specialty retailer who sells comics and related products. Usually serviced by a **Direct Market distributor.** Also see **Retailer.**

Comic Magazine Association of America: An association formed in 1954 by publishers committed to wholesome comics. Sometimes abbreviated as **CMAA.** Administers the Comics Code.

Comic Shop: See **Comic Book Store.**

Comic Shop Locator Service: A free service administered by Diamond to help fans locate comic shops near them. Also referred to as **CSLS.**

Comic-Con: A comic book convention, such as the annual one held in San Diego each July.

Comics: Shorthand for **Comic Books.**

Comics Code Authority: The self-censoring association that some comic book companies use to assure distributors of compliance to certain standards. Sometimes abbreviated as **CCA.**

Comix: See **Underground Comix.**

Complete Run: All issues of a given title.

Completist: A comics collector who must have the **complete run** of specific series rather than selected issues (such as #1s).

Computer Generated Imagery (CGI): Computer graphics used in movies.

Continuity: In comic books, this means a set of contiguous events, sometimes said to be "set in the same universe" (see **Crossover**) or "separate universes" (see **Intercompany Crossover**).

Copy: This term can mean a physical publication, or it can mean to reproduce something, or it can refer to written text.

Copyediting: Checking written text for clarity, grammar, flow, and accuracy.

Copyright: A legal claim to an expression of an idea, a concept, or in comic book terms, to a character.

Cosplay: Costume play, a new phrase to describe fans wearing Hall Costumes at **Comic-Con.**

Costume: The unique outfit worn by a particular superhero. It often includes a **cape** and/or **cowl**.

Costumed Hero: A costumed crime fighter with "developed" human powers instead of "super" powers.

Covers: The four pages wrapping around a comic book's interior pages. The **front cover** features the title of the comics (see **Logo**) and a full-page illustration related to a story inside. Usually printed on a slightly thicker paper (that is, cover stock).

Cowl: A hoodlike mask that cover the head and part of the face. Example: Batman wears a cowl to hide his identity.

Creator: A writer or artist involved in creating a specific comic book or character.

Creator-Owned: The trademark and copyright of an intellectual property are retained by the original creator.

Creator Rights: The ethical and legal claim that writers and artists have on their own creations.

Crossover: A comic book in which characters from another series or another publisher make an appearance.

CSLS: See **Comic Shop Locator Service.**

Diamond Comic Distributors: The main distributor of comic books and related products to the Direct Market.

Digest: A smaller comic book format, similar in size to *Reader's Digest.*

Direct Market: The system for distribution directly to comic book and specialty retailers on a nonreturnable basis.

Direct Market Distributor: A company that oversees the distribution of comics and related products to specialty retailers on a nonreturnable basis. This essentially means **Diamond.**

Distributor: A company that represents the publisher in distributing comics and periodicals to retail outlets.

Doc Savage: A pulp magazine hero noted for his strength and derring-do. Considered one of the influences in the creation of Superman and the superhero genre.

Double Splash: A drawing that covers two pages. Sometimes called a two-page spread.

Dump: A cardboard display provided to retailers to promote sales. Often holds copies of a publication.

Dynamic Duo: A description often applied to Batman and his sidekick.

Editor: An employee of the publisher who oversees a comic book series, guides storylines, and assigns the creative team.

Emanata: The visual symbols used in comic books to describe an action, a term invented by cartoonist Mort Drucker. Example: a light bulb over the head to suggest an idea.

Eisner Awards: The annual comics industry awards recognizing the finest stories, publications, and creators in the medium. The awards are named for the late writer-artist Will Eisner.

"Excelsior!": An enthusiastic expression of "onward and upward" made popular by Stan Lee.

Exclusive: A contract under which an artist or writer works exclusively for one publisher for a set period of time.

Fanboy: A comic book fan (usually male).

Fangirl: A female fan.

Fanzine: A fan magazine.

FMV: Full motion video.

Free Comic Book Day: A publicity event designed to introduce comic books to new readers by giving away free copies.

Front Cover: The facing page of the thicker-stock paper wrapping around a comics or magazine. Displays the title and a **full-bleed** illustration based on the story contents.

Full Bleed: Refers to a photo or illustration extending to the page trim, with no **margin** or **gutter**.

Fumetti: A form of comics illustrated with photos rather than drawings. Popular in Italy.

Funny Animals: Comics featuring anthropomorphic animal characters. Example: Mickey Mouse.

Furries: Another name for Funny Animal comics.

FX: A movie term for special effects.

Geek: Another name for **fanboys** or comic book fans. Generally not considered pejorative.

Gold Foil: A comic book cover embossed with gold-colored leaf.

Golden Age: A period in comics history that followed the **Platinum Age**. From June 1938 (*Action Comics* #1) until the mid-1950s (*Seduction of the Innocent* and the Kefauver hearings).

Golem: A mythological creature created to protect sixteenth-century Jews. A basis for the Superman mythos.

Good Girl Art: Drawings of pretty girl-next-door females.

Graphic Album: An anthology-format comic book with multiple stories, published as a book rather than a periodical. (A **graphic novel** has similar format but tells a single story.)

Graphic Novel: A novel-length book containing a single story told using sequential art techniques.

Graphic Story Album: Basically a traditional book, but with dozens of full-page illustrations.

Gutter: The space between panels, or the space in the center of the page where the comic book is bound.

Hard Cover (HC): A book with a stiff board binding.

Harvey Awards: Named after Harvey Kurtzman, co-founder of *Mad* magazine, these awards are voted on by professionals in the industry.

Hollywood Accounting: An entertainment industry practice of deliberately reducing profits to avoid royalty payments or other profit-sharing agreements.

Holofoil: Sections of a comic book's cover are embossed with a holographic leaf.

"Holy Moly!": An exclamation often uttered by Captain Marvel's alter ego, Billy Batson.

House of Ideas, The: A euphemism for Marvel Comics.

Independent Comics: Comic books produced outside the mainstream system, often by individuals who write, draw, and letter the entire book. See **Indies.**

Indicia: A paragraph of small type in the front of most comic books, indicating the publication's title, date, publisher, and other relevant information.

Indies: Shorthand for **independent comics** or **independent publishers.**

Inker: An artist who adds the lines and shading over a penciler's drawing.

Intellectual Property: An original creative work that can be legally protected by patent, trademark, or copyright. Sometimes called **IP.**

Intercompany Crossover: A comic or series of comics in which a character (or group of characters) published by one company meets a character published by another. For example, DC's Superman meeting Marvel's Spider-Man. Such storylines usually occur within special one-shots or a miniseries.

IP: Lawyer-talk for **Intellectual Property.**

Justice League of America (JLA): A superhero organization, a latter-day version of the **JSA** as revamped by DC editor Julius Schwartz.

Justice Society of America (JSA): The first superhero organization, founded by DC characters in 1940's *All-Star Comics* #3.

Krypton: The planet where Superman was born.

Kryptonite: A substance from the planet Krypton that rends Superman powerless.

Letterer: Someone who adds the lettering to comic books, either by hand or computer fonts.

Letters to the Editor: A page in a comic book devoted to reader correspondence. See **Stan's Soapbox.**

Limited Series: A series of comic books with a set finite number of issues telling a complete story.

Logo: Either the symbol of the publisher—like the DC Bullseye or its current redesign as the DC Swirl—or the graphic presentation of the publication's title (name).

Mainstream: Comics that appeal to the broadest fan base. In today's comic book industry that would predominately reflect the superhero genre.

Man of Steel: A nickname often applied to Superman.

Manga: Japanese comic books. Generally, thick, black-and-white comics read back to front.

Manhwa: Korean manga.

Margins: The white space (unprinted portion of the page) surrounding the editorial content.

Marvel Method: A shortcut collaboration between writer and artist developed by Stan Lee. As opposed to the more common **Scripted Method.**

Marvelite: A devout and loyal reader of Marvel Comics.

Maxiseries: A **limited series** consisting of twelve or more individual issues (Dark Horse), or nine or more (DC).

Merry Marvel Marching Society: A fan club for Marvel, a promotional invention of Stan Lee. Membership was 75 cents per year. It folded in the mid-1970s.

Miniseries: A **limited series** consisting of fewer than twelve individual issues (Dark Horse), or fewer than eight (DC).

Mint: A comic book in perfect condition. Mints will have a value up to ten times one that's merely in good condition.

Model Sheet: A page of drawings of a character in various poses to help other artists draw him with consistency.

Modern Age: A period in comics history that follows the **Silver Age.** Approximately mid-1980s through the late '90s. Largely characterized by darker and more psychologically complex characters.

Monthly: Published once a month.

Motion Lines: Sometimes called **speed lines.** Graphic symbols that suggest movement.

Multiverse: A continuity construct in which multiple fictional universes exist in the same space, with each universe varying either slightly or greatly from the others.

Nonreturnable: The basis on which comics and other products are sold to **Direct Market** specialty store retailers (**comic book shops**).

No-Prize Prize: An award with no physical prize, a humorous interaction with comic book readers devised by Stan Lee.

"'Nuff Said": An expression associated with Stan Lee, closing a subject.

OGN: An original **graphic novel** (as opposed to compiled reprints).

One-and-Done: A single-issue comic story, a **one-shot**.

One-Shot: A self-contained, one-issue series. See **One-and-Done**.

Ongoing: A comic book series that has no ending planned and will continue until sales dictate its cancellation.

Online Comics: See **Webcomics**.

On-Sale Date: The day a comic or periodical is scheduled to go on sale to the public.

Origin: A character's beginnings. See also **Secret Origin.**

Pamphlet: A slim magazine-like format. Sometimes used to describe comic books.

Panel: The bordered box within a comic book where the storytelling art appears.

Panelologist: Slang for a person who researches comic books and/or comic strips.

Parallel Universe: A self-contained separate reality coexisting with our own. Sometimes called alternate reality or parallel worlds.

Penciler: An artist who draws the pictures that appear in comic books, the first step done in pencil.

Perfect Binding: Pages are glued to the cover as opposed to being stapled. Sometimes called square bound or square back.

Phone Book: A thick, telephone book–sized publication, often collecting classic issues of a comic book series in an inexpensive black-and-white format.

Platinum Age: A historical period that marks the beginnings of the American comic book. Anything published pre-June 1938 (*Action Comics* #1). Came before the **Golden Age.**

Postmodern Age: The (proposed) historical period following Marvel's bankruptcy and takeover by Toy Biz titan Ike Perlmutter in the late 1990s up to today.

Pre-Code: Describes comics published before March 1955. Refers to **Comics Code Authority.**

Prestige Format: Typically longer than a standard comic book, between forty-eight and seventy-two pages, printed on glossy paper with a card stock cover.

Proofreading: The act of spellchecking copy prior to publication.

Publisher: Refers to either the publishing company or the person responsible for managing its activities.

Pulp: Cheaply produced magazine made from low-grade newsprint. The term comes from the wood pulp that was used in the paper manufacturing process.

Quarterly: A comic book published four times a year (every three months).

Reboot: The retelling of a comic book character's story from the beginning (that is, to discard all previous continuity in the series and start anew).

Remainders: Comic books that "remained" unsold at the newsstand. Sometimes called **returns.** In the past the top quarter to third of the cover (or in some cases the entire cover) was removed and physically returned to the publisher for credit. This practice is the reason many comics from 1936 to 1965 are sometimes found as coverless copies or three-fourths-cover copies.

Resolicitation: A comic book being offered to retailers again, after previous preorders have been cancelled due to some unavoidable reason.

Retailers: Outlets that sell comics and other periodicals. See **Comic Book Store.**

Retcon: Short for retroactive continuity. This refers to the adding of new information to "historical" material, or deliberately changing previously established facts in a work of serial fiction.

Returnable: The consignment-like basis by which periodicals (magazines and comic books) are distributed to retailers in the so-called newsstand channel.

Reuben Awards: Presented by the National Cartoonists Society, this award is bestowed upon illustrators in numerous categories, including comic strips, comic books, and animation. Named after cartoonist Rube Goldberg.

Saddle Stitch: Binding a magazine or comic book with staples.

Sci-Fi: Science fiction. Fantastic fiction often set in the future.

Scripted Method: The tradition method of producing a comic book in which a writer designates panel-by-panel the images to go with his script.

Secret Identity: A disguise that allows a superhero to hide his identity from the general populace.

Secret Origin: The story of a superhero's beginnings.

Sell-Through: The percentage of periodical copies sold versus copies distributed in the newsstand channel.

Sequential Art: A term coined by artist Will Eisner to describe a series of illustrations that create a coherent narrative. Example: Comics are a form of sequential art storytelling. Sometimes shortened to "sequart."

"Shazam!": The magic word that turns Billy Batson into Captain Marvel.

Shoujo: Manga aimed at teen girls.

Sidekick: The "second banana" to a hero.

Silver Age: A period in comics history that followed the **Golden Age**. From the mid-1950s (*Seduction of the Innocent,* the new Flash) to 1970 (the breakup of Kirby and Lee).

Spandex: A type of stretchy polyurethane fabric often associated with superheroes' costumes. Sometimes used as a synonym for *costume.*

Speech Balloon: Cloudlike areas containing lettering to indicate speech in a comic book panel. Also see **Balloon.**

Special Effects: Illusions created for movies and television by props, camerawork, computer graphics, and so on. Also see **FX.**

Speed Lines: A drawing technique (popularized by Jack Kirby) denoting a sense of motion. Also see **Motion Lines.**

Splash Page: A full-page drawing, often used as the title page of a comic book containing title and credits.

Stan's Soapbox: The **Letters to the Editor** page in a Marvel Comic edited by Stan Lee.

Story Arc: An episodic storyline that extends through four to six issues of a comic book.

Storyboard: A sequence of still drawings, used to illustrate the key points of a story for film or animation.

Style Guide: A visual reference to how a character looks, a means of maintaining quality control when using many different artists.

Superhero: A comic book character who exhibits superhuman abilities and heroic qualities.

Superpower: The extrahuman ability possessed by a particular superhero. Examples: flying, super strength, magnetism, X-ray vision, flame throwing, mind reading, the ability to control weather, speed, and so on.

Supervillain: A bigger-than-life villain with elaborate criminal schemes.

Swimsuit Edition: Comic books featuring popular female characters in pinup poses. A take-off on the famous *Sports Illustrated* swimsuit issue.

TPB: An abbreviation for **trade paperback**, a book with softcover binding.

Trekkies: Fans devoted to the *Star Trek* science-fiction franchise, whether TV shows, movies, or comics.

Telephone Book: See **Phone Book.**

Thought Balloon: Similar to a **Speech Balloon** but usually scalloped to indicate inner dialogue. Also see **Balloon.**

3-D Comic: A comic book drawn in two layers that produces a three-dimensional effect when viewed through special glasses.

Three-Fourths Cover: See **Remainder.**

Tokusatsu: The Japanese term for a live-action production that heavily features special effects.

Trade Paperback: A reprint collection of a comic series bound together as one volume. Example: *Star Wars: Crimson Empire* #1–6 are collected into a single volume called *Star Wars: Crimson Empire.* Softcover. Sometimes abbreviated **TPB.**

Trademark: A legal claim to a brand.

True Believer: A fan who remains loyal to Marvel. A familiar Stan Lee catchphrase.

Try-out Book: A publication designed to allow comic book fans try their hand at drawing comics.

Underground Comix: Counterculture comic books, usually produced by small independent artists. Example: R. Crumb's *Fritz the Cat.*

Universe: A fictional world in which a publisher's array of comic book characters co-exist.

Variant: A comic book with differing versions of a cover.

Very Rare: One to ten copies are estimated to exist.

Wallcrawler: A nickname often applied to Spider-Man.

Webcomics: Also known as **online comics.** A digital online comic book or strip available on the Internet.

Webslinger: A nickname often applied to Spider-Man.

Wholesalers: Middlemen in the newsstand distribution chain who work with national distributors to deliver periodicals to retailers.

Word Balloon: Speech Balloon. Also see **Balloon.**

Work for Hire: A working relationship in which all work product remains the property of the employer. A legal copyright term.

Writer: Someone who writes the storyline for a comic book.

'Zine: Fanzine.

Zombie: A term sometimes used to describe a devoted fan of Marvel Comics. As in "Marvel Zombie."

COMIC BOOK QUIZ

1. Which comic book company is older (including its corporate antecedents)?
 a. Marvel
 b. DC
 c. Image
 d. Tokyopop

2. Which came first?
 a. The Bronze Age
 b. The Golden Age
 c. The Platinum Age
 d. The Titanium Age

3. Stanley Lieber went to work for . . .
 a. His uncle's company
 b. His wife's cousin's company

 c. His cousin's husband's company

 d. His neighbor's uncle's company

4. Which of the following comic book pioneers grew up on New York's Lower East Side?

 a. Harry Donenfeld

 b. Jack Liebowitz

 c. Jack Kirby

 d. All of the above

5. Which of the following comic book creators lived in Cleveland?

 a. Joe Shuster and Jerry Siegel

 b. Robert Crumb

 c. Harvey Pekar

 d. Brian K. Vaughan

 e. All of the above

6. Wonder Woman was created by . . .

 a. A Swiss psychiatrist

 b. An American psychologist

 c. A famous girlie photographer

 d. The founder of the Girl Scouts

7. Which of the following did *not* own Marvel at one time?

 a. A movie studio

 b. The guy who owns Revlon

 c. The fellow who took over TWA

 d. A former job lot dealer

 e. The president of the Rock and Roll Hall of Fame

8. Which character did Jack Kirby *not* have a hand in creating?

 a. Captain America

 b. Silver Surfer

 c. Tuk the Cave-Boy

 d. Boy Commandos

 e. He helped create all of the above

9. Jack Kirby's birth name was . . .

 a. Jacob Kurtzberg

 b. Harvey Kurtzman

 c. Harvey Pekar

 d. Julius Schwartz

10. MLJ Publications stood for . . .
 a. The initials of the founders' first names
 b. The initials of the founders' sons' first names
 c. A candy bar
 d. The merger of three distribution companies

11. The Clock was the first superhero to . . .
 a. Wear a cape
 b. Wear a mask
 c. Fly
 d. Have X-ray vision

12. Shuster and Siegel originally sold the rights to Superman for . . .
 a. $2 million
 b. $2,500
 c. $130
 d. $52 and a bag of peanuts

13. Batman assumed his fearsome identity because . . .
 a. His girlfriend was killed
 b. His best buddy was killed
 c. He was a former district attorney and hated crooks
 d. His parents were killed

14. Stan Lee got the idea for Spider-Man . . .
 a. After seeing a fly on the wall
 b. From Jack Kirby
 c. From an old concept by Joe Simon
 d. From . . . well, we're not sure

15. Which prize did Art Spiegelman win for *Maus?*
 a. Nobel
 b. Pulitzer
 c. Peace
 d. None of the above

16. Alan Moore fancies himself to be . . .
 a. A mind reader
 b. A soothsayer
 c. A true magician
 d. A cannibal

17. Who of the following people was *not* a president of Marvel?
 a. Terry Stewart
 b. Scott Sassa

 c. Bill Jemas

 d. Jerry Calabrese

18. Joe Simon's longtime partner was . . .
 a. Gil Kane
 b. Bob Kane
 c. Jack Kirby
 d. Stan Lee

19. Which two creators launched Marvel Knights?
 a. Jeph Loeb and Rob Liefeld
 b. Kevin Smith and Quentin Tarantino
 c. Joe Quesada and Jimmy Palmiotti
 d. Joe Simon and Jack Kirby

20. Stan Lee did not have a hand in creating . . .
 a. Stripperella
 b. Spider-Man
 c. Swamp-Thing
 d. The Incredible Hulk

21. Who launched EC Comics?
 a. Maxwell C. Gaines
 b. William M. Gaines
 c. Major Malcolm Wheeler-Nicholson
 d. Alfred E. Neuman

22. Wildstorm Productions was founded by . . .
 a. Stan Lee
 b. Jae Lee
 c. Ang Lee
 d. Jim Lee

23. Charlton Comics was the inspiration for characters in which graphic novel?
 a. *Kingdom Come*
 b. *The Dark Knight Returns*
 c. *Watchmen*
 d. *Maus*

24. The most celebrated X-Men writer was probably . . .
 a. F. Scott Fitzgerald
 b. Otto Binder
 c. William Moulton Marston
 d. Chris Claremont

25. Dark Horse founder Mike Richardson . . .
 a. Owned horse farms
 b. Owned comic book stores
 c. Owned a gold mine
 d. Owned a travel agency

COMIC BOOK QUIZ

ANSWERS

1. b. DC
2. c. The Platinum Age
3. c. His cousin's husband's company
4. d. All of the above
5. e. All of the above
6. b. An American psychologist
7. e. The president of the Rock and Roll Hall of Fame
8. e. He helped create all of the above
9. a. Jacob Kurtzberg
10. a. The initials of the founders' first names
11. b. Wear a mask
12. c. $130

13. d. His parents were killed
14. d. From … well, we're not sure
15. b. Pulitzer
16. c. A true magician
17. b. Scott Sassa (he was chairman and CEO)
18. c. Jack Kirby
19. c. Joe Quesada and Jimmy Palmiotti
20. c. Swamp-Thing
21. a. Maxwell C. Gaines
22. d. Jim Lee
23. c. *Watchmen*
24. d. Chris Claremont
25. b. Owned comic book stores

CREDIT WHERE CREDIT'S DUE

1. Dr. Robert MacDougall, "Superman I: Secret Origins," Old Is the New New, robmacdougall.org, March 15, 2006.
2. Allison Kugel, "Stan Lee: From Marvel Comics Genius to Purveyor of Wonder with POW! Entertainment," pr.com, March 13, 2006.

PREFACE

1. Valerie D'Orazio, "Rants and Reviews for August," silverbulletcomicbook.com, August 22, 2005.

INTRODUCTION: HISTORY OF THE COMIC BOOK WORLD, PART I

1. Dan Whitehead, "Kapow! A Talk with Joe Simon," The Web, simoncomics.com.
2. Jamie Coville, "An Interview with Joe Simon," Coville's Clubhouse, collectortimes.com, 1999.
3. Ibid.

4. David Hajdu, "Comics for Grown-Ups," *New York Review of Books* 50, no. 13, nybooks.com, August 14, 2003.

5. "Comic Book," thefreedictionary.com.

6. Scott McCloud, *Understanding Comics: The Invisible Art,* Harper Paperbacks, 1994.

7. Robert M. Overstreet, *Official Overstreet Comic Book Price Guide,* 36th ed., House of Collectibles, 2006.

8. "Victorian Age Key Tops $10,000!," Industry News: Scoop, scoop.diamond-galleries.com, February 24, 2006.

9. "Rodolphe Töpffer," en.wikipedia.org.

10. "The Adventures of Tintin," en.wikipedia.org.

11. Scott McCloud, *Understanding Comics.*

12. "Comic Book Ages," everything2.com.

13. Ken Quattro, "The New Ages: Rethinking Comic Book History," Comicartville Library, comicartville.com.

14. "Comic Book Ages: Part IV," The Main Event, Scoop, scoop.diamondgaller-ies.com, October 24, 2003.

CHAPTER 1: THE PLATINUM AGE: THE FIRST COMICS

1. "Birth of the Comic Book," Talk of the Nation, npr.org, October 27, 2004.

2. Gerard Jones, *Men of Tomorrow: Geeks, Gangsters, and the Birth of the Comic Book,* Basic Books, 2004.

3. Robert M. Overstreet, *Official Overstreet Comic Book Price Guide,* 36th ed., House of Collectibles, 2006.

4. Rafael de Viveiros Lima, "Some History (so Far . . .)," Comic Book HomePage, *www.geocities.com.*

5. Don Markstein, "Famous Funnies," Don Markstein's Toonopedia, toonope-dia.com.

6. "Max Gaines," en.wikipedia.org.

7. "Famous Funnies," en.wikipedia.org.

8. Ron Goulart, *Comic Book Encyclopedia,* Harper Entertainment, 2004.

9. Jamie Coville, "See You in the Funny Pages," History of Comic Books, col-lectortimes.com.

10. Jamie Coville, "Before *Super* Heroes," History of Superhero Comic Books, geocities.com.

11. Don Markstein, "Famous Funnies."

12. Ibid.

13. Ibid.

14. "New Fun Comics #1," 100 Greatest Comics of the 20th Century, geocities.com.

15. Claude Lalumière, "A Short History of American Comic Books," january-magazine.com.

16. Bob Hughes, "Who Drew the Superman?," supermanartists.comics.org, February 27, 2000.

17. Ron Goulart, *Ron Goulart's Great History of Comic Books,* Contemporary Books, 1986.

18. "Malcolm Wheeler-Nicholson," en.wikipedia.org.

19. "WonderCon," News from Me, povonline.com, April 21, 2002.

20. Gerard Jones, *Men of Tomorrow.*

21. Robert J. Rosenberg, "Comic Geniuses," businessweek.com, December 6, 2004.

22. Gerard Jones, *Men of Tomorrow.*

23. Robert MacDougall, "Superman I: Secret Origins."

24. Gerard Jones, *Men of Tomorrow.*

25. Jay Schwartz, "Jews and the Invention of the American Comic Book," *New Jersey Jewish Standard,* April 27, 2006.

26. Robert J. Rosenberg, "Comic Geniuses."

27. Gerard Jones, *Men of Tomorrow.*

28. Ibid.

29. Robert J. Rosenberg, "Comic Geniuses."

30. "DC Timeline 1835–45," supermanartists.comics.org.

31. Ibid.

32. Robert MacDougall, "Superman I: Secret Origins." "DC Timeline 1835–45."

33. "DC Timeline 1835–45."

34. Ibid.

35. "DC's Other Comics," DC History, supermanartists.comics.org.

36. Ibid.

37. "DC Timeline 1835–45."

38. Ibid.

39. Gerard Jones, *Men of Tomorrow.*

40. "Detective Comics," comics.ign.com.

41. "DC Timeline 1835–45."

42. Ron Goulart, *Ron Goulart's Great History of Comic Books.*

43. Gerard Jones, *Men of Tomorrow.*

44. Ibid.

45. Ibid.

46. "Auction Prices," scoop.diamondgalleries.com.

47. Barbara Crews, "Million Reward for Rare Comic Book Offered by Baltimore Business Executive," collectibles.about.com, October 31, 2003.

48. Jenette Kahn, "Foreword," *Superman from the Thirties to the Eighties,* Crown Publishers, revised ed., 1983.

49. E. Nelson Bridwell, "Introduction," *Superman from the Thirties to the Eighties,* Crown Publishers, revised ed., 1983.

50. "Reign of the Superman," Superman through the Ages, superman.ws.

51. Mike Catron, "Comics Pioneer Jack Liebowitz Dies at 100," *The Comics Journal,* tcj.com, December 11, 2000.

52. Gerard Jones, *Men of Tomorrow.*

53. "Superman," en.wikipedia.org.

54. "A Golem for Our Times," *Hillel,* Jewish Resources, hillel.org.

55. *Action Comics* #1, Detective Comics, Inc., June 1938.

56. "Superman," en.wikipedia.org.

57. "Jack Kirby," geocities.com/brenni_au/JackKirby.html.

CHAPTER 2: THE GOLDEN AGE: THE FIRST SUPERHEROES

1. Stan Lee, POW! Entertainment, personal interview, Spring 2007. *Variation:* Stan Lee and George Mair, *Excelsior! The Amazing Life of Stan Lee,* Fireside, 2002.

2. "Golden Age of Comic Books," en.wikipedia.org.

3. Stan Lee and George Mair, *Excelsior!*

4. Gary Groth, "Gil Kane," *The Comics Journal* #186, tcj.com.

5. Jean Depelley, "Will Eisner Speaks!," *Jack Kirby Collector* #16, TwoMorrows Publishing. .

6. Gary Groth, "Gil Kane," *The Comics Journal* #186, *ibid.*

7. Claude Lalumière, "A Short History of American Comic Books," *January Magazine,* januarymagazine.com.

8. Jon B. Cooke, *Comic Book Artist Collection,* vol. 1, TwoMorrows Publishing.

9. Gary Groth, "Carmine Infantino," *The Comics Journal* #191, tcj.com.

10. Jon Beck, "The Weird, Wonder(ous) World of Victor Fox's Fantastic Mystery Men," *Comicartville Library,* comicartville.com.

11. Joe Simon, "More than Your Average Joe," *Jack Kirby Collector* #25, TwoMorrows Publishing.

12. Jon Beck, "The Weird, Wonder(ous) World of Victor Fox's Fantastic Mystery Men."

13. Gerard Jones, *Men of Tomorrow: Geeks, Gangsters, and the Birth of the Comic Book,* Basic Books, 2004.

14. Jon Beck, "The Weird, Wonder(ous) World of Victor Fox's Fantastic Mystery Men."

15. Ibid.

16. Ibid.

17. Roy Thomas, "A Moon . . . a Bat . . . a Hawk: A Candid Conversation with Sheldon Moldoff," *Alter Ego* 3, no. 4, TwoMorrows Publishing.

18. "Alex Raymond," en.wikipedia.org.

19. Michael Silberkleit, Archie Comics, personal interview, Fall 2006.

20. Gary Groth, "Jerry Robinson," *The Comics Journal* #271, tcj.com.

21. Mark Juddery, "Jacob 'Jack' Liebowitz," markjuddery.com.

22. Don Markstein, "All-American Publications," Don Markstein's Toonopedia, toonopedia.com.

23. Roy Thomas, "So I Took the Subway and there Was Shelly Mayer . . . ," Alter Ego 3, no. 1, TwoMorrows Publishing.

24. "DC Comics," worldcollectorsnet.com.

25. Ibid.

26. Jennifer M. Contino, "New Whirlwind of a DC Logo **Updated," comicon. com, May 9, 2005.

27. "Jack S. Liebowitz, 1900–2000," obits.com.

28. "Superman," ImageTexT, english.ufl.edu.

29. "Archie," en.wikipedia.org.

30. "Golden Age of Comics," en.wikipedia.org.

31. *Writers Digest,* June 1941.

32. "Comic Book Success Stories," Museum of Comic Book Advertising, comic-bookads.leafpublishing.com.

33. Ron Goulart, *Over 50 Years of American Comic Books,* Mallard Publishing, 1991.

34. "Martin Goodman (Publisher)," en.wikipedia.org.

35. Jim Amash, "I Let People Do Their Jobs: A Conversation with Vince Fago," *Alter Ego* 3, no. 11, TwoMorrows Publishing.

36. "Timely Comics," internationalhero.co.uk.

37. "Sub-Mariner" and "Homo Mermanus," en.wikipedia.org.

38. Keif Fromm, *Alter Ego* 49.

39. Joe Simon, "More than Your Average Joe," *Jack Kirby Collector 25,* TwoMorrows Publishing.

40. Ibid.

41. Alan Hewetson, "Syd Shores," Now and Then Times 1, no. 2, ess.comics.org, October 1973.

42. "Jack Kirby Biography," Jack Kirby Museum and Research Center, kirbymuseum.org.

43. Jess Nevins, "The Timely Comics Story," geocities.com/Athens/Olympus/7160/Timely3.htm.

44. Joe Simon with Jim Simon, *The Comic Book Makers,* Crestwood/II, 1990.

45. Joe Simon, "More Than Your Average Joe."

46. Jim Amash, "I Let People Do Their Jobs: A Conversation with Vince Fago."

47. Roy Thomas, "Stan the Man and Roy the Boy," *Comic Book Artist 2,* TwoMorrows Publishing.

48. Joe Simon, "More than Your Average Joe."

49. Stan Lee and George Mair, *Excelsior!*

50. Arie Kaplan, "How Jews Created the Comic Book Industry," Reform Judaism, ariekaplan.com.

51. Jess Nevins, "The Timely Comics Story."

52. Dan Whitehead, "Kapow! A Talk with Joe Simon," The Web, simoncomics. com.

53. "Jack Kirby," geocities.com/brenni_au/JackKirby.html.

54. Ibid.

55. Ibid.

56. "Thumbnail: Rob Liefeld," ninthart.com, October 4, 2004.

57. "Jack Kirby, King of Comics," Biography, Comic Art and Graffix Gallery, comic-art.com.

58. Don Markstein, "The Young Allies," Don Markstein's Toonopedia, toono-pedia.com.

59. Jordan Raphael and Tom Spurgeon, *Stan Lee and the Rise and Fall of the American Comic Book,* Chicago Review Press, 2003.

60. Don Markstein, "The Newsboy Legion," Don Markstein's Toonopedia, toonopedia.com.

61. "Jack Kirby," geocities.com.

62. Ibid.

63. Jim Amash, "The Incredible Infantino Interview," *Jack Kirby Collector 34,* TwoMorrows Publishing.

64. Kenneth Plume, "Interview with Stan Lee (Part 1 of 5)," *IGN.com,* movies. ign.com, June 26, 2000.

65. Dr. Michael Vassallo, "A Timely Talk with Allen Bellman," comicartville. com.

66. Stan Lee, personal interview.

67. Jim Amash, "I Let People Do Their Jobs."

68. William W. Savage, Jr., "Patriotism in World War II Comic Books," bookrags. com.

69. "How Superman Would End the War," *Look,* February 27, 1940.

70. "German Propaganda Archive," Calvin College, calvin.edu.

71. "Antebellum Part 1," The Timely Comics Story, geocities.com.

72. Stan Lee and George Mair, *Excelsior!*

73. Jim Amash, "I Let People Do Their Jobs."

74. Ronin Ro, *Tales to Astonish: Jack Kirby, Stan Lee, and the American Comic Book Revolution,* Bloomsbury USA , reprint ed., 2005.

75. Jim Amash, "I Let People Do Their Jobs."

76. Ibid.

77. Ibid.

78. Rabbi Simcha Weinstein, "Jewperheroes," Rabbi Simcha: The Comic Book Rabbi, rabbisimcha.com.

79. Don Markstein, "Captain America," Don Markstein's Toonopedia, toono-pedia.com.

80. "Superman Sketch," *History Detectives,* PBS, a co-production between Lion Television and Oregon Public Broadcasting.

81. "Superman," ImageText.

82. Bradford W. Wright, *Comic Book Nation: The Transformation of Youth Culture in America,* Johns Hopkins University Press (New ed.), 2003.

83. "Captain Marvel," An International Catalogue of Superheroes, internationalhero.co.uk.

84. "Part Two: At the Rock of Eternity!," dialbforblog.com.

85. "Matrix," the-numbers.com.

86. "Thunderbolts (Comics)," en.wikipedia.org.

87. Ibid.

88. Aaron Albert, "Top 10 Superhero Teams," comicbooks.about.com.

89. Damon Cave, "Review of *Comic Book Nation* by Bradford W. Wright," salon.com, 2005.

90. Joe Simon, "More than Your Average Joe."

91. Jim Amash, "The Incredible Infantino Interview," *Jack Kirby Collector 34,* TwoMorrows Publishing.

92. Michael Silberkleit, Archie Comics, personal interview, Fall 2006.

93. Ibid.

94. Stan Lee and George Mair, *Excelsior!*

95. Ibid.

96. Kenneth Plume, "Interview with Stan Lee (Part 1 of 5)."

97. "Golden Age of Comic Books," en.wikipedia.org.

98. Neil Rennie, "Pulp Fiction," Guardian Unlimited, books.guardian.co.uk, July 21, 2001.

99. Gerard Jones, *Men of Tomorrow.*

100. Don Markstein, "EC Comics," Don Markstein's Toonopedia, toonopedia.com.

101. Maria Reidelbach, *Completely Mad,* Little, Brown and Company, 1991.

102. "Biography of Max Gaines," Mad Magazine: Irreverent and Discontent, psu.edu/dept/inart10_110/inart10/cmbk5mad.html.

103. Ibid.

104. "Irwin Donenfeld, Veteran RTM Member and Comic Industry Giant, Dead at 78," westportnow, November 30, 2004.

105. Mark Evanier, "Irwin Donenfeld," POVonline, News from Me Archives, newsfromme, December 1, 2004.

106. Michael E. Grost, "The Legion of Super-Heroes," Classic Comic Books, members.aol.com/MG4273/legion.htm.

107. Ray Bottorff, Jr., "Let's You and Him Fight," *The Comics Reporter,* comicsreporter.com, December 20, 2005.

108. "American Comic Book," en.wikipedia.org.

109. Mike Benton, *The Comic Book in America: An Illustrated History,* Taylor Publishing Company, 1989.

110. "Carl Barks," filmbug.com.

111. *Howard the Duck* (1986), directed by Willard Huyck, imdb.com.

112. Mike Benton, *The Comic Book in America.*

113. "Vince Fago and the Timely Funny Animal Dept.," *Comicartville Library,* comicartville.com.

114. Dr. Michael J. Vassallo, "A Timely Talk with Allen Bellman," *Comicartville Library,* comicartville.com, 2005.

115. Mike Benton, *The Comic Book in America.*

116. "Furries! Introduction to the Furry Fandom," claws-and-paws.com.

117. Don Markstein, "Harold Teen," Don Markstein's Toonopedia, toonopedia. com.

118. Mike Benton, *The Comic Book in America.*

119. Ibid.

120. Ibid.

121. "Jungle Twins," en.wikipedia.org.

122. Mike Benton, *The Comic Book in America.*

123. Ibid.

124. Bob Harras, DC Comics, personal interview, Spring 2007.

125. Mike Benton, *The Comic Book In America: An Illustrated History, ibid.*

126. "EC Comics," en.wikipedia.org.

127. Mike Benton, *The Comic Book in America.*

128. Joe Kubert, Fax from Sarajevo, amazon.co.uk.

129. XTC, *Black Sea,* Geffen Records, 1980.

130. Mike Benton, *The Comic Book in America.*

131. Ray Bradbury, *Stories of Ray Bradbury,* Knopf, 1980.

132. "Mike Danger," thrillingdetective.com.

133. "EC Comics," en.wikipedia.org.

134. Mike Benton, *The Illustrated History of Horror Comics,* Taylor Publishing, 1991.

135. "Tales from the Crypt (Comic)," Trivia and Outstanding Stories, en.wikipedia. org.

136. Ray Bradbury, *Stories of Ray Bradbury.*

137. Mike Benton, *The Illustrated History of Horror Comics.*

138. "EC Comics," en.wikipedia.org.

139. Mike Benton, *The Illustrated History of Horror Comics.*

140. "Horror Comics," *Time,* May 3, 1954.

141. Don Markstein, "Tales from the Crypt, The Vault of Horror, etc.," Don Markstein's Toonopedia, toonopedia.com.

CHAPTER 3: SEDUCTION OF THE INNOCENT: A COMICS WITCH HUNT

1. Fredric Wertham, *Seduction of the Innocent,* Rinehart (1954).

2. "Geppi's Remarks on Joining the CBLDF Board," Comic Book Legal Defense Fund, cbldf.org, September 14, 2004.

3. "Dr. Fredric Wertham," History and People, The Amazing Adventures of Kavalier & Clay, sugarbombs.com.

4. "Fredric Wertham," en.wikipedia.org.

5. Greg Legman, "The Comic Books and the Public," Symposium, Association for the Advancement for Psychotherapy, March 19, 1948.

6. "Horror on the Newsstand," *Time,* September 27, 1954.

7. Fredric Wertham, *Seduction of the Innocent.*

8. Ibid.

9. Dan DiDio, DC Comics, personal interview, Fall 2006.

10. Alan Grant, "Is Batman Gay?" The Panel, silverbulletcomicbooks.com.

11. Ibid.

12. "Batman: Homosexual Interpretations," aaronlanguage.com.

13. Jen Yamato, "Clooney Claims His Batman Was Gay; Barbara Walters Interviews Other People," News Features, rottentomatoes.com, March 1, 2006.

14. "Batman," aaronlanguage.com.

15. Gary Groth, "Spiegelman on Kirby," *The Comics Journal* 180, tcj.com.

16. Trina Robbins, "Wonder Woman: Lesbian or Dyke," originally presented at WisCon, May 2006.

17. "Lie Detector," *The Columbia Encyclopedia,* 6th ed., 2001–5.

18. "Wonder Woman," uky.edu/Projects/Chemcomics/html/ ww_21_cov. html.

19. "Golden Age," The Wonder Woman Pages, wonderwoman-online.com.

20. "Wonder Woman," uky.edu/Projects/Chemcomics/html/ ww_21_cov. html.

21. "Golden Age," The Wonder Woman Pages.

22. "Creation," The Wonder Woman Pages, wonderwoman-online.com.

23. Ibid.

24. Dave Gieber, "Wonder Woman, Amazon or Princess?," comic-book-collec-tion-made-easy.com.

25. Les Daniels, *Wonder Woman: The Complete History,* Chronicle Books, reprint ed., 2004.

26. "Golden Age," The Wonder Woman Pages.

27. Dan DiDio, DC Comics, personal interview, Fall 2006.

28. Amy Kiste Nyberg, "The Senate Investigation," Crime Comic Books of the 1940s and 1950s, crimeboss.com.

29. Richard Corliss, "Horrible Surprise Ending," *Time* Viewpoint, time.com, April 29, 2004.

30. Stan Lee and George Mair, *Excelsior! The Amazing Life of Stan Lee,* Fireside, 2002.

31. Don Markstein, "EC Comics," Don Markstein's Toonopedia, toonopedia. com.

32. Richard Corliss, "The Glory and Horror of EC Comics," *Time,* jcgi.pathfinder. com/time/columnist/corliss/article/0,9565,631203,00.htm, April 29, 2004.

33. Bob Meadows, "EC Comics Horror," horror-wood.com.

34. "Horror on the Newsstand," time.com, September 27, 1954.

35. Diane DeBlois, "When the Comics Migrate from the Funnies," booksourcemonthly.com.

36. "Code for Comics," *Time,* November 8, 1954.

37. Michael Silberkleit, personal interview.

38. James McWilliams, "Overview: Comic Books," firstamendmentcenter.org.

39. "Horror on the Newsstand."

40. Don Markstein, "EC Comics."

41. "Comic Code Authority," en.wikipedia.org.

42. Grant Geissman and Fred Von Bernewitz, *Tales of Terror: The EC Companion,* New ed., Fantagraphics Books, 2002.

43. Dan DiDio, personal interview.

44. Joyce Millman, "Queertoons," Joyce Millman on Television, salon.com.

45. City Mama, "Superman: Ambiguously Gay Superhero?" blogher.org, July 21, 2006.

46. "Superman 'Not Gay' Says Director," BBC News, news.bbc.co.uk.

47. "Trade Round-up: Bryan Singer Returns to Superman Franchise, Asked to 'Butch Him up a Little This Time, OK?,'" defamer.com, October 30, 2006.

48. "Interviews with the X Men," *View,* viewlondon.co.uk.

49. City Mama, "Superman: Ambiguously Gay Superhero?"

50. "Smith Slams Singer's Superman for Not Being Gay Enough," News, contactmusic.com, July 24, 2006.

51. "Superman 'Not Gay' Says Director."

52. "Northstar," en.wikipedia.org.

53. Meghan Daum, *Los Angeles Times,* latimes.com.

CHAPTER 4: THE SILVER AGE: A NEW KIND OF SUPERHERO

1. Steven Ringgenberg, "Gil Kane Interview," Comic Art and Graffix Gallery, comic-art.com.

2. "Review of *Tales to Astonish: Jack Kirby, Stan Lee and the American Comic Book Revolution* by Ronin Ro," bloomsburyusa.com.

3. Matt Rossi, "DC's Crisis on Infinite Earths," Marginalia, thehighhat.com.

4. Roy Thomas, "A Conversation with Editorial Legend Julius Schwartz," *Alter Ego* 7, no. 3, TwoMorrows Publishing.

5. "Silver Age," en.wikipedia.org.

6. *Alter Ego* 3, no. 54, November 2005.

7. "Archie Comics," en.wikipedia.org.

8. Gary Groth, "Gil Kane," *The Comics Journal* 186–187, tcj.com.

9. Michael Silberkleit, Archie Comics, personal interview, Fall 2006.

10. Richard Goldwater, Archie Comics, personal interview, Fall 2006.

11. Michael Silberkleit, personal interview.

12. "Misfits and Mavericks," University of Nebraska Press blog, nebraskapress. typepad.com.

13. Michael Silberkleit, personal interview.

14. "Television Stats," Museum of Broadcasting, New York.

15. Mike Benton, *The Comic Book in America: An Illustrated History,* Taylor Publishing, 1989.

16. Zoë Ingalls, "Holy Pop Culture!," *Duke Magazine* 89, no. 6, September–October 2003.

17. Mike Benton, *The Comic Book in America.*

18. "Atlas Comics (1950s)," en.wikipedia.org.

19. Roy Thomas, "Stan the Man and Roy the Boy," *Comic Book Artist 2,* TwoMorrows Publishing.

20. "*Amazing Adventures #3,*" The Grand Comics Database, comics.org.

21. Stan Lee and George Mair, *Excelsior!.*

22. "Joe Sinnott Interview," *Alter Ego* 26, TwoMorrows Publishing.

23. Robert Lee Beerbohm, "The Mainline Comics Story: An Initial Examination," *Jack Kirby Collector 25,* twomorrows.com.

24. Robert Lee Beerbohm, "The Mainline Comics Story."

25. Joe Simon with Jim Simon, *The Comic Book Makers,* Crestwood/II, 1990.

26. Robert Lee Beerbohm, "The Mainline Comics Story."

27. "The End of Simon and Kirby, Chapter 3, Unlikely Port in the Storm," The Jack Kirby Museum, kirbymuseum.org, May 18, 2006.

28. Joe Simon, "More than Your Average Joe," *Jack Kirby Collector 25,* TwoMorrows Publishing.

29. Jon Cooke and Christopher Irving, "The Charlton Empire," *Comic Book Artist 9,* TwoMorrows Publishing.

30. Jon Cooke and Christopher Irving, "The Charlton Empire."

31. "Jack Kirby," geocities.com/brenni_au/JackKirby.html.

32. Ibid.

33. "Jack Kirby Interview," *The Comics Journal* 134, February 1990.

34. Roy Thomas, "Stan the Man and Roy the Boy."

35. "Jack Kirby Interview," *The Comics Journal.*

36. Ibid.

37. "Meet the Monsters," monsterblog.oneroom.org.

38. "Atlas Comics (1950s)," en.wikipedia.org.

39. "American Comic Book," en.wikipedia.org.

40. Stan Lee, *Origins of Marvel Comics,* Simon and Schuster/Fireside Books, 1974.

41. Ibid.

42. *The Ice Storm* (1997), directed by Ang Lee, imdb.com.

43. Kenneth Plume, "Interview with Stan lee (Part 1 of 5)," movies.ign.com, June 26, 2000.

44. Jeet Heer, "Jack Kirby and Stan Lee," *National Post,* October 11, 2003.

45. Claude Lalumière, "A Short History of American Comic Books," january-magazine.com.

46. Stan Lee, POW! Entertainment, personal interview, Spring 2007.

47. Kenneth Plume, "Interview with Stan Lee (Part 1 of 5)."

48. "Spider-Man," en.wikipedia.org.

49. *Spider-Man Tech,* Prometheus Entertainment.

50. Peter Sanderson, *Marvel Universe,* Harry N. Abrams, 1998.

51. Jeet Heer, "Jack Kirby and Stan Lee."

52. "Dave Sim's Blogandmail #89," davesim.blogspot.com, December 9, 2006.

53. Joe Simon with Jim Simon, *The Comic Book Makers.*

54. Gary Martin, "Steve Ditko: A Portrait of the Master," *Comic Fan* 2, Summer 1965.

55. Joe Simon with Jim Simon, *The Comic Book Makers.*

56. *Stan Lee's Mutants, Monsters, and Marvels* (2002), directed by Scott Zakarin, Sony Pictures.

57. Dan Whitehead, "Kapow! A Talk with Joe Simon," *The Web,* simoncomics.com.

58. Kenneth Plume, "Interview with Stan Lee (Part 2 of 5)."

59. Jordan Raphael and Tom Spurgeon, *Stan Lee and the Rise and Fall of the American Comic Book,* Chicago Review Press, 2003.

60. "Review of *Tales to Astonish: Jack Kirby, Stan Lee and the American Comic Book Revolution* by Ro Ronin," Bloomsbury USA, bloomsburyusa.com.

61. Gerard Jones, *Men of Tomorrow: Geeks, Gangsters, and the Birth of the Comic Book,* Basic Books, 2004.

62. Jack "The King" Kirby, geocities.com.

63. Gerard Jones, *Men of Tomorrow.*

64. Ibid.

65. Jon B. Cooke, "Kirby's Mean Streets, the Lower East Side of Jacob Kurtzberg," *Jack Kirby Collector 16,* TwoMorrows Publishing.

66. Jean Depelley, "Will Eisner Speaks!," *Jack Kirby Collector 16,* TwoMorrows Publishing.

67. "Jack Kirby," geocities.com/brenni_au/JackKirby.html.

68. Mark Evanier and Steve Sherman, *Kirby Unleashed,* Communicators Unlimited, 1972.

69. "Jack Kirby," geocities.com/brenni_au/JackKirby.html.

70. "The Return of the King?" comictreadmill.com, June 9, 2004.

71. Jordan Raphael and Tom Spurgeon, *Stan Lee and the Rise and Fall of the American Comic Book.*

72. Ibid.

73. Kurt Vonnegut, Jr., *Mother Night,* Dial Press Trade Paperback, May 1999.

74. Ray Tomczak, "Happy Birthday, Stan Lee," wordfromonhigh.blogspot.com, December 28, 2006.

75. Jeet Heer, "Jack Kirby and Stan Lee."

76. Brian Hofacker, "DF Review: Stan Lee," dynamicforces.com.

77. Mike Allred, SilverBulletComics, silverbulletcomicbook.com.

78. "DC: Overview of 'The Establishment,'" ImageTexT, english.ufl.edu/ imagetext/archives/exhibit1/dc.shtml.

79. Sara Pendergast and Tom Pendergast, *St. James Encyclopedia of Popular Culture,* Gale Group, 1999.

80. Mark Millar, "Stan Lee," fractalmatter.com.

81. "Julius Schwartz," Telegraph Media Group Limited, telegraph.co.uk, December 2, 2004.

82. "Paul Levitz: A Collector at the Top," The Main Event, Scoop, scoop.diamondgalleries.com, November 22, 2002.

83. Bob Harras, DC Comics, personal interview, Spring 2007.

84. "'Roy the Boy' in the Marvel Age of Comics," *Alter Ego 3,* no. 50, July 2005.

85. "Jim Steranko," en.wikipedia.org.

86. "The Will Eisner Award Hall of Fame," en.wikipedia.org.

87. Alexander Ness, "Super Dudes in Super Costumes," *TFTLOF WEEKLY* 1, no. 10, columns.stlcomics.com.

88. "Merry Marvel Marching Society," en.wikipedia.org.

89. "Warren Publishing," en.wikipedia.org.

90. Jon B. Cooke, "From Art Director to Publisher: The Infantino Interview," *Comic Book Artist 1,* TwoMorrows Publishing.

91. Jon B. Cooke, "The James Warren Interview," *Comic Book Artist 4,* TwoMorrows publishing.

92. "Submarine, Grand Canal Get Creepy, Eerie," Superstars, Scoop, scoop.diamondgalleries.com, March 2 2007.

93. "Jack Liebowitz Dies at 100," Comic Book News and Views, orcafresh.net, December 15, 2000.

94. "DC's Checkerboard," Comic Book Spinner Rack, moocowcomics. blogspot.com/2005/07/dcs-checkerboard.html, July 7, 2005.

95. Ibid.

96. Mark Evanier, "A Checkered Experience," POVonline, News from Me, newsfromme.com, July 2, 2005.

97. Mark Evanier, "Living la Vida Logo," POVonline, News from Me, newsfromme.com, October 5, 2006.

98. Jon B. Cooke, "From Art Director to Publisher: The Infantino Interview."

99. Robert J. Rosenberg, "Review of *Men of Tomorrow* by Gerard Jones," *BusinessWeek,* December 6, 2004.

100. "Jack Liebowitz Dies at 100," Comic Book News and Views.

101. "Kinney Parking Company," "Kinney National Company," and "Time Warner," en.wikipedia.org.

102. Mark Evanier, "Irwin Donenfeld, R.I.P.,"newsfromme.com, December 1, 2004.

103. Ibid.

104. TimeWarner 2006 Annual Report, ir.timewarner.com.

105. "Fanzine," en.wikipedia.org.

106. "Alter Ego (fanzine)," en.wikipedia.org.

107. Rik Offenberger, "Paul Levitz: Living in an Amazing World," silverbullet-comicbooks.com.

108. Rachel J. Allen, "From Comic Book to Graphic Novel," CBS News, cbsnews.com, July 31, 2006.

109. David S. Stoffer, "Who Is This Crumb Dude?," University of Pittsburgh, stat.pitt.edu.

110. "Robert Crumb," lambiek.net.

111. Todd Gitlin, "R. Crumb and Art Spiegelman," *Civilization,* June–July 1998.

112. "Graphic Novels: History and Basics," *Teen Space,* ipl.org.

113. "Underground Comix," en.wikipedia.org.

114. John Ficcara, *Mad,* personal interview, Spring 2007.

115. "Witzend," en.wikipedia.org.

116. "Underground Comix," en.wikipedia.org.

117. "Silver Age of Comic Books," en.wikipedia.org.

118. "Bronze Age of Comic Books," en.wikipedia.org.

CHAPTER 5: THE BRONZE AGE: THE RETURN OF SUPERHEROES

1. Alan David Doane, "Interviews: Walter Simonson," *Comic Book Galaxy,* comicbookgalaxy.com.

2. Alex Ness, "The Ultimate Universe ala the Original Marvel Universe," Thoughts From the Land of Frost, stlcomics.com.

3. "What Are My Comics Worth?," ebay.com.

4. "Paul Levitz: A Collector at the Top," The Main Event, Scoop, scoop.diamondgalleries.com, November 22, 2002.

5. Jon B. Cooke, *Comic Book Artist Collection,* vol. 1, TwoMorrows Publishing.

6. "Jack Kirby," geocities.com/brenni_au/JackKirby.html.

7. Ibid.

8. Ibid.

9. Jon B. Cooke, *Comic Book Artist Collection.*

10. Kenneth Plume, "Interview with Stan Lee (Part 2 of 5), movies.ign.com, June 27, 2000.

11. Jordan Raphael and Tom Spurgeon, *Stan Lee and the Rise and Fall of the American Comic Book,* Chicago Review Press, 2003.

12. Kenneth Plume, "Interview with Stan Lee (Part 3 of 5), movies.ign.com, June 28, 2000.

13. "Marvel Comics," en.wikipedia.org.

14. Jon B. Cooke, *Comic Book Artist Collection.*

15. Jordan Raphael and Tom Spurgeon, *Stan Lee and the Rise and Fall of the American Comic Book.*

16. Jon B. Cooke, *Comic Book Artist Collection.*

17. Jon B. Cooke, "The Man Called Ploog," Comic Book Artist 2, TwoMorrows Publishing.

18. Alex Ness, "Wolfman Enters the Land of Frost: The Marv Wolfman Interview," *The Land of Frost,* stlcomics.com.

19. Mike Benton, *The Comic Book in America: An Illustrated History,* Taylor Publishing, 1989.

20. "The Post-Silver Age," The Comic Page, dereksantos.com.

21. Kenneth Plume, "Interview with Stan Lee (Part 2 of 5)."

22. "Giant-Size X-Men," en.wikipedia.org.

23. "Marvel 1991 Annual Report," spiderfan.org.

24. John C. Snider, "Interview: Chris Claremont," scifidimensions.com, 2003.

25. Chris Claremont, personal interview, Spring 2007.

26. Mark Paniccia, Marvel Comics, personal interview, Spring 2007.

27. "Carmine Infantino," en.wikipedia.org.

28. Jon B. Cooke, "From Art Director to Publisher."

29. "Carmine Infantino," en.wikipedia.org.

30. Burl Burlingame, "Drawn and Quartered," *Honolulu Star-Bulletin,* starbulletin.com.

31. Jon B. Cooke, "From Art Director to Publisher."

32. David R. Black, "The DC Implosion," fanzing.com.

33. Topic: "When Did DC 'Jump the Shark,'" DC Comics Message Boards, dcboards.warnerbros.com.

34. "Paul Levitz," The Main Event, Scoop, scoop.diamondgalleries.com, November 22, 2002.

35. Jennifer M. Contino, "A Chat with Kahn," sequentialart.com.

36. Ibid.

37. Paul Levitz, DC Comics, personal interview, Spring 2007.

38. Jennifer M. Contino, "A Chat with Kahn."

39. "DC Timeline 1976–1979," DC History, supermanartists.comics.org, June 5, 2006.

40. Roy Thomas, "Stan the Man and Roy the Boy," *Comic Book Artist 2,* TwoMorrows Publishing.

41. Ibid.

42. Michael David Thomas, "Jim Shooter Interview: Part 1," CBR News, comicbookresources.com, October 6, 2000.

43. Michael David Thomas, "Jim Shooter Interview: Part 1."

44. "The Coming of Age of the Graphics Novel," The Skinny, skinnymag.co.uk, March 3, 2006.

45. Claude Lalumière, "A Short History of American Comic Books," januarymagazine.com.

46. Peter S. Scholtes, "Of Micronauts and Men," citypages.com, December 25, 2002.

47. "Amazing Heroes," en.wikipedia.org.

48. Michael David Thomas, "Jim Shooter Interview: Part 1."

49. Chuck Rozanski "Evolution of the Direct Market, Part 1," milehighcomics.com/tales/cbg95.html.

50. Ibid.

51. Gary Sassaman, "We All Loved a Girl and Her Name Is Nostalgia (Revisited) . . . ," innocentbystander.typepad.com, February 2007.

52. Bob Wayne, DC Comics, personal interview, Fall 2006.

53. Roy Thomas, "Stan the Man and Roy the Boy," *Comic Book Artist 2.*

54. Matt Groening, *Comic Book Guy's Book of Pop Culture* (Simpsons Library of Wisdom), Harper Paperbacks, 2005.

55. "Stan Lee," en.wikipedia.org.

56. Diamond Comic Distributors, Frequently Asked Questions, diamondcomics.com.

57. Jim McCann, Marvel Comics, personal interview, Spring 2007.

58. Chuck Rozanski, "Marvel Comics to Self-Distribute Heroes World," milehighcomics.com.

59. Jim Sokolowski, DC Comics, personal interview, Spring 2007.

60. Jennifer M. Contino, "A Chat with Kahn."

61. "Camelot 3000," en.wikipedia.org.

62. Jim Sokolowski, DC Comics, personal interview, Spring 2007.

63. "Towards a Unified Theory of Comic Book Crossover Events," faerye.net, March 21, 2005.

64. "Prime Eternal's New Universe Primer," New Universe Profile Index, marvunapp.com.

65. Michael David Thomas, "Jim Shooter Interview: Part 1."

66. Michael Doran, "Marvel's Nextwave/Ultimate Extinction Press Conference," newsarama.com, December 8, 2005.

67. Michael David Thomas, "Jim Shooter Interview."

68. John Romita, *The Art of John Romita,* Marvel Comics, 1996.

69. Michael Silberkleit, Archie Comics, personal interview, Fall 2006.

70. Ibid.

71. "Company Overview," Dark Horse, darkhorse.com.

72. Ibid.

73. "Landmarks," Media Profile, ketupa.net.

74. Kenneth Plume, "Interview with Stan Lee (Part 3 of 5), movies.ign.com, June 28, 2000.

CHAPTER 6: THE MODERN AGE: DARKER KNIGHTS

1. Barry Kavanagh, "The Alan Moore Interview," blather.net, October 17, 2000.

2. "Modern Age of Comic Books," en.wikipedia.org.

3. Stephen John Padnick, "For Mature Readers: The Adult Audience and Superhero Comic Books," Harvard College, March 1, 2002.

4. Les Daniels, "Watching the Watchmen," *DC Comics: Sixty Years of the World's Favorite Comic Book Heroes,* Bulfinch Press/Little, Brown and Company, 1995.

5. Les Daniels, "Watching the Watchmen."

6. Ibid.

7. Claude Lalumière, "A Short History of American Comic Books," january-magazine.com.

8. "The Circle of Comic Book Life," Eye of the Goof, mrbalihai.com, July 1, 2004.

9. Les Daniels, "Watching the Watchmen."

10. Ibid.

11. Patrick Furlong, "The Dark Knight Returns," *The Dark Knight,* darkknight. ca, June 9, 2006.

12. Andy, "Batman: The Dark Knight Returns," grovel.org.uk.

13. Jennifer M. Contino, "A Chat with Kahn," sequentialart.com.

14. Claude Lalumière, "A Short History of American Comic Books."

15. Franklyn Harris, "Put the Fun Back into 'Funnybooks,'" Pulp Culture, Decatur Daily, decaturdaily.com.

16. Matt Povey, "What Makes a Hero?," *Matt's Notepad,* eftel.com/ ~mattcbr/ exam01.html.

17. A. David Lewis, "The Hydrogen Age: Part III: Manhattan's Age," Library of Babel, brokenfrontier.com, March 14, 2005.

18. Art Spiegelman, *Maus: A Survivor's Tale: My Father Bleeds History,* Pantheon, 1986.

19. Art Spiegelman, *Maus II: A Survivor's Tale: And Here My Troubles Began,* Pantheon, 1992.

20. Art Spiegelman, *Maus: A Survivor's Tale: My Father Bleeds History/Here My Troubles Began,* Pantheon, 1993.

21. Todd Gitlin, "R. Crumb and Art Spiegelman," *Civilization,* June–July 1998.

22. Alexandra Stanley, "'Thousand Acres' Wins Fiction as 21 Pulitzer Prizes Are Given," *New York Times,* April 8, 1992.

23. Jerry Calabrese, Lionel LLC, personal interview, Spring 2007.

24. "Marvel Enterprises, Inc.: Item 10: Directors and Executive Officers of the Registrant," Edgar Online, sec.edgar-online.com, April 15, 1997.

25. Dan Raviv, *Comic Wars,* randomhouse.com, 2002.

26. Dan Raviv, *Comic Wars: How Two Tycoons Battled over the Marvel Comics Empire—and Both Lost,* Broadway Books, 2002.

27. "Comic Book Collecting," en.wikipedia.org.

28. "$100,000 Club, the World's Most Valuable Comic Books," It's All Just Comics, comics.drunkenfist.com.

29. John Dokes, Marvel Comics, personal interview, Fall 2006.

30. Chuck Rozanski, "How Ronald O. Perelman Caused Harm to the Comics Industry," milehighcomics.com.

31. "Comic Book Collecting," en.wikipedia.org.

32. Ryan McLelland, "Valiant Days, Valiant Nights: A Look back at the Rise and Fall of Valiant," valiantcomics.com, September 24, 2003.

33. John Marcotte, "The Comic Book Apocalypse," badmouth.net, May 14, 2005.

34. "1856 One Cent—Flying Eagle: Recent Appearances," coinfacts.com.

35. Rachel J. Allen, "From Comic Book to Graphic Novel," CBS News, cbsnews.com, July 31, 2006.

36. "Comic Book Collecting," en.wikipedia.org.

37. Sara Pendergast and Tom Pendergast, *St. James Encyclopedia of Popular Culture,* Gale Group, 1999.

38. Michael Dean, "Image Story: Part One: Forming an Image," *The Comics Journal,* tcj.com, October 25, 2000.

39. Ibid.

40. Stewart, Rock and Roll Hall of Fame, personal interview, Spring 2007.

41. "Comics Industry Questions," faqs.org/faqs/comics/xbooks/main-faq/ part8/section-2.html.

42. Eric Evans, "Marvel's Failed Promises," *The Comics Journal,* tcj.com.

43. Michael Dean, "Image Story."

44. "Image Comics," en.wikipedia.org.

45. Gary Groth, "The Time of the Toad: The Comics Profession 1980–2000," *The Comics Journal* 220, tcj.com, February 2000.

46. "Image Comics," en.wikipedia.org.

47. Claude Lalumière, "Review of *Comic Book Nation* by Bradford W. Wright," LOCUSonline, locusmag.com, August 14, 2001.

48. Gary Groth, "The Time of the Toad."

49. Michael Bailey, "Where Were You the Day Superman Died?," superman-homepage.com, December 2002.

50. Jim Sokolowski, DC Comics, personal interview, Spring 2007.

51. Michael Bailey, "Where Were You the Day Superman Died?"

52. Ibid.

53. Ibid.

54. Dan Jurgens et al., *The Death of Superman,* DC Comics, 1993.

55. "The Death of Superman," Editorial Reviews, amazon.com.

56. Name withheld by request.

57. Michael Bailey, "Where Were You the Day Superman Died?"

58. Kate Lohnes, "Comic Books Revival Nothing More than Economics," the-monitor.com, July 29, 2006.

59. Chuck Rozanski, "Death of Superman Promotion 1992," milehighcomics.com.

60. "Image Comics," An International Catalogue of Superheroes, international-hero.co.uk/i/image.htm.

61. Michael Dean Thomas, "The Image Story, Part Two: The Honeymoon," *The Comics Journal,* tcj.com, October 25, 2000.

62. Jerry Calabrese, personal interview.

63. Ray Mescallado, "Trimmings: Kurt Busiek," *The Comics Journal* 216, tcj.com.

64. Michael Doran, "Ten Years Later: Onslaught Reborn," newsarama.com.

65. Gary Groth, "The Time of the Toad."

66. "Rec.arts.comics.misc FAQ," faqs.org.

67. "Vertigo Comics," en.wikipedia.org.

68. Daniel Robert Epstein, "Neil Gaiman," ugo.com.

69. Jerry Calabrese, personal interview.

70. Bob Harras, DC Comics, personal interview, Spring 2007.

71. "Alternative Comics," *Steve's Reads,* geocities.com, July 6, 1998.

72. "Alternative Comics," en.wikipedia.org.

73. "Malibu Comics," Platinum Studios, original.platinumstudios.com.

74. "The Golden Age (Comics)," en.wikipedia.org.

75. "Marvels," grovel.org.uk.

76. Jim McCann, personal interview, Summer 2007.

77. David Campbell, "Kingdom Come DC Comics 1996," daveslongbox.blogspot.com, July 31, 2006.

78. "The Kingdom (Comic Book)," en.wikipedia.org.

79. Danilo Guaeino, "Mark Waid," Interviste, amazingcomics.it.

80. Beau Yarbrough, "DC's Next Crisis: 'Kingdom' to Undo Previous Fix," CBR.cc, comicbookresources.com, August 17, 1998.

81. Terry Stewart, Rock and Roll Hall of Fame, personal interview, Spring 2007.

82. Ibid.

83. Jerry Calabrese, personal interview.

84. Ibid.

85. Rick Pogue, Marvel Entertainment, 1996.

86. Jerry Calabrese, personal interview.

87. "Marvel Entertainment Group, Inc.: 10-Q for 9/30/96 EX-10.2," Accession Number 950136–96–1075, secinfo.com, November 14, 1996.

88. Name withheld by request.

89. Jerry Calabrese, personal interview.

90. Name withheld by request.

CHAPTER 7: COMIC WARS: THE BATTLE OVER MARVEL

1. "Dan Raviv: CBS News Correspondent and Best-Selling Author," stockarena.com, April 5, 2005.

2. "Comic Wars," RTMisc, Raving Toy Maniac, toymania.com.

3. "Ronald Perelman," en.wikipedia.org.

4. "The World's Billionaires," Forbes.com, March 8, 2007.

5. Dan Raviv, *Comic Wars: How Two Tycoons Battled over the Marvel Comics Empire—and Both Lost,* Broadway Books, 2002.

6. Geoffrey Gray, "Tough Love," News and Features, nymag.com, March 27, 2006.

7. Dan Raviv, *Comic Wars.*

8. Ibid.

9. Ibid.

10. Jeremy Lott, "Smash! Pow! Bam! Boardroom Supervillains Shred The Marvel Comics Empire," metrotimes.com, October 30, 2002.

11. Dan Raviv, *Comic Wars.*

12. Ibid.

13. "MacAndrews and Forbes Holdings, Inc.," answers.com.

14. Robert J. Rosenberg, "Marvel's Misery," businessweek.com, May 6, 2002.

15. Jeremy Lott, "Smash! Pow! Bam!," metrotimes.com, October 30, 2002.

16. J. R. Fettinger, "The MadGoblin's Reading Log," spideykicksbutt.com.

17. Dan Raviv, "Timeline," *Comic Wars,* randomhouse.com.

18. "Marvel Comics," en.wikipedia.org.

19. Dan Raviv, "Timeline."

20. "Ron Perelman," en.wikipedia.org.

21. "Toy Biz, Inc.," fundinguniverse.com.

22. Terry Stewart, Rock and Roll Hall of Fame, personal interview, Spring 2007.

23. Ibid.

24. "Toy Biz, Inc.," fundinguniverse.com.

25. Dan Raviv, *Comic Wars.*

26. "Ronald Perelman," en.wikipedia.org.

27. Dan Raviv, *Comic Wars.*

28. "Toy Biz," en.wikipedia.org.

29. "Ronald Perelman," en.wikipedia.org.

30. Chuck Rozanski, "How Ronald O. Perelman Caused Harm to the Comics Industry," milehighcomics.com.

31. John Jackson Miller, "1997: The Year in Comics," *Comic Buyer's Guide,* cbgxtra.com.

32. "The World's Billionaires," Forbes.com, March 8, 2007.

33. Dan Raviv, "Q&A with Comic Wars Author," Comic Wars, randomhouse. com.

34. "MacAndrews and Forbes Holdings, Inc.," answers.com.

35. John Jackson Miller, "1997: The Year in Comics."

36. Dan Raviv, "About the Book," Comic Wars, randomhouse.com.

37. D. Smithee, "Make Mine Marvel!," Spotlight Reviews, amazon.com, August 12, 2002.

38. "Portfolio Description," Carl Icahn Holdings, stockpickr.com, December 31, 2006.

39. D. Smithee, "Make Mine Marvel!"

40. Andy Serwer, "Carl Icahn's New Life as a Hedge Fund Manager," CNN Money, money.cnn.com, November 29, 2004.

41. Joe Nocera, "Talking Business: From Raider to Activist, but Still Icahn," *New York Times,* nytimes.com, February 3, 2007.

42. "Marvel Holding Companies File Voluntary Chapter 11 Petitions," Troubled Company Reporter, bankrupt.com, December 27, 1996.

43. Paul Crecca, Haights Cross, personal interview, Spring 2007.

44. "Marvel Entertainment Group Files Voluntary Chapter 11 Petition to Implement Financial Restructuring Plan," Troubled Company Reporter, bankrupt.com, December 27, 1996.

45. Robert Smithers, "Marvel: Part 2: Bankruptcy Follow-up Part 2," suite101. com, February 28, 1997.

46. "Marvel Entertainment Group Files Voluntary Chapter 11 Petition to Implement Financial Restructuring Plan."

47. "High River Limited Partnership Comments on Today's Chapter 11 Filing of Marvel Entertainment Group, Inc.," Troubled Company Reporter, bankrupt. com, December 27, 1996.

48. "Marvel Entertainment Group Files Voluntary Chapter 11 Petition to Implement Financial Restructuring Plan."

49. Ibid.

50. Robert Smithers, "Marvel Declares Bankruptcy: Part 2," suite101.com, December 27,1996.

51. John Jackson Miller, "1997: The Year in Comics."

52. Robert Smithers, "Marvel Declares Bankruptcy: Part 1," suite101.com, December 27, 1996.

53. Central European Media, sec.edgar-online.com, 1996.

54. Ed Dietze, Walberg Pinkus, personal interview, Spring 2007.

55. Robert Smithers, "Marvel Bondholders Replace Board of Directors: Carl Icahn—Larg," suite101.com, July 18, 1997.

56. Robert Smithers, "Marvel Bondholders replace Board of Directors."

57. "United States Court of Appeals for the Third Circuit, Nos. 98–7001, 98–7040 and 98–7041," vls.law.vill.edu, March 25, 1998.

58. Dan Raviv, "Q&A with Comic Wars Author."

59. "Ronald Perelman," en.wikipedia.org.

60. "Comic Wars," RTMisc, Raving Toy Maniac, toymania.com.

61. Dan Raviv, *Comic Wars.*

62. J. R. Fettinger, "The MadGoblin's Reading Log."

63. Dan Raviv, *Comic Wars.*

64. "Toy Biz to Control Marvel," CNN Money, money.cnn.com, June 29, 1998.

65. John Jackson Miller, "The Marvel Saga: Just Imagine What Chapter *12* Will Be Like!," *Comic Buyer's Guide, cgbXtra.com.*

66. "Marvel Terminates Relationship with Avi Arad as head of Marvel Studios," HighBeam Encyclopedia, encyclopedia.com, October 20, 1997.

67. "Head of Marvel Studios Terminated," *IBL,* bankrupt.com, October 22, 1997.

68. Ibid.

69. "Toy Biz," en.wikipedia.org.

70. "Judge Approves Plan for Marvel," *New York Times,* select.nytimes.com, July 14, 1998.

71. "Marvel Entertainment: Prepares to Exit Chapter 11," Troubled Company Reporter, bankrupt.com, June 25, 1998.

72. Dan Raviv, "Timeline," Comic Wars, randomhouse.com.

73. Adam Bryant, "Pow! The Punches That Left Marvel Reeling," *New York Times,* select.nytimes.com, May 24, 1998.

74. Ian Johnson, "Two Different Companies, Two Different Directions," The Final Word, collectortimes.com.

75. Rich Johnston, "The House of Recrimination," *Ramblings 98,* twistandshout-comics.com, October 29, 1998.

76. John Marvel, "Marvel Stockholder," Spotlight Reviews, amazon.com, May 2, 2004.

77. The Comic Book Net Electronic Magazine #189, members.aol.com/ComicBkNet/_cbem98 /index.html, November 20, 1998.

78. Susanna Hamner, "Marvel Comics Leaps into Movie-Making," CNN Money, money.cnn.com, June 1, 2006.

79. Ibid.

80. Jeremy Lott, "Smash! Pow! Bam!," Reasonline, reason.com, October 2002.

81. D. Smithee, "Make Mine Marvel!."

82. Prepared by Karl Bracken, Nathan Chandrasekaran, Justin Kessler, Hitoshi Mitani, Urapa Nontasut, and David Youn, "Marvel Comics Turnaround," turnaround.org, February 26, 2004.

83. Dan Raviv, "Q&A with Comic Wars Author."

84. Prepared by Karl Bracken, Nathan Chandrasekaran, Justin Kessler, Hitoshi Mitani, Urapa Nontasut, and David Youn, "Marvel Comics Turnaround."

85. Mark Krantz, "Marvel's Profit Sense Is Tingling as Superhero Films Prevail," *USA Today,* May 6, 2003.

86. Prepared by Karl Bracken, Nathan Chandrasekaran, Justin Kessler, Hitoshi Mitani, Urapa Nontasut, and David Youn, "Marvel Comics Turnaround."

87. Dan Raviv, *Comic Wars.*

88. "Toy Biz," en.wikipedia.org.

89. Ronald Glover, "Spider-Man's Guardian Angels, BusinessWeek Online, businessweek.com, June 27, 2005.

90. Ibid.

91. "Avi Arad," en.wikipedia.org.

92. Daniel H. Bigelow, "Business for Comic Book Fans," Spotlight Reviews, amazon.com, October 26, 2002.

93. J. R. Fettinger, "The MadGoblin's Reading Log."

94. Daniel H. Bigelow, "Business for Comic Book Fans."

95. D. Smithee, "Make Mine Marvel!"

96. R. Christensen, "One of the Best Business Books Ever!" Spotlight Reviews, amazon.com, August 16, 2006.

97. Jerry Calabrese, Lionel LLC, personal interview, Spring 2007.

98. Terry Stewart, Rock and Roll Hall of Fame, personal interview, Spring 2007.

99. Name withheld by request.

100. John Marvel, "There Were Few Winners in This Battle," Spotlight Reviews, amazon.com, May 2, 2004.

101. J. R. Fettinger, "The MadGoblin's Reading Log."

102. "Comic Wars," RTMisc., Raving Toy Maniac, toymania.com.

CHAPTER 8: THE POSTMODERN AGE: A NEW DAY FOR COMICS

1. Heritage Galleries and Auctioneers, "What Are My Comics Worth?," eBay Reviews and Guides, reviews.ebay.com.

2. Michael Dean, "How Michael Jackson Almost Bought Marvel," *The Comics Journal* 270, tcj.com, August 17, 2005.

3. Kenneth Plume, "Interview with Stan Lee (Part 4 of 5), ign.com, June 29, 2000.

4. "Stan Lee's Just Imagine," dcomics.com.

5. "Superman and Batman Join Forces with Arch-Rival Stan Lee to Create an Alternate Universe," DC Comics News Bullet, dccomics.com.

6. "Stan Lee's Just Imagine," DC Comics.

7. Stan Lee, POW! Entertainment, personal interview, Spring 2007.

8. Michael Dean, "How Michael Jackson Almost Bought Marvel."

9. Kenneth Plume, "Interview with Stan Lee (Conclusion)," IGN.com, movies.ign.com, June 30, 2000.

10. "Ask the Pros: Darick Robinson," *Wizard*, wizarduniverse.com, June 14, 2006.

11. "Bio," Darick Robertson Studios, darickrobertson.com.

12. "Ask the Pros: Darick Robinson," *Wizard*.

13. Gary Groth, "The Time of the Toad: The Comics Profession 1980–2000," *The Comics Journal* 220, February 2000.

14. "Image Comics," en.wikipedia.org.

15. Ibid.

16. Diamond Comic Distributors, Market Share, diamondcomics.com.

17. Gary Groth, "The Time of the Toad."

18. McDonald Law Offices PLLC, "Celebrity Sightings," doney.net/aroundaz/celebrity/mcfarlane_todd.htm.

19. Jordan Raphael and Tom Spurgeon, *Stan Lee and the Rise and Fall of the American Comic Book,* Chicago Review Press, 2003.

20. "Marvel Masterworks: Interviews and Essays," Barnes and Noble, search. barnesandnoble.com, June 24, 1998.

21. Michael Dean, "How Michael Jackson Almost Bought Marvel and Other Strange Tales from the Stan Lee/Peter Paul Partnership," *The Comics Journal* 270, tcj.com, August 17, 2005.

22. Michael Dean, "How Michael Jackson Almost Bought Marvel."

23. Ibid.

24. "Bill Jemas," answers.com.

25. Franklyn Harris, "Marvel Comics' Publisher Is Spoiled by Success," Pulp Culture, hiwaay.not, October 16, 2003.

26. Alex Ness, "The Ultimate Universe ala the Original Marvel Universe," Thoughts from the Land of Frost, stlcomics.com.

27. Alex Ness, "A Conversation with Bryan Hitch," Thoughts from the Land of Frost, slushfactory.com, September 12, 2003.

28. Alex Ness, "The Ultimate Universe ala the Original Marvel Universe."

29. Capricious Chris Ryall, "Stan Lee Interview," comicbookgalaxy.com.

30. Franklyn Harris, "Marvel Comics' Publisher Is Spoiled by Success."

31. *Marvel Vision* 19, Marvel Comics, July 1997.

32. Dan Raviv, *Comic Wars: How Two Tycoons Battled over the Marvel Comics Empire—and Both Lost,* Broadway Books, 2002.

33. "X-Men (Film)," en.wikipedia.org.

34. Avi Arad, "Brainy Quotes," brainyquote.com.

35. Joe Quesada, Marvel Comics, personal interview, Fall 2006.

36. "Marvel Rating System," marvel.com/catalog/ratings.htm.

37. Joe Quesada, personal interview.

38. Dan DiDio, Marvel Comics, personal interview, Fall 2006.

39. Dave Potter, *Savant,* savantmag.com.

40. Stan Lee, personal interview, Spring 2007.

41. Arthur Pendragon, Blog, newsarama.com

42. Joe Quesada, personal interview.

43. Ttroy, Blog, newsarama.com.

44. The Comic Book Net Electronic Magazine 375, members.aol.com/ ComicBkNet/_cbem02 /index.html, July 5, 2002.

45. Ibid.

46. Robert Smithers, "Marvel Gatefold Cover," suite101.com, July 25, 1997.

47. *Spider-Man,* the-numbers.com.

48. Janet Shprintz, "Spider-Man's Legal Web May Finally Be Unraveled," variety. com, August 19, 1998.

49. Ronald Grover, "Unraveling Spider-Man's Tangled Web." BusinessWeek Online, businessweek.com, April 15, 2002.

50. Michael A. Hiltzik. "Spider-Man Caught in a Tangled Web," *Star-Ledger,* October 5, 1998

51. "Spider-Man (Film)," en.wikipedia.org.

52. "Spider-Man Film Series," en.wikipedia.org.

53. Daniel Frankel, "Cameron Spun out of Spider-Man Movie," The Vine @ E! Online, royaltyfromatoz.net, April 5, 1999.

54. Ibid.

55. Claude Brodesser, "Spider-Man Snares Scribe," *Variety,* June 16, 2000.

56. Ronald Grover, "Unraveling Spider-Man's Tangled Web."

57. Ibid.

58. "Spider-Man (Film)," en.wikipedia.org.

59. *Spider-Man,* the-numbers.com.

60. Ronald Grover, "Unraveling Spider-Man's Tangled Web."

61. Matt Brady, "Updated: Jemas out of Marvel by January?," forum.newsarama. com, October 10, 2003.

62. Julia Hanna, "Mr. Super Hero," *HBS Alumni Bulletin,* December 2005.

63. Daniel Robert Epstein, "Stan Lee," UnderGroundOnline, ugo.com.

64. "June 2003 Programming Highlights," CableTVMan, cabletvtalk.com, May 18, 2003.

65. Ryan Ball, "Stan Lee to Animate Hefner," animationmagazine.net, July 18, 2003.

66. Kevin Rose, "Stan 'the Man' Lee," G4, g4tv.com, September 11, 2004.

67. Stan Lee, personal interview.

68. Ibid.

69. Allison Kugel, "Stan Lee: From Marvel Comics Genius to Purveyor of Wonder with POW! Entertainment," pr.com, March 13, 2006.

70. "Who Wants to Be a Superhero? Picked up for a Second Season," movieweb. com, October 17, 2006.

71. Stan Lee, personal interview.

72. "Stan Lee to Trick or Treat with Kevin Smith," Daily News, hollywoodsmas-terstorytellers.com, October 19, 2006.

73. Michael Sangiacomo, "Marvel Makes Fantastic Find," *Cleveland Plain Dealer,* cleveland.com, August 5, 2006.

74. Ibid.

75. Dan Buckley, Marvel Comics, personal interview, Spring 2007.

76. Heidi MacDonald, "ICv2 Graphic Novel Conference Report," The Beat, pwbeat.publishersweekly.com, February 23, 2007.

77. Charles McGrath, "Not Funnies," *New York Times,* July 11, 2004.

78. Lev Grossman, "The Undiscovered Megaplex, Part One," *Time* in Partnership with CNN, time-blog.com, January 6, 2007.

79. Jimmy Palmiotti, personal interview, Spring 2007.

80. Amanda Conner, personal interview, Spring 2007.

81. "HarperCollins Publishers and Tokyopop Announce Innovative Co-Publishing, Sales and Distribution Agreement," harpercollins.com, March 27, 2006.

82. Dirk Deppey, "The *Trouble* with Marvel," *The Comics Journal,* tcj.com, June 14, 2003.

83. Harry Knowles, "Avi Arad Leaves Marvel," Cool News, aintitcool.com, May 31, 2006.

84. Ibid.

85. Ibid.

86. "Bratz (Film)," en.wikipedia.org.

87. Matt Brady, "Archie and Riverdale Get a New Look," newsarama.com, December 16, 2006.

88. "Table of Malcontents," Wired Blogs, blog.wired.com, December 19, 2006.

89. Ibid.

90. Matt Brady, "Ten Years Later: Onslaught Reborn," newsarama.com, March 29, 2006.

91. Michael Dean, "Image Story: Part One: Forming an Image," *The Comics Journal,* tcj.com, October 25, 2000.

92. Matt Brady, "Ten Years Later: Onslaught Reborn."

93. Craig Byrne, "Heroes' Finest," 9thwonders.com.

94. Matt Brady, "Ten Years Later: Onslaught Reborn."

95. "League of Extraordinary Gentlemen," en.wikipedia.org.

96. *The League of Extraordinary Gentlemen* (2003), directed by Stephen Norrington, imbd.com.

97. "All Time 100 Novels," time.com.

98. "The Amazing Adventures of Kavalier & Clay," en.wikipedia.org.

99. Michael Chabon, *The Amazing Adventures of Kavalier & Clay: A Novel,* Random House, 2000.

100. "Michael Chabon," Stephen Barclay Agency, barclayagency.com.

101. "Interviews: Michael Chabon on *The Escapist,*" darkhorse.com.

102. Ibid.

103. Ibid.

104. "Final *Escapists* Hits the Stands," The Amazing Website of Kavalier & Clay, sugarbombs.com, December 14, 2006.

105. Nate Raymond, "Interview with Brian K. Vaughan," The Amazing Website of Kavalier & Clay, sugarbombs.com, November 7, 2005.

106. "The Escapists," Comic Books, The Amazing Website of Kavalier & Clay, sugarbombs.com.

107. Matt Brady, "Brian K. Vaughan and The Escapists," newsarama.com, November 8, 2005.

108. Ibid.

109. George Gene Gustines, "The Feelings of Life, Illustrated," *New York Times,* September 2, 2006.

110. George Gene Gustines, "The Feelings of Life, Illustrated."

111. Brian K. Vaughan, personal interview, Fall 2006.

112. Ben Morse, "Wizard Best of 2006 Winners Announced," *Wizard* 183, January 2007.

113. "Batman Begins," the-numbers.com.

114. "Batman Begins," en.wikipedia.org.

115. Jonah Weiland, "'Superman Returns' Press Junket: DC President Paul Levitz," CBR News, comicbookresources.com, June 9, 2006.

116. Scott Brown, "Hit List," *Entertainment Weekly,* March 23, 2007.

117. "Stan Lee Gathers the Avengers . . . Again." Superstars, Scoop, scoop.diamondgalleries.com, May 25, 2007.

118. Peter Vinton, Jr., "Review of *How to Read Superhero Comics and Why* by Geoff Klock," Spotlight Reviews, amazon.com, November 5, 2003.

119. "A New Golden Age for Comics?," The Main Event, Scoop, diamondgalleries. com, March 12, 2004.

120. Mike Szymanski, "Stan Lee Doesn't Mind Being Called a Legend—as Long as He's Being Called a *Living* Legend," Sci Fi Weekly, scifi.com, February 6, 2006.

CHAPTER 9: COLLECTING COMIC BOOKS FOR FUN AND (MAYBE) PROFIT

1. Gerry Gladstone, Midtown Comics, personal interview, Spring 2007.

2. "FAQ," darkhorse.com.

3. Jon B. Cooke, "The James Warren Interview," *Comic Book Artist 4,* TwoMorrows Publishing.

4. "Paul Levitz: A Collector at the Top," The Main Event, Scoop, scoop.diamondgalleries.com, November 22, 2002.

5. "Completist," wordspy.com.

6. Richard Corliss, "Does *Mad* Need a Museum," time.com, February 3, 2007.

7. Shawn Langlois, "A Starter's Guide to Vintage Comic Book Investing," CBS Market Watch, marketwatch.com.

8. Ibid.

9. Ibid.

10. Robert M. Overstreet, *Official Overstreet Comics Guide,* 36th ed., House of Collectibles, 2006.

11. Kate Lohnes, "Comic Books' Revival Nothing More than Economics," the-monitor.com, July 29, 2006.

12. Ibid.

13. Conor Dougherty, "Bang! Pow! Cash! Comic-Book Prices Soar," Wall Street Journal Online, startupjournal.com, October 3, 2005.

14. Shawn Langlois, "A Starter's Guide to Vintage Comic Book Investing."

15. "Nicolas Cage Collection Sold for 1.6 Million," Auction Prices, Scoop, scoop. diamondgalleries.com, October 18, 2002.

16. Chuck Rozanski, "Marvel's Limited Print Runs," milehighcomics.com.

17. Chuck Rozanski, "Marvel's Limited Print Runs Part II," milehighcomics. com.

18. "Inverted Jenny," en.wikipedia.org.

19. Matt Brady, "Dark Horse Clears up Conan's Naked Cover Issue," forum. newsarama.com, December 22, 2005.

20. "Overstreet Comic Book Price Guide," en.wikipedia.org.

21. Robert M. Overstreet, *Official Overstreet Comic Price Guide.*

22. "The Standard Catalog of Comic Books," en.wikipedia.org.

23. John Jackson Miller, Maggie Thompson, Peter Bickford, and Brent Frankenhoff, *The Standard Catalog of Comic Books,* F + W, 2006.

24. Alex G. Malloy, Stuart W. Wells III, and Robert J. Sodaro, *Comics Values Annual 2006,* Krause Publications, 2006.

25. Wizard Entertainment, wizarduniverse.com.

26. "Wizard (Magazine)," en.wikipedia.org.

27. Shawn Langlois, "A Starter's Guide to Vintage Comic Book Investing."

28. Auction Prices, Scoop, scoop.diamondgalleries.com, April 20, 2007.

29. Conor Dougherty, "Bang! Pow! Cash! Comic-Book Prices Soar."

30. "GPAnalysis: Online CGC Price Report and Analysis," GPAnalysis for CGC Comics, gpanalysis.com.

31. Ibid.

32. Chuck Rozanski, "CGC Comics, Part 1," milehighcomics.com.

33. Burl Burlingame, "Drawn and Quartered," *Honolulu Star-Bulletin,* starbulletin.com.

34. "Collecting Comic Art . . . Part One," *Comic Art and Graffix Gallery,* comic-art.com.

35. Glass House Graphics, glasshousegraphics.com.

36. Ibid.

37. Paragon Comics, Original Art, paragoncomics.com.

38. eBay, ebay.com.

39. David Hyde, DC Comics, personal interview, Spring 2007.

40. "Collecting Comic Art . . . Part One."

41. Tom Mclean, "Taking a New Initiative," Bags and Boards, weblogs.variety. com, September 18, 2006.

42. "CBLDF Announces Raffles, Auctions, and More at NYCC," CBR News, comicbookresources.com, February 20, 2007.

43. "Collecting Comic Art . . . Part One."

44. Wizard Entertainment, wizarduniverse.com.

45. "Fleer," en.wikipedia.org.

46. "Trading Card," en.wikipedia.org.

47. "Famous Honus Wagner Card Sells for Record $2.35M," Baseball, ESPN, sports.espn.go.com, February 27, 2007.

48. Sonia Moghe, "Massive Comic Book Collection up for Sale after Owner's Death," *Daily Texan,* media.www.dailytexanonline.com, August 11, 2006.

49. Gareth Atha, "Comic Books: A Beginner's Guide," The Comic Book Bin, comicbookbin.com, June 5, 2006.

50. "Paul Levitz: A Collector at the Top."

ACKNOWLEDGMENTS

Thanks to Paul Levitz, President and Publisher, DC Comics; Dan DiDio, Executive Vice President, DC Comics; Dan Buckley, President and Publisher, Marvel Comics; Joe Quesada, Editor in Chief, Marvel Comics; Michael Silberkleit, Chairman and Co-Publisher, Archie Comics; Richard Goldwater, President and Co-Publisher, Archie Comics; Victor Gorelick, Managing Editor, Archie Comics; Steve Geppi, President, Diamond Comic Distributors; Chuck Rozanski, President, Mile High Comics; Terry Stewart, President, Rock and Roll Hall of Fame; Jerry Calabrese, Lionel Trains; David McKillips, Vice President, Six Flags; John Ficarra, Editor in Chief, *Mad;* John Morrow and Roy Thomas; David Hyde; Jim McCann; Jimmy Palmiotti and Amanda Conner; John Nee; Jay Kogan; Bob Wayne; Karen Berger; John Dokes; Tom Brevoort; Ralph Macchio; Mark Paniccia; Thomas King; Jim Salicrup; Danny Fingeroth; Jackie Carter; Chelsea Cain and Marc Mohan; Scott McCloud; Les Daniels; Peter Sanderson; Mike Benton; Gerard Jones; Dan Raviv; Jon B. Cooke; Michael Dean; Gary Groth; Dirk Deppey; Darren Hick; R. C. Harvey; Don Markstein; Jim Arnash; Jean Depelley; Valerie D'Orazio; Christopher Irving; Robert Beerbohm; Mike Gartfam; Jennifer M. Contino; Lee Atchison; Matt Povey; Richard Halegua; Paul O'Brien; Gareth Atha; Rik Offenberger; Jerry A. Sierra; David Fear; MSN.com; Associated Press; Mary Savigar and Damon Zucca; David E. Sumner; Nancy Klingener; J. T. Thompson, Solares Hill Design Group; Bob Harras; Jim Sokolowski; Chris Claremont; Joe Simon. And, of course, my ol' pal Stan Lee.

ILLUSTRATION CREDITS:

INDEX